Visual Culture
and the
Holocaust

Rutgers Depth of Field Series

Charles Affron, Mirella Jona Affron, Robert Lyons, Series Editors

———

Richard Abel, ed., Silent Film

John Belton, ed., Movies and Mass Culture

Matthew Bernstein, ed., Controlling Hollywood: Censorship and Regulation in the Studio Era

John Thornton Caldwell, ed., Electronic Media and Technoculture

Marcia Landy, ed., The Historical Film: History and Memory in Media

Peter Lehman, ed., Defining Cinema

James Naremore, ed., Film Adaptation

Stephen Prince, ed., Screening Violence

Valerie Smith, ed., Representing Blackness: Issues in Film and Video

Janet Staiger, ed., The Studio System

Linda Williams, ed., Viewing Positions: Ways of Seeing Film

Barbie Zelizer, ed., Visual Culture and the Holocaust

Edited and with an Introduction by
Barbie Zelizer

Visual Culture and the Holocaust

Rutgers
University
Press
New Brunswick,
New Jersey

Library of Congress Cataloging-in-Publication Data

Visual culture and the Holocaust / edited and with an introduction by Barbie Zelizer.
 p. cm.—(Rutgers depth of field series)
 Includes bibliographical references and index.
 ISBN 0-8135-2892-5 (alk. paper)—ISBN 0-8135-2893-3 (pbk.: alk. paper)
 1. Holocaust, Jewish (1939–1945), in art. 2. Arts, Modern—20th century. I. Zelizer,
Barbie. II. Series.

NX650.H57.V57 2000
700'.458—dc21 00-034203

British Cataloguing-in-Publication Data for this book is available from the British Library

Manufactured in the United States of America

Contents

FILM

ARTIFACTS

PHOTOGRAPHS

THE BODY

INTERNET AND THE WEB

Visual Culture
and the
Holocaust

Barbie Zelizer

Introduction:
On Visualizing the Holocaust

The visualization of the Holocaust remains one of the quandaries of Holocaust representation. Through films, television, cultural artifacts, art, comic books, and photographs, the Holocaust's visualization is so prevalent that it has become an integral part of our understanding and recollection of the atrocities of World War II. It is difficult to contemplate the Holocaust without traces of familiar visual images coming to mind.

Yet we do not know enough about our capacity to visualize those atrocities. Although we know that visualization works best when it plays to the schematic, iconic, and simplistic features of a representation, we have not yet figured out the ways in which those dimensions facilitate our understanding of real-life events in certain ways and not others. *Visual Culture and the Holocaust* aims to enhance our understanding of the Holocaust's visual representation. It examines the shape of the Holocaust's visual representation and considers the impact of that representation on collective understanding of the phenomenon of Nazi atrocity. Given that generations of individuals were not alive to experience the Holocaust firsthand, its visual representation thereby possesses a critical importance in the shaping of public consciousness.

This book considers the visualization of the Holocaust through its various domains of visual representation. Expanding on the traditional forms of representation that have been associated with the Holocaust, it explores a wide and increasing number of settings by which the Holocaust has come to be visually represented—in film, photography, comic books, art and artistic installations, museum artifacts, the human body, television and video, and the Internet. In so doing, it gives pause to the surplus of visual material that has proliferated over the past half-decade or so in order to consider what it means to visualize the Holocaust, why doing so makes sense, for whom and under which conditions it works most effectively.

When thinking about visual representation and its emergence and sustenance as a way of representing the Holocaust, one is struck by the extent to which Western epistemology has always been ocular-centric or vision-based. With "the seen" taken as a primary ground of knowledge in Western thought, "seeing" has

become in many cases a metaphor for perspective. In this sense, the ways in which the Holocaust is visually represented have become a concrete corollary for our sense of how the Holocaust means.

Yet we have at our disposal more ways of "seeing" the Holocaust than we realize at first glance. This book provides one attempt to consider the array of existing visual representational forms by which we have come to "see" the Holocaust. Using the conventions that are available within each domain of representation, the translation of Nazi atrocity into visual form in itself is seen not only as an act of expression but as an act of negotiation with the array of meanings by which the Holocaust presents itself to us.

What does it mean to visualize the Holocaust? To capture all that it entailed? To capture part of what it entailed? To capture the core of what it entailed? We have long assumed that each of these propositions is doubtful, for, as Saul Friedlander (1992) reminded us at the beginning of the 1990s, the Holocaust lies beyond the limits of representation. Yet if we view representation as translation work rather than mere reportage, as metaphor rather than index, as incomplete rather than comprehensive, then we admit the frailty of representational codes into our own expectations of what each representational code can and should do. In so doing, we take the conversation about Holocaust representation beyond its "preferred" template, that which has tended to privilege the factual over the represented, and silence the alarm bells that tend to ring when representation tugs at reality. In visual representation, these alarm bells have encouraged evaluations that are of two minds: first, to steadfastly uphold the underprivileging of the visual alongside the verbal; and second, to valorize visual forms like the filmed testimony, archival photograph, or documentary film more than representations that track reality in a less manifest fashion. This book, then, contemplates a multivalent jump forward: it leaps into terrain that utilizes the visual as the simultaneous high and low ground of Holocaust representation, a default setting for considering the Holocaust not only through high modes of visual representation but also through recent phenomena such as virtual reality or tattoos, its so-called low modes. Each domain boasts its own shadows and reflections, and each needs to be considered on its own terms.

It is against these frailties that this book is set in place. Each domain of visual representation outlined here translates some aspect of the Holocaust into another code by which it can be made differently meaningful. Whether it be the sharp juxtapositions of Judy Chicago's vases of flowers and survivors' pained faces or the façade of a Holocaust monument in Germany that disappears as it dips underground, the translation work involved in visualizing the Holocaust borrows from other codes of meaning to lend shape to the horrific and the atrocious. And, as with all translation work, each act of representation succeeds by overstating certain aspects of that which is being represented and understating others. No act of translation succeeds by reproducing the original event in its entirety.

At heart in much of this discussion lies a recognition of the uneasiness set in place by each of these domains surrounding the popularization of the Holocaust. When *Schindler's List* was released in 1993, we asked ourselves whether Stephen Spielberg had matured sufficiently as a filmmaker to leave behind *E.T.* and *Jaws* and do the Holocaust justice (Loshitzky, 1997). When the artist Robert Morris affixed neon lights and dashes of red paint across a dead naked woman in Bergen-Belsen and turned her into a contemporary Sleeping Beauty, we wondered about the appropriateness of recycling such an atrocious image into the realm of erotic art (Zelizer, 1998). When the U.S. Holocaust Memorial Museum played with the idea of generalizing the Holocaust beyond the Nazi experience to additional, more contemporary atrocities, we concerned ourselves with whether and how to retain the separate category of Nazi horror (Linenthal, 1995). And when Roberto Begnini won award upon award from the filmmaking community for his film *Life Is Beautiful*, we caustically wondered how it was possible to render the Holocaust comedic. At the heart of each of these questions was an attempt to wrestle with expectations that visual representation could, should, and would provide us with an altered glimpse of the horrific nature of Nazi atrocity.

But are we asking the right questions about these domains of representation? Might we not be better served by asking what these modes of representation do differently from each other than by focusing on where they each fall short in comparison with some honorific standard? In other words, by admitting the frailty of each visual code of representation, we may find ourselves better able to go beyond that frailty and locate the strengths of each code.

It is upon these premises that this book emerges. In separating out each domain of representation, *Visual Culture and the Holocaust* tackles the codes and conventions by which the different modes of Holocaust visualization have been independently set in place. Significantly, none of these domains of representation is mutually exclusive. Photographs appear as the grounding of artwork, monuments reproduce the distinctive lines of familiar paintings, and films incorporate familiar televised sequences. Visual representation is always at some level concerned with transformations, and the visuals of the Holocaust have been recycled, reclaimed, and refashioned to fit the codes and conventions of the mode of visual representation that is at hand. Yet each depends in some sense on our familiarity with an aesthetic through which we first saw visual evidence of Nazi atrocity.

This book is both wide-ranging in its tracking of visual domains of representation as well as broad in its inclusion of major scholars from different geographic locations and academic disciplines. Scholars from the United States, Britain, the Netherlands, Israel, Canada, and Germany have used the academic tools of film, fine art, comparative literature, German, art history, Jewish studies, English, communications, philosophy, law, and museum studies to provide here a variegated look at how we "see" the Holocaust in the contemporary era. Through this variegated setting, *Visual Culture and the Holocaust* aims to advance

our understanding of how the different domains of the Holocaust's visual representation help us see.

The book begins with two essays that tackle the general realm of the Holocaust's visual representation. In her essay "In Plain Sight," German and comparative literature scholar Liliane Weissberg explores what it means to visually accommodate a Holocaust aesthetics. Most recently editor of Hannah Arendt's *Rahel Varnhagen: The Life of a Jewess* (1997) and coeditor (with Dan Ben-Amos) of *Cultural Memory and the Construction of Identity* (1999), Weissberg argues for an aesthetic sensibility that admits both silence and absence as its formulating principles, because it suggests a different understanding of visual culture and the Holocaust than that accorded other events. In tracking different examples of the Holocaust's visual representation, including the placement of objects in the U.S. Holocaust Memorial Museum and a recently published photographic album of concentration camps, Weissberg discusses not only the aesthetization of the Holocaust but also its ethical and political consequences.

Following upon his important work in Holocaust memory (*Twilight Memories: Marking Time in a Culture of Amnesia*, 1996), critical scholar Andreas Huyssen addresses the general domain of visual representation by considering *Maus*, Art Spiegelman's second-generation account of the Holocaust, through Theodor Adorno's concept of mimesis. Huyssen demonstrates that mimesis offers a way of offsetting the long-held distinction between mass culture and high culture by allowing us to approach the unapproachable and imagine the unimaginable through representations that employ mimesis. By reading *Maus* in terms of its mimetic dimension (the personal, historical, and traumatic), Huyssen takes us beyond an existing stalemate in debates about how to represent the Holocaust properly. The concept of mimesis invalidates the lingering effects of the high culture versus mass culture debate that was influentially articulated by Adorno himself over fifty years ago and that has been so central in discussions of Claude Lanzmann's *Shoah* and Stephen Spielberg's *Schindler's List*. Mimesis also couples Spiegelman and Adorno in a way that allows us to read them against the grain of both their own basic convictions and those of long-standing Holocaust scholarship. Importantly, Huyssen raises the question whether Adorno's own writing helped block certain representational possibilities of the Holocaust until now.

These essays set the stage for the fundamental concern that lies at the core of the book's remaining chapters. They raise the question of how we can best understand, evaluate, and appreciate all fields of the Holocaust's visual representation. Pushing us beyond our default assumption that the visual might look different from its nonvisual counterpart, these essays encourage us to evaluate the different domains of visual representation against their own strengths and weaknesses.

The remainder of the book considers the visual representation of the Holocaust domain by domain. First on the agenda is art, the ways in which the Holocaust

has been represented in artistic installations. Long heralded as a fertile domain for visualizing the Holocaust, art and artistic installations have wavered in the degree to which they have made the Holocaust explicit. In these essays, two scholars take the issue of artistic representation further, by interrogating the boundaries between artistic representation and other modes of engagement with the Holocaust.

Following upon his recent book *Caught by History: Holocaust Effects in Contemporary Art, Literature, and Theory* (1997), Dutch museum director and comparative literature scholar Ernst van Alphen tackles the crossing between artistic and historical representation. He discusses installations by French artist Christian Boltanski that adopt those modes of representation that are supposed to provide an objective, truthful account of past reality. His essay, "Deadly Historians: Boltanski's Intervention in Holocaust Historiography," contends that Boltanski's installations—which consist of vitrines, collections of photographic portraits, and inventories—are privileged archival genres that attempt to represent the historical paradigm and embody a promise of the presence of the past. However, Van Alphen argues that Boltanski's return to these historical genres reveals an awareness that what is being reconstructed is also lost. Boltanski's collections, archives, and inventories have a direct impact on historical recording, in that they underscore the disciplining of history as a scholarly field. Reenacting the Holocaust in unexpected and uncanny ways, Boltanski forces us to realize that the disciplining of history was exactly what the Nazis did as they made history and practiced genocide.

Art historian Lisa Saltzman similarly considers the intersection between art and history, but she adds poetry into the consideration. Extending upon her recent work on the postwar German painter Anselm Kiefer (*Anselm Kiefer and Art after Auschwitz*, 1999), she pursues the possibilities and impossibilities of painterly representation in the aftermath of postwar abstraction and historical trauma. Her essay, "Lost in Translation: Clement Greenberg, Anselm Kiefer, and the Subject of History," addresses a series of Kiefer's works from the 1980s that are conventionally understood to translate poetry (Paul Celan's "Fugue of Death") and, concomitantly, history (the historical trauma of the Holocaust) into the visual field of postwar painting. Capturing the intertwining of different modes of representation that bear upon the visual, she pursues the very specificity of Kiefer's act of translation and representation in the aftermath of historical trauma, while exploring another act of translation, that performed by the reigning critic of modernist painting, Clement Greenberg. He, too, translated Celan's "Fugue of Death," in this case, from German to English, for the pages of *Commentary* in 1955, producing in poetic form that which he denied to the pictorial field of modernist painting. Thus, as much as the essay explores the very specificity of Kiefer's project, it also considers the subject of history in postwar aesthetics and painting.

Following its consideration of art, *Visual Culture and the Holocaust* tackles the controversial yet increasingly popular domain of televisual and video representation of the Holocaust. A growing field over the past four decades that boasts

distinct formulas, genre of programming, and predictable schedules, the intersection of television, video, and the Holocaust is one of the most widely accessible domains of visual representation. The two essays here isolate two moments at either side of the temporal continuum in which television and video Holocaust representations situate themselves—early uses of television in the 1960s and the most recent trend in video testimonies.

Expanding upon his recent book, *While America Watches: Televising the Holocaust* (1999), Jewish studies scholar Jeffrey Shandler addresses the televisual relay of the war crimes trial of Adolf Eichmann by the Israeli government, held in Jerusalem in the spring and summer of 1961. In the essay, "The Man in The Glass Box: Watching the Eichmann Trial on American Television," Shandler demonstrates that the trial was not only a major watershed of Holocaust remembrance but also a landmark of communications history—the first major trial to be televised internationally, anticipating Court TV by a full three decades. Championed as a technological marvel that enabled "the whole world to have a seat" in the courthouse, the televised coverage of the trial in fact proved to have a more complex impact on the trial's reception, particularly in the United States. While the medium promised viewers an unprecedented opportunity to scrutinize and judge a man regarded as the embodiment of evil, television actually offered a frustratingly unsatisfying spectacle. "Watching Eichmann," which emerged as the central activity for many trial observers, became an exercise in confronting the performative limitations of public trials and of television's ability to reveal and enlighten. Indeed, the inscrutable, undemonstrative presence of Eichmann on television may have validated Hannah Arendt's explanation of the case as a lesson in the "banality of evil."

Literary scholar Geoffrey Hartman of Yale University moves to the other side of the temporal continuum to consider yet another role of television and video in representing the Holocaust—video testimonies. Coming directly from his experience as a founder and project director of Yale's Fortunoff Video Archive for Holocaust Testimonies, Hartman utilizes the considerable time he has spent with this audiovisual genre to raise questions about memory, pedagogy, and cultural transmission. Expanding on some of his most recent work, including *The Longest Shadow: In the Aftermath of the Holocaust* (1996), Hartman uses his essay, "Tele-Suffering and Testimony in a Dot Com Era," to discuss the importance of video testimonies for memory and the ways in which this new genre has changed the communicative environment. The essay also addresses certain problems that have emerged as video has become an increasingly fashionable mode of representing the Holocaust.

One of the oldest domains of visual representation of the Holocaust is that of film, and hundreds of cinematic representations have appeared over the past half-decade, ranging from the documentary to the tragi-comedic. *Visual Culture and the Holocaust* explores the domain of film, by first reproducing film and literary scholar Miriam Hansen's seminal essay, "*Schindler's List* Is Not *Shoah:* The

Second Commandment, Popular Modernism, and Public," which appeared in *Critical Inquiry* (Winter 1996). In this essay, Hansen tracks the critical and controversial reception of the film and the way in which visual Holocaust remembrance connects to a more general linkage with the cinema, television, and American intellectual life. Hansen identifies three levels of public reception to *Schindler's List* and connects them to broader issues concerning cinematic subjectivity, the question of representation, and the problem of narrative.

The next essay considers one of the most productive settings of films concerning the Holocaust—Israel. In "Hybrid Victims: Second-Generation Israelis Screen the Holocaust," film scholar Yosefa Loshitzky, author of *Conflicting Projections: Identity Politics on the Israeli Screen* (2000) and editor of *Spielberg's Holocaust: Critical Perspectives on Schindler's List* (1997), discusses how art has preceded purely political debate in Israeli cinematic representations of the Holocaust. Loshitzky argues that Holocaust films made by second-generation Israelis show more openness toward the more contradictory and disturbing aspects of the event, opening a new space in Israeli public discourse to the formerly suppressed plight of the diaspora survivors and to the effect of their lived experience on their sons and daughters. Circumstances as wide-ranging as the emergence of the Israeli "new historians" and their revisionist reading of the history of the Israeli-Palestinian conflict, the corrosive effect of the Intifada (the Palestinian popular uprising) on the Israeli public, and the start and continuation of the peace process with the Palestinians and other Arab neighbors, have all impacted upon the Holocaust's visual representation, synthesizing the concerns of Israel's artistic, intellectual, and academic communities and encouraging the Israeli public at large to reexamine the space occupied by the Shoah in the grand narrative of Zionism.

As contemporary museums have become increasingly variegated and interactive environments for assessing and engaging artifacts, the materiality of the Holocaust's visual representation, manifested in artifacts, has come under increasing degrees of public attention. Two essays discuss the employment of visual artifacts in two museum settings, one in Berlin and one in Israel.

In "Daniel Libeskind's Jewish Museum in Berlin: The Uncanny Arts of Memorial Architecture," literary scholar James Young, author most recently of *At Memory's Edge: After-Images of the Holocaust in Contemporary Art and Architecture* (2000), considers the fundamental question of how a city "houses" the memory of a people no longer at home in that city. Analyzing Daniel Libeskind's Jewish Museum in Berlin, Young recounts the story of Libeskind's attempt to help Berlin reintegrate its lost Jewish past. That story, he argues, begins with the establishment of the original Jewish Museum in 1933 and situates itself in Libeskind's redesign of a place to house Jewish memory in Berlin. Via its antimodernist design, the museum articulates the dilemma Germany faces whenever it attempts to formalize the self-inflicted void at its center—the void of its lost and murdered Jews.

Communications scholar Tamar Katriel takes the Holocaust's visual

representation into the Israeli museum. Following her most recent book, *Performing the Past: A Study of Israeli Settlement Museums* (1997), Katriel explores the phenomenon of Israeli heritage museums and the role that the Holocaust plays in lending them a coherent theme. Focusing on the immigration of Jewish refugees from Nazi persecution, her essay, "From Shore to Shore": The Holocaust, Clandestine Immigration, and Israeli Heritage Museums," demonstrates how the story of the Holocaust has been incorporated within the broader story of Jewish national struggle. Katriel explores a range of representational practices, both verbal and visual, by which the story of clandestine immigration from Nazi Europe has found its climax in a Palestine that narratively emerges as a haven for persecuted and homeless Jews. Combining the core themes of victimage and heroism, she inventories the museum setting by which the Holocaust serves as background to the story of clandestine immigration.

Photography of the Holocaust, which had its beginning in documentary images of the atrocities, has had a long afterlife in the images' recycling from the time of Nazi persecution. The two essays here consider the boundaries of photographic authority in conjunction with larger meaning systems about the Holocaust.

In "Surviving Images: Holocaust Photographs and the Work of Postmemory," French and comparative literature scholar Marianne Hirsch, author of *Family Frames: Photography, Narrative and Postmemory* (1997), tackles the dilemma of repetitive and recycled Holocaust photos. Tracking their appearance in venues as wide-ranging as the Tower of Faces in the U.S. Holocaust Memorial Museum and the work of cultural critic Susan Sontag, Hirsch argues that the Holocaust's visual landscape has been limited and reduced to a repetitive stock of the same photos seen in endless settings. She contends that the compulsive and traumatic repetition of such photos fills a recuperative function of connecting across generations, forcing later generations to work through the traumatic past of their forebears.

I adopt a slightly different take on Holocaust photos in my discussion of the photos of the liberation of the concentration camps of World War II. Following upon my recent book, *Remembering to Forget: Holocaust Memory Through the Camera's Eye* (1998), here I examine the way in which the visualization of the atrocity story has accommodated the issue of gender. In "Gender and Atrocity: Women in Holocaust Photographs," I argue that the atrocity narrative is unable to accommodate the issue of gendered experience within the broader visual representation of atrocity. Instead, the gender of women in Holocaust photos is simplified, either overgendered in ways that play to stereotypical notions of gender or rendered genderless. This suggests disturbing findings concerning the inability of atrocity to reflect the nuances, complications, and contradictions that exist in gendered experience.

Visual Culture and the Holocaust also tackles a controversial, if increasingly recognized, domain of visual representation—the human body. Emerging as the embodied articulation of numerous rituals and taboos concerning its "appropriateness" as a vehicle of representation, the body is discussed in two essays as a

terrain for mnemonic impulses, both at the time of the Nuremberg trials and in contemporary instances of remembering the Nazi atrocities.

In his essay, "The Shrunken Head of Buchenwald: Icons of Atrocity at Nuremberg," reprinted from *Representations* (Summer 1998), legal scholar Lawrence Douglas demonstrates that the shrunken head of Buchenwald which was displayed during the Nuremberg trials possesses not only instrumental but symbolic importance. By serving as an icon of atavism, the shrunken head presents an image of atrocity familiar to liberal jurisprudence that facilitated the trial's progression. It visually reminds the public of the efficacy of the law as civilization's bulwark against barbarism and helps underscore Nazi aggression as a barbaric assault against civilization.

Art historian Dora Apel addresses an equally controversial site of visual memory and the body—tattooed Jews. In "The Tattoed Jew," Apel analyzes the form of full-body tattoos of graphic concentration camp imagery, as embodied by 24-year-old California photographer Marina Vainshtein. Apel argues that the photographer defies the scriptural ban on cutting or marking the body and instead physically inscribes herself into a history for which she was born too late. Her tattoos must thereby be read as a personal testimonial to the events of the Holocaust, a reenactment of memory performed by a surrogate witness in whom trauma has also been induced.

Visual Culture and the Holocaust concludes its exploration of the Holocaust's visual representation by attending to one of its newest venues—virtual reality, exemplified by the Internet and the Web. Fast becoming the most prolific setting for information relay, the domain of virtual representation is new enough to require significant scholarly attention. The two essays here consider two instances of the Holocaust's virtual representation, creating a template by which the Holocaust is brought into interactive, domesticated, and personal space.

In "Clicking on Hitler: The Virtual Holocaust @Home," media scholar Anna Reading explores the shape of the Holocaust's virtual representation. She considers materials provided on the Internet, the World Wide Web, and CD-ROM and argues that the interactive experiences with these documents, photographs, film footage, commentaries, and multimedia CD-ROMs suggest an encounter with Holocaust materials that may be qualitatively different from that offered by more traditional visual forms. Reading considers how such interactive forms narrativize Holocaust memory in a nonlinear manner and raises questions concerning the particular ways in which cyberspace and interactive media shape a topic such as the Holocaust.

Alongside Reading's essay, fine arts scholar Elizabeth Legge examines the Internet installations of Vera Frenkel's website *Body Missing*. In "Analogs of Loss: Vera Frenkel's *Body Missing* (http://www.yorku.ca/BodyMissing)," Legge demonstrates how Frenkel uses the Internet illusion of infinite space and time to situate the installation in a number of imagined times and places simultaneously—in a 1941 war zonc, a downtown bar in the present, and the Vienna Academie für Bildenden Kunst, which refused Hitler admission. Through it all, Frenkel recycles

artworks originally pillaged by the Nazis. Legge shows how Frenkel takes on the problem of representation by turning conceptual art's love of documentation inside out: the rigorous documentation and coding of the transported works of art stand for the bureaucracies of the Holocaust. Legge argues that loss must be unhomogeneous, implying instead multiple possibilities, shifting categories, and relative and infinitely malleable truths.

Visual Culture and the Holocaust is a book about crossing boundaries—boundaries of time, of space, of issue, and ultimately of discipline. In adopting such a malleable stance on the Holocaust, the book expands what we think of as the visual domain of the Holocaust's representation. Against the broad intersection of focal points offered here, *Visual Culture and the Holocaust* aims to substantially enhance what we know of the Holocaust's visual representation. The eclecticism at the core of this book will hopefully lend its signature to advancing our understanding of what it means to "see" the Holocaust, not only in accordance with the usual suspects of the Holocaust's visual representation but with its novel and provocative agents as well.

REFERENCES

Ben-Amos, Dan, and Liliane Weissberg (eds.). 1999. *Cultural Memory and the Construction of Identity.* Detroit: Wayne State University Press.

Friedlander, Saul (ed.). 1992. *Probing the Limits of Representation: Nazism and the "Final Solution."* Cambridge, Mass.: Harvard University Press.

Hartman, Geoffrey. 1996. *The Longest Shadow: In the Aftermath of the Holocaust.* Bloomington: Indiana University Press.

Hirsch, Marianne. 1997. *Family Frames: Photography, Narrative and Postmemory.* Cambridge: Cambridge University Press.

Huyssen, Andreas. 1996. *Twilight Memories: Marking Time in a Culture of Amnesia.* New York: Routledge.

Katriel, Tamar. 1997. *Performing the Past: A Study of Israeli Settlement Museums.* Mahwah, N.J.: Erlbaum.

Linenthal, Edward T. 1995. *Preserving Memory: The Struggle to Create America's Holocaust Museum.* New York: Viking.

Loshitzky, Yosefa (ed.). 1997. *Spielberg's Holocaust: Critical Perspectives on "Schindler's List."* Bloomington: Indiana University Press.

Loshitzky, Yosefa. 2000. *Conflicting Projections: Identity Politics on the Israeli Screen.* Austin: University of Texas Press.

Saltzman, Lisa. 1999. *Anselm Kiefer and Art after Auschwitz.* Cambridge: Cambridge University Press.

Shandler, Jeffrey. 1998. *While America Watches: Televising the Holocaust.* Oxford: Oxford University Press.

Van Alphen, Ernst. 1997. *Caught by History: Holocaust Effects in Contemporary Art, Literature, and Theory.* Stanford: Stanford University Press.

Weissberg, Liliane (ed.). 1997. *Hannah Arendt's Rahel Varnhagen: Life of a Jewess.* Baltimore: Johns Hopkins University Press.

Young, James E. 2000. *At Memory's Edge: After-Images of the Holocaust in Contemporary Art and Architecture.* New Haven: Yale University Press.

Zelizer, Barbie. 1998. *Remembering to Forget: Holocaust Memory Through the Camera's Eye.* Chicago: University of Chicago Press.

High Culture, Low Culture, and the Domains of the Visual

Liliane Weissberg

In Plain Sight

*Did not our man himself, quickly after his war ended, see in the first books
of photographs of Auschwitz, Bergen-Belsen and Buchenwald naked, skeletal
men and women alive and staring in the camera, corpses lying in disorderly
piles, warehouses of eyeglasses, watches, and shoes?*
—Louis Begley, *Wartime Lies*

I. Beauty's Image

There is, no doubt, a new obsession with beauty. Just at the end of one millen-
nium and the beginning of another, literary critics, art historians, and philoso-
phers have been less concerned with the postmodern world, or with issues of
multiculturalism, than with the revival of aesthetics. "Aesthetics is returning
to the academy," declared Craig Lambert in a recent article for the *Harvard Mag-
azine* that cited English professor Emory Elliott, who organized a large conference
on aesthetics and the return of beauty at the University of California at Riverside
in 1998.[1] Speaking of his students, Elliott explained, "They want to hear about
more than race and politics" (46). While Elliott may regard beauty as the extension
of any discussion of race and politics, if not as its alternative, Elaine Scarry has
reserved beauty for individual contemplation. For her, beauty encourages its
repeated representation—"it makes us draw it, take photographs of it, or describe
it to other people"[2]—and serves as "a call" (109) for our attention. Our fascination
with beauty may have been ongoing, but it has moved to the background of our
discussion— not the least because beauty has occupied a peculiar place within
philosophical discourse, as Scarry explained:

> The sublime (an aesthetic of power) rejects beauty on the grounds that it is
> diminutive, dismissible, not powerful enough. The political rejects beauty on
> the grounds that it is too powerful, a power expressed both in its ability
> to visit harm on objects looked at and also in its capacity to so overwhelm
> our attention that we cannot free our eyes from it long enough to look at
> injustice. Berated for its power, beauty is simultaneously belittled for its
> powerlessness. (85)

"Beauty is the most discredited philosophical notion," Alexander Nehamas agreed.[3] Scarry, who wanted to rescue beauty from its victim position, insisted on its relationship to justice. A close bond between both is already expressed in language itself, as the word "fair" exemplifies: it refers to the beautiful and to the just. Moreover, Scarry saw the relationship between aesthetics and ethics as a causal one. Citing philosopher Stuart Hampshire and economist Amartya Sen, she explained: "beautiful things give rise to the notion of distribution, to a lifesaving reciprocity, to fairness not just in the sense of loveliness of aspect but in the sense of 'a symmetry of everyone's relation to one another'" (95).

If Scarry's insistence on the relationship between beauty and justice, between aesthetics and ethics seems provocative here, she claimed nothing else but to restore beauty's importance. Thus, her study achieved a certain nostalgic air. Within any social or political context, beauty became irrelevant, its notion a luxury good in the academic trade of images and words. By introducing the notion of justice, and, with it, the ethical realm, Scarry featured beauty as representative of an utopian social order, offering a pedagogical impact as well. She tried to establish a need for the perception and production of beauty, offering an argument that spoke against beauty's strongest counterclaim. A critic could argue, for example, that beauty is dangerous, that it could blind and disengage a person from his or her surroundings, and trivialize the horrors of a not-too-perfect world.

If one would exchange the notion of beauty with that of poetry, this strong claim can be ascribed to a specific historical moment, namely, the end of World War II. In 1949, shortly after his return to Germany from American exile, Theodor W. Adorno concluded that to write poetry after Auschwitz would be barbaric—if it would be possible at all.[4] No other statement by Adorno has been so often repeated as his announcement of, or perhaps demand for, the death of poetry. As Adorno explained later, his call for the end of poetry was not as much linked to its representational failings as to its irrelevance in the face of torture and death. Moreover, poetry effected pleasure. Pleasure, in turn, seemed not only untimely in view of the recent historical events, it also seemed impossible to derive from any accurate depiction of reality. "The so-called artistic rendering of the naked physical pain of those who were beaten down with rifle butts contains, however distantly, the possibility that pleasure can be squeezed from it," Adorno wrote in his *Notes to Literature*. "'Does living have any meaning when men exist who beat you until your bones break?' is also the question whether art as such should exist at all."[5]

Whereas Scarry seemed to find beauty in the natural and common objects of her surroundings, Adorno concentrated on the production of art. For Scarry, beauty gave evidence for a balance of thought and justice; for Adorno, art turned into an unjustifiable lie in the face of a reality that had excluded all ethical concerns. Pleasure, a goal that poetry and art may strive for, seemed for him antithetical to the historical event of the Holocaust, an event that Dan Diner described, quite simply, as a "break with civilization."[6] While art may strive to create some

meaning, no meaning can possibly be derived from the event of the Holocaust. But whereas Adorno's injunction has often been cited, his own revision of his stance is barely known. Thus, it is important that Ernestine Schlant reminds us of Adorno's later statement in her recent book on post-Holocaust German literature: "The enduring suffering has as much right to expression as does the tortured man to scream; therefore it may have been wrong that after Auschwitz poetry could no longer be written," Adorno wrote in 1966.[7] In the 1960s—and already at work on his own magnum opus on aesthetic theory[8]—he envisioned an art that would, quite clearly, parallel a scream. To save art, Adorno severed its ties with beauty, and introduced instead an aesthetics of pain.

II. Birthing Pains

An aesthetics of pain is nothing new, of course. One could argue that pain as much as pleasure—understood as bodily sensations—lies at aesthetics' very origin and core.

Aesthetics became a discipline in 1735, when Alexander Gottlieb Baumgarten published his treatise on poetry, *Meditationes philosophicae de nonnullis ad poema pertinentibus.* Baumgarten coined the term "aesthetics" by referring to its roots in the Greek notion of *aistheta. Aisthesis* referred to perception, and the new field was to concentrate on the perception of the human senses. Baumgarten understood aesthetics as a philosophical discipline, but it was also closely related to medicine and, as Hans Adler has persuasively shown, the newly emerging study of anthropology.[9] Aesthetics offered yet another study of the self. In Baumgarten's *Meditationes,* moreover, aesthetics did not relate to art or beauty. Indeed, the author did not mention "beauty" anywhere in this early treatise. Concentrating on the human senses as a means to learn about the world, Baumgarten bypassed any discussion of the distinction between objects of nature and objects of art that would later occupy Immanuel Kant in his *Critique of Judgment* (1790), for example—and most aestheticians in Kant's time and after him. Baumgarten's goal can be summarized easily: "Aesthetics is to be the science which will investigate perception for the purpose of describing the kind of perfection which is proper to it. It will have its counterpart in the science of logic which will perform the same office for thought."[10] Thus, Baumgarten distinguished between rational reflection and sensual perception, and posed them side by side.

In his later lectures, published as *Aesthetica* (1750/1758), Baumgarten still focused on the experience of the human body, but increasingly insisted on the question of the "perfection" of the sensatory experience.[11] With this notion of perfection, described as *perfectio cognitionis sensitivae,* aesthetics changed to become the science of the beautiful—a step that would ultimately trigger the decline of the field's importance in relationship to "traditional" philosophy (i.e., logic), as

Georg Buhr and Manfred Klaus speculate.[12] But the number of its practitioners grew rapidly. "Our time seems to be teeming with aestheticians, more than anything else," wrote the poet Jean Paul in his own treatise on the subject at the beginning of the new century.[13]

While Baumgarten's aesthetics concentrated on "representation," insofar as an individual's senses inform him or her about the outside world, Kant placed his stress on judgment. With Kant, an individual decided whether something was beautiful. The subject, moreover, performed this judgment with the help of his or her imagination (*Einbildungskraft*), evaluating feelings of pleasure or displeasure. For Kant, aesthetics was therefore a field much different from that of logic, and removed from any objective realm. The individual contemplated an object, and perceived beauty with disinterested pleasure. Only with Karl Philipp Moritz did the discussion of beauty shift from the subject to the object itself. This new aesthetics was later elaborated by Hegel, who established a system that ordered all artistic genres and offered a place to art itself. In his *Lectures on Aesthetics*, Hegel imagined a particular closure to this system. He did not demand an end to poetry, but predicted the end of art in a process of sublimation (*Aufhebung*) that subsumed art to philosophy and religion in its historical path of progression.

Still, this history of aesthetics as a turn toward beauty—be it as simply perceived or judged by the subject, or stated of an object itself—was intricately linked not only to the experience of pleasure, but also to its opposite. Already in his *Meditationes*, Baumgarten left room for the sensory experience of pain, and this pain seemed inscribed in one of the prime examples of eighteenth-century aesthetics, the statue of Laocoon. At issue here was not the pain experienced by the subject, but by the figure rendered. The sculpture showed Laocoon struggling with a snake that was ready to bite his thigh at the moment of depiction. Laocoon's face and body were contorted.

The sculpture was discovered in 1506 just outside Rome, and was soon regarded as a masterpiece of Roman art. Hailed by the art historian Johann Joachim Winckelmann as a work of "noble simplicity and quiet grandeur," it became an emblem for German classicism[14] and received a much wider European reception as well. Lessing's essay on the *Laocoon*, published in 1766, was one of the earliest pieces to follow Winckelmann's mid-century work on Greek art, and gained instant fame. In his essay, Lessing discussed the differences between painting and poetry, and concentrated on nothing else but Laocoon's painful struggle with the snake. Painting froze Laocoon's scream in time, Lessing wrote, while poetic narrative was able to tell the pain's story and restore the sculpture to movement. As painting or sculpture could not incorporate time, the viewer had to add temporal changes via his or her imagination. Thus, it was important for the artist to choose a "pregnant moment" that would encourage this imagination:

> If the artist can never make use of more than a single moment in everchanging nature, and if the painter in particular can use this moment only with ref-

erence to a single vantage point, while the works of both painter and sculptor are created not merely to be given a glance but to be contemplated—contemplated repeatedly and at length—then it is evident that this single moment and the point from which it is viewed cannot be chosen with too great a regard for its effect. But only that which gives free rein to imagination is effective. The more we see, the more we must be able to imagine. And the more we add in our imaginations, the more we must think we see. In the full course of an emotion, no point is less suitable for this than its climax. There is nothing beyond this, and to present the utmost to the eye is to bind the wings of fancy and compel it, since it cannot soar above the impression made on the senses, to concern itself with weaker images, shunning the visible fullness already represented as a limit beyond which it cannot go.[15]

The viewer's ability to use his or her imagination, to reconstruct the event by unfolding the pregnant moment into a temporal sequence, finally lent credence to the visual artwork's success.

Herder, Goethe, Moritz, and others dedicated essays to the Laocoon sculpture as well, hailing this artwork as beautiful, ironically because of its contorted figure, the snake's bite, the depicted grimace, the imagined scream. As Simon Richter has convincingly shown in his study on *Laocoon's Body*,[16] the eighteenth-century construction of beauty—and hence our modern notion of it—rested on an aesthetics of pain as well.

III. Beauty and Suffering

But how is one to reconcile the tradition of Baumgarten and Lessing with Adorno's remarks on the possibilities of art after the Holocaust?

With Lessing, the artist was asked to depict a scream but to leave room for the viewer's imagination; the viewer had "to complete" the event by envisioning its motion. Thus, the scream took place in her or his mind; it was the viewer's imagination (*Einbildungskraft*) that finally appreciated the work of art. Nehamas pointed at something similar when he stated that "aesthetic pleasure is the pleasure of anticipation, and therefore of imagination, not of accomplishment" (5), although he did not reflect on the reconstruction of a temporal sequence, but rather pointed to an unknown future. But while imagination was able to perceive a depiction of suffering as an object of beauty, Lessing's explanation fell short in regard to the choice of the scream. Why should beauty emerge from (a depiction of) suffering?

Adorno was not concerned with the viewer's imagination, but with the object represented. For him, the search for a language of art after the Holocaust, the ultimate event of suffering, could only lead to one of two results. The first still insisted on a bond between art and beauty, and denied art after the Holocaust any

legitimacy. The post-Holocaust world needed to be encountered with artistic silence and an insistence on the void and gap that had marked (and in some way continues) the "break with civilization." The second option was to deny the link of art with beauty and to define art as a mode of expression instead. Thus, art had to be made to render the scream, to give words and images to a suffering that denied any listener or viewer the experience of pleasure. Perhaps art had to express suffering rather than try to depict it. It is interesting to note that this option mainly coincided with a postwar development in modern art, where forms of abstraction often replaced figurative representation, and, more radically perhaps, representational art was replaced by performance art that redrew the boundaries between art and life, time and experience. Indeed, in West Germany, where politicians and the media have engaged in an ongoing discussion of the Holocaust and German fascism, these new forms of abstraction thrived, while in East Germany, which did not view the recent fascist past as its own political history, figurative painting—socialist realism in its most generous interpretations—flourished.

In either option, the bond between pain and beauty, suffering and pleasure, which gave birth to aesthetics in the first place, was seemingly broken by an event whose "completion" exceeded human imagination. Art lost its innocence, and artists began to reject or question traditional modes of "representation." Adorno's problem of conceiving of an art after the Holocaust seemed intensified by any artistic endeavor to deal with the event directly. Holocaust memorials that represented the past by reproducing contorted human figures—many of which are reproduced in James Young's encyclopedic work[17]—seemed hopelessly naïve, too comforting even in their limitedness. There was no place for a Laocoon sculpture anymore. New attempts were made to search for a different language and other forms of expression. And, like the return of the repressed, the danger of beauty continues to haunt art, even in those works that question representation, insist on the void, counter the tradition of art. Is it possible at all to create a work of art that does not offer some sense of pleasure? And is one permitted to feel this aesthetic satisfaction in viewing a work of art about the Holocaust?

IV. Exhibiting the Holocaust

The question of the relationship of the Holocaust to art not only emerges with each work dedicated to this event and historical period, but also with the museums that are built to display the Holocaust's residue: photographs, clothing, objects gathered from concentration camps. "The Holocaust in its enormity defies language and art, and yet both must be used to tell the tale, the tale that must be told," wrote Elie Wiesel.[18] Again, a relationship between art and narrative was forged, and a tradition of aesthetics both denied and insisted upon.

Wiesel was a driving force behind the construction of the U.S. Holocaust

Memorial Museum, and the occasion for his statement was the announcement of the selection of the museum's architect, James Ingo Freed, in 1986. The museum opened in 1993. Much has been written on the museum's design, and Freed has been widely celebrated for his building. Quite obviously, Wiesel wrote only of the "use" of art, but the difference between the use of art for the documentation of the Holocaust and the artistic expression of the Holocaust is a subtle one. In a review published in the *New York Times*, Herbert Muschamp praised the building as defying us to separate "esthetics from morality, art from politics, form from content" (32), thus confirming, and at the same time challenging, Scarry's thoughts on the relationship between beauty and the ethical realm. The museum offers an overwhelming visual experience, even if the objects displayed tell a horrible tale. In the U.S. Holocaust Memorial Museum, names of places that have lost all or most of their Jewish population are engraved in alphabetical order in straight lines on the glass walls of a corridor; the first names of victims are engraved into the glass wall of another. These corridors evoke the Vietnam memorial with its seemingly endless row of victims' names. Rendered in glass, however, the museum's inscriptions do not bear the heaviness of any gravestone. Like smoke from chimneys, these names seem to dance in air and, at the same time, diffuse the light and provide an oblique view of the floor below. Bridges evoke those built to connect parts of the Warsaw ghetto, but they are crafted in perfectly rendered steel. The building itself offers multiple angles, and the glass panels refract light. Thus, the architecture alludes not only to the architectural models of the ghetto and concentration camp, but also to the refraction in which we are now forced to view the historical events.

The *Architectural Record* lauded the design as a challenge to "literal architectural interpretations of history." For this journal's critic, however, another separation could be made. The Holocaust Museum could function without its objects:

> At first glance, the U.S. Holocaust Memorial Museum . . . appears to mirror the built symbols of American democracy that surround it. PCF design partner James Ingo Freed, however, organizes these elements into a cathartic evocation, even without exhibits, of the physically and psychically disturbed world.[19]

Freed's building, praised for a design that would allow multiple point of views and interpretations, wanted to tell the story of the Holocaust already, as well as the ambiguity of the symbols of American democracy that surround it and that it transforms. The museum structure itself may suffice as a memorial, without offering any of the "authentic" objects of the Holocaust that its rooms want to display, and it can become such a memorial because of its artistic success. A brochure about the museum, published by Freed's architectural firm, is distributed at the museum's entrance. It gives minute details of the museum's plan and the story of its construction, and is a description of an object fully mastered by its

creators. It is longer, and more extensive, than any descriptions of the displayed exhibits. New museum buildings have been praised elsewhere for their appropriateness, innovative design, and visual gratification. But Freed's building attempted an unusual effort. Its steel and glass construction of corridors not only tells the story of ghetto bridges and railroad tracks, but turns them into an object praised for its aesthetic satisfaction, even pleasure.

In his book on the Holocaust Museum, its first director, Jeshajahu Weinberg, was eager to describe it as a "living museum."[20] What keeps a museum that offers objects of death alive? While the U.S. Holocaust Memorial Museum was opened to exhibit an already established and growing collection of images and objects relating to the Holocaust, the Jewish Museum in Berlin has not been conceived of as a Holocaust museum at all. It was planned as an "Extension to the Berlin Museum," and to house Berlin's small collection of Jewish artifacts. Initially, at least, the Berlin Museum's theater collection should be added there as well. Daniel Libeskind's design of 1989 coincided with a new period in German history: the fall of the Berlin Wall and the move for German reunification.

Libeskind created the building in the shape of a broken Star of David that extends the older, classical structure of the Berlin Museum. It came to signify German Jewish history and Berlin history after the Holocaust. Like Freed's building, Libeskind's museum's design was guided by a list of victims' names. Freed etched them in glass on the walls of his corridors, Libeskind used them as a builder's alphabet. While Freed tried to reimagine elements of concentration camp architecture, Libeskind's structure lived by abstraction. He described it thus:

> [T]he first aspect is the invisible and irrationally connected star which shines with absent light of individual address. The second one is the cut of Act Two of [Arnold Schönberg's opera] *Moses and Aaron,* which has to do with the non-musical fulfilment of the word. The third aspect is that of the deported or missing Berliners, and the fourth aspect is Walter Benjamin's urban apocalypse along the One Way Street. . . . Out of the terminus of history, which is nothing other than the Holocaust with its concentrated space of annihilation and complete burn-out of meaningful redevelopment of the city, and of humanity—out of this event which shatters this place comes that which cannot really be given by architecture. The past fatality of the German Jewish cultural relation in Berlin is enacted now in the realm of the Invisible. (It is this remoteness which I have tried to bring to consciousness.)[21]

Libeskind's building—a building which relates to the invisible, which "enacts" the impossibility of architecture rather than architecture itself—has become a landmark nevertheless. Like Freed, Libeskind received multiple awards for his museum, and it has indeed become a tourist site even before its completion. Tour guides lead visitors through the empty building. The official opening of the museum has now been delayed until 2001, and no concrete plans for the exhibitions have been finalized yet. Thus, it is Libeskind's building which has realized precisely what the *Architectural Record*'s reviewer had imagined: it is a museum that could

exist without any exhibitions. Planned to house a collection that should give evidence of the Jewish life in Berlin, it has, perhaps unavoidably, turned into the only Holocaust museum in Germany. One may suspect that it is not only the "cathartic effect" of its dramatic performance that pleases the museum's many visitors. This is not a building for the blind. Like Freed's structure, although more by symbolic abstraction than by visual citations, it can offer aesthetic pleasure.

It is difficult to separate Freed's building from the plans of the exhibition designers who use the building's features and the objects displayed to forge a bond between the visitor and the victim.[22] Libeskind's deconstructionist building, on the other hand, offers a challenge for exhibitors. In Libeskind's writings, it is interesting to note how the notion of the void and the invisible shifts from the impossibility of the depiction of the Holocaust to the invisibility of a higher power in which faith may rest: "[It is a] conception, rather, which reintegrates Jewish/ Berlin history through the unhealable wound of faith, which, in the words of Thomas Aquinas, is the 'substance of things hoped for; proof of things invisible'" (87). Lessing's imagination that tries to complete the sculpture's narrative is here replaced by the unhealable wound of faith and the paradoxical projection of hope.

If Libeskind's museum is able to turn recent history into a work of art, has art become just that, an "unhealable wound of faith"? The Greek term for wound is, of course, trauma. Libeskind's architecture seems to be inherently informed by psychoanalytic theory—the trauma not only of the Holocaust, but of architecture itself: "It's not a collage or a collision or a dialectic simply, but a new type of organization which really is organized around a center which is not, the void, around what is not visible. And what is not visible is the collection of this Jewish Museum, which is reducible to archival and archeological material since its physicality has disappeared" (87).

V. The Origin of the Work of Art

Human beings give testimony. Testimonies are also given by objects. In Freed's Holocaust museum, hundreds of photographs of the prewar Lithuanian shtetl Ejszyszki near Vilnius and its inhabitants, placed in a tower-like structure, are made to tell the story of a destroyed community. Another room offers not photographs, but objects, hundreds of shoes of the victims of the Majdanek concentration camp near Lublin, Poland. Metonymically, they give evidence for people about whom little more is known today.

Miles Lerman, national campaign chairman for the museum, recalled the transfer of artifacts from Poland in one of his fund-raising letters, and the moment when he was asked to pose for a photograph with a child's shoe:

> I was asked to pose for a photograph with one of these items—a child's shoe. Let me tell you, when this little shoe was handed to me, I froze.

> Bear in mind that I am a former partisan. I was hardened in battle and I deal with this Holocaust story almost on a daily basis. But when I held in my hand that shoe—the shoe of a little girl who could have been my own granddaughter—it just devastated me.[23]

An object like a shoe should aid identification and bridge time. But Lerman did not speak about any shoe, but the shoe of a child whose innocence was made palpable by the object. Innocence and victimhood came within one's grasp. The museum wanted to repeat this experience, even if the objects exhibited were beyond the visitor's reach.

In the museum's exhibition, however, this child's shoe is not singled out. It is the mere number of shoes, a fraction of the surviving pairs found in a concentration camp, that gives evidence of the enormity of the crime. These were shoes sorted out by prisoners once their owners had been selected for the gas chambers, but they were not used again: sandals, walking shoes, children's slippers. In the photograph published in Weinberg and Elieli's publication, the shoes are depicted as a sea of leather and canvas, discolored by time into a uniform gray.[24] The museum installation itself does not show an endless horizontal cover; instead, the shoes are piled high in an otherwise empty room.

In 1936, Martin Heidegger, a German philosopher who was an early member of the National Socialist Party, published an essay on the origin of the work of art. In this essay, Heidegger distinguished among a (natural) thing (*Ding*), a useful artifact (*Zeug*), and a work of art (*Kunstwerk*). To elucidate the special qualities of a work of art, Heidegger chose a painting by Vincent van Gogh, depicting a pair of shoes (indeed, van Gogh painted several such paintings between 1886 and 1888).[25] Heidegger was not concerned with van Gogh's technique of painting or impressionist style. Instead, he reflected on the special properties of the shoes depicted. For him, they were useful objects that told of the soil they had touched and the feet they had protected. The shoes provided him in turn with a speculation about their probable owner and the owner's occupation (a peasant woman). Heidegger turned these observations into an almost lyrical narrative that referred to what could be seen and to what could only be imagined:

> [A]s long as we only imagine a pair of shoes in general, or simply look at the empty, unused shoes as they merely stand there in the picture, we shall never discover what the equipmental being of equipment in truth is. In van Gogh's painting we cannot even tell where these shoes stand. There is nothing surrounding this pair of peasant shoes in or to which they might belong, only an undefined space. There are not even clods from the soil of the field or the path through it sticking to them, which might at least hint at their employment. A pair of peasant shoes and nothing more. And yet.
>
> From the dark opening of the worn insides of the shoes the toilsome tread of the worker stands forth. In the stiffly solid heaviness of the shoes there is the accumulated tenacity of her slow trudge through the far-spreading and

ever-uniform furrows of the field, swept by a raw wind. On the leather there lies the dampness and saturation of the soil. Under the soles there slides the loneliness of the field-path as the evening declines. In the shoes there vibrates the silent call of the earth, its quiet gift of ripening corn and its enigmatic self-refusal in the fallow desolation of the wintry field. This equipment is pervaded by uncomplaining anxiety about the certainty of bread, the worldless joy of having once more withstood want, the trembling before the advent of birth and shivering at the surrounding menace of death. This equipment belongs to the *earth* and it is protected in the *world* of the peasant woman. From out of this protected belonging the equipment itself rises to its *resting-in-itself*.[26]

"What happens here? What is at work in the work?" Heidegger finally asked, and gave the answer himself: "[v]an Gogh's painting is the disclosure of what the equipment, the pair of peasant's shoes, *is* in truth" (664). The truth evoked by the painting not only concerned the essence of shoes, but also a truth about their bearer; they stood for her hardships as well.

For art critic Meyer Schapiro, these remarks are highly speculative, "grounded rather in [Heidegger's] own social outlook with its heavy pathos of the primordial and earthy" (138), and he rather assigned the shoes to the painter van Gogh himself. What truth could the painting show, he seemed to ask, if the individual bearer is wrongly identified? For Schapiro, van Gogh's shoes are studies in physiognomy, they replace a face's portrait. Thus, they stand less for a gendered "class of persons" (peasant women) than for an individual.[27] The picture in question offers a character study and autobiographical tale of sorts: the shoes tell of the painter's wanderings from the Netherlands to Belgium, to preach to a group of miners.

The shoes in the Holocaust museum speak less about the sufferings of their bearers, than of their lives cut short by suffering and death. The story of why they were purchased or received and worn is rivaled by that of their forced removal and of their owners' disappearance. They become useless objects; and their owners' real sufferings take place after they were left behind. Faded to a uniform color that masks their individual shapes, they are unable to tell any stories of their bearers. If Schapiro described the shoes as a form of portrait painting, these faces lost their features, they become unrecognizable. They turned into a still life. Once worn by living human beings, these shoes are now evidence of their death, and of the anonymity of their owners, the anonymity they found in death. Homogenized as one group, these shoes speak as a mass and exemplify mass murder.

Individuality has turned into this faceless mass. The pile of shoes revises van Gogh's painting as an installation that resembles conceptual art. Here, too, may rest the truth of its objects, of the material residue that is "equipment" and has reached the limits of this definition. Thus, the display of objects results in another story of the origin of art. The installation of a mountain of shoes translates into the experience of the vastness of a crime; it is a peculiar form of the sublime.

VI. Still Lives

In the winter of 1993, the Magnum photographer Erich Hartmann returned to Germany to take pictures of concentration camps that were later gathered in a volume entitled *In the Camps.* Hartmann had left Germany with his family in the summer of 1938 for America, and his journey back was emotionally charged. The time chosen—a couple of years before the fiftieth anniversary of Germany's surrender and the end of World War II—as well as the season seemed carefully chosen:

> The weather was fitting—nearly always overcast and wet; often there was snow on the ground and sometimes heavy fog in the air. The days were short and most of the time it was half dark even at noon. In the great stillness I heard little except the barking of dogs, the crunch of my shoes on the ground, sometimes the throb of my pulse. Even when my wife was along it was a voyage of silence; words are of no avail there. Visitors, if any, were few—it was the season of holidays and school vacations.[28]

While concentration camps may not be proper destinations for holidays or school vacations, they seem to have a seasonal attraction here. Not only silence is in demand (the silence of strangers, or of one's own wife), but also the absence of any visual distraction that other living beings offer. Hartmann's pictures show barracks, rooms, railroad tracks, barbed wire—some of it already replaced by a maintenance crew that preserves these sites. The photographs are taken in black and white, and a cold light and melancholic air pervade them. Architectural structures and signs appear as geometrical shapes. The property of the victims is featured as well. One picture of Auschwitz offers a pile of suitcases, placed in a showcase. It is reflected through the camera lens, taken through the glass of the showcase, and the image reflects the backlit windows of the room. The suitcases, like gravestones, bear the names of their owners, their birthdays, their places of origin; the dates of death are absent. Another picture shows an already familiar sight. In another glass case that reflects those backlit windows, Hartmann reproduces another of Auschwitz's current exhibits: a pile of shoes. Like many others in this book, this photograph is printed in a black frame that resembles a death notice. The text that accompanies the picture could have been taken from a history book:

> A top-secret document of February 6, 1843, from the Reich Ministry of Economics listed among almost three million kilograms of clothing from Auschwitz and Majdanek 31,000 men's, 11,000 women's, and 22,000 children's shoes to be redistributed to "ethnic Germans." (28)

Visible here are obviously not only the remains of the victims' possessions, but also a residue of another kind: shoes that failed to reach their new owners. The photograph documents a war effort that was stopped, quite literally, in its tracks.

While Hartmann emphasizes the mass of shoes, one shoe stands out in the window light's reflection.

The reflection of the showcase produces the simulacrum of a double exposure; the picture is a document of imprisonment that hints toward a world outside. But Hartmann renders an image that has already become a marker for the suffering of the camp's inhabitants. The museum's shoes were a "gift" from the Majdanek camp; these are photographed in Auschwitz. Both the museum installation and photograph remind the viewer that images can easily turn into repeatable motives; the pile of shoes is similar as well to the images of countless bones, corpses, and victims' objects discovered shortly after the liberation of the camps, and published by the international press.[29]

There is a certain similarity between Hartmann's black-and-white photographs and those by Ira Nowinski, for example, published in Sybil Milton's book, *In Fitting Memory*, in 1991.[30] Nowinski's photographs, which documented memorial sights, communicate a melancholy mood, work with oblique lighting, and search for new and unconventional vantage points. "His documentary style discloses the unexpected and the haunting natural beauty that exists even at sites of humanity's evil" (271), Milton wrote. For her, these were images that "enable the reader to access the visual heritage of the Holocaust" (271). But what would the "visual heritage" of the Holocaust be? Certainly, this "heritage" did not only pertain to the concentration camp sites, but to a vocabulary of images that has become a common language (see the citations in Freed's museum architecture). In Nowinski's photographs as well, no human beings were visible; the landscapes were transformed into still lifes. Trees appeared as weeping willows; in Hartmann's photographs, they are bare of leaves. In the work of both photographers, objects take on the feel of ruins, and the difference between nature and machine is blurred. Bush and shoe and wire become monuments of sorts. The perspectival geometry has a modernist feel, but the decaying structures and the wintery gloom conform to the Romantic tradition of infinite spaces and nature's grandeur, as well as its preference for ruins. These are images of mourning. The camera completes, paradoxically, the work of a technology that had death as its primary imperative, turning human beings into objects in the first place. These are not images of trauma, but of belatedness.

VII. Holocaust Aesthetics

Quite obviously, Adorno's call for the end of poetry was never heeded, not even by himself. Even after World War II and after the Holocaust, art and poetry seem to be alive and well. Moreover, we have come to witness an extraordinary amount of poetry and art created *about* Auschwitz and the Holocaust. Auschwitz has been a preoccupation for many visual artists, just as there has been the repeated

challenge to translate these recent historical events into a visual display for museums and exhibitions. The demand to articulate the limits of representation has not resulted in the end of artistic productivity. It has resulted in its own language of mourning, absence, and trauma. In the mid-twentieth century, the sculpture of Laocoon was replaced with a pile of shoes: and these shoes are no longer the sign of unique individuality, but objects of technological reproducibility. They are historical evidence and art at once. Like the *Laocoon,* they tell a narrative, too, but pain can only be shown obliquely. The Holocaust aesthetics no longer centers on the scream, but on its absence.

In its introduction of silence, the void, breaks, and afterimages, this aesthetics has found its allies in psychoanalytic theory and its conception of the unconscious, and poststructuralist philosophy. It has also produced criteria of judgment: Holocaust memorials and museum buildings, as well as individual artworks, selected through competitions whose judges ask not only for historical message or educational impact, but also for "good" art. "[B]eautiful things give rise to the notion of distribution, to a lifesaving reciprocity, to fairness not just in the sense of loveliness of aspect but in the sense of 'a symmetry of everyone's relation to one another,'" wrote Scarry. Can beauty exist when the relationships are broken, and no lifesaving reciprocity exists? Do we as artists or audience carry any ethical responsibility if we derive pleasure from "unfairness"? These questions will remain, even as the new academic interest in beauty continues.

NOTES

1. Craig Lambert, "The Stirring of Sleeping Beauty," *Harvard Magazine* (September–October 1999): 46.

2. Elaine Scarry, *On Beauty* (Princeton: Princeton University Press, 1999), 3.

3. Alexander Nehamas, "An Essay on Beauty and Judgment," *The Threepenny Review* 80 (Winter 2000), 4.

4. Theodor W. Adorno, "Cultural Criticism and Society," tr. Samuel and Shierry Weber, *Prisms* (Cambridge, Mass.: MIT Press, 1981), 34.

5. Adorno, "Commitment," *Notes to Literature* 2, ed. Rolf Tiedemann, tr. Shierry Weber Nicholsen (New York: Columbia University Press, 1991), 88, 87.

6. Dan Diner (ed.), *Zivilisationsbruch: Denken nach Auschwitz* (Frankfurt/M: Fischer Verlag, 1988).

7. Adorno, cited in Ernestine Schlant, *The Language of Silence: West German Literature and the Holocaust* (New York: Routledge, 1999), 9.

8. Adorno, *Aesthetic Theory,* ed. Gretel Adorno and Rolf Tiedemann; ed. and tr. Robert Hullot-Kentor (Minneapolis : University of Minnesota Press, 1997). Adorno's *Ästhetische Theorie* was published posthumously in 1970.

9. Hans Adler, "Aisthesis, steinernes Herz und geschmeidige Sinne: Zur Bedeutung der Ästhetik-Diskussion in der zweiten Hälfte des 18. Jahrhunderts," in *Der ganze Mensch: Anthropologie und Literatur im 18. Jahrhundert,* ed. Hans-Jürgen Schings (Stuttgart: J. B. Metzler, 1994), 96–111.

10. Karl Aschenbrenner and William B. Holther, "Introduction," in *Alexander Gottlieb Baumgarten's Reflections on Poetry/Meditations philosophicae de nonnullis ad poema pertinentibus,* tr. and ed. Karl Aschenbrenner and William B. Holther (Berkeley: University of California Press, 1954), 4.

11. For a discussion of Baumgarten's *Aesthetica*, see Hans Rudolf Schweizer, *Ästhetik als Philosophie der sinnlichen Erkenntnis* (Basel: Schwabe & Co., 1973).

12. "Ästhetik," in *Philosophisches Wörterbuch* I, ed. Georg Klaus and Manfred Buhr, 8th ed. (Leipzig: VEB Bibliographisches Institut, 1971), 119.

13. Jean Paul Richter, *Vorschule der Ästhetik* (1804), cited in Joachim Richter, "Ästhetik," in *Historisches Wörterbuch der Philosophie* I, ed. Joachim Ritter (Darmstadt: Wissenschaftliche Buchgesellschaft, 1971), 556. Translation mine.

14. Johann Joachim Winckelmann, *Reflection on the Imitation of Greek Works in Painting and Sculpture*, tr. Elfriede Heyer and Roger C. Norton (La Salle, Ill.: Open Court, 1987).

15. Gotthold Ephraim Lessing, *Lacoon*, tr. Edward Allen McCormick (Indianapolis: Bobbs-Merrill, 1962), 19–20.

16. Simon Richter, *Laocoon's Body and the Aesthetics of Pain: Winckelmann, Lessing, Herder, Moritz, Goethe* (Detroit: Wayne State University Press, 1992).

17. James Young, *The Texture of Memory: Holocaust Memorials and Meaning* (New Haven: Yale University Press, 1993).

18. Herbert Muschamp, "Shaping a Monument to Memory," *New York Times* (April 11, 1993), sec. 2; 1, 32; here 1.

19. "U.S. Holocaust Museum Challenges Literal Architectural Interpretations of History," "Design News," *Architectural Record* (May 1993): 27. Freed is a member of the architectural firm Pei Cobb Freed.

20. Jeshajahu Weinberg and Rina Elieli, *The Holocaust Museum in Washington* (New York: Rizzoli, 1995), 17.

21. Daniel Libeskind, *Countersign* (New York: Rizzoli, 1992), 86–87.

22. For a more extensive discussion, see Liliane Weissberg, "Memory Confined," *documents* 4–5 (1994): 81–98; reprinted in *Cultural Memory and the Construction of Identity*, ed. Dan Ben-Amos and Liliane Weissberg (Detroit: Wayne State University Press, 1999), 45–76.

23. Miles Lerman, undated letter mailed to potential donors, spring 1993.

24. Weinberg and Elieli, 14.

25. See Meyer Schapiro, "The Still Life as a Personal Object—A Note on Heidegger and van Gogh (1968)," in *Theory and Philosophy of Art: Style, Artist, and Society: Selected Papers* (New York: George Braziller, 1994), 136.

26. Martin Heidegger, "Origins of the Work of Art" [Der Ursprung des Kunstwerks], tr. Albert Hofstadter, in *Philosophies of Art and Beauty: Selected Readings in Aesthetics from Plato to Heidegger*, ed. Albert Hofstadter and Richard Kuhns (New York: Random House/Modern Library, 1964), 662–3.

27. Compare to Schapiro, "Further Notes on Heidegger and van Gogh (1994)," in *Theory and Philosophy of Art*, 150.

28. Erich Hartmann, "Afterword," *In the Camps* (New York: W. W. Norton & Co., 1995), 99.

29. See Barbie Zelizer, *Remembering to Forget: Holocaust Memory Through the Camera's Eye* (Chicago: University of Chicago Press, 1998).

30. Sybil Milton, *In Fitting Memory: The Art and Politics of Holocaust Memorials*, photographs by Ira Nowinski (Detroit: Wayne State University Press, 1991).

Andreas Huyssen

Of Mice and Mimesis: Reading Spiegelman with Adorno

I resist becoming the Elie Wiesel of the comic book.

—Art Spiegelman

Since the 1980s, the question no longer is *whether* to represent the Holocaust in literature, film, and the visual arts but *how* to do so. The conviction about the essential unrepresentability of the Holocaust, typically grounded in Adorno's famous and often misunderstood statement about the barbarism of poetry after Auschwitz, has lost much of its persuasiveness for later generations who only know of the Holocaust through representations: photos and films, documentaries, testimonies, historiography, and fiction. Given the flood of Holocaust representations in all manner of media today, it would be sheer voluntarism to stick with Adorno's notion of a ban on images which translates a theological concept into a very specific kind of modernist aesthetic. It seems much more promising to approach the issue of Holocaust representations through another concept that holds a key place in Adorno's thought, that of mimesis.

In his recently published book, *In the Shadow of Catastrophe: German Intellectuals Between Apocalypse and Enlightenment*,[1] Anson Rabinbach has persuasively shown how Adorno's understanding of Nazi anti-Semitism is energized by his theory of mimesis.[2] More important, however, he has linked Adorno's discussion of the role of mimesis in anti-Semitism to Horkheimer and Adorno's historical and philosophical reflections on mimesis as part of the evolution of signifying systems, as they are elaborated in the first chapter of the *Dialectic of Enlightenment*.[3] Here Horkheimer and Adorno discussed mimesis in its true and repressed forms, its role in the process of civilization and its paradoxical relationship to the *Bilderverbot*, the prohibition of graven images.[4] At the same time, the concept of mimesis in Adorno (and I take it that Adorno rather than Horkheimer is the driving force in articulating this concept in the coauthored work) was not easily defined, as several recent studies have shown.[5] It actually functioned more like a palimpsest that partakes in at least five different yet overlapping discursive registers in the text: first, in relation to the critique of the commodity form,

its powers of reification and deception, a thoroughly negative form of mimesis (*Mimesis ans Verhärtete*); second, in relation to the anthropological grounding of human nature which, as Adorno insists in *Minima Moralia*, was "indissolubly linked to imitation";[6] third, in a biological somatic sense geared toward survival as Adorno had encountered it in Roger Caillois's work, some of which he reviewed for the *Zeitschrift für Sozialfoschung*;[7] fourth, in the Freudian sense of identification and projection indebted to *Totem and Taboo*; and lastly, in an aesthetic sense and with strong resonances of Benjamin's language theory, in relation to the role of word and image in the evolution of signifying systems. It is precisely this multivalence of mimesis, I would argue, that makes the concept productive for contemporary debates about memory, trauma, and representation in the public realm. Thus it is more than merely a paradox that mimesis served Adorno to read Nazi anti-Semitism, whereas it serves me to understand the ethics and aesthetics of approaching Holocaust memory in our time.

In this essay, then, I focus on one specific aspect of memory discourse, namely, the vexing issue of (in Timothy Garton Ash's succinct words) if, how, and when to represent historical trauma.[8] My example for the representation of historical trauma is the Holocaust, a topic on which, as already indicated, Adorno had provocative things to say, although he never said quite enough. But I do think that the issues raised in this essay pertain as much to other instances of historical trauma and their representation. Whether we think of the *desaparecidos* in Argentina, Guatemala, or Chile, the stolen generation in Australia, or the post-apartheid debates in South Africa, in all of these cases issues of how to document, how to represent, and how to view and listen to testimony about a traumatic past have powerfully emerged in the public domain.

I hope to show that a reading through mimesis of one specific Holocaust image-text may allow us to go beyond arguments focusing primarily on the rather confining issue of how to represent the Holocaust "properly" or how to avoid aestheticizing it. My argument is based on the reading of a work, Art Spiegelman's *Maus*,[9] which has shocked many precisely because it seems to violate the *Bilderverbot* in the most egregious ways, but which has also been celebrated, at least by some, as one of the most challenging in an ever widening body of recent works concerned with the Holocaust and its remembrance.

But more is at stake here than just the reading of one work through the conceptual screen of another. A discussion of Art Spiegelman's *Maus* in terms of the mimetic dimension may move us beyond a stalemate in debates about Holocaust representations, a stalemate which, ironically, rests on presuppositions that were first and powerfully articulated by Adorno himself in a different context and at a different time. Reading *Maus* through the conceptual screen of mimesis permits us to read Adorno against one of the most lingering effects of his work on contemporary culture, the thesis about the culture industry and its irredeemable link with deception, manipulation, domination, and the destruction of subjectivity. While this kind of uncompromising critique of consumerist culture, linked

as it is to a certain now historical type of modernist aesthetic practice, resonates strongly with a whole set of situationist and poststructuralist positions developed in France in the 1960s (Barthes, Debord, Baudrillard, Lyotard, Tel Quel), it has generally been on the wane in contemporary aesthetic practices. For obvious reasons, however, it has proven to have much staying power in one particular area: that of Holocaust representations where Adorno's statements about poetry after Auschwitz (often misquoted, unanalyzed and ripped out of their historical context)[10] have become a standard reference point and have fed into the recent revival of notions of an aesthetic sublime and its dogmatic antirepresentational stance.[11]

This is where the issue of public memory emerges. Politically, almost everybody seems to agree, the genocide of the Jews is to be remembered (with allegedly salutory effects on present and future) by as large a public as possible, but mass cultural representations are not considered proper or correct. The paradigmatic case exemplifying this broad, though now perhaps fraying, consensus is the debate over Spielberg's *Schindler's List* and Lanzmann's *Shoah.* Spielberg's film, playing to mass audiences, fails to remember properly because it represents, thus fostering forgetting: Hollywood as fictional substitute for "real history." Lanzmann's refusal to represent, on the other hand, is said to embody memory in the proper way precisely because it avoids the delusions of a presence of that which is to be remembered. Lanzmann's film is praised as something like a heroic effort in the Kulturkampf against the memory industry, and its refusal to re-present, its adherence to *Bilderverbot,* becomes the ground for its authenticity.[12] Aesthetically speaking, these opposing validations of Spielberg versus Lanzmann still rest on the unquestioned modernist dichotomy that pits Hollywood and mass culture against forms of high art.[13] Looking at Spiegelman's *Maus* through the various discursive screens of mimesis may allow us to approach Holocaust memory and its representations today in a way different from this earlier dominant paradigm.

Narrative Strategies

Maus undercuts this dichotomy in the first rather obvious sense that Spiegelman draws on the comic as a mass cultural genre, but transforms it in a narrative saturated with modernist techniques of self-reflexivity, self-irony, ruptures in narrative time, and highly complex image sequencing and montaging. As comic, *Maus* resonates less with Disney than with a whole tradition of popular animal fables, from Aesop to LaFontaine to even Kafka. At the same time, it evolved from an American comic book countertradition born in the 1960s that includes such works as *Krazy Cat, Fritz the Cat,* and others. Yet, *Maus* remains different from the older tradition of the enlightening animal fable. If the animal fable (George Orwell's *Animal Farm* as a twentieth-century fictional example) had enlightenment as its purpose through either satire or moral instruction, *Maus* remains thoroughly

ambiguous, if not opaque, to the possible success of such enlightenment. Rather than providing us with an enlightened moral or with a happy reconciliation between high and low, human and animal, trauma and memory, the aesthetic and emotional effect of *Maus* remains jarring throughout. This irritating effect on the reader results from a variety of pictorial and verbal strategies that have their common vanishing point in mimesis, in both its insidious and salutory aspects which, as Adorno would have it, can never be entirely separated from each other.

Let me turn now to the dimensions of mimesis in this image-text. As is well-known, *Maus* as narrative is based on interviews Art Spiegelman conducted with his father, Vladek, an Auschwitz survivor, in the 1970s. Spiegelman taped these interviews in Rego Park, Queens, in the house in which he grew up, and during a summer vacation in the Catskills. These interviews trace the story of Spiegelman's parents' life in Poland from 1933 to 1944, but the telling of this traumatic past, as retold in the comic, is interrupted time and again by banal everyday events in the New York present. This crosscutting of past and present, by which the frame keeps intruding into the narrative, allows Spiegelman, as it were, to have it both ways: for Vladek, it seems to establish a safe distance between the two temporal levels; actually the tale of his past is visually framed by Spiegelman as if it were a movie projected by Vladek himself. As Vladek begins to tell his story, pedalling on his exercycle, he says proudly: "People always told me I looked just like Rudolph Valentino" (I:13). Behind him in the frame is a large poster of Rudolph Valentino's 1921 film *The Sheik* with the main actor as mouse holding a swooning mouse lady in his arms, and the whole exercycle mechanism looks remotely like a movie projector with the spinning wheel resembling a film reel and Vladek as narrator beginning to project his story. This crosscutting of past and present points in a variety of ways to how this past holds the present captive independently of whether this knotting of past into present is being talked about or repressed. Thus one page earlier, Art, who is sitting in the background and has just asked Vladek to tell him the story of his life in Poland before and during the war, is darkly framed within the frame by the arms and the exercycle's handlebar in the foreground. Vladek's arms, head, and shirt with rolled-up sleeves are all striped, and the Auschwitz number tattoed into his left arm hovers ominously just above Art's head in the frame (I:12). Both the narrator (Art Spiegelman) and the reader see Vladek's everyday behavior permeated by his past experiences of persecution during the Nazi period.

This first narrative framing is also itself split in two. In addition to the narrative frame the interviews provide, another level of narrative time shows the author Art Spiegelman, or rather the *Kunstfigur* Artie, during his work on the book from 1978 to 1991, years during which Vladek Spiegelman died and the first part of *Maus* became a great success, all of which is in turn incorporated into the narrative of the second volume. The complexity of the narration is not just an aesthetic device employed for its own sake. It rather results from the desire of members of the second generation to learn about their parents' past of which they

are always, willingly or not, already a part: it is a project of mimetically approxi-
mating historical and personal trauma in which the various temporal levels are
knotted together in a way that refuses to allow talk about the past to pass away,
as discussed in the German *Historikerstreit* of the mid-1980s.[14] The survivors'
son's life stands in a mimetic affinity to his parents' trauma long before he ever
embarks on his interviews with his father.[15] Therefore, this mimetic relationship
cannot be thought of simply as a rational and fully articulated working through.[16]
There are dimensions to mimesis that lie outside linguistic communication and
that are locked in silences, repressions, gestures, and habits—all produced by a
past that weighs all the more heavily as it is not (yet) articulated. Mimesis in its
physiological, somatic dimension is *Angleichung,* a becoming or making similar,
a movement toward, never a reaching of a goal. It is not identity, nor can it be
reduced to compassion or empathy. It rather requires us to think of identity and
nonidentity together as nonidentical similitude and in unresolvable tension with
each other.

 Maus performs precisely such a mimetic approximation. Spiegelman's
initial impetus for conducting these interviews with his father came out of a trau-
matic experience: the suicide of his mother Anja in 1968, an event Spiegelman
made into a four-page image-text originally published in 1973 in an obscure under-
ground comic under the title "Prisoner of the Hell Planet." It is only in the latter
half of the first part of *Maus* that Artie suddenly and unexpectedly comes across
a copy of this earlier, now almost forgotten attempt to put part of his own life's
story into the comics. *Maus* then reproduces the "Prisoner of the Hell Planet" in
toto (I:100–103). These four pages, all framed in black like an obituary in German
newspapers, intrude violently into the mouse narrative, breaking the frame in
three significant ways. First, in this earlier work, the figures of Vladek and Artie
mourning the death of Anja are drawn as humans, a fact that goes surprisingly
unremarked by the mice Artie and Vladek as they are looking at these pages in the
narrative of the later work. The identity of the nonidentical seems to be taken for
granted in this porousness between human and animal realms. Second, the comic
"Prisoner on the Hell Planet" opens with a family photo that shows 10-year-old
Art in 1958 with his mother on summer vacation in the Catskills.[17] It is the first
of three family photos montaged into the comic, all of which function not to
document, but to stress the unassimilability of traumatic memory.[18] Third, "Pris-
oner" articulates an extreme moment of unadulterated despair that disrupts the
"normal" frame of the interviewing process, the questioning and answering, the
bickering and fighting between father and son. These pages give testimony to
the emotional breakdown of both father and son at Anja's burial: in Art's case, it
is overlaid by a kind of survivor guilt of the second degree, once removed from the
original trauma his parents experienced. The memories of Auschwitz not only
claim Anja; they also envelop the son born years after the war. Thus Art draws
himself throughout this episode in striped Auschwitz prisoner garb, which gives
a surreal quality to these starkly executed, woodcut-like, grotesque images.

In this moment of secondary Holocaust trauma Spiegelman performs a kind of spatial mimesis of death in the sense of Roger Caillois's work of the 1930s, which Adorno read and commented on critically in his correspondence with Benjamin.[19] Spiegelman performs a compulsive imaginary mimesis of Auschwitz as space of imprisonment and murder, a mimesis, however, in which the victim, the mother, becomes perpetrator while the real perpetrators have vanished. Thus at the end of this raw and paralyzing passage, Art, incarcerated behind imaginary bars, reproaches his mother for having committed the perfect crime: "You put me here . . . shorted all my circuits . . . cut my nerve endings . . . and crossed my wires! . . . // You MURDERED me, Mommy, and you left me here to take the rap!!!" (I:103). The drawings are expressionist, the text crude though in a certain sense "authentic," but it is easy to see that Spiegelman's comic would have turned into disaster had he chosen the image and language mode of "Prisoner" for the later work. It could only have turned into psycho-comikitsch.

Spiegelman did need a different, more estranging mode of narrative and figurative representation in order to overcome the paralyzing effects of a mimesis of memory-terror. He needed a pictorial strategy that would maintain the tension between the overwhelming reality of the remembered events and the tenuous, always elusive status of memory itself. As an insert in *Maus*, however, these pages function as a reminder about the representational difficulties of telling a Holocaust or post-Holocaust story in the form of a comic. But they also powerfully support Spiegelman's strategy to use animal imagery in the later, longer work. The choice of medium, the animal comic, is thus self-consciously enacted and justified in the narrative itself. Drawing the story of his parents and the Holocaust as an animal comic is the Odyssean cunning that allows Spiegelman to escape from the terror of memory—even "postmemory" in Marianne Hirsch's terms—while mimetically reenacting it.[20]

Image Strategies

But the question lingers. What do we make of the linguistic and pictorial punning of Maus, Mauschwitz, and the Catskills in relation to mimesis? The decision to tell the story of Germans and Jews as a story of cats and mice as predators and prey should not be misread as a naturalization of history, as some have done. Spiegelman is not the Goldhagen of the comic book. After all, the comic does not pretend to be history. More serious might be another objection: Spiegelman's image strategies problematically reproduce the Nazi image of the Jew as vermin, as rodent, as mouse. But is it simply a mimicry of racist imagery? And even if mimicry, does mimicry of racism invariably imply its reproduction, or can such mimicry itself open up a gap, a difference that depends on who performs the miming and how? Mimesis, after all, is based on similitude as making similar

(*Angleichung* in Adorno's terminology), the production of "the same but not quite," as Homi Bhabha describes it in another context.[21] And *Angleichung* implies difference. Thus Spiegelman himself draws the reader's attention to his conscious mimetic adoption of this imagery. The very top of *Maus* I's copyright page features a Hitler quote: "The Jews are undoubtedly a race, but they are not human." And *Maus* II, right after the copyright page, begins with a motto taken from a Pomeranian newspaper article from the mid-1930s: "Mickey Mouse is the most miserable ideal ever revealed. . . . Healthy emotions tell every independent young man and every honorable youth that the dirty and filth-covered vermin, the greatest bacteria carrier in the animal kingdom, cannot be the ideal type of animal. . . . Away with Jewish brutalization of the people! Down with Mickey Mouse! Wear the Swastika Cross!" *Maus* thus gives copyright where it is due: Adolf Hitler and the Nazis.

But that may still not be enough as an answer to the objection. More crucial is the way in which the mimesis of anti-Semitic imagery is handled. Here it would be enough to compare Spiegelman's work with the 1940 Nazi propaganda movie *The Eternal Jew*, which portrayed the Jewish world conspiracy as the invasive migration of plague-carrying herds of rodents who destroy everything in their path. Such a comparison makes it clear how Spiegelman's mimetic adoption of Nazi imagery actually succeeds in reversing its implications while simultaneously keeping us aware of the humiliation and degradation of that imagery's original intention. Instead of the literal representation of destructive vermin, we see persecuted little animals drawn with a human body and wearing human clothes, with a highly abstracted, nonexpressive mouse physiognomy. "Maus" here means vulnerability, unalloyed suffering, victimization. As in the case of the "Prisoner of the Hell Planet," here, too, an earlier more naturalistic version of the mouse drawings shows how far Spiegelman has come in his attempt to transform the anti-Semitic stereotype for his purposes by eliminating any all-too-naturalistic elements from his drawings.

Defenders of *Maus* have often justified the use of animal imagery as a necessary distancing device, a kind of Brechtian estrangement effect. Spiegelman's own justification is more complex:

> First of all, I've never been through anything like that—knock on whatever is around to knock on—and it would be a counterfeit to try to pretend that the drawings are representations of something that's actually happening. I don't know exactly what a German looked like who was in a specific small town doing a specific thing. My notions are born of a few scores of photographs and a couple of movies. I'm bound to do something inauthentic. Also, I'm afraid that if I did it with people, it would be very corny. It would come out as some kind of odd plea for sympathy or 'Remember the Six Million,' and that wasn't my point exactly, either. To use these ciphers, the cats and mice, is actually a way to allow you past the cipher at the people who are experiencing it. So it's really a much more direct way of dealing with the material.[22]

It is, in my terms, an estrangement effect in the service of mimetic approximation, and thus rather un-Brechtian, for at least in his theoretical reflections, Brecht would not allow for any mimetic impulse in reception. Spiegelman accepts that the past is visually not accessible through realistic representation: whatever strategy he might choose, it is bound to be "inauthentic." He also is aware of his generational positioning as someone who mainly knows of this past through media representations. Documentary *authenticity* of representation can therefore not be his goal, but *authentication* through the interviews with his father is. The use of mice and cats is thus not simply an avant-gardist distancing device in order to give the reader a fresh, critical, perhaps even "transgressive" view of the Holocaust intended to attack the various pieties and official memorializations that have covered it discursively.

Of course, Spiegelman is aware of the dangers of using Holocaust memory as screen memory for various political purposes in the present. His narrative and pictorial strategy is precisely devised to avoid that danger. It is actually a strategy of another kind of mimetic approximation: getting past the cipher to the people and their experience. But before getting past the cipher, Spiegelman has to put himself into that very system of ciphering: as Artie in the comic, he himself becomes mouse, imitates the physiognomic reduction of his parents by racist stereotype, the post-Auschwitz Jew still as mouse, even though now in the country of the dogs (America) rather than the cats. Paradoxically, we have here a mimetic approximation of the past that respects the *Bilderverbot* not despite but rather because of its use of animal imagery, which tellingly avoids the representation of the human face. *Bilderverbot* and mimesis are no longer irreconcilable opposites, but enter into a complex relationship in which the image is precisely not mere mirroring, ideological duplication, or partisan reproduction,[23] but where it approaches writing. This Adornean notion of image becoming script was first elaborated by Miriam Hansen and Gertrud Koch in their attempts to make Adorno pertinent for film theory.[24] But it works for Spiegelman's *Maus* as well. As its image track indeed becomes script, *Maus* acknowledges the inescapable inauthenticity of Holocaust representations in the "realistic" mode, but achieves a new and unique form of authentication effect on the reader precisely by way of its complex layering of historical facts, their oral retelling, and their transformation into image-text. Indeed, it is as animal comic that *Maus*, to quote a typically Adornean turn of phrase from the first chapter of *Dialectic of Enlightenment*, "preserves the legitimacy of the image . . . in the faithful pursuit of its prohibition."[25]

If this seems too strong a claim, consider the notion of image-becoming-script in *Maus* from another angle. Again, Spiegelman himself is a good witness for what is at stake:

> I didn't want people to get too interested in the drawings. I wanted them to be there, but the story operates somewhere else. It operates somewhere between the words and the idea that's in the pictures and in the movement between the pictures, which is the essence of what happens in a comic. So by not focusing

you too hard on these people you're forced back into your role as reader rather than looker.[26]

And in a radio interview of 1992, he put it even more succinctly by saying that *Maus* is "a comic book driven by the word."[27]

I cannot hope to give a full sense of how the linguistic dimension of *Maus* drives the image sequences. A few comments will have to suffice. Central here is the rendering of Vladek's language taken from the taped interviews. The estranging visualization of the animal comic is counterpointed by documentary accuracy in the use of Vladek's language. The *gestus* of Vladek's speech, not easily forgotten by any reader with an open ear, is shaped by cadences, syntax, and intonations of his East European background. His English is suffused by the structures of Yiddish. Residues of a lost world are inscribed into the language of the survivor-immigrant. It is this literally—rather than poetically or mystically—broken speech that carries the burden of authenticating that which is being remembered or narrated. On the other hand, Vladek himself is aware of the problematic nature of any Holocaust remembrance, even in language, when he says: "It's no more to speak" (II:113). Spiegelman's complex arrangement of temporal levels finds its parallel in an equally complex differentiation of linguistic registers. Thus the inside narration about the years in Poland as told by Vladek are rendered in fluent English. A natural language gestus is required here because at the time Vladek would have spoken his national language, Polish. It is logical that Vladek's broken speech only appears on the level of the frame story, the narrative time of the present. Past and present, clearly distinguished by the language track, are thus nevertheless suffused in the present in Vladek's broken English, which provides the linguistic marker of the insuperable distance that still separates Artie from Vladek's experiences and from his memories. Artie, after all, always speaks fluent English as his native language.

If Spiegelman's project is mimetic approximation not of the events themselves, but of the memories of his parents, and thus a construction of his own "postmemory,"[28] then this mimesis is one that must remain fractured, frustrated, inhibited, incomplete. The pain of past trauma is repeated through narration in the present and attaches itself to the listener, to Artie as listener inside the text as well as to the reader who approaches the contents of Vladek's autobiographic tale through its effects on Artie. Artie as a *Kunstfigur*—the same but not quite the same as the author Art Spiegelman—thus becomes the medium in the text through which we ourselves become witnesses of his father's autobiographic narration. While this narration, gently and sometimes not so gently extracted from the survivor, aims at a kind of working through in language, it is a mimetic process that will never reach an end or come to completion, even if and when Vladek's tale catches up to the postwar period.

And then there is always that other most painful obstacle to a full mimetic knowledge of the past. For the process of an *Angleichung ans Vergangene,* an assim-

ilation to the past, is not only interrupted by the inevitable intrusion of everyday events during the time of the interviews; another even more significant gap opens up in the sense that only Vladek's memories are accessible to Artie. The memories of Artie's mother, whose suicide triggered Art Spiegelman's project in the first place, remain inaccessible not only because of her death, but because Vladek, in a fit of despair after her death, destroyed her diaries in which she had laid down her own memories of the years in Poland and in Auschwitz. And just as Artie had accused his mother for murdering him, he now accuses his father for destroying the diaries: "God DAMN you! You . . . you murderer!" (I:159). Anja's silence thus is total. If it was Anja's suicide that generated Art Spiegelman's desire to gain self-understanding through mimetic approximation of his parents' story and of survivor guilt, then the discovery that the diaries have been burned points to the ultimate elusiveness of the whole enterprise. Artie's frustration about the destruction of the diaries only makes explicit that ultimate, unbridgeable gap between Artie's cognitive desires and the memories of his parents. Indeed, it marks the limits of mimetic approximation, but it marks them in a pragmatic way, without resorting to new definitions of the sublime as the unpresentable within representation.

Bilderverbot and Mimetic Approximation

All of Spiegelman's strategies of narration thus maintain the insuperable tension within mimetic approximation between closeness and distance, affinity and difference. *Angleichung* is not identification or simple compassion. Artie's listening to his father's story makes him understand how Vladek's whole habitus has been shaped by Auschwitz and the struggle for survival, while Vladek himself, caught in traumatic reenactments, may remain oblivious to that fact. Rather than assuming continuity, Vladek's storytelling seems to assume a safe and neutralizing distance between the events of the past and his New York present. But his concrete behavior constantly proves the opposite. Artie, on the other hand, is always conscious of the fact that the borders between past and present are fluid, not only in his observation of his father, but in his self-observation as well. Mimetic approximation as a self-conscious project thus always couples closeness and distance, similitude and difference.

This dimension becomes most obvious in those passages in *Maus* II where Spiegelman draws himself drawing *Maus* (II:41ff.). The year is 1987; Vladek has been dead for five years; Art works on *Maus* II from the tapes which now have become archive; and *Maus* I has become a great commercial success. This chapter, entitled "Auschwitz (Time Flies)," demonstrates how beyond the multiply fractured layering of language and narrative time, the very pictoriality of the animal comic is significantly disrupted as well. We see Art in profile, sitting at his drawing table, but now drawn as a human figure wearing a mouse mask. It is as if

the image track could no longer sustain itself, as if it collapsed under its own weight. Artie's mimicry reveals itself to be a sham. The mask reveals the limits of his project. The ruse does not work any longer. The task of representing time in Auschwitz itself, just begun in the preceding chapter, has reached a crisis point.

This crisis in the creative process is tellingly connected with the commercial success of *Maus* I: the Holocaust as part of the culture industry. Crisis of representation and crisis of success throw the author into a depressive melancholy state, in which he resists the marketing of his work (translations, film version, TV) through a fit of total regression. He avoids the annoying questions of the media sharks (questions such as: What is the message of your book? Why should younger Germans today feel guilty? How would you draw the Israelis? II:42) by literally shrinking in his chair from frame to frame until we see a small child screaming: "I want . . . I want . . . my Mommy!" (II:42). The pressures of historical memory are only intensified by Holocaust marketing, to the point where the artist refuses any further communication. The culture industry's obsession with the Holocaust almost succeeds in shutting down Spiegelman's quest. The desire for a regression to childhood, as represented in this sequence, however, is not only an attempt to cope with the consequences of commercial success and to avoid the media. This moment of extreme crisis, as close as any in the work to traumatic silence and refusal to speak, also anticipates the very ending of *Maus* II.

On the very last page of *Maus* II, as Vladek's story has caught up with his postwar reunification with Anja, ironically described by Vladek in Hollywood terms as a happy ending and visually rendered as the iris-like fade-out at the end of silent films,[29] Artie is again put in the position of a child. In a case of mistaken identity resulting from a merging of past and present in his father's mind, Vladek addresses Artie as Richieu, Artie's own older brother who did not survive the war, whose only remaining photo had always stared at him reproachfully during his childhood from the parents' bedroom wall, and to whom *Maus* II is dedicated. As Vladek asks Artie to turn off his tape recorder and turns over in his bed to go to sleep, he says to Artie: "I'm tired from talking, Richieu, and it's enough stories for now" (II:136). This misrecognition of Artie as Richieu is highly ambiguous: it is as if the dead child had come alive again, but simultaneously the traumatic past proves its deadly grip over the present one last time. For these are the last words a dying Vladek addresses to Artie. This last frame of the comic is followed only by an image of a gravestone with Vladek's and Anja's names and dates inscribed and, at the very bottom of the page and below the gravestone, by the signature "art spiegelman 1978–1991," years that mark the long trajectory of Spiegelman's project of approaching an experience that ultimately remains beyond reach.

Much more could be said about Spiegelman's mimetic memory project, but I hope to have made the case that the Adornean category of mimesis helps us read Holocaust remembrance in a way that brackets the debate about the proper or correct Holocaust representation and shifts the criteria of judgment. If mimetic

approximation, drawing on a variety of knowledges (historical, autobiographic, testimonial, literary, museal), were to emerge as a key concern, then one could look at other Holocaust representations through this prism rather than trying to construct a Holocaust canon based on narrow aesthetic categories that pit the unrepresentable against aestheticization, modernism against mass culture, or memory against forgetting. This field of discussion might be more productive than the ritualistic incantations of Adorno regarding the culture industry or the barbarity of poetry after Auschwitz.

As a work by a member of the "second generation," *Maus* may indeed mark a shift in the ways in which the Holocaust and its remembrance are now represented. It is part of a body of newer, "secondary" attempts to commemorate the Holocaust that simultaneously incorporate the critique of representation and stay clear of official Holocaust memory and its rituals. I have tried to show how Spiegelman confronts the inauthenticity of representation within a mass cultural genre while telling an autobiographic story and achieving a powerful effect of authentication. Like many other creators of works of film, sculpture, monuments, literature, theater, even architecture, Spiegelman rejects any metalanguage of symbolization and meaning, whether it be the official language of Holocaust memorials or the discourse that insists on thinking about Auschwitz as the telos of modernity. The approach to Holocaust history is sought in an intensely personal, experiential dimension that finds expression in a variety of media and genres. Prerequisite for any mimetic approximation (of the artist/reader/viewer) is the liberation from the rituals of mourning and of guilt. Thus it is not so much the threat of forgetting as the surfeit of memory[30] that is the problem addressed by such newer work. How to get past the official memorial culture? How to avoid the trappings of the culture industry while operating within it? How to represent that which one knows only through representations and from an ever-growing historical distance?

All of this requires new narrative and figurative strategies including irony, shock, black humor, even cynicism, much of which is present in Spiegelman's work and constitutive of what I have called mimetic approximation. *Bilderverbot* is simply no longer an issue since it has itself become part of official strategies of symbolic memorializing. This very fact may mark the historical distance between Adorno, whose "after Auschwitz" chronotope with its insistence on the prohibition of images and the barbarism of culture has a definite apocalyptic ring to it, and younger postmodernist writers and artists to whom the prohibition of images must appear like Holocaust theology. But if, on the other hand, Adorno's notion of mimesis can help us understand such newer artistic practices and their effects in a broader frame, then there may be reason to suspect that Adorno's rigorously modernist reflection itself blocked out representational possibilities inherent in that mimetic dimension. In its hybrid folding of a complex and multilayered narration into the mass cultural genre, Spiegelman's image-text makes a good case

against a dogmatic privileging of modernist techniques of estrangement and negation, for it demonstrates how estrangement and affective mimesis are not mutually exclusive, but can actually reinforce each other.

Finally, there is a weaker, less apocalyptic reading of Adorno's "after Auschwitz" statements. Such a reading would emphasize Adorno's historical critique of that attempt to resurrect German culture after the catastrophe, that attempt to find redemption and consolation through classical cultural traditions— Lessing's *Nathan, der Weise* as proof of German "tolerance" of the Jews, Goethe's *Iphigenie* as proof of German classical humanism, German poetry, music, and so forth: "healing through quotation"—as Klaus Scherpe has called it.[31] The spirit of such a critique of an official German post-Auschwitz culture is one that Adorno shares with the newer generation of artists in many countries today, all of whom try to work against the contemporary versions of an official Holocaust culture, the dimensions of which Adorno could not have imagined during his lifetime. There is another sentence, less frequently quoted, but perhaps more pertinent today than the famous statement "to write poetry after Auschwitz is barbaric." This sentence continues to haunt all contemporary attempts to write the Holocaust: "Even the most extreme consciousness of doom threatens to degenerate into idle chatter."[32] Only works that avoid that danger will stand. But the strategies of how to avoid such degeneration into idle chatter in artistic representations cannot be written in stone.

NOTES

1. Anson Rabinbach, *In the Shadow of Catastrophe: German Intellectuals between Apocalypse and Enlightenment* (Berkeley: University of California Press, 1997).

2. Central here is the chapter entitled "Elements of Antisemitism" in Horkheimer and Adorno's classic work, *Dialectic of Enlightenment*, originally published in 1947, English translation by John Cumming (New York: Continuum, 1982).

3. As is to be expected, the discussion of signification, hieroglyphs, language, and image is pre-Saussurean, presemiotic in the strict sense. It remains indebted to Benjamin on the one hand, and through Benjamin also to a nineteenth-century tradition of German language philosophy. But it is precisely the non-Saussurean nature of this thought that allows the notion of mimesis to emerge in powerful ways.

4. See Gertrud Koch, "Mimesis und Bilderverbot in Adorno's Ästhetik," in Koch, *Die Einstellung ist die Einstellung* (Frankfurt am Main: Suhrkamp, 1992).

5. See Josef Früchtl, *Mimesis: Konstellation eines Zentralbegriffs bei Adorno* (Würzburg: Könighausen & Neumann, 1986); Karla L. Schultz, *Mimesis on the Move: Theodor W. Adorno's Concept of Imitation* (Bern: Peter Lang, 1990); Gunter Gebauer and Christoph Wulf, *Mimesis: Kultur, Kunst, Gesellschaft* (Reinbek: Rowohlt, 1992), esp. 374–422; Martin Jay, "Mimesis and Mimetology: Adorno and Lacoue-Labarthe," in Jay, *Cultural Semantics* (Amherst: University of Massachusetts Press, 1998), 120–37.

6. Theodor W. Adorno, *Minima Moralia: Reflections from a Damaged Life*, tr. E. F. N. Jephcott (London: Verso, 1974), 154.

7. Theodor W. Adorno, Review of Roger Caillois, *La Mante religieuse, Zeitschrift für Sozialforschung* 7 (1938): 410–11. See also Adorno's letter to Benjamin of September 22, 1937, and Benjamin's response in his letter of October 2, 1937, in *Theodor W. Adorno—Walter Benjamin: Briefwechsel 1928–1940*, ed. Henri Lonitz (Frankfurt am Main: Suhrkamp 1994), 276–78, 286.

41

Of Mice and Mimesis

8. The literature on representing the Holocaust is by now legion. One of the richest and still influential collections of essays is Saul Friedlander, ed., *Probing the Limits of Representation: Nazism and the "Final Solution"* (Cambridge, Mass.: Harvard University Press, 1992). Most recently, Dominick LaCapra, *History and Memory after Auschwitz* (Ithaca and London: Cornell University Press, 1998).

9. Art Spiegelman, *Maus I: A Survivor's Tale. My Father Bleeds History* (New York: Pantheon, 1986) and *Maus II: A Survivor's Tale and Here My Troubles Began* (New York: Pantheon, 1991). Page references will be given in the text.

The following publications were extremely helpful in preparing this essay. I acknowledge them summarily since my concern is a theoretical proposition rather than a new and differentiated reading of the text per se. Joseph Witek, *Comic Books as History* (Jackson and London 1989); Andrea Liss, "Trespassing Through Shadows: History, Mourning, and Photography in Representations of Holocaust Memory," *Framework* 4:1 (1991): 29–41; Marianne Hirsch, "Family Pictures: *Maus*, Mourning, and Post-Memory," *Discourse* 15:2 (Winter 1992–93): 3–29; Miles Orvell, "Writing Posthistorically: *Krazy Kat, Maus*, and the Contemporary Fiction Cartoon," *American Literary History* 4:1 (Spring 1992): 110–28; Rick Iadonisi, "Bleeding History and Owning His [Father's] Story: *Maus* and Collaborative Autobiography," *CEA Critic: An Official Journal of the College English Association* 57:1 (Fall 1994): 41–55; Michael Rothberg, "'We Were Talking Jewish': Art Spiegelman's *Maus* as 'Holocaust' Production," *Contemporary Literature* 35:4 (Winter 1994): 661–87; Edward A. Shannon, "'It's No More to Speak': Genre, the Insufficiency of Language, and the Improbability of Definition in Art Spiegelman's *Maus*," *The Mid-Atlantic Almanac* 4 (1995): 4–17; Alison Landsberg, "Toward a Radical Politics of Empathy," *New German Critique* 71 (Spring–Summer 1997): 63–86. And most recently Dominick LaCapra, "'Twas Night before Christmas: Art Spiegelman's *Maus*," in LaCapra, *History and Memory after Auschwitz* (Ithaca and London: Cornell University Press, 1998); James Young, "The Holocaust as Vicarious Past: Art Spiegelman's *Maus* and the Afterimages of History," *Critical Inquiry* 24:3 (Spring 1998): 666–99.

10. For a discussion of the worst offenders see Michael Rothberg, "After Adorno: Culture in the Wake of Catastrophe," *New German Critique* 72 (Fall 1997): 45–82.

11. The paradox is that when Adorno accused poetry after Auschwitz of barbarism, he deeply suspected the apologetic temptation of a poetic and aesthetic tradition, whereas much of the recent poststructuralist discourse of the sublime in relation to Holocaust representations does exactly what Adorno feared: it pulls the genocide into the realm of epistemology and aesthetics, instrumentalizing it for a late modernist aesthetic of nonrepresentability. A very good documentation and discussion of notions of the sublime can be found in Christine Pries, ed., *Das Erhabene: Zwischen Grenzerfahrung und Größenwahn* (Weinheim: VCH Acta Humaniora, 1989).

12. Paradigmatically in Shoshana Felman's much discussed essay "The Return of the Voice: Claude Lanzmann's *Shoah*," in Shoshana Felman and Dori Laub, *Testimony: Crises of Witnessing in Literature, Psychoanalysis, and History* (New York: Routledge, 1992), 204–83. For a convincing critique of Felman's work see Dominick LaCapra, *Representing the Holocaust: History, Theory, Trauma* (Ithaca and London: Cornell University Press, 1994) as well as LaCapra, *History and Memory after Auschwitz* (Ithaca and London: Cornell University Press, 1998). The latter volume also contains a well-documented essay on Spiegelman's *Maus* that includes a critical discussion of much of the literature on this work.

13. This argument has been made very forcefully and persuasively in Miriam Hansen, "*Schindler's List* Is Not *Shoah*: The Second Commandment, Popular Modernism, and Public Memory," *Critical Inquiry* 22 (Winter 1996): 292–312, also in this volume. For the earlier debate on the TV series *Holocaust*, a similar argument can be found in Andreas Huyssen, "The Politics of Identification: *Holocaust* and West German Drama," in *After the Great Divide: Modernism, Mass Culture, Postmodernism* (Bloomington: Indiana University Press, 1986), 94–114.

14. These were central topoi in the German debate about Holocaust memory. See the special issue on the *Historikerstreit, New German Critique* 44 (Spring–Summer 1988) as well as Charles S. Maier, *The Unmasterable Past: History, Holocaust, and German National Identity* (Cambridge, Mass.: Harvard University Press, 1988).

15. Cf. the two-page prologue initiating volume I, dated Rego Park, N.Y. ca. 1958 when Art is only ten years old, or the photo of his dead brother Richieu that overshadowed his childhood,

but is later used at the beginning of volume II to dedicate this part of the work to Richieu and to Nadja, Art Spiegelman's daughter.

16. The category of working through has been most thoroughly explored for this context by Dominick LaCapra, *Representing the Holocaust: History, Theory, Trauma* (Ithaca: Cornell University Press, 1994). LaCapra bases his approach on Freud, and he acknowledges that there cannot be a rigorous and strict separation between acting out and working through for trauma victims. While I feel certain affinities to LaCapra's general approach, I prefer not to engage the psychoanalytic vocabulary. While the psychoanalytic approach is certainly pertinent to the analysis of survivor trauma, it does have serious limitations when it comes to artistic representations of the Holocaust and their effect on public memory. The notion of "mimetic approximation" which I try to develop through my reading of *Maus* tries to account for that difference.

17. Significantly, the prologue to volume I that shows Artie roller-skating and hurting himself is also dated 1958, and when just a few pages and many years later Artie asks his father to tell his life's story, he is looking at a picture of his mother, and he says: "I want to hear it. Start with Mom" (I:12).

18. With this insight and so much more, my reading of *Maus* is indebted to Marianne Hirsch's incisive essay "Family Pictures: *Maus*, Mourning, and Post-Memory," *Discourse* 15:2 (Winter 1992–93): 3–29. Reprinted in Hirsch, *Family Frames: Photography, Narrative, and Postmemory* (Cambridge, Mass.: Harvard University Press, 1997). Cf. also M. Hirsch, "Projected Memory: Holocaust Photographs in Personal and Public Fantasy," in Mieke Bal, Jonathan Crewe, and Leo Spitzer, eds., *Acts of Memory: Cultural Recall in the Present* (Hanover and London: University Press of New England, 1999), 3–23.

19. See note 6.

20. Marianne Hirsch, *Family Frames: Photography, Narrative, and Postmemory* (Cambridge, Mass.: Harvard University Press, 1997).

21. See Homi K. Bhabha, "Of Mimicry and Man: The Ambivalence of Colonial Discourse," in Bhabha, *The Location of Culture* (New York and London: Routledge, 1994), 86.

22. Interview conducted by Gary Groth, "Art Spiegelman and Françoise Mouly," in Gary Groth and Robert Fiore, eds., *The New Comics* (New York: A Berkley Book, 1988), 190–91.

23. These are the terms Adorno uses in the first chapter of the *Dialectic of Enlightenment* where they discuss the irremediable splitting of linguistic sign and image. Horkheimer and Adorno, *Dialectic of Enlightenment*, 17–18.

24. Miriam Hansen, "Mass Culture as Hieroglyphic Writing: Adorno, Derrida, Kracauer," *New German Critique* 56 (Spring–Summer 1992): 43–75. Gertrud Koch, "Mimesis und Bilderverbot in Adorno's Ästhetik," in Koch, *Die Einstellung ist die Einstellung* (Frankfurt am Main: Suhrkamp, 1992), 16–29.

25. Horkheimer and Adorno, *Dialectic of Enlightenment*, 24. In German: "Gerettet wird das Recht des Bildes in der treuen Durchführung seines Verbots." Theodor W. Adorno, *Gesammelte Schriften* 3 (Frankfurt am Main: Suhrkamp, 1983), 40.

26. Quoted in Joshua Brown's review of *Maus I* in *Oral History Review* 16 (1988): 103–4.

27. "A Conversation with Art Spiegelman. With John Hockenberry," Talk of the Nation, National Public Radio, February 20, 1992.

28. Marianne Hirsch, *Family Frames*.

29. An observation I owe to Gertrud Koch.

30. The term is Charles S. Maier's. See his essay "A Surfeit of Memory? Reflections on History, Melancholy, and Denial," *History and Memory* 5 (1992): 136–51.

31. Klaus R. Scherpe, ed., *In Deutschland unterwegs 1945–48* (Stuttgart: Reclam, 1982).

32. Theodor Adorno, *Prisms*, 34.

Art

Ernst van Alphen

Deadly Historians: Boltanski's Intervention in Holocaust Historiography

My work is not about xxxxxxx it is after xxxxxxx[1]

Despite many disagreements, the debate about Holocaust representations has been strikingly unanimous on one point: the presumption that Holocaust survivors and new generations after the Holocaust have a special responsibility toward its historical events. This presumption is not surprising, for the Holocaust has disrupted every conventional notion of history. While its factual events are over and belong to the past, the experience of partaking in historical events continues. In that many survivors are still inside the event, its history is in both the past and the present. Thus, the cultural responsibility that befalls all those living now is to establish contact with the "past" part of the present survivors, to integrate them and their past within our present.

But what does this cultural responsibility toward the historical events mean? For most critics and Holocaust scholars, it implies that bare realism must be the most effective and proper mode for representing the Holocaust in art or literature. The genres then most appropriate to depict the Holocaust are realistic and offer history in its most direct, tangible form—testimonies, autobiographical accounts of the Holocaust, documentaries. This preference is based not on aesthetic but on moral grounds, for these modes of representation are thought to best serve our moral responsibility toward this gruesome past, because they stay closest to its factual events.

When I use expressions like the "pressure on" or "moral imperative" of Holocaust studies, I am not overstating the case.[2] Indeed, Terrence Des Pres has formulated prescriptions for "respectable" Holocaust studies in all seriousness. Appropriating the voice of God in his use of the "genre" of the Commandments, he dictates:

1. The Holocaust shall be represented, in its totality, as a unique event, as a special case and kingdom of its own, above or below or apart from history.
2. Representations of the Holocaust shall be as accurate and faithful as possible to the facts and conditions of the event, without change or manipulation for any reason—artistic reasons included.
3. The Holocaust shall be approached as a solemn or even sacred event, with a seriousness admitting no response that might obscure its enormity or dishonour its dead. (1988, 217)

Setting aside the question of the Holocaust as "sacred" event, in this essay I explore what is implied in a "faithfulness to the facts and conditions of the event" and how it relates to artistic representation. I dwell on the notion of commanded accuracy and the conceptions of history and representation to which it leads.

The pressure exercised by and on Holocaust studies is derived from not only a moral imperative, but also from a particular conception of art that seems to impose itself on the face of the Holocaust. This conception of art and literature turns authors and artists into historians, who are expected to model themselves in the image of the archivist or the historian, in the image of professionals whose task is to inventory the facts and reconstruct them in a correct place and order. Whatever the differences between the historian's options in representational modes, they share an orientation by which they pursue making past events objectively present.

The pressure I have in mind specifies the available modes of representation even further. The pursuit of the barest representation of factual events gives preference to the archivist's practice over that of the historian, who transforms the facts and events into an historical narrative. This preference may be unexpected for students of literature, because realism as a literary mode of representation has always used narrative plot as its most elementary and seductive device. Aristotle already pointed out that in order to be successful the mimetic impulse must focus on action, making narrative plot the inevitable result.

But when considering what makes the historical mode so urgent, we reach the inevitable conclusion that even history writing is not sufficient for this purpose. Many historians today, influenced if not determined by neopositivist thinking, approach even the most elementary narrative plot with suspicion. They have a point, in that narrative plots are always simplifications when compared to the complexity of historical reality. And the coherence and unity of traditional plots produce meaning effects that may not have been present in the past. One aspect of the traditional, realist plot, for instance, is its closure: everything comes to an end, an end that somehow satisfies. And more often than not, that end is good.

If the shaping of facts into a narrative, however truthful, is unable to do justice to the facts, then the only mode of representation that might do so, however poorly, is the archival mode: the collecting, ordering, and labeling of facts, items, pieces of evidence, testimonies. The rigorous endorsement of that conclu-

sion is what made Claude Lanzmann's film *Shoah* such a compelling work. Convinced of the inherent untruthfulness and the negative effects of any realist narrative account of the Holocaust, he made a film in which he presented the testimonies of survivors. He did not create a fictional account in the realist mode, but he *collected* the memories of those who had been the victims of that past. By making *Shoah* he did not represent or tell the Holocaust; he *presented* the stories of survivors one after another (themselves representations, of course). *Shoah* is, however, not a documentary in the traditional sense. In fact, Lanzmann insists that his film is not a documentary but a performance. He asks survivors to go with him, back to the places where they lived the events of the Holocaust. Hirsch and Spitzer formulate his filmic practice adequately: "Like an analyst, he brings each of them to the point of re-experiencing their most profound encounter with the Nazi death machinery" (1994, 16). But from that moment, Lanzmann becomes a real archivist: he collects the traces that the Holocaust had left in the form of reexperienced memories of the survivors.[3]

Lanzmann's refusal to adopt the narrating function himself is the logical consequence of a more general suspicion toward realist narrative plots that underlies the critical debate about Holocaust art and literature. So it came as no surprise when Lanzmann criticized Stephen Spielberg for his account of the Holocaust in his film *Schindler's List*. Spielberg does not present traces of the Holocaust; he *re*presents the Holocaust in the traditional realist mode. This results in a coherent narrative account with a redemptive closure. Relying on all the realist conventions, he creates the illusion of providing a transparent entrance to the historical events. Lanzmann criticizes Spielberg, for instance, because the film's closure suggests that the Holocaust has been meaningful: it has led to the birth of the State of Israel. According to Lanzmann, the film's closure, set in color while the rest of the film is black and white, looks like a reconciliation with the Holocaust. To avoid this image of reconciliation, Lanzmann ended his documentary *Shoah* with footage of a moving train in order to signify his conviction that the Holocaust never ends. Redemption is impossible. Although Lanzmann betrays his rigorous refusal of the narrating subject with this symbolic ending, it is nonetheless possible to claim that he has modeled himself on the image of the archivist. Spielberg, on the contrary, identifies himself as the storyteller. He is the narrativizing historian who uses all the devices of fictional realism to tell a rounded narrative.[4]

Boltanski the Archivist

In the face of the aforementioned pressure to represent the Holocaust in the mode of the historian or the archivist, it is remarkable that the French artist Christian Boltanski has chosen to consistently present his work as that of an archivist. At first sight he gives the impression of being a docile artist, giving in to the moral

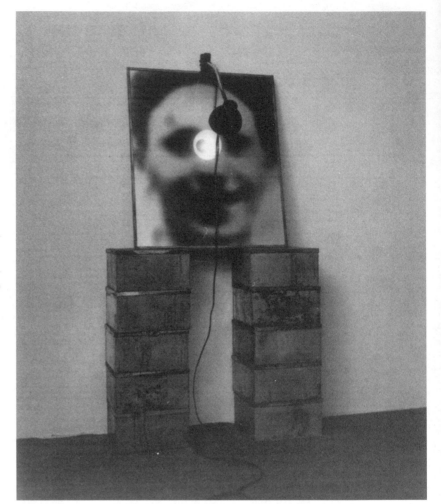

Figure 1. Christian Boltanski, Chases High School, 1988. Detail. Black-and-white photographs, photomechanical prints, metal lamps. Installation. Approximately 120 × 60 × 23 cm.

imperative of the ongoing discussions about Holocaust representations. In fact, some of his works are explicitly entitled *Inventories* or *Archives*. And although Boltanski did not approach the subject of the Holocaust head-on until 1988 with his installations *Chases High School* (1988), *Reserves: The Purim Holiday* (1989), and *Canada* (1988), one can argue—and I do so later—that his earlier works and those after 1988–89 deal with aspects of the Holocaust, albeit in a noniconic, non-historical mode. The question that arises, then, is: What does this engagement with the favorite modes of the Holocaust historian mean as an artistic practice?

The first two installations just mentioned evoke the Holocaust more or less directly by using images of specifically Jewish children. For *Chases High School* (figure 1) Boltanski used a photograph of the graduating class of a private Jewish high school that he found in a book on Jews of Vienna. The installation consisted of eighteen blurry black-and-white close-ups of each of the students. Boltanski rephotographed the students individually, enlarging their faces until they lost their individual features. As an effect their eyes became transformed into

empty black sockets while their smiling mouths turned into grimaces of death. The photographs, presented in tin frames perched on top of a double stack of rusty biscuit tins, were overlighted by extendable desk lamps. In their aggressive over-exposing of the images, these lamps evoked those which are used in interrogation rooms. Instead of being illuminating they are blinding, obscuring the enlarged faces even further.

The exhibition catalogue, published by the Kunstverein in Düsseldorf, reproduced the original photograph, to which Boltanski gave the following caption: "All we know about them is that they were students at the Chases High School in Vienna in 1931." This caption stresses the fact that the remaining picture no longer has correspondence with a present reality. The faces of the children as we see them in the photograph have disappeared. This disappearance is acted out in enlarged close-ups. What we see there is no longer the realistic illusion of the presence of a living subjectivity, as the standard views on photography and the portrait would have it, but empty, blinded faces. And the blinding of a face is a figurative way of objectifying or even killing somebody.

It is more than likely that most or even all of the represented Jewish students did not survive the Holocaust. *Chases High School* and also *Reserves: The Purim Holiday* (figure 2) are in that sense explicit and direct *references* to the Holocaust. Thanks to this quality of referring to a factual reality, Boltanski the artist qualifies himself as an historian. He has traced some victims of the Holocaust and now shows them to us. This aspect of his work is based on the same historical, archival principle as, for instance, Lanzmann's *Shoah*.

Yet, the Holocaust is evoked not only by means of reference to its victims, but also by means of the connotative effects of the photographic signifiers. The enlarged images that transform the faces into skeletal vestiges remind us of the photographs that were published after the Second World War had come to an end and which showed emaciated survivors of the Holocaust. This effect complicates Boltanski's position as a loyal practitioner of traditional Holocaust studies.

Once this complication is foregrounded, one notices still another aspect of these works which evokes the Holocaust in a nonreferential way. Both installations can be seen as archives. They bring together images of Jewish victims of the Holocaust, reminding us of the lists of people who died in the camps. Seen in this light, the number of pictures evokes the incomprehensible numbers who died in the concentration camps. But the object of this representation is the archive as institution, not the "archived" subjects.

It is important to realize that the last two ways in which Boltanski evokes the Holocaust are not based on reference. He produces what I would like to call a *Holocaust-effect,* by reenacting principles that are defining aspects of the Holocaust: a radical emptying out of subjectivity as a road leading to the wholesale destruction of a people—genocide. The reenactment of these two principles and the Holocaust-effect they produce is, however, not at all specific for the works that address the Holocaust head-on. In the same way that Boltanski produces Holocaust-

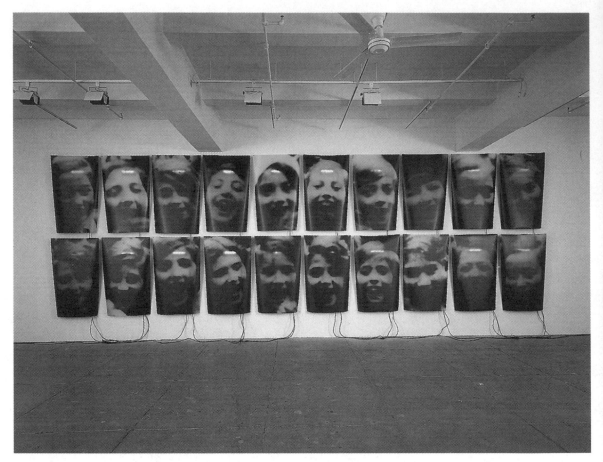

Figure 2. Christian Boltanski, Reserves: The Purim Holiday, *1994. Moving photographs, fluorescent lamps, nails, fan. Installation dimensions variable.*

effects in most of his other works that do not deal with the Holocaust in a direct, referential way, this effect defines not only his work but also the engagement with the debate on modes of representation that this art embodies.

I do not want to imply that any systematic emptying out of subjectivity by means of photographic enlargement or use of the archival mode automatically gives rise to a Holocaust-effect. It is Boltanski's oriented use of these devices and modes that brings it about, reenacting a principle that literally or figuratively defines Nazism in one of its aspects, according to the rhetorical mode of synecdoche. One aspect, which would in itself not necessarily lead to the same overarching destruction, here, according to synecdochic logic, represents the whole of these practices, including their consequences. It is the conjunction of this use of reenactment (concerning the practices of the perpetrators) with the overwhelming awareness of total loss it evokes (concerning the victims of Nazism) that I call a "Holocaust-effect."

The two elements of Boltanski's works that create this Holocaust-effect are his consistent use of photographic portraits and the archival mode. But what

is it that makes these two elements so effective? What have portraits and archives in common that enables Boltanski to use their principles in such a way that they both create Holocaust-effects? I first dwell on the portrait, its generic premises and Boltanski's appropriations of the genre for his own ends. That discussion enables me to relate Boltanski's use of portraiture to the archival mode as the emblem or extreme mode of bare realism.

The Absence of Portraiture's Presence

The pictorial genre of the portrait, whether painterly or photographic, doubly cherishes the cornerstone of bourgeois Western culture. The uniqueness of the individual and his or her accomplishments are central in that culture. And in the portrait, originality appears twice. The portrait is highly esteemed as a genre because, according to the standard view, in a successful portrait the viewer is not only confronted with the "original," "unique" subjectivity of the portrayer, but also that of the portrayed. Linda Nochlin has expressed this abundance of originality tersely: in the portrait we watch "the meeting of two subjectivities" (1974, 29).

Such a characterization of the genre immediately foregrounds those aspects of the portrait that heavily depend on specific notions of the human subject and the practice of representation. As for the represented object, this view implies that subjectivity can be equated with notions like the "self," "personality," or "individuality." Somebody's subjectivity is then defined and delimited in its uniqueness and originality, rather than in its social connections; it is someone's interior essence or presence, rather than a moment of short duration in a differential process. Somebody's continuity or discontinuity with others is denied in order to present the subject as personality. One may ask if this view does justice even to the traditional portrait.

As for the representation itself, the notion we get from the representational characteristics of the portrait is equally specific. It implies that the portrait *refers* to a human being which is (was) present outside the portrait. A recent book on portraiture makes this notion of the portrait explicit on its first page: "Fundamental to portraits as a distinct genre in the vast repertoire of artistic representation is the necessity of expressing this intended relationship between the portrait image and the human original."[5]

The artistic portrait differs, however, from the photographic portrait as used in legal and medical institutions, by doing slightly more than just referring to somebody. It is more than documentation.[6] The portrayer proves her or his originality and artistic power by *consolidating* the self of the portrayed. Although the portrait refers to an original self already present, this self needs its portrayal in order to increase its own being. The portrayer has enriched the interiority of the portrayed's self by bestowing exterior form to it. For without outer form the

uniqueness of the subject's essence could be doubted. The artistic portrayer proves her or his own uniqueness by providing this proof.

By consolidating the self, portraiture gives authority not only to the portrayed self, but also to the mimetic conception of artistic representation which enables that increase of authority. Since no pictorial genre depends as much on mimetic referentiality as the traditional portrait, it becomes the emblem of that conception. The German philosopher Hans-Georg Gadamer is a clear spokesman for this exemplary status of the portrait.

> The portrait is only an intensified form of the general nature of a picture. Every picture is an increase of being and is essentially determined as representation, as coming-to-presentation. In the special case of the portrait this representation acquires a personal significance, in that here an individual is presented in a representative way. For this means that the man represented represents himself in his portrait and is represented by his portrait. The portrait is not only a picture and certainly not only a copy, it belongs to the present or to the present memory of the man represented. This is its real nature. To this extent the portrait is a special case of the general ontological value assigned to the picture as such. What comes into being in it is not already contained in what his acquaintances see in the sitter.[7]

In the portrait, Gadamer claims, an individual is not represented as idealized, nor in an incidental moment, but in "the essential quality of his true appearance."

This description of the portrait as exemplum of the (artistic) picture shows the contradictory nature of mimetic representation. It shows how the traditional notion of the portrait depends on the rhetorical strategy of mimesis, a strategy of make-believe.[8] Let us read Gadamer's argument in more detail. In the portrait, more than in any other kind of picture, an "increase of being" comes about. This increase of being turns out to be the essential quality of the true appearance of the sitter. The portrait refers to this sitter who exists outside the work. Since the sitter exists outside the work, we may also assume that her or his essence exists outside the work.[9]

This implies that the portrait brings with it two referents. The first is the portrayed as body, profile, material form. The second is the essential quality of the sitter, his or her unique authenticity.[10] Within the traditional notion of the portrait, it is almost a truism to say that the strength of a portrait is judged in relation to this essential quality, not just in relation to the looks or appearance of a person. This explains, for instance, the possibility of negative judgments on photographic portraits. Although a camera captures the material reality of a person automatically and maximally, the photographer has as many problems in capturing a sitter's "essence" as a painter does. Camera-work is not the traditional portrayer's ideal but its failure, because the essential quality of the sitter can only be caught by the artist, not by the camera.

But in Gadamer's text we do not read about an essential quality that has been captured. The essential quality of the sitter is the increase of being, *produced*

by the portrayer in the portrait. "What comes into being in it is not already contained in what his acquaintances see in the sitter." The portrayer makes visible the inner essence of the sitter and this visualizing act is creative and productive. It is more than a passive rendering or capturing of what was already there, although interior and hence invisible. The portrayer gives this interiority an outer form so that we viewers can see it. This outer form is then the signifier of the signified, of the sitter's inner essence.

What to do with the surplus of the increase of being? Gadamer *makes us believe* that what comes into being in the portrait is the same as the referent or origin of the painting. Semiotically speaking, he presumes *a unity* between signifier and signified, between increase in being and the essential quality of the sitter. By presuming that unity he denies that the increase of being is a surplus. By doing that Gadamer exemplifies the semiotic economy of mimetic representation. This economy involves a straightforward relationship between signifier and signified.

This identity between signifier and signified is not inevitable. Andrew Benjamin historicizes the kind of semiotic conception that also underlies Gadamer's view in the following terms:

> The signifier can be viewed as representing the signified. Their unity is then the sign. The possibility of unity is based on the assumed essential homogeneity of the signified. The sign in its unity must represent the singularity of the signified. It is thus that authenticity is interpolated into the relationship between the elements of the sign. Even though the signifier and the signified can never be the same, there is, none the less, a boundary which transgressed would render the relationship unauthentic. (62)

Most surprisingly in this argument, Benjamin attributes authenticity neither to the signifier nor to the signified, but to the special relationship between the two. In the case of the portrait, this semiotic economy implies that the qualifications "authenticity," "uniqueness," or "originality" do not belong to the portrayed subject, portrait, or portrayer but to the mode of representation that makes us believe that signifier and signified form a unity. In connection with the issue of authority, this entails a socially embedded conception: the bourgeois self depends on a specific mode of representation for its authenticity.

The link between a mimetic rhetoric and the production of authority can be illustrated with the example of Rembrandt. We think we know the face of the self-portraitist Rembrandt, even though other painters have presented a face of Rembrandt quite different from his self-portrait, just because we adopt the mimetic way of reading when we look at Rembrandt self-portraits.[11] Perhaps Lievens's or Flinck's Rembrandts are closer to what the artist "really" looked like, but how can we mistrust such a great artist to tell us the truth about himself?

My earlier remark that the portrait embodies a dual project at this point becomes clearer yet more specific: it gives authority to the portrayed subject as well as to mimetic representation. The illusion of the presence and authenticity

Figure 3. Christian Boltanski, The 62 members of the Mickey Mouse Club in 1955, *1972. Detail. Sixty-two black-and-white photographs in tin frames with glass. Each photo 30.5 × 22.5 cm.* Collection Ydessa Hendeles Art Foundation, Toronto. (Picture shows only one photograph, of sixty-two.)

of the portrayed subject presupposes, however, belief in the unity of signifier and signified. As soon as this unity is challenged, the homogeneity and authenticity of the portrayed subject fall apart.

This is exactly what we see happen in Boltanski's works with portraits. He challenges the unity between the photographic signifier and its signified mercilessly. He does so by focusing on the idea of reference, the presumed fundamental premise of the genre of the portrait as well as the medium of photography. In his works, referentiality has become an object of intense scrutiny. Boltanski is very outspoken in his desire to "capture reality", and many of his works consist of rephotographed "found" snapshots. The "capturing of reality" happens twice in these works, not only by using found, captured images, but also by photographing them, which doubles the gesture of capturing.

He incorporates these photographs in larger installations. In his *The 62 members of the Mickey Mouse Club in 1955* (1972), for instance, he presents rephotographed pictures of children which he had collected when he was 11 years old (figure 3). The original photos were pictured in the children's magazine *Mickey Mouse Club.* The children had sent in pictures that best represented them. We see

them smiling, well-groomed, or with their favorite toy or animal. Seventeen years after he had collected the pictures, watching them, Boltanski is confronted with the incapacity of these images to refer: "Today they must all be about my age, but I can't learn what has become of them. The picture that remains of them does not correspond any more with reality, and all these children's faces have disappeared."[12] These portraits do not signify "presence," but exactly the opposite: absence. If there were "interiority" or "essence" in a portrait, as traditional beliefs on portraiture would have it, these photographs should still enable Boltanski to get in touch with the represented children. But they do not. They only evoke absence.

In some of his later works he intensifies this effect by enlarging the photos so much that most details disappear. The eyes, noses, and mouths become dark holes, the faces white sheets. The Holocaust-effect these blowups produce is inescapable. They remind us of pictures of survivors of the Holocaust just after they were released. In these works the Holocaust is not referred to by choosing images of Jewish children, as Boltanski did for his *Chases High School* and *Reserves: The Purim Holiday*. It is not evoked by means of reference. It is produced as an effect.

The importance and possibilities of dealing with the Holocaust in a non-referential or historical way is provocatively addressed by Boltanski in his work *The Dead Swiss* (1990) (figure 4). For this work he cut out illustrated obituaries from a Swiss newspaper. The photographs of the recently deceased were usually snapshots or studio portraits taken in order to commemorate events such as a wedding or a graduation. Just as in his other works in which he used photographs, Boltanski reshot the already grainy images, enlarging them slightly over life-size. The near life-size portraits, as well as his decision to present portraits of Swiss instead of Jews, were intended to evoke normality. These portraits did not refer to humans who were victimized in an unimaginable way, nor did they refer to the absoluteness or overwhelming power of death. Boltanski said the following about this work: "Before, I did pieces with dead Jews but 'dead' and 'Jew' go too well together. There is nothing more normal than the Swiss. There is no reason for them to die, so they are more terrifying in a way. They are us."[13] Boltanski has done everything to make identification and correspondence possible between the living spectators and the images of dead Swiss represented. The images are life-size and they connote life instead of death. Nevertheless, two features of this work make the Holocaust-effect unavoidable. Again, the sheer number of similar portraits evokes the dehumanization of the Holocaust. While the portrait as genre evokes the idea of individual identity, the number of portraits transforms the evoked idea of individuality into anonymity. It is precisely this transformation that happens while watching the work. Therefore, the work can be seen as a reenactment of one of the principles that define the Holocaust: the transformation of subjects into objects.

Seeing the first image, one is still able to activate the traditional beliefs in

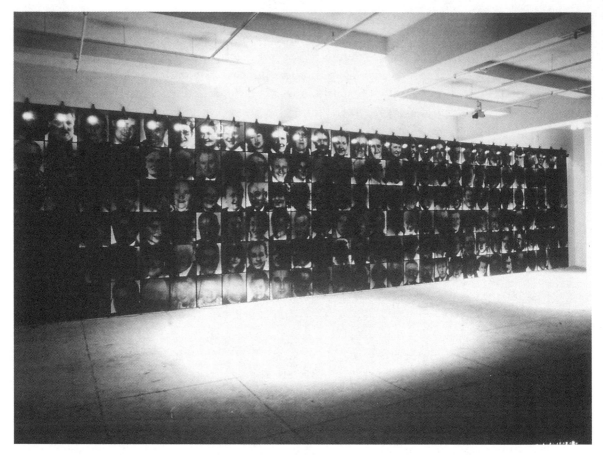

Figure 4. Christian Boltanski, 174 Dead Swiss, 1990. Installation view, Marian Goodman Gallery, New York. Black and white photographs, metal lamps.

the capacities of portraiture. One is in touch then with the presence of a unique individual being. Seeing more of them, all similar or ultimately all the same, one realizes that the opposite effect has taken over. The sameness of all the faces is enforced by the fact that the photographs have been enlarged: individual features disappear in that process. One is confronted with the absence of the presence of unique human beings. One sees a collection of exchangeable objects. Precisely this transformation in one's experience as a spectator reenacts the Holocaust. This reenactment is an *effect*, not a representation; it *does* something instead of showing it.

The produced Holocaust-effect undercuts two elements of the portrait's standard view. By representing these people as (almost) dead, Boltanski foregrounds the idea that the photographs have no referent. And by representing these human beings in the "Nazi mode," that is, without any individual features, he undermines the idea of the "presence" in the individual portrait. All the portraits are exchangeable, in that the portrayed have become anonymous. They all evoke absence, absence of a referent outside the image, as well as absence of "presence" in the image.

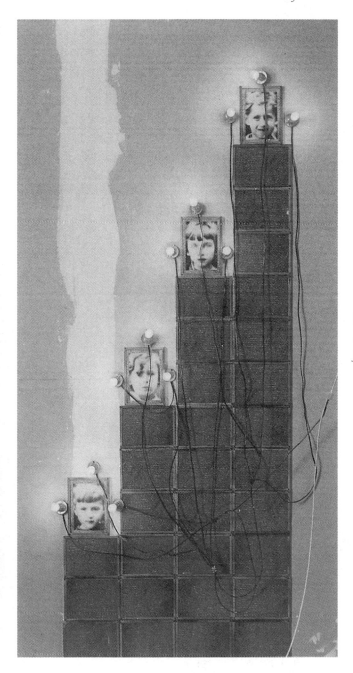

Figure 5. Christian Boltanski, Monuments, *1986. Seventeen color photographs, tin frames, five lights with wires. 130 × 60 cm.*

About his *Monuments* (1986) (figure 5), for which he used a photograph of himself and of seventeen classmates, Boltanski says the following:

> Of all these children, among whom I found myself, one of whom was probably the girl I loved, I don't remember any of their names, I don't remember anything more than the faces on the photograph. It could be said that they disappeared from my memory, that this period of time was dead. Because now these children must be adults, about whom I know nothing. This is why I felt

the need to pay homage to these "dead," who in this image, all look more or less the same, like cadavers.[14]

The photographs do not help bring back the memories of his classmates. He calls his classmates "cadavers," because their portraits are dead. The portraits are dead because they do not provide presence or reference. He only remembers that which the picture offers in its plain materiality as a signifier: faces. He clearly denies any "increase of being."

The dead portraits are in tension with another important element of Boltanski's installations. These are often framed as monuments, memorials, altars, or shrines (*Monuments* [1985], *Monument* [1986], *Monuments: The Children of Dijon* [1986], *Monument (Odessa)* [1991], *The Dead Swiss* [1991]). The portraits are in many cases lit by naked bulbs, as if to represent candles and emphasize the work's status as memorial or shrine. The framings make explicit the intention of the installation. These works want to remember, to memorize or to keep in touch with the subjects portrayed. The photographs, however, are in conflict with this stated intention, unable to make the portrayed subject present. They evoke absence. That is why the memorials are not so much memorials of a dead person, or, already less ambitiously, of a past phase of somebody's life, but of a dead pictorial genre. The portrait is memorized in its failure to fulfill its traditional promises.

Boltanski has also made works with photographs that make a slightly different point about the genre of the portrait; as a consequence, the Holocaust-effect is evoked on the basis of a different mechanism there. For the works *The Archives: Détective* (1987) and *Réserve: Détective III* (1987) (figure 6) he used images from the French tabloid *Détective*. This journal reproduces photographs of murderers and their victims. In the first-mentioned work he used the images rephotographed and enlarged; for the second he used the newspaper images themselves. He taped the clippings onto the front of cardboard cartons on which a random date from 1972 was also written. The cartons were stacked on crudely constructed wooden shelves. It was intimated that the cartons contained documents concerning the individuals whose images were taped to the outside.

But since one was not supposed to open the cartons, it was impossible to relate the documents to the images. And as is often the case in Boltanski's work, this work is not a "real" archive, but only has an archival effect. In reality the boxes contained only unrelated newspaper stories. But let us take its effect seriously. The separation of image and text, then, makes it impossible to distinguish the murderers from the murdered. We only see smiling individuals. It is not possible to recognize criminal personalities in the portraits. Another part of the same installation foregrounded the failed effort to distinguish the criminal personality from its victims even more explicitly. The installation not only consisted of four wooden shelves with the cardboard boxes, but also of twelve framed collages of the photographs with clamp-on lamps. These lamps created the connotation of interrogation and scrutiny, the portraits being interrogated as if they had to reveal

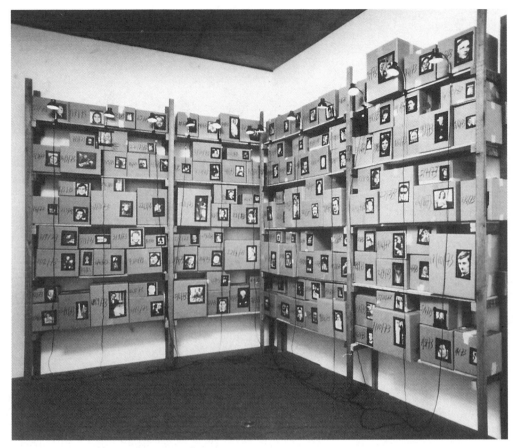

Figure 6. Christian Boltanski, Réserve: Détective III, *1987. Wooden shelves with cardboard boxes, photographs, stories, and twelve black lamps.*

their truth. But again this is without success. We do not see the difference between murderer and murdered, rendering this too a disturbing statement about portraiture as well as about photography, with neither genre nor medium able to provide the presence of someone's subjectivity. Genre and medium have turned the subjects into objects, and the only things we see are faces.

A similar effect is reached in works for which Boltanski used snapshots from German family photo albums that he found at a flea market. Gumpert says the following about these family albums:

> Like the snapshots of the *Family D.*, these albums documented the lives of ordinary people during extraordinary times. Among the ritualized shots of birthdays and anniversaries were uniformed Nazi soldiers—smiling and holding babies, happy, it seems, to have a respite from their duties. (1994, 143)

Boltanski used the photographs in his work *Conversation Piece* (1991) but also for his book *Sans-Souci* (1991) (figure 7). This book showed snapshots of several Nazi families, who probably did not know each other. As in "real" photo albums, a sheet of cobweb paper was inserted between the pages.

Figure 7. Christian Boltanski, page from Sans-Souci, *1991. Frankfurt am Main and Cologne: Portikus and Walther König, 1991. 16 pp., black and white illustrations, two thousand copies.*

The intriguing and disturbing effect of *Sans-Souci* was caused by the fact that traditional meanings of the family photo album overruled the subjectivities supposed to be represented *in* the snapshots. The Nazi soldiers in these photographs do not show any signs or symptoms of the ideology and destruction of which they partake. We only see affectionate friends, lovers, husbands, and fathers. Gumpert reads the impossibility of recognizing the Nazi character or subjectivity in these pieces as Boltanski's disinterest in ascribing blame to the Nazis. He is presumed to "underscore the potential evil that resides in us all" (1994, 143). Boltanski's works, then, make a general claim about humankind.

Gumpert's reading seems implausible to me because it neglects the mode of this artistic practice itself. She ignores the fact that these works all consist of photographic portraits. In fact, she quotes a remark of Boltanski that allegedly illustrates his intentions behind works like *Conversation Piece* and *Sans-Souci*. In 1987, when the trial of the infamous Nazi war criminal Klaus Barbie in Lyons was recorded in the media, Boltanski said the following: "Barbie has the face of a Nobel Peace Prize winner. It would be easier if a terrible person had a terrible face."[15]

With this remark, however, Boltanski is not making a claim about potential evil which hides in us all. On the contrary, he labels one specific person, namely, Klaus Barbie, as a terrible person. His remark broaches the problem that this terrible subjectivity cannot be recognized when we see this person as an image in newspapers or on television, or even when we see him in person. In the process of representing the terrible subject Barbie as an image, he is transformed into something else and he loses his terribleness.

In an interview with Delphine Renard, Boltanski explains this transformation of a subjectivity when a person is being portrayed photographically: "In most of my photographic pieces I have manipulated the quality of evidence that people assign to photography, in order to subvert it, or to show that photography lies—that what it conveys is not reality but a set of cultural codes."[16] In the case of the work *Sans-Souci*, it is very clear which set of cultural codes blocks access to the Nazis as subjects—the family album as a traditional medium bound up in a fixed set of meanings. This implies that the snapshots that fill family albums do the opposite of capturing and representing the reality of a family.[17] In Boltanski's own words: "I had become aware that in photography, and particularly in amateur photography, the photographer no longer attempts to capture reality: he attempts to reproduce a pre-existing and culturally imposed image."[18]

The photographic portrait fails to fulfill its promises now in another way. As I recalled before, according to traditional views, the photographic portrait captures the reality and truth of somebody's subjectivity; it makes the portrayed subject present. Most of Boltanski's photographic works confront their viewers, however, with absence instead of presence, with objects instead of subjects, with cadavers instead of living human beings. But the photographic pieces with images of murderers or Nazi soldiers do not confront us with absence but rather with lies. With these works Boltanski does not make the point that Nazi soldiers were also loving husbands or fathers, but that we are not able to capture the reality of the Nazi subject by means of the photographic medium. We end up with lies.

By showing that photography is a medium of lies, Boltanski creates another Holocaust-effect. This time he does not reenact the absolute dehumanization of Nazism, but another aspect of Nazism which is also an intrinsic feature of the Holocaust. Boltanski confronts the viewers of his works with a mechanism that is consistently producing deceit and lies. He stimulates viewers to activate a set of cultural codes (e.g., the family album) that projects false meanings, lies, on the portrayed subjects. By adopting these cultural codes, it is as if we, as viewers, are placed in the shoes of the Nazi soldiers who believed that they were decent citizens by doing what they were doing.

Boltanski's use of portraits repeatedly produces the same disturbing effect. They do not evoke the illusion of the presence of a human being in all her or his individuality, but only the idea of plain absence or the projection of lies. He deconstructs the photographic portrait in its promise of providing an exact, faithful correspondence with a historical or living reality. One is confronted with the split

between signifier and signified or the disappearance of the signified. Provocatively and consistently Boltanski's works fail to provide living realities which correspond with the represented persons.

Leftovers of Reality

The two modes of representation that produce Holocaust-effects in Boltanski's work are photographic portraiture and the archive. As argued earlier, both modes of representing reality can be seen as emblems of bare realism, the representational effect so much favored by Holocaust commentary. The photographic portrait and the archive seem to share an ability to represent (historical) reality in an apparently objective way. We can almost speak of a presentation instead of a representation of reality. In both cases there seems to be a minimum of intrusion or "presentness" of the subject or medium of representation in the product of representation. Another common aspect that links these two modes in Boltanski's practice is the foregrounding, and then questioning, of the individual: most archival installations consist of the belongings of one individual.

I now want to explore Boltanski's use of the archive in order to see possible consequences of the archival mode for our understanding of the Holocaust itself. In only one series of his works is the Holocaust directly evoked by means of reference to it. In 1988 he made some installations to which he gave the title *Canada*. This title refers to the euphemistic name the Nazis gave to the warehouses that stored all the personal belongings of those who were killed in the gas chambers or interned in the labor camps. "Canada" here stands for the country of excess and exuberance to which one wants to emigrate, because it can offer a living to everybody. In the works with the title *Canada* (figure 8) Boltanski showed piles of secondhand garments. For the first version of this installation, at the Ydessa Hendels Art Foundation in Toronto, he used six thousand garments. The brightly colored clothes were hung by nails on all four walls. Every inch of the room was covered by them. This installation not only brought to mind the warehouses in the concentration camps, but by the sheer number of garments it also evoked the incredible number of people who died in the camps and whose possessions were stored in "Canada."

Like *Chases High School* and *Monument: The Purim Holiday, Canada* evokes the Holocaust referentially. This time it is not the used "material"—photographs that show European Jewish children before the war, hence, targets of the Holocaust—which denote the Holocaust, but the title of the work. These garments, probably obtained from the Salvation Army in Toronto, represent a specific historical space: the warehouses in Auschwitz, because the title denominates the installation as such. But Boltanski's other works based on the same archival, inventory principle do not *refer* to the Holocaust by denominating a specific ele-

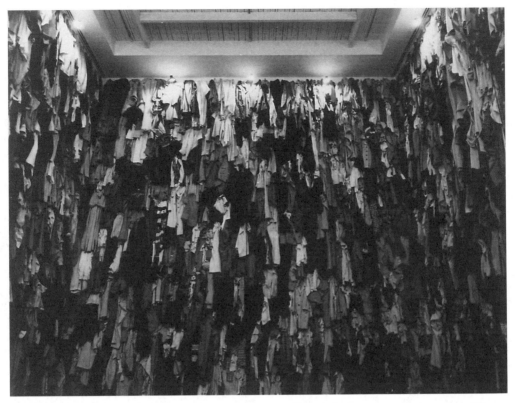

Figure 8. Christian Boltanski, Canada, *1988. Secondhand clothing. Installation view, Ydessa Hendeles Art Foundation, Toronto.*

ment of it. Still, they have "Holocaust-effects" as well, effects similar to his photographic portraiture pieces that do not use images of Jewish people.

In 1973 and 1974 Boltanski made several installations, generically called *Inventories,* which consisted of the belongings of an arbitrarily selected person. In his *Inventory of objects that belonged to a woman of New York* (figure 9), for instance, shown in the Sonnabend Gallery in New York (1973), he presented furniture of a woman who had just died. These belongings had the function of witnessing the existence of the woman who had died. Semiotically speaking, these *Inventories* are fundamentally different from the installations with photographs. While the photographs refer iconically, or fail to do so, the inventories refer indexically. The pieces of furniture represent the woman, not by means of similarity or likeness, but by contiguity. The woman and her belongings have been adjacent. These belongings pretend to be and thus represent the idea of having been contiguous to the woman, because later Boltanski admitted that he had "cheated" the audience by exhibiting furniture that he had borrowed from personal acquaintances. This cheating only enhances the semiotic status of his work. The sign, according to Umberto Eco's definition, is "everything which can be used in order to lie" (1976, 10). The installations are not "real" indexes but "look like" them; just like fake signatures they are icons parading as indexes.

Figure 9. Christian Boltanski, Inventory of objects that belonged to a woman of New York, *1973. Installation view, Centre National d'Art Contemporain, Paris.*

The point here, however, is the shift from icon to index.[19] The difference between the iconical and the indexical works is a matter of pretension. The photographic portraits claim, by convention, to refer to somebody and to make that person present. They fail, as I have argued, in both respects. The indexical works, however, do not claim presence: they show somebody's belongings, not the person herself or himself. And, strangely enough, they seem to be successful as references to the person to whom the objects belonged.

At first sight, it is rather unexpected that Boltanski's installations, based on the archival mode, are slightly closer to fulfilling the standard claims of portraiture than his pieces with photographic portraits. This success is due to the fact that one of the traditional components of the portrait has been exchanged for another semiotic principle. Likeness, similarity has gone and contiguity is proposed as the new mode of portraiture. When we stay with the standard definition of the portrait (see Brilliant) Boltanski's indexical works fit much better in the genre of the portrait than his photographic portraits.

Although referentiality is more successfully pursued in the indexical installations, the problem of presence in these works is again foregrounded as a failure. In *The Clothes of François C* (1972) (figure 10), we see black-and-white, tin-framed photographs of children's clothing. The photographs of these clothes immediately raise the question of the identity and the whereabouts of their owners. This leads again to the Holocaust-effect. The clothes connote the warehouses in the death and concentration camps, where all the belongings of the inmates were sorted (thus depriving them of individual ownership) and stored for future

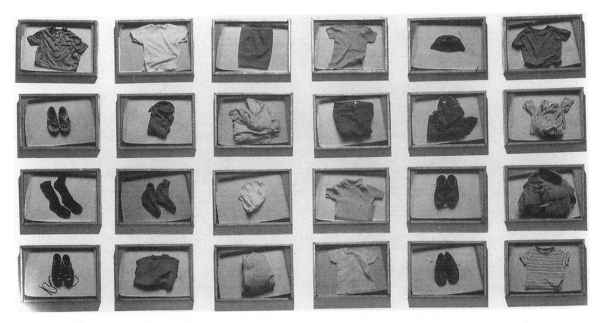

Figure 10. Christian Boltanski, The Clothes of François C, *1972. Black-and-white photographs, tin frames, glass. Each photograph 22.5 × 30.5 cm.* Musée d'art Contemporain, Nîmes, on loan from the Fonds Musée d'Art Moderne de la Ville de Paris, 1989.

use by the Germans. After the war, some of these storages were found, and became symbols, indexical traces, of the millions who were put to death in the camps.

In other indexical "portraits" the Holocaust-effect is pursued even more directly. Part of the installation *Storage Area of the Children's Museum* (1989) (figure 11), for instance, consisted of racks with clothing. The piles of clothes stored on the shelves referred to the incomprehensible numbers who died in the concentration camps. But in contrast with the series of works entitled *Canada,* these works do not refer to the Holocaust; they have a Holocaust-effect because they reenact a principle that defines the Holocaust as the deprivation of individuality applied in the most extreme and radical way. Deprived of their individuality, the victims of the Holocaust were treated impersonally as specimens of a race that first had to be collected and inventoried before they could be used (in the labor camps) or destroyed (in the gas chambers). The Nazis not only inventoried the possessions of their victims, but the same principles were in fact applied to the victims themselves.

The notions of usability and uselessness are of crucial importance for an understanding of how Boltanski's archival works produce Holocaust-effects. The "inventories" or selections, performed when one entered the camps but which returned almost daily in the labor camps, were based on the distinction between usable and unusable. The mechanisms of the Holocaust were such that ultimately everybody had to end up in the category "useless."

It is exactly this idea of uselessness that overwhelms Boltanski when, like many other artists in the 1960s and the 1970s, he became interested in

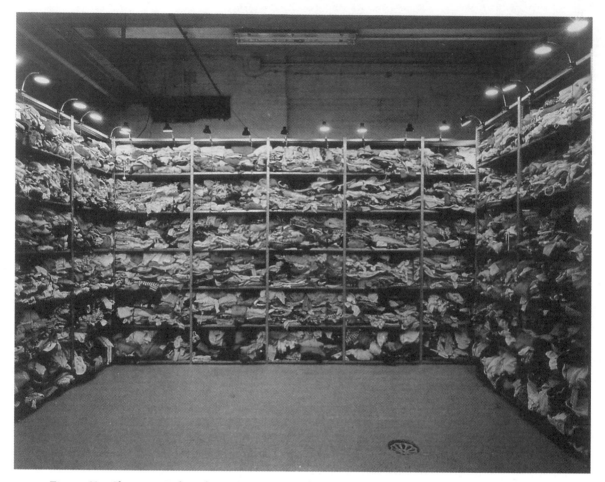

Figure 11. Christian Boltanski, Storage Area of the Children's Museum, *1989. Children's clothing, metal shelves, lamps.* Installation view, "Histoires de musées," Musée d'Art Moderne de la Ville de Paris.

anthropological museums. The *Musée de l'Homme* in Paris made the following impression on him:

> It was . . . the age of technological discoveries, of the Musée de l'Homme and of beauty, no longer just African art, but an entire series of everyday objects: eskimo fishhooks, arrows from the Amazon Indians . . . The Musée de l'Homme was of tremendous importance to me; it was there that I saw large metal and glass vitrines in which were placed small, fragile, and insignificant objects. A yellowed photograph showing a "savage" handling his little objects was often placed in the corner of the vitrine. Each vitrine presented a lost world: the savage in the photograph was most likely dead; the objects had become useless—anyway there's no one left who knows how to use them. The Musée de l'Homme seemed like a big morgue to me.[20]

While Boltanski expected to find "beauty" in the museum, an expectation inspired by the kind of eye Cubist artists had for the objects of African cultures, he found

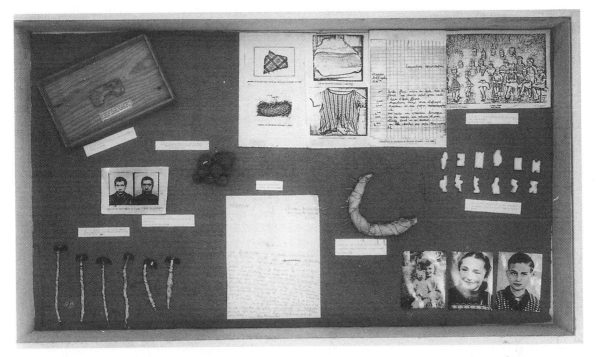

Figure 12. Christian Boltanski, Reference Vitrines, *1969–70. Various objects in wooden vitrine with Plexiglas. 120 × 70 × 15 cm.*

instead lost worlds in the vitrines. The inventories reveal the same meaning to him as do photographic portraits. He sees absence instead of presence. The anthropological museum did not become a fine arts museum; it was transformed into a morgue of useless objects.

In the early 1970s Boltanski made two series of works in which he made use of the museological vitrine (*Attempt to Reconstruct Objects that Belonged to Christian Boltanski between 1948 and 1954, Reference Vitrines* [figure 12]). One series of works, generically entitled *Reference Vitrines* (1970–73), consisted of museum-type vitrines in which Boltanski displayed a sampling of the work he had made since 1969. He showed small piles of the dirt balls, self-made knives, traps, carved sugar cubes, pages from his books, and parts of his mail-art. Each item in the vitrines had a label that usually listed the title and the date of the work. With this series of works Boltanski turned himself into the archivist of his own work. In his similar series *Attempt to Reconstruct* he was the archivist of his childhood.[21]

However, these "reconstructions" fail utterly as reconstructions, unable to reconstruct either his childhood or his artistic career. Instead we see useless objects. The frame of the museological vitrine or the archaeological museum, in short, the archival mode of representation, withdraws objects from the contexts in which they were originally present. In the vitrine, museum, or archive they become subjected to principles that not only define the objects as useless, but

which were defining for the Holocaust practice. Through his archival work as well as in his photographic work, then, Boltanski, rather than "obeying" the historian's prescriptions, challenges and subverts them.

Boltanski as Historian

In his *Reflections of Nazism,* historian Saul Friedlander suggests that systematic historical research, which uncovers the facts in their most precise and meticulous interconnection, provides little understanding of the Holocaust; it rather protects us from the past and keeps it at a distance. He holds the language of the historian responsible for that effect. The distance is caused by the reading attitude the reader is encouraged to adopt by the historian's language. The attitude of the expert, in charge of checking the accuracy of the facts and the connections between them, protects the reader:

> That neutralizes the whole discussion and suddenly places each one of us, before we have had time to take hold of ourselves, in a situation not unrelated to the detached position of an administrator of extermination. Interest is fixed on an administrative process, an activity of building and transportation, words used for record keeping. And that's all. (91)

But Friedlander's words suggest that the historian's detached position involves more than a neutralization of the discussion on the Holocaust. Paradoxically, Friedlander suggests that the historian could be said to reenact the Holocaust precisely by his or her detached position as an administrator of extermination. So, whereas the historian provides only little understanding of the Holocaust, what he provides his readers is a Holocaust performance. This can be quite uncanny when the historian is not self-reflexive and is unaware of the effects of his practice.

Friedlander, however, *is* self-reflexive. But he indicates that for the historian there is no way out: "The historian cannot work in any other way, and historical studies have to be pursued along the accepted lines. The events described are what is unusual, not the historian's work. We have reached the limits of our means of expression. Others we do not possess" (92).

Boltanski the artist presents himself not as a "believing," but as a self-reflexive historian like Friedlander.[22] He adopts and explores the archival modes of the historian as if he wanted to follow the rules formulated by many Holocaust commentators. He consistently uses modes of representation that are supposed to be most promising in providing a truthful, objective account of past realities. From this perspective the photographic portraits, vitrines, reconstitutions, and inventories all belong to the same historical paradigm. They are all extreme examples of non-narrative genres that stand for bare realism, embodying the promise of the

presence of the past. Yet this promise is never fulfilled. Nor is, by implication, the historian's.

Boltanski foregrounds the Janus's head of historical realism. He shows us, again and again, the presence of absence. His acts of reconstruction and making present hit us with the awareness that what is being reconstructed is lost. But Boltanski does more than inflict a general idea of death, loss, and absence. He specifies the modes of production semiotically as well as historically. Foregrounding the principles of the archival mode, he foregrounds the Holocaust, its presentness in its pastness, in the same act. The way he does this can be summarized by the epigraph with which I began this analysis: "My work is not about xxxxxxx it is after xxxxxxx."

In this sentence the word "Holocaust" is not mentioned. Twice we see an unreadable mark, the result of Boltanski's "corrections" in the text of an interview. His copy in which he made the corrections was published in the catalogue in this form. It is quite plausible, however, that the crossed-out word was "Holocaust." Boltanski has said in several interviews that he considers his work as post-Holocaust work, a formulation which indicates that for him the Holocaust is a fundamental break in history. If we assume that the unreadable word is "Holocaust," he seems to suggest that the Holocaust itself is unreadable or incomprehensible. That is exactly why his work is not "about" the Holocaust.

For making work "about" the Holocaust would be a hopeless project. It is hopeless because of the impossibility of having a detached position from it which would enable one to write "about" it. Although one cannot make work about the Holocaust, one can focus on the fundamental changes in our perception of life after the Holocaust. Boltanski favors an indexical approach to the Holocaust over an iconic, realistic one. Thus, it was more effective to represent a dead woman by the belongings she left behind than by a photographic portrait of her.

The break caused by the Holocaust consists for Boltanski a loss of hope or utopia:

> For a long time humanity was in a childhood-like state believing that things would get better and better, that man would become more and more wise. What is terrible is that after the Holocaust we can see that it was not true. And now with the end of Communism, which is something very sad, we no longer have a good utopia any more. Communism was the last Christian utopia. Holocaust was the worst thing that could happen. In the 19th century it was possible to believe in a moral utopia and a scientific utopia. Today we have lost everything.[23]

It is remarkable that Boltanski mentions the nineteenth century as the century of utopias.

This is an important historiographic statement, albeit unelaborated. For, as Hayden White has argued, the nineteenth century marks the professionalization and disciplinization of historical thinking. In order to transform itself into a

modern scientific discipline it had to disengage itself from political and ideological thinking. "History" had to repress utopian thinking if it wished to claim the authority of a discipline. It is only then that historical modes of representation are defined by distinguishing them from fiction and imagination. Historical thinking is de-rhetoricized, an effort that was a "rhetorical move in its own right, the kind of rhetorical move that Paolo Valesio calls the rhetoric of anti-rhetoric."[24]

The disciplinization of history led to an image of history as something that can be ordered, understood, explained. Political and utopian thinking to which history was subordinated until then had presented history as a spectacle of confusion, uncertainty, and moral anarchy.[25] Prior to the nineteenth century, history possessed all kinds of sublime, unrepresentable qualities. It had been conceived "as a spectacle of crimes, superstitions, errors, duplicities, and terrorisms" that justified visionary and utopian recommendations for a politics that would anchor social processes on a new, rational ground. It is this spectacle of the historical sublime that is suppressed when history is domesticated as an understandable and explainable domain, a respected object of a disciplinary field of study.

When we take this history of the field of history and its modes of representation into consideration, it seems as if Boltanski suggests that the disciplinization of history, and the loss of utopian thinking that goes with it, define the Holocaust in a crucial way. Again and again, he makes use of the archival mode of representation as a way of evoking the Nazi mode of making history and practicing genocide. His works, then, evoke the Holocaust by being "about" the disciplinization of history. But another danger lurks here. This conclusion might seem paradoxical if his distance from the disciplinization of history entailed a nostalgia for the state of history that preceded it. For, as Hayden White already remarked, fascist ideologies are those seen as a return of utopian thinking after the disciplinization of history: "it is possible that fascist politics is in part the price paid for the very domestication of historical consciousness that is supposed to stand against it" (1987, 75). The nostalgic desire for sublimity serves there as a legitimization of the project for the future.

This opens the possibility that Boltanski's work, in its critique of historical modes of representation and of the domestication of the past, is unconsciously drawn into the Nazi project that he assumes to have laid bare. I do not think that this is so, but the reason why he does not fall into that trap needs spelling out. It cannot be denied that Boltanski is turning the past, the past of the Holocaust that is, into something that can evoke the sublime. By means of his *failing* domestication of the past, he presents the opposite of a well-ordered and understood image of history. He presents history as sublime, as something that recedes into absence when we try to capture it.

Importantly, this resublimation of the past is not performed, as in the case of Nazism, as a way of legitimizing the utopian thinking of fascism. For Boltanski, the Holocaust means the end of any utopia: "Holocaust was the worst thing that could happen. In the 19th century it was possible to believe in a moral utopia and

a scientific utopia. Today we have lost everything. . . . We have no more hope" (1994, 43). Boltanski defines not only the past but also the future in terms of a sublime chaos that cannot be ordered. It is here, in this different conception of the future (instead of the past), that his critique of Nazism comes to a closure. The only space which is left for him, then, is the present.

NOTES

1. Georgia Marsh, "Christian, Carrion, Clown and Jew: Christian Boltanski interviewed by Georgia Marsh, revised by Christian Boltanski," in *Reconstitution* (London: Whitechapel Art Gallery, 1990), 10.

2. An exception to this general tendency is Sidra Dekoven Ezrahi's valuable book *By Words Alone: The Holocaust in Literature*. Without any moral pressure she discusses all kinds of Holocaust literature: literature that keeps close to the documentary as well as literature that has mythical proportions. She sees what she calls the "survival novel" as "the first breach in the tyranny of fact over imagination, employing memory, fantasy, and metaphor as a manner of escape from and denial of reality within the private soul of the victim" (14). For her, Holocaust literature is not submitted exclusively to the function of providing historical knowledge.

3. Lanzmann's refusal of the fictional mode of realism in favor of the archival mode of collecting memories should not be understood as an effort to reach more "objective" knowledge of the Holocaust. As Bartov *(Murder in our Midst: The Holocaust, Industrial Killing, and Representation)* and Hirsch and Spitzer ("Gendered Translations: Claude Lanzmann's Shoah") have pointed out, Lanzmann's choice of witnesses for his documentary has been highly selective. The constructedness of his documentary manifests itself especially in his choice of whom he has asked to testify and whom not.

4. When we compare these filmmakers with "real" historians, Lanzmann has the position of those historians who have criticized Simon Schama (Spielberg) for adopting the narrativist mode too liberally and eagerly in his *Death Certainties*.

5. Richard Brilliant, *Portraiture*, 7.

6. For the use of the photographic portrait in medical and legal institutions, see Tagg *(The Burden of Representation: Essays on Photography and Histories)* and Sekula ("The Body and the Archive"). Sekula argues that the photographic portrait extends and degrades a traditional function of artistic portraiture, that is, providing the ceremonial presentation of the bourgeois self. "Photography came to establish and delimit the terrain of the *other*, to define both the *generalized look*—the typology—and the *contingent instance* of deviance and social pathology" (345).

7. Gadamer *Truth and Method*, 131.

8. See Kendall L. Walton, *Mimesis as Make-Believe*.

9. Brilliant sees the portrait as a transcendent entity: "Portraits concentrate memory images into a single, transcendent entity; they consolidate many possible, even legitimate, representations into one, a constant image that captures the consistency of the person, portrayed over time but in one time, the present, and potentially, forever" ("Portraits: A Recurrent Genre in World Art," 13). I contend that his transcendent entity, the result of the concentration of several images into one, is based on the same representational logic as Gadamer's "increase of being."

10. See Andrew Benjamin, "Betraying Faces: Lucian Freud's Self-Portraits," in his *Art, Mimesis, and the Avant-Garde* (London, 1991). Benjamin discusses the semantic economy of mimetic representation from a philosophical perspective. I follow here the main points of his argument.

11. This example is mentioned by Svetlana Alpers in *Rembrandt's Enterprise: The Studio and the Market*. For a study of Rembrandt's self-portraits, see H. Perry Chapman, *Rembrandt's Self-Portraits*. A semiotic perspective on his self-portraits, related to psychoanalysis, is proposed by Bal in *Reading "Rembrandt."*

12. Boltanski, in *Monumente, eine fast zufällige Ausstellung von Denkmäler in der zeitgenössischen Kunst* (Düsseldorf: Städtische Kunsthalle, 1973); quoted in Lynn Gumpert, *Christian Boltanski*.

13. Georgia Marsh, "The White and the Black," 36; quoted in Lynn Gumpert, *Christian Boltanski,* 128.

14. Interview with Christian Boltanski by Démosthènes Davvetas, *New Art* (October 1986): 20; quoted in Lynn Gumpert, *Christian Boltanski.*

15. Boltanski quoted in René van Praag, "Century '87, een expositie van 'ideetjes'." *Het Vrije Volk* 28 (August 1987).

16. Delphine Renard, "Interview with Christian Boltanski," 1984; quoted in Lynn Gumpert, *Christian Boltanski,* 176.

17. See Marianne Hirsch's analysis of the family portrait, "Masking the Subject: Practicing Theory." She uses Lacanian concepts for that which Boltanski calls a "cultural set of codes." The subjectivities of portrayed persons in family portraits are "masked" because "existing in the familial, the subject is subjected to the familial gaze and constructed through a series of familial looks" (114).

18. Delphine Renard, "Interview with Christian Boltanski"; quoted in Lynn Gumpert, *Christian Boltanski,* 177.

19. For a seminal discussion of the important role of the index in contemporary art, see Krauss, "Notes on the Index: Part 1" and "Notes on the Index: Part 2."

20. Delphine Renard, "Entretien avec Christian Boltanski," in *Boltanski,* Musée National d'Art Moderne, 71. English translation by Cynthia Campoy, quoted by Gumpert, *Christian Boltanski,* 32.

21. In his site-specific work in Berlin, *Missing House* (1990), Boltanski has turned himself into the archivist of a vacant lot in a former Jewish neighborhood. *The Missing House* consists of name plates attached to the fire walls of houses adjacent to the empty lot created by the destruction of a house in the Second World War. The plates included the names, dates of residence, and professions of the last inhabitants of the missing house. For an excellent reading of this site-specific work, see Czaplicka, "History, Aesthetics, and Contemporary Commemorative Practice in Berlin."

22. Karen Holtzman points in her article "The Presence of the Holocaust in Contemporary Art" at the danger that artists may become guilty of using techniques analogous to those of the Nazis. This is indeed a serious danger but Boltanski has not fallen into this trap because he explores the archival mode of the (Nazi) historian in such a self-reflexive and critical way.

23. Steinar Gjessing, "Christian Boltanski—An interview," 42–43.

24. White, "The Politics of Historical Interpretation," in *The Content of the Form: Narrative Discourse and Historical Representation* (Baltimore: Johns Hopkins University Press), 158–82. Valesio, *Novantiqua: Rhetorics as a Contemporary Theory.*

25. White, "The Politics of Historical Interpretation," 72.

REFERENCES

Alpers, Svetlana. 1988. *Rembrandt's Enterprise: The Studio and Market.* Chicago: University of Chicago Press.

Bal, Mieke. 1991. *Reading "Rembrandt": Beyond the Word-Image Opposition.* New York: Cambridge University Press.

Bartov, Omer. 1996. *Murder in our Midst: The Holocaust, Industrial Killing, and Representation.* New York and Oxford: Oxford University Press.

Benjamin, Andrew. 1991. *Art, Mimesis and the Avant-Garde.* London and New York: Routledge.

Boltanski, Christian. 1997. "Momment à une personne inconnu: Six questions a' Christian Boltanski." In *And Actuel Skira Annuel* (Geneva, 1975), 145–48. English translation of part of this text in: Lynn Gumpert, *Christian Boltanski* (1994), 171–72.

———. 1987. *Classe Terminale du Lycée Chases, 1931: Castelgasse-Vienne* (exhibition catalogue). Düsseldorf: Kunstverein für die Rheinlande und Westfalen.

Brilliant, Richard. 1990. "Portraits: A Recurrent Genre in World Art." In Jean M. Borgatti and Richard Briljant, (eds.), *Likeness and Beyond: Portraits from Africa and the World,* 11–27. New York: The Center for African Art.

———. 1991. *Portraiture.* London: Reaktion Books/Cambridge, Mass.: Harvard University Press.

Chapman, H. Perry. 1990. *Rembrandt's Self-Portraits.* Princeton: Princeton University Press.

Czaplicka, John. 1995. "History, Aesthetics, and Contemporary Commemorative Practice in Berlin." *New German Critique* (Spring 1995): 155–87.

Des Pres, Terrence. 1988. "Holocaust Laughter." In Berel Lang (ed.), *Writing and the Holocaust*, 216–33. New York and London: Holmes & Meier.

Eco, Umberto. 1976. *A Theory of Semiotics.* Bloomington: Indiana University Press.

Ezrahi, Sidra DeKoven. 1980. *By Words Alone: The Holocaust in Literature.* Chicago and London: University of Chicago Press.

———. 1996. "Representing Auschwitz." *History and Memory* 7, no. 2, 121–54.

Friedlander, Saul. (1982) 1993. *Reflections of Nazism: An Essay on Kitsch & Death.* Translated from the French by Thomas Weyr. Bloomington: Indiana University Press.

Gadamer, Hans-Georg. (1960) 1975. *Truth and Method.* New York: Continuum.

Gjessing, Steiner. 1993. "Christian Boltanski—An interview, November 1993." *Treskel/Threshold* 11 (January 1994): 41–50.

Gumpert, Lynn. 1994. *Christian Boltanski.* Paris: Flammarion.

Hirsch, Marianne. 1994. "Masking the Subject: Practicing Theory." In Mieke Bal and Inge E. Boer (eds.), *The Point of Theory: Practicing Cultural Analysis*, 109–24. Amsterdam: Amsterdam University Press.

Hirsch, Marianne, and Leo Spitzer. 1994. "Gendered Translations: Claude Lanzmann's Shoah." In Miriam Cooke and Angela Wollacott (eds.), *Gendering War Talk*, 4–19. Princeton: Princeton University Press.

Holtzman, Karen. 1994. "The Presence of the Holocaust in Contemporary Art." In *Burnt Whole: Contemporary Artists Reflect on the Holocaust*, 22–26. Washington, D.C.: Washington Project for the Arts.

Krauss, Rosalind. 1985. "Notes on the Index: Part 1" and "Notes on the Index: Part 2." In *The Originality of the Avant-Garde and Other Modernist Myths*, 196–209 and 210–20. Cambridge, Mass.: MIT Press.

Marsh, Georgia. 1989. "The White and the Black." *Parkett* 22, 36–40.

Nochlin, Linda. 1974. "Some Women Realists." *Arts Magazine*, May, 29–32.

Renard, Delphine. 1984. "Interview with Christian Boltanski." In *Boltanski* (exhibition catalogue). Paris: Musée National d'Art Moderne, Centre Georges Pompidou.

Sekula, Alan. 1989. "The Body and the Archive." In Richard Bolton (ed.), *The Contest of Meaning: Critical Histories of Photography*, 343–88. Cambridge, Mass.: MIT Press.

Tagg, John. 1988. *The Burden of Representation: Essays on Photography and Histories.* Amherst: University of Massachusetts Press.

Valesio, Paolo. 1980. *Novantiqua: Rhetorics as a Contemporary Theory.* Bloomington: Indiana University Press.

Walton, Kendall L. 1993. *Mimesis as Make-Believe.* Cambridge, Mass.: Harvard University Press.

White, Hayden. 1987. *The Content of the Form: Narrative Discourse and Historical Representation.* Baltimore and London: Johns Hopkins University Press.

Lisa Saltzman

Lost in Translation:
Clement Greenberg, Anselm Kiefer,
and the Subject of History

Modernist painting and its history are deeply marked by the work of Clement Greenberg. Whether through adherence or resistance to his aesthetic vision, generations of American artists, critics, and art historians have contended with the presence and legacy of Greenberg's prodigious body of critical writings. As the preeminent proponent of formalist criticism and painterly abstraction in postwar America, Greenberg crafted and championed an aesthetic paradigm founded upon the inviolable principles of purity, autonomy, and self-reflexivity. Articulated and refined over a period of more than fifty years, Greenberg's aesthetic paradigm was as strict as it was simple. Namely, it was the task of painting to emphasize the opacity of its medium, surrender to the flatness of the picture plane, and destroy realistic pictorial space. In short, Greenberg believed the essential task of painting to be the exploration of painting at its essence. Concomitantly, Greenberg believed the essential task of criticism to be the reception and recognition of such aesthetic enterprises.

Much as my words thus far might suggest yet another essay devoted to revisiting, if not revising, Greenberg's critical contribution to the history of modernist painting, establishing, if only to critique, that legacy, I should assure the reader that it will be quite the contrary. That is, even as I construct an account of Greenberg's critical contributions and predilections, it is my intention to turn, or return, to another aspect of his activity in the domain of culture, namely, Greenberg's work in the field of translation.

It has not gone unacknowledged that Greenberg began his career as a translator. We know from both Greenberg's own writings and those of his commentators, critics, and biographers that upon graduating from college, he went back to his parents' home in Brooklyn and spent two years studying German, Italian, French, and Latin. We know further that although during the 1930s and 1940s, he would devote time to his father's business, work in various capacities for the federal government, and begin his career as a critic for *Partisan Review*, periods of unemployment would twice push Greenberg into work as a translator.[1] But if it is repeated in the scholarship on Greenberg that his two substantial works of

translation, both done in 1936 for Knight Publications, included a report by the World Committee for the Victims of German Fascism, entitled *The Brown Network: The Activities of the Nazis in Foreign Countries*, and a biography of the artist Goya, neither translated text is treated in any detail, as interesting as an analysis of either might prove for understanding Greenberg's later position as a critic. Nor, for that matter, is much attention given to his work in the 1940s translating Kafka for Schocken Books.

Much as I briefly raised, if only to foreclose, the question of the legacy of Greenberg's critical writings, it is not, in the end, to these acts of translation that I intend to turn, although his translation of the World Committee report and his work with Kafka's texts are certainly of parenthetical interest. Rather, it is to a later act of translation that I turn, one that was undertaken in 1955, when Greenberg was well established as a leading modernist critic and editor at *Commentary* magazine.[2]

In March 1955, Greenberg translated and published a piece of poetry. That poem was Paul Celan's lyrical evocation of the Nazi death camps, *"Todesfuge"* ("Death Fugue"—Greenberg's translation—or, more commonly, "Fugue of Death"). Appearing only several years after the first American translation of *The Diary of Anne Frank* (Doubleday, 1952) and in the same year that its stage production brought intense public attention to the diary and the historical trauma to which it bore witness, Greenberg's translation was part of the first wave, if belated, of the American cultural encounter with the Holocaust.[3]

One might say that Celan's poem began as a translation, only the first in its linguistic path from conception to publication. First and foremost, it might be said that for Celan, the poem was a means of translating into language, into poetic form, the reported horrors of the death camps, transforming trauma into lyric, history into poetics, atrocity into aesthetics. Dated 1945, Celan's "Death Fugue" was written perhaps as early as the autumn of 1944,[4] in German, which was, quite literally, Celan's mother tongue, if not the native tongue, of his childhood in polyglot Bukovina. Notably, Celan's "Death Fugue" first appeared not in its original German but as a translation—*"Tangoul Mortii"* ("Tango of Death")—published in Romanian for a Bucharest journal in 1947. Celan's poem did not appear in its original German, in an Austrian publication, until the following year, and it was not published in Germany until 1952. It was from this doubly belated German appearance of the poem that Greenberg produced his translation in March 1955.[5]

Greenberg's translation appeared in *Commentary* as follows:

> Black milk of the dawn we drink it evenings
> we drink it noon and morning we drink it nights
> we drink and drink
> we dig a grave in the wind you won't lie cramped there
> A man lives in the house who plays with the snakes who writes
> who writes at dusk to Germany your golden hair Margarete
> he writes it and comes out of the house and the stars twinkle he whistles
> his hounds out

he whistles forth his Jews has a grave dug in the ground
he orders us strike up now for the dance

Black milk of the dawn we drink you nights
we drink you morning and noon we drink you evenings
we drink and drink
A man lives in the house who plays with the snakes who writes
who writes at dusk to Germany your golden hair Margarete
your ashen hair Sulamith we dig a grave in the wind you won't lie
 cramped there

He cries dig deeper in the ground you ones you others sing and play
he reaches for the iron in his belt he swings it his eyes are blue
dig your spades deeper you ones you others keep playing for the dance
Black milk of the dawn we drink you nights
we drink you noon and morning we drink you evenings
we drink and drink
a man lives in the house your golden hair Margarete
your ashen hair Sulamith he plays with the snakes

He cries play death sweeter death is a master from Germany
he cries fiddle lower then you'll raise in the air as smoke
then you'll have a grave in the clouds you won't lie cramped there

Black milk of the dawn we drink you nights
we drink you noon death is a master from Germany
we drink you evenings and mornings we drink and drink
death is a master from Germany his eye is blue
he strikes you with leaden balls his aim is true
a man lives in the house your golden hair Margarete
he sicks his hounds on us he gives us the gift of a grave in the air
he plays with the snakes death is a master from Germany

your golden hair Margarete
your ashen hair Sulamith[6]

If subsequent translations, the most recent of which is John Felstiner's,[7] will correct some of the infelicities of Greenberg's 1955 effort, it is less the precision or artfulness of his translation than the very fact of its existence that I want to pursue.

By 1955, Greenberg had already written some of his most important pieces of modernist art criticism, among them "Avant-Garde and Kitsch" (1939), "Towards a Newer Laocoon" (1940), "The Crisis of the Easel Picture" (1948), "On the Role of Nature in Modernist Painting" (1949), and "Abstract and Representational" (1954). Taken together, cumulatively, the essays progressively and ever more rigorously banish the presence of any content from painting beyond painting's

own self-reflexive exploration of its possibilities and limits. As Greenberg wrote in "Abstract and Representational":

> That the *Divine Comedy* has an allegorical and analogical meaning as well as a literal one does not make it necessarily a more effective work of literature than the *Iliad*, in which we fail to discuss more than a literal meaning. Similarly, the explicit comment on a historical event offered by Picasso's *Guernica* does not make it necessarily a better work than an utterly 'non-objective' painting by Mondrian that says nothing explicitly about anything.[8]

If literary theorists and historians might contend with Greenberg's assessments of Dante and Homer, his words make clear his aversion to what might be termed modernist history painting, as is emblematized for Greenberg in Picasso's 1937 elegy to the suffering of the Spanish victims of fascism, *Guernica*. More than Greenberg's own criticism, it is the words of Greenberg's most ardent and articulate disciple, Michael Fried, that bring the rigors of the formalist paradigm into sharper focus. Fried writes:

> Criticism concerned with aspects of the situation in which it was made other than its formal context can add significantly to our understanding of the artist's achievement. But, criticism of this kind has shown itself largely unable to make convincing discriminations of value among the works of a particular artist, and in this century it often happens that those paintings that are most full of explicit human content can be faulted on formal grounds— Picasso's *Guernica* is perhaps the most conspicuous example—in comparison with others virtually devoid of such content.[9]

With even greater force, and brevity, Fried sums up the formalist paradigm as follows: "It is one of the prime, if tacit, convictions of modernist painting—a conviction matured out of painful experience, individual and collective—that only an art of constant formal self-criticism can bear or embody or communicate more than trivial meaning."[10] That modern art might recapitulate the grand tradition of history painting, that modern painting might be the site for historical subjects, that Picasso's *Guernica* might indeed be an important painting precisely for the horrors of the political situation it sought to represent, was a possibility denied to it by the rigors and refusals of the modernist paradigm.

Recent critics and art historians motivated, if not at times frustrated, by the limits and lacunae of Greenberg's modernist paradigm, have labored to discover and define a Greenberg who wavered from its logic. A generation of Marxist art historians sought and found, if not a Marxist Greenberg or a Trotskyite Greenberg, at least a Greenberg, an early Greenberg, who did not utterly foreclose history from his critical vision, as much as the painting he came to champion may have insistently done so.[11]

Other art historians have pursued the issue of identity, seeking to uncover the subjectivity of the presumptive universal Kantian spectator, their quest particularized in the issue of Greenberg's "Jewishness."[12] It is the case that by 1955,

Greenberg had written what Sidney Tillim would term a number of pieces of "Jewish interest,"[13] addressing in relation to literature issues that he would withhold from his critical contemplation of art. Despite his reticence about and resistance to subject matter, to content, to the subject, in art, it is interesting to note that Greenberg began 1955 with the publication of his "Autobiographical Statement." And in April 1955, just one month after the publication of his translation of Celan's poem, Greenberg published one of his most self-revelatory pieces, "The Jewishness of Franz Kafka: Some Sources of His Particular Vision."[14]

As Marxism has waned and identity politics have risen within art historical scholarship, the particular intersection of history and Jewishness, as it might be said to converge in the moment of Greenberg's translation of Paul Celan's poetic evocation of the death camps, has not been explored. I should note that I am interested in this critical moment not only for the publication of Celan's poem, although it is the poem and its translation that I will discuss. I am interested in this moment more generally because it marks a turning point in the history of modernist painting.

Looking back to the future from the mid-1950s, it is certainly the case that abstract painting continued to flourish for at least a decade, whether in the continued practice of abstract expressionists or in the ensuing work of color-field painters and minimalists. Nevertheless, it is also the case that by the mid-1950s, the presumptively unified and purified painterly field of pictorial modernism was shattered, literally and figuratively, not only by the tragedy of Pollock's premature death, but by the advent of Pop, augured in the mid-1950s assemblages of Robert Rauschenberg and Jasper Johns. That is, history, subject matter, content, began to intrude, if only as fragments, upon the previously pristine surfaces of Greenberg's cherished modernist painting.[15]

That Greenberg translated Celan's "Death Fugue" for an American audience does not mean that in 1955 he broke with his prior critical criteria and advocated that painting abandon the project of abstraction. Nor does it mean that Greenberg advocated that painting pursue the subject matter of Celan's poem, reductively, the Holocaust, German and Jewish identity, and the death camps. If anything, his continued critical preoccupation with preserving the purity of abstraction suggests that painting continued to function for Greenberg as an aesthetic haven, what might even be termed an aesthetic utopia, where painting would be free of the political and aesthetic contamination he ascribed to the art of totalitarian regimes. His translation suggests that despite the presumptive importance that he ascribed to Celan's poem and to its subject for an American audience, he persisted, some might say stubbornly, in his conviction that painting was not the site for historical subjects. In other words, his translation suggests that despite his apparent belief that poetry (as evidenced in his own act of selection and translation) could indeed be a site for historical subjects, a site where history, or historical experience, might be translated into poetic form, for Greenberg, modernist painting was to remain steadfastly apart from world historical events.

Of course, I am not suggesting that Greenberg believed history, particularly the history of the Holocaust, could be "translated" into poetry, made fully immanent, known, in poetic form. We do not know his critical response to Celan's work, even if his act of translation suggests his interest and support. Although Greenberg did write on other German-language authors (among them Kafka and Brecht), he did not publish any critical writings on Celan. But, as I have already said, he did choose to translate and publish Celan's poem. And in so doing, he revealed a certain conviction, about Celan, about poetry, about "Death Fugue," and about translation.

To the latter, I will add the following. Through his act of translation, Greenberg suggested, if not enacted, a belief in the power of language and the possibility of understanding. He displayed, as perhaps many a writer of his day still would, a conviction in the semantic transparency of words, a transparency that would allow even the words of Celan's poem to be transposed not only into another language, but into another culture, another time, another place. His translation enacted and literalized the very concept of translation, namely, that which is carried from one place to another, transported across borders at once temporal and geographic.[16] That is, it could be said that the Greenberg who had once labored in the Appraiser's Division of the Customs Service in the Port of New York transported and imported for an American audience a work that is considered perhaps the most important postwar poetic evocation of the Holocaust.

For some critics, among them Walter Benjamin, the act of translation involves a certain empowerment of language, albeit necessarily belated.[17] For others, among them Jacques Derrida, the act of translation reveals quite the contrary. For even if translatable, a text remains always, at the same time, untranslatable, and in that inevitable impossibility of translation, reveals the very incommensurability, the very inadequacy, the very foreignness, the very condition of language itself.[18] In the belatedness of Celan's poem, its distance from the experience it seeks to represent, and in the further belatedness of its publications and translations, we get a sense of what Benjamin would call the "afterlife" of the translation,[19] its necessary distance from, despite its close connection to, the original. But even more, in the belatedness of Celan's poem, whether in its "original" or translated form, we get a sense of the gap it can never close, the distance it can never recover, the experience it can never fully represent as much as it strives to provide access and bear witness. And that belatedness, that temporal, even conceptual distance, is only made all the more acute when we contemplate its subject, the Holocaust, the trauma of Auschwitz, the historical event which may be said to deny, if not entirely defy, representation.[20]

Celan's poetic oeuvre seemed to embody and articulate in its language a deep awareness of the limitations (and yet necessity) of language and representation. As Theodor Adorno writes of Celan's work, "Celan's poems articulate unspeakable horror by being silent."[21] Against Celan, if not Adorno, Greenberg's act of translation seemed to grant to his own words, if not to Celan's, a certain

Benjaminian power and "afterlife," a voice to countermand the silence. Celan's poem, introduced to an American reading public in 1955 by Greenberg and immediately followed in *Commentary* by a piece of expository prose about Celan and his wartime experiences, was framed as able to express, represent, put into language, something of the historical trauma it took as its subject. More simply, on the pages of *Commentary* magazine in 1955, poetry was allowed to portray what was forbidden, in Greenberg's formalist paradigm, to painting.

What, then, would Greenberg have made of a series of paintings, executed in the early 1980s, that might be said to so challenge his critical convictions? Moreover, what would Greenberg have made of a series of paintings that in some ways repeated his act of initial translation, introducing, translating, Celan's *"Todesfuge"* once again for an American audience? The painter is the postwar German artist Anselm Kiefer, known for his aesthetic explorations of German national identity. The particular paintings in question bear the names, and the titles, *Margarethe* and *Sulamith* (figures 1 and 2). As their titles and basic iconography suggest, the paintings take as their source, if not their subject, the figures of German and Jewish womanhood who structure and haunt Celan's poem. They might well be considered a painterly translation, transcription, transposition, transformation, transcendence, if not transgression, of Celan's poem. And, as such, they introduce yet another belated translation, albeit this time into the realm of visual culture, of Celan's *"Todesfuge."* And with that, they (re)introduce the historical trauma of the Holocaust to an American audience, this time through the forum of a mid-career retrospective that traveled to Chicago, Philadelphia, New York, and Los Angeles in the late 1980s.

Were Kiefer's paintings to be viewed strictly through the lens of Greenberg's criticism, they would be considered an outrage, departing wildly from the tenets and strictures of his formalist paradigm. For as much as their treatment of surface may be indebted to earlier moments in a history of modernism, whether to the painting of Pollock or to the collage of Picasso, their composition insistently challenges, if not simply ignores, the essential purity, autonomy, and self-reflexivity demanded by Greenberg of the modernist picture plane. Word and image compete on the densely layered canvases. Surfaces are at once obdurate and illusionistic, materials at once literal and insistently referential. If figuration itself is put into a certain visual and thematic tension, if not suspension, in many of Kiefer's major paintings, there is no doubt that subject matter intrudes heavily upon their surfaces. Whether drawing, in this case, upon Celan's leitmotif, or elsewhere, for example, upon Wagnerian libretti or kabbalistic tales, Kiefer's work resolutely, if not at times repetitively, puts forth subject matter.

And yet, the question might be asked, What is the "subject" of Kiefer's painting, of these Kiefer paintings? If we focus our attention on the more conventionally "representational" of the pair, *Sulamith*, we might well ask just what might

Figure 1. Anselm Kiefer, Margarethe, *1981. Oil and straw on canvas; 280 × 380 cm.* Courtesy Anselm Kiefer and Marian Goodman Gallery, New York.

be the subject of this architecturally exacting rendering. Many critics have likened Kiefer's monumentalized representation and revision of Wilhelm Kreis's *Memorial to German Soldiers* to a crematorium, its darkened brick interior and recessional movement to a row of painterly flames (some would say suggestive of a menorah), a presumptive evocation through transformation of the Nazi apparatus of destruction. Once an architectural space commemorative of German war heroism, the extinguished lateral lanterns and the inscription of a name, Sulamith, allow the space to become a different kind of memorial space.

It would seem that much of the transformation of the space rests on the power of the name, a biblical name, a Jewish name, a name that is born in the "Song of Songs" and comes to rest in the "Fugue of Death." With the conferral of a name, Sulamith, and with the evocation of both the Hebrew Bible and Celan's poem, it is presumed that the darkened chamber is transformed, transfigured, translated, into a site of Jewish memory, a Holocaust memorial in painterly form.

And yet, I ask again, What does it represent? What is its subject? On the surface (and ultimately, or literally, that is all that we have when we look at a painting), it is the representation of the interior of a piece of Nazi architecture. So

Figure 2. Anselm Kiefer, Sulamith, *1983. Oil, acrylic, emulsion, shellac, and straw on canvas, with woodcut; 290 × 370 cm.* Courtesy Anselm Kiefer and Marian Goodman Gallery, New York.

we might say that there is a certain historical referent, a certain historical speci-ficity to the painting. Like many of Kiefer's paintings that preceded it and some that will follow, it takes us into the history of the Third Reich by way of its most concrete aesthetic trace, architecture, even if that architecture is mediated, and at times also singularly preserved by the form of the photograph.

Given the frequency with which Kiefer made use of Nazi architecture in his work in the 1970s and 1980s, it is not the architectural edifice, as visually arresting as that form may be, that marks this work as a memorial to, or as a rep-resentation of, the Holocaust. It is, as I have already said, the inscription of a name upon that form. It is the inscription of the name Sulamith, the dark-haired woman of the Song of Songs, who is reincarnated, if only as an image of Jewish death, in Celan's haunting poem. She, in name alone, becomes a figure, a cipher for Kiefer and his asymptotic imaging of the Holocaust.

Ironically, but perhaps significantly, Celan's poetic image—your ashen hair Sulamith—turns, when translated into painterly form, not into an image, but into a word, a word alone, Sulamith.[22] Inscribed in a small, constrained hand in the uppermost left corner of the painting, the white letters occupy the most marginal and unobtrusive position within the otherwise massive painting. Where Celan's poem evokes, through its use of the first-person pronoun "we" and an insistent pres-

ent tense, the fragile and futile activities of human life, of Jewish life, lived, if only to be extinguished, in a place of death, Kiefer's painting shows us only stasis, the concrete, hulking form of an architectural monument to death. Kiefer takes us into, forces us into, given his insistent use of perspectival visual cues, a concretized space of Nazism, of the past, of history, only to withhold from us its presumptive subject, Sulamith and the Jewish victims of Nazism.

We might say that absent, lost, is Celan's grounding figure of Jewish womanhood, of Jewish victimhood. We might say that Kiefer takes us into the very site of history, the concrete trace and vestige of the Nazi regime (here architecture but elsewhere, landscape, the forest), only to withhold from us the human subject, the victims of that very regime. We then might ask whether that withholding of the subject, of the subject of history, registers as a failing of the painting, a failing in Kiefer's act, or acts, of translation, transformation, and interpretation.[23] For if in Kiefer's translation of poetry into painting, history into aesthetic form, the image is missing, if we see, not a figurative representation of Sulamith and her ashen hair, but the inscription of her name alone, does this mean that she, and with her, history, is missing as well, that all are, indeed, lost, irrevocably, in translation? What are we to do with the seemingly absent subject of Kiefer's painting, the subject at once named and negated in the aching void that is the architectural mausoleum, that is, in the end, the crypt?

Might Kiefer's painting function as a two-dimensional analogue to the contemporaneous "countermonuments" posited by James Young, commemorative structures in 1980s Germany that eschew figuration and are characterized more by absence then presence?[24] For these are structures—sculptures and installations—that mark and configure absence, gesturing, in their refusal to figure, both to the enormity of the historical loss and the impossibility of ever finding forms appropriate to its representation. Might Kiefer's painting echo, if only mutely and statically, the staging and aesthetic ethics of Claude Lanzmann's *Shoah*? For Kiefer's painting, like Lanzmann's film, takes us to a historical site of Nazism, but refuses to represent the historical human subject.

The absent subject of the German monuments of the 1980s may be closer in gesture to Kiefer's painting. And certainly, they share a nationality. In the case of Lanzmann, although he refuses the use of either archival footage or historical re-creation, choosing instead to narrate the film from the present, the historical subject returns through interviews, on site and off, with survivors and former perpetrators.[25] As such, Lanzmann's film fills the void in ways that neither Young's "countermonuments" nor Kiefer's empty edifices can do. For narrative completion, for human presence, both Young's monuments and Kiefer's paintings are reliant on the presence, and with that, on the knowledge, of the spectator.[26]

I could continue to explore the relative merits and weaknesses of Kiefer's aesthetic endeavor. But rather than so doing, I should admit that, thus far, I have withheld one crucial detail in my description of Kiefer's painting. That is, even as the painting establishes an illusionistic recession into the depths of Kreis's

architectural form and stops at a small row of flames, the painting also establishes a countering force. Namely, the movement toward the murky vanishing point of the empty chamber is destabilized, blocked, by the intense materiality of the surface of the painting, particularly the upper register, which is embedded, encrusted, covered, with ashen residue. That is, just as the spectatorial eye recedes into the depths of the chamber, it is pulled back to the texture of the surface.

If that surface matter may be linked back to the recessional depths of the painting, that is, if it may be read as the very ash produced by the represented fire, it may also be linked, quite powerfully, to Celan's poem. For it is with the application of ash to the surface of the canvas that Kiefer gestures, most literally, to Celan's poem, Kiefer's material gesture, his metonymic gesture, his iconographic gesture, concretizing Celan's words—your ashen hair, Sulamith . . . you'll rise then as smoke to the sky. Made present as absence, embodied in the very metaphoric construction employed by Celan, Sulamith occupies Kiefer's cavernous chamber, if only as ashen trace. The ash that recurs in Celan's poetic oeuvre becomes—is translated into—an ashen residue that covers the surface of this and many a subsequent Kiefer painting. And yet, what is ash?

As Derrida writes, as he writes on Celan: "There is ash, perhaps, but an ash is not. This remainder *seems* to remain of what was, and was presently; it seems to nourish itself or quench its thirst at the spring of being-present, but it emerges from being, it uses up in advance the being from which it seems to draw."[27] Ash (elsewhere translated as cinder) is absence made present, the trace, the remain without a remainder. It draws its very being, as absence, from destruction. It is that which is not. It is, were Derrida to write, when he writes on Celan, of *"Todesfuge,"* which, sadly, he does not, Sulamith and the absence of Sulamith, her biblical creation and her historical destruction, as one. Ash becomes, on Derrida's account, an all-consuming specter. In Kiefer's work, Sulamith, as ashen hair, as ashen trace, as a specter haunting not just representation, but, in this instance, the pictorial field, gives way to Lilith, the ghostly demoness, the biblical specter, who will come to displace Sulamith in Kiefer's subsequent ashen canvases that take as their source, not Celan, but kabbalistic literature.

But if Sulamith materializes more fully in Kiefer's subsequent *Lilith* pictures, where ash and inscription are joined by tresses of dark hair, here, in *Sulamith*, her presence is marked, identified, with the inscription of the name. It is the name that gives the ash its absent presence. It is the name that marks the painting as a transformed space of commemoration, of Jewish memory. As Derrida goes on to write, in a passage that might be seen at moments as an uncanny description of the very picture in question,

> The loss cannot be worse than when it extends to the death of the name, to the extinction of the proper name which a date, bereaved commemoration, remains. It crosses that boundary where mourning itself is denied us, the interiorization of the other in memory *(Erinnerung)*, the preserving of the other in a sepulcher or epitaph. For in securing a sepulcher, the date would still

make room for mourning, for what one calls its work. Whereas Celan also names the incinerated beyond of the date, words lost without sepulcher, "wie unbestattete Worte." But once dead, and without sepulcher, these words of mourning which are themselves incinerated may yet return. They come back then as phantoms.[28]

In Kiefer's *Sulamith*, the name, translated from the biblical to the poetic to the painterly domain, becomes an epitaph, the painting a sepulcher, but neither epitaph nor sepulcher is fixed in time by a date. Nazi Germany, the postwar present, the future as architectural ruin, the painting hovers in an atemporal netherworld that is neither fully past nor fully present, much like Sulamith, dispersed as ashen residue. Unmoored, and, as such, unmourned, Sulamith, the absent Jewish subject of Kiefer's dark and funereal painting, haunts the scene of representation. Kiefer's architectural rendering, his painterly crypt, his visual sepulcher, becomes a space for preserving, if only as ashen trace, as that which is never fully there, as that which is never fully visualized, that which cannot, or will not, be mourned.[29] It becomes what Derrida, or, more typically, psychoanalysts would refer to as the space of repression, of internalization, but here externalized, displaced, into the form of a painting.[30] It becomes the space where the absent Jewish subject, the Holocaust, is gestured toward but never fully represented, and in turn, never fully mourned. The painting as sepulcher functions, then, as a space not of mourning and memorialization, but of melancholia and forgetting, where the remains of history give way to ashen remainder.

If I might return, as a gesture toward a conclusion, not just to Kiefer, but to Greenberg the critic and the matter of his act of translation, I would offer the following thought. If history and its subjects remain lost, lost in translation, lost in the matter of language and painting, lost in representation, perhaps Kiefer's painting upholds Greenberg's aesthetic ethics far more closely than I initially allowed. For Kiefer does resist conventional forms of figuration, withholding the human figure, the subject, even as he gives us its staging grounds, the scene, if not the seen, of representation. He refuses to translate Celan's poetry into painting, even as he takes "Death Fugue" as his subject. He avoids representation even as he is trapped in its prison house. And it is thus that in figuring the very impossibility of figuration, in translating the very impossibility of translation, in representing the very impossibility of representation, Kiefer's *Sulamith* refuses the historical subject, turning content into pure abstraction, even as the image remains grounded in the contested field of painterly practice.

NOTES

1. See, for example, Greenberg's "Autobiographical Statement" (1955) in *Clement Greenberg: The Collected Essays and Criticism, vol. 3: Affirmations and Refusals: 1950–56*, ed. John

O'Brian (Chicago and London: University of Chicago Press, 1993), 194–96. See also, to name but two possible sources, Susan Noyes Platt, "Clement Greenberg in the 1930s: A New Perspective on His Criticism," *Art Criticism* 5 (1989): 47–64 and Bradford Collins, "Le pessimism politique et 'la haine de soi juive': Les origines de l'esthetique purité de Greenberg," *Les Cahiers du Musée National d'Art Moderne* 45–46 (1993): 61–84.

2. It is also of parenthetical interest that Greenberg had begun at *Commentary* in 1944, when *Commentary* was still known as the *Contemporary Jewish Record*, as published by the American Jewish Committee.

3. For the most recent, if polemical and cynical, discussion of the American reception of the *The Diary of Anne Frank*, with particular attention given to the stage play, see Peter Novick, *The Holocaust in American Life* (Boston: Houghton Mifflin, 1999).

4. John Felstiner makes this claim for the earlier date of the poem in his *Paul Celan: Poet, Survivor, Jew* (New Haven and London: Yale University Press, 1995), 27–28.

5. In the explanatory text that follows Greenberg's translation, it is noted that "Death Fugue" is taken from the "lone book of poems Mr. Celan has published so far, *Poppies and Memory (Mohn und Gedächtnis)*, which was brought out in 1952 by the Deutsche Verlags-Anstalt in Stuttgart." *Commentary* (March 1955): 243. The editors are mistaken. It is the case that a prior collection, *Der Sand aus den Urnen* (Vienna: A. Sexl, 1948), had already been published, but in Austria, not in Germany. It is also the case that Greenberg's was not necessarily the first English-language translation as in that same spring, a British version appeared, translated by Michael Bullock, *Jewish Quarterly* 2, no. 4 (Spring 1955): 6.

6. Paul Celan, "Death Fugue," tr. Clement Greenberg, *Commentary* (March 1955): 242–43.

7. Felstiner, 31–32.

8. O'Brian, "Abstract and Representational" (1954), *Clement Greenberg*, 187.

9. Michael Fried, *Three American Painters: Kenneth Noland, Jules Olitski, Frank Stella* (Cambridge, Mass.: Fogg Museum of Art, 1965), 5.

10. Ibid., 25.

11. See, for example, the essays anthologized in *Pollock and After: The Critical Debate*, ed. Francis Frascina (New York: Harper & Row, 1985), particularly those of T. J. Clark and Thomas Crow.

12. In addition to the essays already cited by Collins and Noyes Platt, see as well Thierry de Duve, *Clement Greenberg between the Lines* (Paris: Dis Voir, 1996), 39–46; Louis Kaplan, "Reframing the Self-Criticism: Clement Greenberg's 'Modernist Painting' in Light of Jewish Identity," in *Jewish Identity in Modern Art History*, ed. Catherine M. Soussloff (Berkeley: University of California Press, 1999), 180–99; and Sidney Tillim, "Criticism and Culture, or Greenberg's Doubt," *Art in America* 75 (May 1987): 122–28.

13. Tillim concentrates on six pieces from the 1940s but one might look as well to his work on Kafka and Jewishness that appeared in 1955, the same year as his translation of Celan's poem.

14. O'Brian, *Clement Greenberg*, vol. 3, 194–96 and 202–09. A significantly revised edition of the Kafka essay appears as "Kafka's Jewishness," in an anthology Greenberg edited of his own work, *Art and Culture: Critical Essays* (Boston: Beacon Press, 1961), 266–73. In it, Greenberg writes, "But might not all art, 'prosaic' as well as 'poetic,' begin to appear falsifying to the Jew who looked closely enough? And when did a Jew ever come to terms with art without falsifying himself somehow? Does not art always make one forget what is literally happening to oneself as a certain person in a certain world? And might not the investigation of what is literally happening to oneself remain the most human, therefore, the most serious and the most amusing, of all possible activities? Kafka's Jewish self asks this question, and in asking it, tests the limits of art" (273).

15. Although Pollock's fatal car crash would not occur until 1956, his painting, and with that, the triumph of abstract expressionism and high modernism, had already succumbed to his heavy drinking and depression. As early as 1952, Greenberg was reported to have said that Pollock had "lost his stuff." Rosalind Krauss cites the comment, in her *The Optical Unconscious* (Cambridge, Mass.: MIT Press, 1993), 251, 322. Her source for the comment is the biography by Steven Naifeh and Gregory White Smith, *Jackson Pollock: An American Saga* (New York: Clarkson Potter, 1989), 698, 731, 895.

16. For my understanding of the practice and theory of translation, I am indebted to several sources, among them Andrew Benjamin, *Translation and the Nature of Philosophy: A New The-*

ory of Words (London and New York: Routledge, 1989); Walter Benjamin, "The Task of the Translator," in *Illuminations*, tr. Harry Zorn (New York: Schocken Books, 1969), 69–82; J. Hillis Miller, "Border Crossings, Translating Theory: Ruth," in *The Translatability of Cultures: Figurations of the Space Between*, ed. Sanford Budick and Wolfgang Iser (Stanford, Stanford University Press, 1996), 207–23; and Azade Seyhan, "Visual Citations: Walter Benjamin's Dialectic of Text and Image," in *Languages of Visuality: Crossing between Science, Art, Politics, and Literature*, ed. Beate Allert (Detroit: Wayne State University Press, 1996), 229–41.

17. Walter Benjamin, "The Task of the Translator," 69–82.

18. See Andrew Benjamin, *Translation*, 9–38, 150–80, which deals, in large measure, with Jacques Derrida's *Ulysse Gramophone* (Paris: Galilée, 1987). See as well Jacques Derrida, "Shibboleth for Paul Celan" (1986), in *Word Traces: Readings of Paul Celan*, ed. Aris Fioretos (Baltimore and London: Johns Hopkins University Press, 1994), 3–72.

19. Walter Benjamin, "The Task of the Translator," 71.

20. In his essay "Symptoms of Discursivity: Experience, Memory, and Trauma," in *Acts of Memory: Cultural Recall in the Present*, ed. Mieke Bal, Jonathan Crewe, and Leo Spitzer (Dartmouth and London: University Press of New England, 1999), 24–38, Ernst van Alphen makes the more radical claim that there are those things (namely, traumatic experiences) that simply cannot be symbolized, for which there is no language, and as such, they are not "experienced." Against such work, although never explicitly invoking the work of van Alphen, would be the contemporaneous work of Dominick LaCapra, who in his "Trauma, Absence, Loss," *Critical Inquiry* 25 (Summer 1999): 696–727, seeks to differentiate between absence and loss, and with that, structural and historical trauma, precisely to prevent what he terms the "quasi-transcendental, endless grieving," the "indiscriminate generalization," through which historical trauma loses its specificity and, on his account, the distinction among victims, perpetrators, and bystanders is effaced.

21. Theodor Adorno, *Aesthetic Theory*, tr. C. Lehnhardt (London and Boston: Routledge & Kegan Paul, 1984), 444.

22. There do (or did) exist other versions of *Sulamith* in Kiefer's private collection in which the female figure is given form. Mark Rosenthal reproduces one such version as small black-and-white marginal illustration in his catalogue *Anselm Kiefer* (Chicago and Philadelphia: Art Institute of Chicago and Philadelphia Museum of Art, 1987), 88. That same picture, accompanied by two others, appears in an issue of *Kunstforum International* 87 (January–February 1987): 185, entitled "Das Brennende Bild: Eine Kunstgeschichte des Feuers in der neueren Zeit." Each painting is inscribed with the title "Dein aschenes Haar Sulamith," in the scrawling script, as opposed to the constrained print, more typical of Kiefer's inscriptions. Two depict a nude woman, with a massive head of black hair, seated before and dwarfing a cityscape of densely skyscrapers. The third, echoing *Margarethe*, depicts a thick tress of darkened hair fixed above a steeply pitched landscape.

23. Elsewhere, I have suggested that Kiefer's refusal to figure the (Jewish) subject may be contextualized within a certain ethics of representation, beginning with the biblical prohibition on figuration and continuing, although not ending, with Adorno's (later qualified) aesthetic prohibition on poetry after Auschwitz. See my "'Thou shalt not make graven images': Adorno, Kiefer, and the Ethics of Representation," in *Anselm Kiefer and Art after Auschwitz* (New York and Cambridge: Cambridge University Press, 1999), 17–47.

24. James Young, *The Texture of Memory: Holocaust Memorials and Meaning* (New Haven and London: Yale University Press, 1993).

25. See Miriam Bratu Hansen, "*Schindler's List* Is Not *Shoah*: The Second Commandment, Popular Modernism, and Public Memory," *Critical Inquiry* 22 (Winter 1996): 292–312, also in this volume.

26. For a discussion of the critical and contemplative role of the spectator in viewing and learning from Holocaust monuments in Berlin, see John Czaplicka, "History, Aesthetics and Contemporary Commemorative Practice in Berlin," *New German Critique* 65 (Spring–Summer 1995): 155–87.

27. Derrida, "Shibboleth for Paul Celan," *Word Traces*, 47. In his subsequent work, *Cinders*, tr. Ned Lukacher (Lincoln and London: University of Nebraska Press, 1987), 39, Derrida writes the following: " If a place is itself surrounded by fire (falls finally to ash, into a cinder tomb), it no longer is. Cinder remains, cinder there is, which we can translate: the cinder is not, is not

what is. It remains *from* what is not, in order to recall the delicate, charred bottom of itself only non-being or non-presence. Being without presence has not been and will no longer be there where there is cinder and where this other memory would speak. There, where cinder means the difference between what remains and what is, will she ever reach it, there?"

28. Derrida, "Shibboleth for Paul Celan," 57.

29. In my chapter "Our Fathers, Ourselves: Icarus, Kiefer, and the Burdens of History," in *Anselm Kiefer and Art after Auschwitz*, 48–74, I have made a related argument in regard to Kiefer's self-representations, what might be termed his symbolic self-portraits, as seen in his *To the Unknown Painter* series. There I am concerned primarily with an act of mourning for the Jewish other that gets displaced onto the self, a displacement that results, for the postwar German subject, in the assumption of a deeply melancholic subject position of victim.

30. See Nicolas Abraham and Maria Torok, "A Poetics of Psychoanalysis: 'The Lost Object— Me,'" *Substance* 43 (1984): 3–18.

Television and Video

Jeffrey Shandler

The Man in the Glass Box:
Watching the Eichmann Trial
on American Television

In the years since the watershed miniseries *Holocaust: The Story of the Family Weiss* was first broadcast in 1978, the Nazi persecution of European Jewry has appeared hundreds of times on American television. The subject of numerous dramas and documentaries, the Holocaust is also frequently invoked in news reports, in public affairs programming, and even in the occasional situation comedy and advertisement. The small screen now plays a central role in maintaining the powerful relationship that millions of Americans have with the Holocaust, enabling them to feel that they understand this forbidding event, remote from their own experience, and that it informs their moral consciousness.[1]

While the miniseries is the most prominent single event in the annals of American Holocaust television, broadcasts that dealt with what became known as the Holocaust were aired beginning in the late 1940s. And there is a major landmark in this chronology of programs that predates the miniseries by seventeen years: telecasts of and about the war crimes trial of Adolf Eichmann in 1961. This marked the first time that the Holocaust received prominent, extended television coverage in the form of news reports, public affairs programs, documentaries, and dramas aired over a period of months. The Eichmann case also provided the first opportunity for television to deal with the Holocaust in the context of reporting a major news story. Indeed, many Americans may have first heard the word "Holocaust" used to describe this chapter of history during telecasts of the trial.[2]

In the history of Holocaust memory culture the Eichmann trial is, of course, widely recognized as a threshold event. It was the first major public effort to conceptualize the Holocaust as a discrete chapter of history, distinguished from larger narratives of World War II or the Third Reich, and defined as a phenomenon centered around Nazi efforts to exterminate Jews. Telecasts of the Eichmann trial, seen by millions of people in dozens of countries, are also noteworthy as a landmark in the annals of television broadcasting, for they mark the first international telecasts of the proceedings of a major trial.

In addition, the Eichmann case provided the occasion for what is, perhaps,

the first extended public contention over the significance of the Holocaust. The Israeli government conceived the trial as an occasion for presenting the Holocaust as a distinctly Jewish phenomenon and as a public event that would validate the new state's political agenda. However, American conceptualizations of the Eichmann case usually approached the Holocaust as a morally charged, paradigmatic event with universal significance. Watching the trial on television played a strategic, although largely unacknowledged, role in this contention. In the United States, where the Eichmann trial had its largest television audience, the medium not only informed viewers but also shaped public discussion of what it meant to be a "witness" to this historic event.

Debating the Eichmann Case

Among the most sought-after Nazi war criminals in the years following World War II was Adolf Otto Eichmann. This former SS officer had been the highest ranking figure in the Nazi hierarchy specifically charged with facilitating the extermination of European Jewry. As soon as the Israeli government announced in May 1960 that, after years of searching for him, they had captured Eichmann and planned to put him on trial, the case became the subject of multiple controversies. Among the issues debated—the legality of Eichmann's abduction from Argentina, where he had been hiding; the legitimacy of trying him in a new nation, by laws enacted ex post facto, before a Jewish court—was the question of the planned war crimes trial as a performance. To some extent, this issue is always at least implicit in public trials, and it is often seen as problematic. As Robert Hariman notes, the perception of a trial as a "performance of the laws" in the "national theater" creates a dilemma: "the more a trial appears to be a scene or product of . . . rhetorical artistry, the less legitimate it appears. . . . It seems that good law and powerful rhetoric do not mix."[3] Yet both supporters and detractors of the Eichmann trial invoked the notion of the trial as performance when discussing its legitimacy and effectiveness.

Some of the Eichmann trial's critics warned of an event whose performative nature would preclude its claim to serving justice. Thus, one American newspaper expected the trial to be "a new wailing wall—a show and spectacle carefully stage-managed to wring the maximum sympathy out of a dramatic exposure of Nazi genocide."[4] Israeli prime minister David Ben-Gurion responded to such charges by validating, rather than denying, the notion of the Eichmann trial as a performance, arguing that the proceedings would effectively and appropriately fulfill a larger agenda: "We want to establish before the . . . world how millions of people, because they happened to be Jews, . . . were murdered by the Nazis. . . . [The world] should know that anti-Semitism is dangerous and . . . should be ashamed of it." Ben-Gurion also hoped that the trial would help "ferret out other Nazis" and

that it would educate "the generation of Israelis who have grown up since the holocaust." Indeed, he claimed not to care what verdict was delivered against Eichmann: "Only the fact that he will be judged in a Jewish state is important."[5]

Chief prosecutor Gideon Hausner was also sensitive to the trial's performative aspects. Rather than present his case primarily through documentary evidence, as was done in the Nuremberg war crimes trials, Hausner wished to "reach the hearts of men" by presenting "a living record" of the Holocaust. In selecting which of many possible witnesses would testify at the trial, Hausner sought effective performers and made dramaturgical choices as to how particular individuals might present similar evidence. For example, he chose to have a plumber testify "in his own simple words" about Nazi persecutions in Bialystok, instead of a well-known writer who had been a leader of the underground.[6]

Televising the Eichmann Trial

The special concern for the Eichmann trial's effectiveness as a performance extended to preparations for its worldwide audience. The Israeli government planned the trial with a large press presence, including television, in mind. Their decision to televise the courtroom proceedings, an unprecedented move, proved controversial. When Eichmann's defense counsel argued against allowing cameras in the courtroom, the prosecution made its case by citing precedents that championed publicity as a guarantor of a fair trial.[7] Israeli judges who ruled in favor of the prosecution cited British law on the subject of witnesses and publicity: "Where there is no publicity there is no justice. It keeps the judge himself, while trying, under trial. The security of securities is publicity."[8]

Beit Ha'am, a new public hall in western Jerusalem, where the trial was conducted, was extensively remodeled to accommodate the event. Renovations included providing hundreds of journalists with workspace and telecommunications services. Of the 756 seats in the spectators' section of the auditorium, 474 were reserved for members of the press (whereas, initially, only about twenty were set aside for the public). The Israeli government provided reporters with transistor radios that received ongoing translation of the trial, which was officially conducted in Hebrew, into English, German, and French. In addition, journalists were able to watch the trial proceedings live on closed-circuit television in the press room.[9]

Israel itself had no broadcast television at the time; Israelis followed the trial by listening to the radio and reading newspapers.[10] The arrangements to televise the trial specifically targeted foreign audiences; in Hausner's words, this was done "so that the whole world could watch."[11] Rather than allow each commercial network and national television system to set up its own cameras in the courthouse, the Israeli government decided to engage a single broadcaster to create an

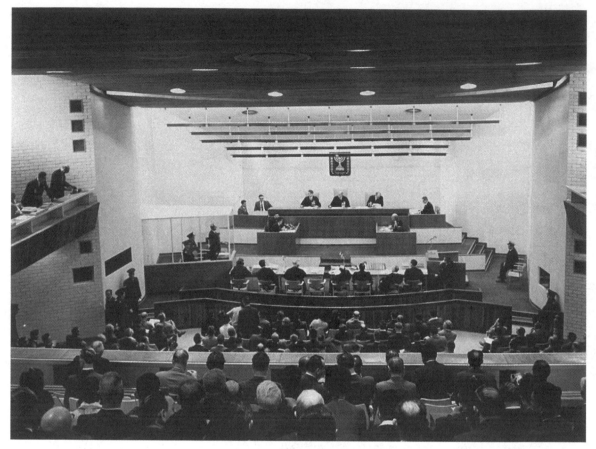

Figure 1. The courtroom set up in Jerusalem's Beit Ha'am for the war crimes trial of Adolf Eichmann, 1961. Television cameras were located behind windows on the left- and right-hand sides of the stage. Israel Government Press Office, courtesy of U.S. Holocaust Memorial Museum Photo Archives.

official video record of the trial. The contract was made with Capital Cities Broadcasting Corporation, then a relatively small, independent company based in New York. Capital Cities set up four cameras in Beit Ha'am, which were concealed in booths located to the left and right of the stage on which the tribunal sat.[12] Capital Cities agreed to provide trial footage to all interested broadcasters and newsreel producers and to turn over any profits from the fees it charged to charity.

Recording the proceedings involved a crew of two dozen men, supervised by Capital Cities's Leo Hurwitz. Under his direction, the filming of the Eichmann trial evolved its own aesthetic criteria. "You can't simply follow a witness all the time he speaks, and then put the camera on Eichmann when his name is mentioned," Hurwitz explained in an interview. "You have to have a sense of the event."[13] Thus, the choices made by Hurwitz's team—camera angles, composition and length of shots, camera-to-camera editing—became a fixed part of the trial's official visual record.

However, most of this footage was never aired. During the trial, broadcasters presented no more than one hour of trial footage daily; most offered much less. Each day, sixty minutes of footage was preselected by Capital Cities producers in Jerusalem before being duplicated and flown to broadcasters around the world. In the United States, the footage was usually aired one day after it was recorded. Television coverage of the Eichmann trial thus represents a transitional stage in international telecommunications. While this "next-day" presentation of trial footage was an advance over newsreels, which took several days to process and distribute, this achievement would soon be eclipsed by simultaneous global broadcasting via satellite.[14]

New York Times media critic Jack Gould noted that television coverage of the Eichmann trial promised to be "the most sustained and extensive attention that TV ever has accorded a single news story, partly because what will be one of history's most celebrated trials will be the first to be televised on home screens around the world."[15] According to Milton Fruchtman, executive producer of Capital Cities, footage of the trial was used by thirty-eight countries, and an estimated "80 per cent of the world's viewers [saw] shots of the trial."[16]

American broadcasters offered more extensive television coverage of the Eichmann trial than did those from any other nation. All three national commercial networks featured reports on the case in their nightly prime-time news programs over the course of the proceedings, and all three presented a variety of special programs dealing with the trial near the time of its opening and closing. Of the three networks, ABC offered the most extensive regular coverage. The network broadcast weekly, one-hour summaries nationally and also presented nightly, half-hour highlights of the previous day's proceedings on its flagship station, WABC-TV in New York City. The full hour of daily videotapes was also aired in New York on independent station WNTA (Channel 13), which advertised the most complete coverage of the Eichmann trial.[17]

Special programs aired during the week that the trial began included public affairs programs focusing on the case itself as well as documentary and dramatic programs offering background on Nazism and the Holocaust.[18] At the same time, the parameters of television coverage of the Eichmann case were articulated by what was *not* broadcast. Comedians Marty Allen and Steve Rossi, scheduled to appear that week on *The Ed Sullivan Show*, reported that "there's nothing you can . . . do with the Eichmann thing that is really funny." While regularly drawing on current events in their routines, they explained that "the crimes charged to Eichmann defy humor."[19]

Although at first telecasts of the trial were treated as newsworthy in themselves, there was relatively little discussion of this unprecedented mediation of a major court case in the American press, in contrast with its extensive coverage of the proceedings themselves. Just before the first day of the Eichmann trial, Gould noted in the *New York Times* that a number of television programs made comparisons between the upcoming Jerusalem trial and the war crimes trials held in

Nuremberg during the immediate postwar years, which "pointed up a little-noticed fact that could have a bearing on the future awareness of Nazi bestiality. In the fifteen years separating the Nuremberg and Jerusalem trials the medium of television was introduced." Gould is one of the few observers to mention television's role in shaping either the presentation of the trial to Americans or their response to the case. Yet in this review he comments directly on the medium's impact only once, noting as problematic the presence of commercials in an ABC broadcast, which "opened with an appropriately somber and serious summation of the meaning of the trial and then switched to a frothy and gay plug for a consumer product; the juxtaposition was jarring."[20]

Television was, of course, not the only source that Americans had for learning about the Eichmann case; the range of American news media treated it as an important story. Nonetheless, television coverage offered an unrivaled combination of the other media's attributes. Compared to newsreels and popular magazine features, television offered Americans reports that were more immediate, presenting courtroom footage as quickly as one day after it had taken place. Although newspaper and radio coverage was often just as prompt, television also offered the trial as spectacle, fostering a sense of "live" contact between event and audience. The medium's intimate scale and domestic viewing context gave viewers an unparalleled sense of proximity to the proceedings.

Moreover, television could present segments of trial footage that, while selectively edited, still ran much longer than the film clips usually shown in theatrical newsreels. For those watching the trial coverage in New York, the daily reports appeared in installments that paralleled the progress of the case. Together these elements fostered what Gould described as "a very real sense of presence at the courtroom drama in Jerusalem."[21] Similar sentiments were expressed elsewhere, such as in an editorial in the newsletter of the American Jewish Congress: "Thanks to the ingenuity of modern communications—particularly the urgent intimacy of television—the distance between us and the *Beit Ha'am* in Jerusalem is almost non-existent; we, too, are present in the courtroom. We *listen* to the recitals of the prosecution. We *hear* the testimony of the witnesses. We *see* Adolf Eichmann."[22]

Although these telecasts do not meet all of Daniel Dayan and Elihu Katz's criteria for what they define as "media events"—for example, they were not broadcast live—the televised coverage of the trial might still be considered a forerunner of these "high holidays of mass communication." Like the more recent media events that Dayan and Katz analyze (such as the *Apollo 11* moon landing in 1969, or Sadat's visit to Jerusalem in 1977), the Eichmann trial broadcasts demonstrate the role that television can play in creating galvanizing viewing experiences that help form political constituencies and shape civil religion. According to Dayan and Katz, such broadcasts "integrate societies in a collective heartbeat and evoke a renewal of loyalty to the society and its legitimate authority."[23] At the same time, the televising of the Eichmann trial in America makes for a valuable

case study in the limits of media events as socially galvanizing phenomena, especially during the early years of television broadcasting.

Verdict for Tomorrow

Although they constitute a watershed, the telecasts of the Eichmann trial were also responsive to sixteen years of previous presentations of the Holocaust in American film, radio, and television. Beginning with some of the first of these—the newsreels screened in movie theaters in the spring of 1945, which showed footage of liberated Nazi concentration camps—Americans were presented with the notion (one that is still very much in effect to this day) that vicariously witnessing the Holocaust through the media is a morally transformative experience. This notion figures strategically in televising the Eichmann trial, where the morally charged act of witnessing is repeatedly linked to a validation of the authority of mass communications media.

This is exemplified by *Verdict for Tomorrow*, a half-hour documentary on the trial produced by Capital Cities after the conclusion of the proceedings. The documentary was aired on American television during the fall of 1961, while the Israeli tribunal was preparing its verdict. *Verdict for Tomorrow* opens with newsreel footage from the 1930s showing Nazis driving through the streets of a German city and putting up boycott signs on Jewish shops. The sound track plays a vintage radio broadcast by Lowell Thomas, a renowned newscaster for CBS during the 1930s, reporting the news of anti-Semitic violence in Germany. Next, Thomas (who in 1961 was a major stockholder of Capital Cities) appears on the screen and addresses the camera:

> I wonder if you recall that news broadcast of mine of November 10, 1938. It was the climax of the opening chapter of one of the most shocking news stories of our time, of all time—the infamous *Kristallnacht*, or "Crystal Night," when Nazi mobs smashed the windows of Jewish shops, plundered synagogues, and beat up Jews in Germany and Austria. This was the beginning—the ending involved the murder of six million Jews as part of Nazi Germany's Final Solution to the Jewish problem.[24]

As Thomas continues his narration of the Nazis' efforts to exterminate the Jews of Europe, more vintage images appear on the screen: footage of German officers directing civilians onto cattle cars is followed by films recorded in liberated concentration camps, including shots of an empty stretcher being pushed into a crematorium oven, of the charred remains of a corpse inside an oven, and of an emaciated corpse lying on the ground.

"The last chapters of this unforgettable nightmare are now being written—written by newsmen crowded into Jerusalem's Beit Ha'am," Lowell continues, as

images of the trial fill the screen, beginning with a long shot of the courtroom interior as seen from the spectators' gallery. Eichmann is shown in the defendant's dock, enclosed with bulletproof glass; on the sound track a male translator asks in English how the defendant pleads, and he responds in German. A female voice translates Eichmann's reply into English: "In the spirit of the indictment, not guilty." As Eichmann continues to respond to each of the counts against him with identical answers, the program's title and opening credits appear on the screen.

This prologue to *Verdict for Tomorrow* offers, in effect, a capsule version of what was then coalescing as the Holocaust's master narrative. Here, radio, newsreel, and television reports not only serve as the instruments of narration; they also embody the creative force behind the narrative's conception. Newsmen are described as forging the last chapters of this epoch, just as journalists—including Thomas himself—authored its opening chapters. Indeed, Thomas first describes this narrative in journalistic terms, as "one of the most shocking news stories of our time."

Early in the documentary's ensuing overview of the Eichmann trial, Thomas addresses the significance of witnessing the proceedings and links it to the role of television: "It was of paramount importance . . . that the whole world see, hear, and understand the causes [of Nazism] and the consequences—the price that must be paid should this ever be allowed to happen again. This job could only be done by a world mass communications medium." As the screen fills with shots of the television control room in the courthouse, Thomas continues: "Through the eyes of the television camera and by means of videotape, the whole world had a front-row seat in the Beit Ha'am."

Like the first newsreels that presented images of liberated Nazi concentration camps, *Verdict for Tomorrow* articulates its moral agenda by contrasting virtuous witnessing with culpable witnessing. In the newsreels, American military personnel appeared appropriately moved by the ordeal of confronting Nazi atrocities; German civilians, forced to visit the camps by the Allies, were shown trying guiltily to avoid looking at them. *Verdict for Tomorrow* similarly juxtaposes survivors who testify for the prosecution against Eichmann, the sole defendant. As prosecution witnesses describe the Nazis' gruesome acts of sadism, torture, and murder, the camera cuts away to show Eichmann listening impassively, his mouth occasionally twisted to one side in a smirking tic.

These reaction shots show a dispassionate Eichmann amid some of the most well-known moments of the trial, including author Yekhiel Dinur collapsing after his agitated and rambling effort to testify about his experiences at Auschwitz. As another witness describes her survival of a mass execution, the image cuts to Eichmann, listening, and then returns to the witness. The editing of this sequence not only contrasts her emotional testimony with Eichmann's detached appearance; it also intimates that she is testifying against the defendant as though he were the man who had actually shot at her, thereby realizing in televisual terms

Hausner's agenda of presenting Eichmann as "the central pillar of the whole wicked system."[25]

Thomas concludes *Verdict for Tomorrow* by championing television's contribution of creating an international audience for the trial and facilitating the transformation of each viewer into a morally charged witness: "What is truly important is that . . . by means of the television camera and videotape, this trial has been seen by thinking men throughout the world. . . . We trust it has caused you to stop and think, to render your own final verdict—a personal resolve . . . that this shall never be allowed to happen again."

Watching Eichmann

Even before Americans saw the first televised images of the Eichmann trial, broadcasters encouraged them to conceptualize watching the proceedings as a morally charged act. Whereas viewing concentration camp footage in newsreels was rooted in wartime propaganda, watching the Eichmann trial was tied to an agenda both more universalized and more individuated. In the mainstream American media, witnessing the courtroom proceedings was linked not so much to the Nazi era as it was to general concerns about human psychology and morality.[26]

Watching the trial on television shifted the center of attention away from the events of the Holocaust and onto the presence of the man accused of their realization. This is borne out in the extensive discourse surrounding the trial and can even be seen in promotions for its presentation on television. For example, a full-page advertisement, run by WABC-TV in New York City's daily newspapers on April 12, 1961 (the date of the first telecast of the trial), exhorted viewers to tune in to "watch the judgment of Eichmann by sitting in judgment of ourselves."[27] By focusing attention on the presence of the trial's sole defendant, this act of witnessing emerged as a psychologized and self-reflexive act.

This approach exemplifies what Michel Foucault describes as the "psychiatrization of crime" in the modern age, which requires not only that a criminal be proved the agent of a transgression, but that a psychologically convincing motive for the crime be established in order to mete out justice. Indeed, Foucault argues, the issue of establishing the criminal's psychological motive as part of the trial process has become so important in modern criminology that it is now "more real . . . than the crime itself."[28]

Like others attending the trial, journalists were preoccupied with watching Eichmann. Before his first public appearance in court, the lack of any vintage film footage and a dearth of photographs of the defendant (which was said to have made his capture that much more challenging) intensified the public anticipation of laying eyes on him. The act of seeing Eichmann proved so central that looking,

watching, and witnessing figured as running motifs in the trial's press coverage. Print journalists offered readers extensively detailed descriptions of Eichmann's physical presence and demeanor. For example, Lawrence Fellows wrote in the *New York Times* at the trial's opening:

> Lean and partly bald, Eichmann was well groomed and poised throughout the first day's sessions. He had a fresh haircut and wore a dark gray suit that had been finished for him only yesterday. It was set off by a starched white shirt and black-and-white tie. There were only the smallest indications that he was at all restive. He frequently tightened his lips and wet them from time to time. He swallowed often and rubbed his right thumb against his left forefinger.[29]

Such reports as this evince a fixation on the ordinariness of Eichmann's appearance (which extended close-ups on television only magnified), in stark contrast to the enormity of the crimes for which he was on trial.

These accounts sought in Eichmann's appearance some revelation regarding the Nazi character, the human condition in general, or the nature of evil as a metaphysical force. In their quest for insight into Eichmann—and all that he had come to embody—through their attention to his body, observers scrutinized his presence for revealing minutiae, his behavior for involuntary betrayals of inner monstrosity. Thus, Elie Wiesel wrote in the *Jewish Daily Forward:* "A man who is a murderer six million times over *can't* be perceived as normal people are. He *must* have a different appearance: he *must* display some sort of nervousness, . . . hatred . . . , [or] madness that would mark him as different from other human beings."[30]

Although (or perhaps because) his physical presence was so undemonstrative, Eichmann inspired a range of symbolic associations, especially for Jewish observers. Leyb Rakhman, also writing for the *Forward*, offered a vision of Eichmann as metonymizing generations of anti-Semites: "Torquemada and Chmielnicki, Haman and Hitler, their shadows filled Eichmann's glass cell."[31] And, in an effort to demonstrate how the Eichmann trial had become a "Kafka nightmare," *New York Times* editor C. L. Sulzburger described the defendant as being "himself more 'Jewish looking,' according to conventional definitions, than the two sunburned Israeli guards who sit with him inside a bullet-proof, glass courtroom cage."[32]

Accounts of Eichmann's appearance tended to include a description of the glass-enclosed defendant's dock as an extension of his presence.[33] According to one source, a number of American observers likened the dock "to the glass cage used in televised quiz shows."[34] The association with television, especially by Americans, is telling. Correspondents who attended the trial in person sometimes watched the proceedings on closed-circuit television themselves, and they were doubtless aware that many of their readers were seeing Eichmann on television at home. Thus, print journalists' detailed descriptions of his appearance and demeanor resonated with readers' own experiences of watching Eichmann closely.

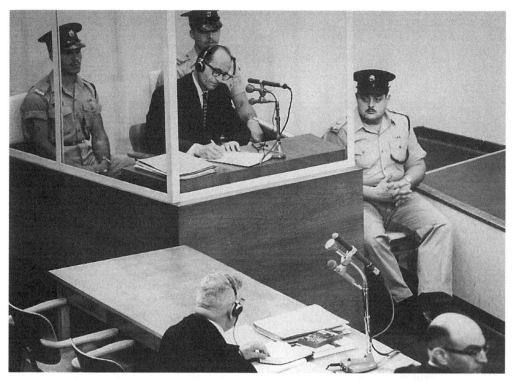

Figure 2. Adolf Eichmann in the glass-enclosed defendant's dock, surrounded by Israeli guards.
Israel Government Press Office, courtesy of U.S. Holocaust Memorial Museum Photo Archives.

This attention to Eichmann's presence was extended to include several incidents during the trial that centered on watching Eichmann watch something (notably, concentration camp footage) or someone in the courtroom (for instance, a "duel of glares" between Eichmann and psychologist Gustave Mark Gilbert). Although these reports on Eichmann as both an insensitive watcher and an impenetrable object of watching do not mention the televising of the trial, they illuminate the problematic nature of the Eichmann trial as a television event. Telecasting the proceedings was vaunted as facilitating for millions the edifying and morally transformative act of witnessing. However, the austere image of Eichmann on television only compounded the inscrutable presence described by journalists who watched him in court. Rather than making him more imminent—and, therefore, ostensibly more comprehensible—television only emphasized Eichmann's enigmatic ordinariness.

This frustrating spectacle was compounded by the audio component of the telecasts. Those attending the trial in person were able to hear Eichmann speak when he testified (albeit via a microphone), but American television audiences heard relatively little of Eichmann's voice, listening instead to most of his testimony in translation. During these sequences, viewers watched Eichmann sit—perhaps listening, perhaps merely waiting—while an interpreter delivered translations of his testimony. The spectacle of Eichmann thus clashed with his displaced

audio presence—a voice other than his own (often female), speaking in a language that he did not know, and doing so when he himself was not talking. The audio component of Eichmann's televisual presence, in effect, further refracted his enigmatic visual image. It disrupted the broadcasts' purported immediacy by undoing the synchronized picture and sound that is fundamental to television's simulation of a continuous present.

This was further compounded by the trial's complex multilingual dynamic. As engineered for American television, the sound track made the English translation the dominant language, so that the trial became, in effect, an event that took place in English. Yet while the subtleties of the trial's multilingual format might well have been lost on the majority of American television viewers, the audio presence of Hebrew, German, Yiddish, and other languages was accessible, even when they could only be heard under the English translation. Thus, the cogent viewer of the trial could discern the significance of each of these languages, irrespective of what was being said in them, but rather as part of what literary scholar Benjamin Harshav calls the "semiotics of Jewish communication."[35] In this symbolic performance of language, Hebrew, as the language of Zionism, was valorized, while German, as the language of Nazism, was demonized, and Yiddish, as the language of diaspora, was marginalized.

Complementing the frustrating, enigmatic presence of the trial's one defendant was the displaced presence of the implicit plaintiffs—the millions of Jewish victims of Nazi persecution whom Hausner claimed to represent in his opening address. They were invoked repeatedly throughout the proceedings—as an abstract number ("the six million"), as communities, or as individuals, both named and anonymous. Their lives and deaths were represented by statistics, documents, oral testimonies, and film footage. Yet, in contrast to Eichmann's corporeal, if inscrutable, presence at the trial, "the six million" remained elusive. "Who were they?" Martha Gelhorn wondered, in her trial reportage; "their names, light as leaves, float through the days of testimony."[36]

Consequently, the Eichmann trial often proved disappointing as dramatic spectacle. Indeed, dissatisfaction with watching the trial increased when, after weeks of testimony by prosecution witnesses, Eichmann took the stand. The American press reported that Israeli spectators apparently found Eichmann's testimony "extremely boring," at times falling asleep in the gallery or leaving well before the court had adjourned for the day.[37] American television audiences may have also found watching the trial less than compelling, especially when compared to the medium's other offerings.[38] Courtroom drama series such as *Perry Mason* or *The Defenders* typically offered tightly constructed episodes with cohesive and suspenseful narratives, as well as readily recognizable villains and heroes who were the agents of a moral problem that was resolved by the episode's end. Compared to the attenuated, enigmatic portrait of Eichmann that emerged over the course of the trial, *Engineer of Death: The Eichmann Story*, a docudrama broadcast on *Armstrong Circle Theater* shortly after Eichmann's capture and

reaired as his trial commenced, presented a succinct, compelling portrait of its subject as a histrionic sadist and reenacted an incident from his youth that was the purported origin of Eichmann's anti-Semitism. And thanks to the liberating possibilities of science fiction, an episode of Rod Serling's *Twilight Zone* televised in the fall of 1961 provided American audiences with a supernatural drama of bringing a Nazi war criminal to justice in a manner that was doubtless much more emotionally satisfying than the Eichmann trial. In this broadcast, entitled *Death's Head Revisited*, viewers could enjoy the spectacle of concentration camp inmates rising from the dead to put their demonstrably villainous, Eichmann-like persecutor on trial and expeditiously sentence him to become the victim of his own tortures.[39]

In contrast, the telecasts of the Eichmann trial may well have seemed slow, diffuse, and extensive beyond the medium's limits. They were, indeed, unlike anything else American television had ever offered. The trial's televised presentation was both exotic and universal, both news and history, both special and routine. The content of the trial itself veered from the histrionics of Jewish "folk opera," as one journalist described the prosecution's case, to the deadliness of what another dubbed Nazi "bureaucratese."[40] The great majority of the plaintiffs were invisible, and their absence became only that much more palpable with every effort to invoke their presence. The trial's arch villain, accused of unfathomable atrocities, appeared to be unexceptional, undemonstrative, and boring. His antispectacular presence matched the trial's visually austere setting—a converted assembly hall that was neither playhouse nor courthouse. The trial's most eye-catching element was the glass box in which the defendant sat throughout the proceedings. This glass box—with its contradictory promises to display and to protect—came to epitomize the enigmas of the trial.[41]

The fact that Eichmann was successfully prosecuted and eventually executed (on May 31, 1962) did not mitigate the widespread sense of the trial as a problematic performance. Many considered his conviction ineffectual, anticlimactic, or a confirmation of the inability of justice to make amends for the enormity of these crimes. The problematic issue of the trial as a performance figured prominently in retrospective analyses of the Eichmann case. Among American Jewish intellectuals, much of the discussion centered on Hannah Arendt's controversial analysis, which was issued in book form in 1963 as *Eichmann in Jerusalem: A Report on the Banality of Evil.*[42] Arendt critiques the effectiveness of the trial as an act of justice in part by faulting its performative elements. Early in the book, she makes derisive references to Ben-Gurion as "the invisible stage manager of the proceedings" and to Hausner's "love of showmanship," as well as to the judges' reluctant presence, "facing the audience as from the stage in a play"; ultimately she proclaims the failure of what she terms "the play aspect of the trial." (Her one reference to the proceedings' presentation on television is a passing expression of contempt for the commercials: "the American program is constantly interrupted—business as usual—by real-estate advertising.")[43]

Although Arendt and the controversy over her work dominated the discussion of the Eichmann trial in the mid-1960s, other intellectuals also offered Americans reflections on the trial's significance. Some of them dealt more centrally with the performative nature of the trial and did so with greater nuance. Susan Sontag, for example, conceptualizes the Eichmann trial as a work of performance art that epitomizes the place of tragedy in the modern age. She sees the role in which Eichmann was cast as crucial to the problematic nature of the proceedings: "Eichmann . . . stood trial in a double role: as both the particular and the generic; both the man, laden with hideous specific guilt, and the cipher, standing for the whole history of anti-Semitism." Sontag also argues that the trial's format thwarted its agenda as a cathartic performance of memory: "The trial is a dramatic form which imparts to events a certain provisional neutrality; the outcome remains to be decided; the very word 'defendant' implies that a defense is possible. In this sense, though Eichmann, as everyone expected, was condemned to death, the form of the trial favored Eichmann. Perhaps this is why many feel, in retrospect, that the trial was a frustrating experience, an anticlimax."[44]

The Eichmann Trial as Holocaust Memory Culture

While the Eichmann case is widely cited as a threshold event in American awareness of the Holocaust, the trial itself—despite Sontag's suggestion that it be regarded as a "work of art"—failed to emerge as a fixture of American Holocaust memory. Televising the trial figured strategically in this landmark of American Holocaust consciousness, yet this landmark presentation and how it was understood also indicate the limits of that consciousness, and of media literacy in general, at the time.

Impact studies undertaken during the trial tabulated which media informants used to follow the proceedings. According to *The Apathetic Majority*, a survey published by the American Jewish Committee in 1962, 68 percent of the informants, all residents of the San Francisco Bay area, said that television news reports were one of their sources of information on the Eichmann trial, and 25 percent cited television specials as a source (versus 78 percent for newspapers, 65 percent for radio news reports, 41 percent for conversation, and 36 percent for magazines). However, this and other studies offered no discussion of the effect that televising the proceedings might have had on responses to the case. If anything, *The Apathetic Majority* questioned the value of the trial's television coverage, concluding that "what most distinguishes the knowledgeable from the unknowledgeable" with regard to the Eichmann case "is the tendency of the former to rely on the written word, rather than the broadcast media, as a source of information."[45]

Yet in her study of Holocaust literature, Sidra Ezrahi argues that telecasts

of the Eichmann trial helped galvanize American writers by "forcing its entry into the homes of all Americans who committed the minimal act of turning on their television sets." In their literary responses to the Holocaust—which were, in Ezrahi's words, "catalyzed" by the trial—American writers such as Arthur A. Cohen, Irving Feldman, Arthur Miller, Sylvia Plath, Charles Reznikoff, Norma Rosen, and Isaac Rosenberg focused not so much on the historical events of the Nazi era but on the paradigmatic—the "psychological possibilities" and "moral options which prevailed in those times and which could be repeated under similar circumstances."[46]

Even so, the Eichmann trial seems to have had less of a lasting impact in America than did other contemporary phenomena, such as the feature film *Judgment at Nuremberg* or the English-language translation of Elie Wiesel's *Night*, which both appeared in 1961. More recent presentations of the Holocaust on American television have also proved to be more enduring. Israeli television now annually broadcasts excerpts of Eichmann trial footage on Yom ha-Sho'ah, but in the United States this material has appeared only in the occasional documentary on Eichmann.[47] And, while American Jews generally acknowledge Israel as having a special relationship with the Holocaust, they experience this connection more regularly and powerfully through local Yom ha-Sho'ah commemorations or Holocaust tourism in Israel than through any institutionalized recollection of the Eichmann trial.[48]

The failure of the Eichmann case to become a lasting fixture of American Holocaust remembrance might be attributed, in part, to the nature of trials as social rituals. Political scientists Lance Bennett and Martha Feldman write that, for trials to "make sense to untrained participants, there must be some implicit framework of social judgment that people bring into the courtroom from everyday life." To that end, criminal trials in Western democracies are organized around the quotidian activity of storytelling, so that the participants in the modern courtroom can "engage some parallel form of social judgment that anchors legal questions in everyday understandings."[49]

In the case of the Eichmann trial, a number of factors complicated, perhaps even confounded, the function of storytelling in the proceedings. The Israeli government's ambitious, multivalent agenda for the trial presented one set of challenges; the multiple audiences that the trial sought to address were another. The repeated identification of the Holocaust as an atrocity unrivaled in scope and beyond description also implicitly challenged the effectiveness of storytelling as a means of bringing about justice. Indeed, Dinur's incoherent testimony and collapse on the witness stand (one of the most often shown excerpts from the trial footage) offers viewers the spectacle of the *inability* to offer narrative. Arendt wrote that this incident "to be sure, was an exception, but if it was an exception that proved the rule of normality, it did not prove the rule of simplicity or of ability to tell a story."[50]

Disparities between the particularist agenda of the Israeli government in

conducting the Eichmann trial and the universalist approach of American television coverage of the event further complicate the trial's effectiveness both as an adjudicating narrative and as a landmark of memory. The American television broadcasters' approach may have been a bid to attract a largely non-Jewish audience to watch the proceedings—in other words, to script a role that American spectators might play in this public performance. This universalizing of the Eichmann case may have also been responsive to a more general reluctance of American Jews during the early postwar years to present themselves or their fellow Jews as forthrightly exceptional in this public arena.

In addition, American television's presentation of the trial as a morally transformative event reflects the industry's larger concern, during the early 1960s, with rehabilitating its tarnished reputation by asserting its role as a moral voice for the nation (this in the wake of scandals surrounding rigged quiz shows and corrupt FCC officials during the late 1950s). Thus, American television further complicated the trial's already ambitious symbolic agenda. Indeed, rather than enhancing the potential for the Eichmann trial to become a fixture of American Holocaust remembrance, television coverage may have contributed to its problematic status as a cultural landmark.

These broadcasts have also failed to become a fixture of the history of American television. Major chronicles of the medium do not mention the Eichmann trial coverage.[51] Yet in 1961 the decision to televise the proceedings was considered both pathbreaking and controversial. While some hailed the broadcasts as a worthy and forward-moving effort, others expressed concern that the very presence of cameras in the courtroom would violate the trial's integrity and dignity. For these critics, the cultural force of television was inherently incompatible with courtroom trials as a social ritual. In part as a concession to these concerns, the Israeli government limited the number of cameras in the courthouse and their presence, while no secret, was concealed from view. In fact, Capital Cities' Milton Fruchtman prided himself on the fact that no one in Beit Ha'am was able to detect where the cameras had been placed.[52]

Aside from the issue of courtroom decorum, this evinces a general innocence, among the press as well as the Israeli government, about the impact of the cultural force of television on the trial as a public event. Reporters covering the Eichmann case usually characterized the decision to broadcast the proceedings on international television as an act that, in effect, simply enlarged the gallery of Beit Ha'am to include millions of viewers from around the world. They reported the televising of the Eichmann trial, like the concomitant coverage of early American and Soviet space missions, as a pioneering achievement of the broadcasting industry and a measure of general technological advancement. By contrast, journalists presented Israel's lack of television at the time as primitive. This is illustrated by the following oft-reported anecdote about Israelis watching the trial on closed circuit television in Jerusalem's Ratisbonne Hall (the one place where members of the Israeli public could see Eichmann on television):

As it happens each morning, the picture fluttered into focus with the bailiff peering from the courtroom toward the judges' chambers to wait for the three men to emerge in their solemn, black robes. When the judges came into sight the bailiff spun around to call the spectators in court to order. "Beit Hamishpat!" he barked (the words mean "court" in Hebrew). Without stopping to think that they were more than a block away from the courtroom, the attorneys [who were watching the trial] in Ratisbonne Hall jumped respectfully to their feet.[53]

But whereas these Israelis, watching live television for the first time, naïvely failed to distinguish the virtual from the actual (much like the first audiences of silent film at the turn of the century, who jumped from their seats to avoid being hit by the image of a locomotive heading toward them), many Americans were still naïve in their acceptance of television coverage of the trial as a simulation of the actual experience of sitting in Beit Ha'am. Not only did the trial footage offer viewers images, such as close-ups of Eichmann's face or hands, that were unavailable to courtroom spectators; the trial's presentation on television had transformed this "actuality" through the process of selecting and editing excerpts of the footage, reengineering its multilingual sound track, and recontextualizing it through reporters' commentary and supplementary coverage. The domestic setting of television watching promoted a distinctively intimate relationship between viewers and the proceedings. Thus, in her 1969 novel, *Touching Evil*, Norma Rosen described the daily ritual of watching the telecasts as transforming viewers into "an experimental, silent film reacting to a film on TV."[54]

Moreover, knowing that a vast public was able to watch the Eichmann trial shaped the prosecution's presentation of its case, striving to make it an emotionally engaging performance for millions as opposed to a legally persuasive argument before the adjudicating tribunal. Television also affected, if obliquely, the way that American journalists and others discussed the trial, directing the focus away from the historical events of the Holocaust and onto both Eichmann's physical presence and the issue of the proceedings as a problematic performance. Indeed, the defendant's antispectacular appearance, made widely available on television, may have made Arendt's notion of explaining the case as a lesson in the "banality of evil" seem a particularly apt way of understanding the trial and the historical events that it recounted.

As the first major televised presentation of actual courtroom proceedings, the Eichmann trial anticipated by three decades the advent of Court TV, the American cable channel devoted to televising current trials. Discussions of the effectiveness and legitimacy of Court TV (especially in the wake of its presentation of the O. J. Simpson trial) have retraced key issues debated in 1961, such as whether the presence of cameras in the courtroom compromises its dignity or otherwise adversely affects the proceedings. Yet the recent discourse on televising trials also demonstrates a more sophisticated level of media literacy, as commentators consider the complex implications of what one critic has dubbed the "cinéma vérité of due process."[55]

The lack of consciousness of television's impact on the Eichmann trial as a public event—understandable, perhaps, in light of the novelty of the enterprise—may have limited the extent to which American viewers embraced it as a galvanizing media event in 1961 or, subsequently, as a fixture of public memory. Yet thanks in considerable measure to television, the Eichmann trial aroused extensive American interest in the Holocaust and inspired a range of works of Holocaust remembrance, including prose fiction, drama, and film. At the time of the Eichmann trial, the issue of presenting the Holocaust on American television barely arose as a subject of discussion—and would not do so until late in the next decade, with the premiere of the *Holocaust* miniseries. These two watershed events provide a telling measure of the dynamics of American Holocaust remembrance and of the changing role that television has played in shaping public memory. Whereas the impact of television on Holocaust remembrance has been largely ignored in the case of the Eichmann trial, it was the focus of attention following the broadcast of the miniseries. Much of this discussion centered on whether a medium as widely popular as television was, by its very nature, an appropriate forum for addressing a subject as vast and disturbing as the Holocaust.

NOTES

1. On the strategic role of television in American Holocaust remembrance, see Shandler, *While America Watches: Televising the Holocaust* (New York: Oxford University Press, 1999), Introduction; for a discussion of American Holocaust television prior to 1961, see chaps 1–3.

2. The word "Holocaust" was used during the proceedings to translate the Hebrew term *sho'ah*. This can be heard in prosecutor Gideon Hausner's summation, for example, in the documentary *Verdict for Tomorrow* (National Jewish Archive of Broadcasting of the Jewish Museum, New York [hereafter, NJAB]: item no. T382).

3. Robert Hariman, ed., *Popular Trials: Rhetoric, Mass Media, and the Law* (Tuscaloosa: University of Alabama Press, 1990), 21, 3.

4. *The Tulsa Tribune*, April 1961, as cited in George Salomon, "The Eichmann Trial: America's Response," in *American Jewish Year Book 1962* (New York: American Jewish Committee/Philadelphia: Jewish Publication Society, 1962), 88.

5. "The Eichmann Case as Seen by Ben-Gurion," *New York Times*, December 18, 1960, sec. 6, 7, 62, *passim*.

6. Gideon Hausner, *Justice in Jerusalem* (New York: Harper and Row, 1966), 4, 291, 296.

7. See "Court Approves Filming of Trial," *New York Times*, March 11, 1961, 4; Hausner, *Justice in Jerusalem*, 307.

8. As cited in Horace Sutton, "Eichmann Goes on Trial: The Charged Air," *Saturday Review* 44, no. 14 (April 8, 1961), 49.

9. Lawrence Fellows, "Eichmann Goes to Trial," *New York Times*, April 9, 1961, sec. 4, 5; Samuel Caplan, "At the Eichmann Trial: Six Million Prosecutors," *Congress Bi-Weekly* 28, no. 9 (May 1, 1961): 5.

10. Lawrence Fellows, "TV Makes Its Israeli Debut with a Tragedy," *New York Times*, July 2, 1961, sec. 2, 9.

11. Hausner, *Justice in Jerusalem*, 307.

12. "Eichmann Goes to Trial," *New York Times*, April 9, 1961, sec. 4, 5.

13. Fellows, "TV Makes Its Israeli Debut with a Tragedy," sec. 2, 9. Fellows notes that the knowledge of the live, albeit unseen, audience in Ratisbonne Hall helped the television crew to remain "alert in its work."

14. *Telstar I* inaugurated satellite relays of television programs in July 1962, followed shortly

thereafter by the enactment of the Communications Satellite Act. COMSAT (the Communications Satellite Corporation) was established in 1962. The Early Bird *(Intelsat I)*, which enabled synchronous transmission, was the first commercial communications satellite; it was launched in 1965.

15. Jack Gould, "TV: The Eichmann Trial," *New York Times*, April 10, 1961, 55. Major congressional investigations had been televised during the 1950s, notably the Senate Crime Committee hearings, conducted by Estes Kefauver in 1951, and the Army–McCarthy hearings in 1954. In addition American television had previously offered regional telecasts of local trials, despite a 1952 ruling by the American Bar Association against the broadcasting of court proceedings. According to Paul Thaler, *The Watchful Eye: American Justice in the Age of the Television Trial* (Westport, Conn.: Praeger, 1994), television cameras were briefly allowed into Oklahoma courts in 1953, and the first live television broadcast of a trial in America was a murder case in Texas, broadcast by KWTX-TV in Waco, beginning on December 6, 1955 (25–26).

16. "Newsfront: The Eichmann Trial," *Television Age* 9, no. 1 (August 7, 1961): 27.

17. "Eichmann Trial: Daily Videotapes, WNTA-TV" [advertisement], *New York Times*, April 12, 1961, 53.

18. See, e.g., "TV Guide Close-up: Eichmann Trial," *TV Guide* 9, no. 14 (April 8–14, 1961), A8.

19. Bert Burns, "Eichmann Case Stymies Comics," *New York World-Telegram and Sun*, April 13, 1961, 32.

20. Jack Gould, "TV: The Eichmann Trial," 55.

21. Jack Gould, "TV: Live Court Drama," *New York Times*, April 13, 1961, 71.

22. "Timely Topics: Reliving the Past," *Congress Bi-Weekly* 28, no. 9 (May 1, 1961): 3.

23. Daniel Dayan and Elihu Katz, *Media Events: The Live Broadcasting of History* (Cambridge, Mass.: Harvard University Press, 1995), 9.

24. This and all other citations from *Verdict for Tomorrow* were transcribed from a copy of the broadcast in the NJAB; see note 2, above.

25. Hausner, *Justice in Jerusalem*, 300.

26. Historian Stuart Svonkin notes that the American Jewish Committee and the Jewish Anti-Defamation League embarked on a media campaign, in print and on radio, to promote a distinctive reading of the trial, which emphasized that there was no doubt that Jews were the chief victims of the Nazis' systematic campaign of extermination ("The Return to Parochialism: American Jewish Communal Life in the 1960s," conference paper presented at the Second Annual Scholars Conference on American Jewish History [June 12–14, 1996], 8). See also Svonkin, *Jews Against Prejudice: American Jews and the Intergroup Relations Movement from World War to Cold War* (New York: Columbia University Press, 1997).

27. "The Judgment of Eichmann: WABC-TV" [advertisement], *New York Times*, April 12, 1961, 82. For other newspapers carrying the same advertisement, see *New York World-Telegram and Sun*, April 12, 1961, 51; *New York Herald Tribune*, April 12, 1961, 29; *New York Post*, April 12, 1961, 90.

28. Michel Foucault, "The Dangerous Individual," in Michel Foucault, *Politics, Philosophy, Culture: Interviews and Other Writings, 1977–1984*, ed. Lawrence D. Kritzman (New York and London: Routledge, 1988), 126–27, 127–28. The essay first appeared as "About the Concept of the Dangerous Individual in 19th Century Legal Psychiatry," *International Journal of Law and Psychiatry* 1, no. 1 (1978): 1–18.

29. Lawrence Fellows, "Eichmann is Neat in New Gray Suit," *New York Times*, April 12, 1961, 16.

30. Eliezer Veyzel [Elie Wiesel], "Der ershter tog" (The first day), *Jewish Daily Forward*, April 12, 1961, 1. My translation from the Yiddish.

31. Leyb Rakhman, "Zitsndik in gerikht baym Aykhman-protses" (Sitting in judgment at the Eichmann trial), *Jewish Daily Forward*, April 14, 1961, 2. My translation from the Yiddish.

32. C. L. Sulzburger, "Foreign Affairs: Kafka Nightmare Come to Court," *New York Times*, August 2, 1961, 28. According to the *New York Times*, the men selected to guard Eichmann were all non-European Jews who had not suffered under the Nazis and presumably would not take revenge against the defendant (Lawrence Fellows, "Eichmann is Neat in New Gray Suit," *New York Times*, April 12, 1961, 16).

33. Special legal provisions were made to allow Eichmann to remain in the glass-enclosed

defendant's dock when he was called as a witness. See, e.g., "Heavy Security Protects Nazi From Himself and From Others," *New York Times*, April 11, 1961, 14; Homer Bigart, "Eichmann to Stay in Glass Cage If He Testifies at Israeli Trial," *New York Times*, June 5, 1961, 5.

34. Sutton, "Eichmann Goes on Trial," 49.

35. Benjamin Harshav, *The Meaning of Yiddish* (Berkeley: University of California Press, 1990), 3.

36. Martha Gelhorn, "Eichmann and the Private Conscience," *Atlantic Monthly* 29, no. 2 (February 1962): 53.

37. See "Eichmann Paints a Robot Portrait," *New York Times*, June 26, 1961, 8.

38. One possible indication of the declining interest in watching the Eichmann trial is the suspension of daily reports showing footage of the proceedings by WNTA New York (Channel 13) in mid-May.

39. *Engineer of Death* (NJAB: item no. T383) was originally telecast on CBS on October 12, 1960 and was rebroadcast on April 12, 1961; *Death's Head Revisited* (NJAB: item no. T380) was originally aired on CBS on November 10, 1961.

40. Homer Bigart, "Servatius Wins Respect in Trial," *New York Times*, July 3, 1961, 3; Fellows, "TV Makes Its Israeli Debut with a Tragedy," sec. 2, 9.

41. In addition to frequent references in the press to Eichmann as the man in the glass box (or booth or cage), the image was selected as the title of Robert Shaw's play, *The Man in the Glass Booth* (New York: Grove Press, 1968), which is based somewhat on Eichmann's capture and trial.

42. Arendt's views were first published as a series of articles entitled "Eichmann in Jerusalem" in the *New Yorker* during February and March 1963. An expanded version of these articles was first published in book form as *Eichmann in Jerusalem: A Report on the Banality of Evil* (New York: Viking, 1963); a revised and enlarged paperback edition was published the following year.

43. Hannah Arendt, *Eichmann in Jerusalem: A Report on the Banality of Evil*, rev. ed. (New York: Viking Penguin, 1964), 4–8, *passim*.

44. Susan Sontag, "Reflections on *The Deputy*," *Against Interpretation and Other Essays* (New York: Delta, 1966 [1964]), 125, 127.

45. Charles Y. Glock, Gertrude J. Selznick, and Joe L. Spaeth, *The Apathetic Majority: A Study Based on Public Responses to the Eichmann Trial* (New York: Harper and Row, 1966), 48–50.

46. Sidra DeKoven Ezrahi, *By Words Alone: The Holocaust in Literature* (Chicago: University of Chicago Press, 1980), 205–6.

47. On telecasts of Eichmann trial footage in Israel, see Tom Segev, *The Seventh Million: The Israelis and the Holocaust*, tr. Haim Watzman (New York: Hill and Wang, 1993), 8. Examples of American documentaries that present this footage include *Justice in Jerusalem Revisited: The Eichmann Trial*, aired on NBC in 1986 (NJAB: item no. T408) and *The Trial of Adolf Eichmann*, aired on PBS on April 30, 1997. The trial's television coverage was the subject of a retrospective exhibition at the Jewish Museum in New York in 1986.

48. See, e.g., Jack Kugelmass, "The Rites of the Tribe: The Meaning of Poland for American Jewish Tourists," *YIVO Annual* 21 (1992): 395–453; Oren Baruch Stier, "Lunch at Majdanek: The March of the Living as a Contemporary Pilgrimage of Memory," *Jewish Folklore and Ethnology Review* 14, nos. 1–2 (1995): 57–66.

49. W. Lance Bennett and Martha S. Feldman, *Reconstructing Reality in the Courtroom: Justice and Judgment in American Culture* (New Brunswick, N.J.: Rutgers University Press, 1981), 3, 4.

50. Arendt, *Eichmann in Jerusalem* (1964), 224. This scene is prominent in the footage shown annually on Israeli television on Yom ha-Sho'ah. See Segev, *The Seventh Million*, 8.

51. See, e.g., Erik Barnouw, *Tube of Plenty: The Evolution of American Television*, 2nd rev. ed. (New York and Oxford: Oxford University Press, 1990); Christopher H. Sterling and John M. Kittross, *Stay Tuned: A Concise History of American Broadcasting*, 2nd ed. (Belmont, Calif.: Wadsworth, 1990); Michael Winship, *Television* (New York: Random House, 1988).

52. "Newsfront: The Eichmann Trial," *Television Age*, 25.

53. Lawrence Fellows, "Eichmann Goes to Trial," *New York Times*, April 9, 1961, sec. 4, 5.

54. Norma Rosen, *Touching Evil* (New York: Harcourt Brace and World, 1969).

55. James Wolcott, "Prime-time Justice," *The New Yorker* 68, no. 41 (November 30, 1992): 159.

Geoffrey Hartman

Tele-Suffering and Testimony
in the Dot Com Era

Why was the sight
To such a tender ball as the eye confined?

—Milton, *Samson Agonistes*

Television is a mechanism bringing us images from far away while making itself as invisible as possible. To be effective it cannot relinquish this magical realism. Arguably, TV shares that characteristic with print or other media: to cite a common definition of imagination, they render what is absent present. Yet TV's difference from a verbal or literary medium is quite clear. Novels or histories in book form respect the absence of those absent things more: their distance is factored in, not only by deliberate devices that expose a (relatively) invisible author's rhetorical manipulations but also by the difference between the mental activities of viewing and reading. TV, to generalize, conveys the illusion not of making absent things present but present things more present (than they are or can be). Even when devoted to information rather than fiction, it emits a hyperbolic form of visuality.

Of course, like literature, TV can become self-conscious and blow the cover of its magic by showing within its pictures a camera taking pictures or a monitor reflecting them. But it does so, usually, only to increase its authority as an objective mediation, or rather to make us think of it as a medium rather than a mediation. Showing the camera is showing what you shoot with: it is no longer a concealed or self-concealing instrument.

Those opposed to the modern world's iconomania can shun the cameras but would find it futile to smash them. Cameras are not icons but productive of them, and the network by which they send images is redundant rather than place-bound, so that any damage would be merely symbolic. In fact, although a religious rhetoric denouncing the lust of the eyes is still heard, many faiths have succumbed to the medium and adopted it for profitable evangelical propaganda.

I do not want to give the impression that TV is purely a mechanism It is, indeed, the most powerful means we presently have for the production of images (if we consider the downloading of images on the Internet as simply a further

extension of its potency). Yet behind the mechanism there are its directors or agents, removed by the magic—the automatism—of photography.[1] The interaction of TV's image production and those who coordinate or manipulate it is a lively and self-complicating topic. Not without reason has journalism (now dominated by TV's influence on the general public) been called the Fourth Estate. Sociologists and others have begun a full-scale critique of the managers who set the conditions of reporting and viewing for the medium. They suspect a "structural corruption" which makes it ineffective to try to modify by discursive means (such as this essay) what goes on.

There exist, no doubt, genial filmmakers who attempt to criticize the image through the image; and I will soon describe the Yale Video Archive's further attempt to do just that. But it is hard not to agree with Pierre Bourdieu that anyone who goes on television will suffer a loss of autonomy, and that the self-analysis occasionally nurtured by TV journalists only feeds their "narcissistic complaisance."[2]

––––––––––

Now and then a murderous incident like the 1999 Columbine School massacre by two Colorado teenagers incites a flurry of speculation about the influence of the imagery video brings into the home. The television set or a computer with video games has become, as it were, a new hearth. But is it a controlled, domesticated fire we have brought into the castle of our privacy?

As parents, my generation tried to limit the viewing of TV, primarily to prevent neglect of homework or a sidelining of intellectual and socializing influences. Increasingly, though, the problem involves not only the proper allotment of leisure time. What is viewed comes into question, as does the very modality of watching. For not only are violent films available on a twenty-four-hour basis but newscasting itself, on the same continuous basis, brings us daily pictures of violence, suffering, and destruction. One of the simplest axioms of psychoanalysis holds that hyperarousal leads to trauma or inappropriate psychic defenses—it seems clear enough that, while human responses are not uniform and our psyches are quite resilient, this intensification has its impact and must be thought about. We live in an artificially enhanced visual culture, but it is premature to claim that we have visual culture.

Yet the issue of TV's responsibility for social violence is a complicated one. The medium does not present a seamless web of visual images. Its hypnotism is far from unalloyed. The medium is more talky, in fact, than most cinematic composition: it adds layers of words to juxtaposed visual excerpts. In addition to the words (and snatches of music) that come with the relayed images, we have the anchor-person's or moderator's commentary. News, talk shows, music montages, and documentaries, therefore, may be the ultimate TV, rather than the retailing of Hollywood-type films. Moreover, while films usually hide the fact that they are episodic and present themselves as wholly new and startling (although playing on

continuities bestowed by famous actors or character-types), TV not only likes to serialize programs but allows arbitrary breaks for advertising that disturb our concentration without quite dehypnotizing it.

TV offers (also because of the ease of surfing) not real breaks or reflective pauses but one audiovisual representation after the other. Its "flow," in short, at once isolates certain sequences and distracts us from them. The reality-effect of its imagery, therefore, is heightened and diminished at the same time. This is one reason why it is hard to generalize about the contagious effect of TV violence: it all depends on whether your inner reception is tuned to what tries to invade you and will not let go, or, alternatively, to the interruptions—visual and verbal—that dissipate it.

Yet one clear danger should not be overlooked. Increasingly, as on-the-spot news reporting and other live broadcasts, especially the wilder kind of talk show ("My sister has two lovers"), gain TV share, the reality-effect of what is viewed verges on an unreality-effect. The reason may be stated as follows: when reading fiction, or seeing it in cinematic form, we adopt what Coleridge called a "suspension of disbelief." We know those multiple gory deaths in action movies are faked, and that a considerable supply of ketchup is used. But what can keep addicted viewers, especially younger ones, from a more fatal "suspension," which consists in looking at everything live as if it were a reality that could be manipulated? The unreality-effect that turns what we actually see into electric phantoms is a new and insidious psychic defense.[3]

Good fiction quietly posts many signs that imply "No Way Through to Action." It constructs reflective detours that convert reading into a many-leveled interpretive act and remind us we are dealing with simulacra. The problem with TV, however, is that, only a click away, and an intimate part of home, it becomes a treacherous servomechanism conspiring with a residual, delusory omnipotence of thoughts. While for most of us TV simply hard-copies the eye, making the "tender ball" less vulnerable, for some it may produce a mental atmosphere that makes it appear as if the very place we live in also came from that box. Televised reality, Norman Manea has noted, "becomes a self-devouring 'proto-reality' without which the real world is not confirmed and therefore does not exist." The world is then no more and no less incredible than what confronts us in the news or ever-more horrific movies.

It is not that there will be, necessarily, a direct link between violent scenes depicted on TV or film and the brutal acts of teenagers: we surely know how confusing, precarious, and potentially catastrophic the passage from late childhood to maturity is, independent of a supposedly malignant TV effect. But there probably is a *derealization* of ordinary life that causes some young people to act out—like a game or drama whose roles they assume—their pain, disillusion, or mania. Animated gadgets rather than people inhabit a world of that kind, and it is easy to fall

into the Manichaean mind-frame of "them and us," or "the good and the bad guys," which our increasingly formulaic and ferocious movies also foster. Youthful idealization of certain role models often goes together with an underestimation or even scapegoating of a despised group.

———————

Concerning this derealization, it is astonishing to reflect that only forty years ago one of the most significant books about the cinema, Siegfried Kracauer's *Theory of Film*, bore the subtitle *The Redemption of Physical Reality*. It argued with great cogency that "film renders visible what we did not, or perhaps could not, see before its advent. [Film] effectively assists us in discovering the material world with its psychophysical correspondences. We literally redeem this world from its dormant state, its state of virtual non-existence."[4] Kracauer dealt with film as the fulfillment of the realistic effect of black-and-white photography. The cinema, he claimed, was animated by "a desire to picture transient material life, life at its most ephemeral," whether street crowds, involuntary gestures, or "the ripple of the leaves stirred by the wind."[5]

Compared to this view of the medium, what we see in movie houses today should be called *photoys*. It is a ghosting of reality, not its redemption. What, for example, is being rendered—made visible—by *The Matrix?* There are, no doubt, some strong "psychophysical" sensations produced by this film's mastery of special effects: the way, for example, it carries the tendency of a body-piercing generation to an extreme by undermining the integrity of personal flesh. So, in addition to the doubling and out-of-body experiences intrinsic to its storyline, near the beginning of the film there is a brilliant visual pun when the movie's involuntary hero is "bugged" by a disgustingly alive mechanical insect inserted via the navel into his innards. This inverted parturition recalls Nietzsche's insight that all preconceptions arise in the entrails. It is as if we had to return there to see the world without prejudice.

Yet ordinary sense-data enter this film only in the form of incongruous scenes, a here-and-now that can no longer be securely confined to a single location. As Christian painters often surround earthly events with heavenly figures, doubling the locus of the action, so every significant adventure of the hero, however external or apparently objective, has its echo in an invasive internal change dramatized as physical agony or the labor pains of rebirth. Moreover, a devious topology leads to defamiliarized interiors that remain absurdly familiar. The contraption to which people are strapped before they undergo their psychophysical journey is a conflated image of a dentist's chair, an electric chair, and how astronauts are buckled up before the launch. Similarly, although we traverse nondescript and potentially mysterious passageways to get to the Oracle, when we meet her she is in an ordinary kitchen baking cookies. And despite the importance to the film of mobile communication, at a crucial final moment the hero steps into the interior of an old-fashioned phone booth, a retro effect that recalls (affection-

ately enough, but hardly realistic) Superman's transfiguration. In a sense we never get outside—outside the movie studio producing all these effects.

What kind of reality, then, are we shown? Interestingly enough, we are not as far from Kracauer's "redemption" as might first appear. For it is precisely a redemption of physical reality that is being aimed at—radically, comically, ingeniously, despairingly—by movies like these. The motif of redemption, in fact, governs *Matrix*'s plot: to find "the One" who has the guts to free us from a world of appearances that limits or controls human perception and presumably keeps us from experiencing the *real* real world.

Yet in truth the movie offers only an engineered reality—an assemblage of phantasms, of illusionistic contraptions that seek to get under our skin yet rarely do so. In fact, in order to remain in the human, it relies on a few sentimental or fairy-tale episodes, such as a life-giving kiss. When Kracauer, then, writes that the cinema is uniquely equipped to "redeem this world from its dormant state, its state of virtual nonexistence," he lays bare the ghostliness of existence revealed by cinematic photography's own countergnostic, technological quest-romance. I continue to prefer poetry's economy of means, as in these (admittedly imploding) stanzas of Emily Dickinson:

> I heard, as if I had no Ear
> Until a Vital Word
> Came all the way from Life to me
> And then I knew I heard.
>
> I saw, as if my Eyes were on
> Another, till a Thing
> And now I know 'twas Light, because
> It fitted them, came in.
>
> I dwelt, as if Myself were out,
> My Body, but within
> Until a Might detected me
> And set my kernel in.[6]

It may have been my own reality-hunger, as well as the duty of memory, that made me take part in a project to film Holocaust survivors. Founded in 1979 by a New Haven grassroots organization, the project was adopted by Yale, which created in 1981 the earliest video archive for Holocaust testimonies. Working with the archive I became more aware of the power and the limits of film and video.

Our aim to record on video the stories of survivors and other witnesses proved more complex than we had assumed. The idea was to put people with direct knowledge of those grim events before the camera and let them speak with the least possible intervention. A series of authentic autobiographical accounts would

emerge and contribute to the collective memory of a time passing away together with the eyewitness generation. That would soon be an era available only through history books.

The project was instinctively right in seeking to extend the oral tradition by means of video testimony, and allowing the voices of witnesses to be heard directly in an embodied, audiovisual form. But we only gradually understood the communal implications of the enterprise and its potential impact on memory and the communicative environment.

Let me illustrate what we learned by discussing a number of practical issues that arose in taping the survivors. How does a venture like this balance the seductive magic of photo-realism—expressive of the wish to make the survivors and their experience more evidential—with an anxiety about intrusion and voyeurism? Should we not hold such an archive to be a sacred deposit and shield it, for a time at least, from the merely curious or prying? We turned to a law school professor who wrote an opinion quoting Justice Brandeis's "sunlight is the best disinfectant." We obtained informed consent from each person interviewed and made sure they understood that their testimony would be a public act of witness open to all who came to consult it in the university library. Moreover, visitors to the archive were asked to read a statement that laid out the reasons for the testimony project.

When I look back at the first two years of filming, I realize what may have made the issue of privacy more sensitive. The survivors who came to be interviewed were totally supportive; but others—a few historians and some survivors not yet interviewed—felt uncomfortable watching the tapes. What disturbed them was partly the emotional, intimate texture of these oral histories, but chiefly their video-visual aspect.

Indeed, among the almost two hundred testimonies initially recorded, I now see inspired but also, at times, irritating camera work. Wishing to project the act as well as narrative of witness, we often sought what one of the project's founders, adopting a legal term, called "demeanor evidence." The result was excessive camera movement. The supposedly "imperturbable" camera (Kracauer's word) zoomed in and out, creating Bergmanesque close-ups. Eventually we advised that the camera should give up this expressive potential and remain fixed, except for enough motion to satisfy more naturally the viewer's eye.

Another decision also involved the visual sense. Should witnesses be recorded in a studio or at home? Our choice was at first forced on us rather than thought out, yet proved to be fortunate. There was so little funding that space provided free on the unoccupied floor of a building became a makeshift studio and more feasible than transporting equipment and interviewers from one home to the other. The makeshift studio was sparsely furnished: chairs as necessary, a backdrop curtain, and sometimes a plant. What we sacrificed was the kind of colorful, personal setting we would have found in the survivors' homes, and which helps when videography has a film in mind; what we gained (this realization came later,

and we stuck with our ascetic decision) was not only simplicity or starkness but a psychological advantage. The interviewees, in a sparse setting, entered their memories with less distraction, or, to put it differently, they could not divert their attention to this or that familiar object. There were also fewer disruptions—such as a child crying, a dog barking, a telephone ringing—to disconnect the flow of thought.

A further decision was for the camera to focus exclusively on the witness and not show the interviewers. In retrospect, I think we might have included at least an initial verification shot of the interviewers; but we were determined to keep the survivor at the center, visually as well as verbally. Despite TV's disdain for "talking heads," that is exactly what we aimed for. The survivor as talking head and embodied voice: a more sophisticated technique would merely distract viewers. We were not filmmakers, even potentially, but facilitators and preservers of archival documents in audiovisual form. In short, our technique, or lack of it, was homeopathic: it used television to cure television, to turn the medium against itself, limiting even while exploiting its visualizing power.

I suppose we did sacrifice by this effacement of the interviewers—heard and not seen, and trained to ask only enough questions to make the witnesses comfortable, to keep them remembering, and sometimes to clarify a statement— a certain amount of transparency. For interviewers have a special importance in this kind of oral history. They are positioned quite differently from investigative journalists. They do seek to elicit information, often of historical value. Yet basically their purpose is to release memories of what happened: not yesterday or a short time ago, but as far back as forty years when the project started in 1979, and fifty-five or more by 2000.

This act of recall cannot be accomplished without respecting the Holocaust's continuing impact on the life of the survivors. Afterthoughts and associations often arise in the very moment of giving testimony: the past cannot be confined to the past. The best interviews result from a testimonial alliance between interviewer and interviewee: a trust-relation forms in which the search for facts does not displace everything else. Such an alliance, however, is a framing event that lies beyond the scope of the camera. It cannot be made transparent (in the sense of visually open) but needs the sort of meditation Dori Laub and others who know the Yale project have given it. When I talk of the project's communal frame, a return of trust, a wounded trust, is involved. The interviewers—indeed, all persons associated with the project—form a provisional community and become, for the survivor-witness, representative of a potentially larger community, one that does not turn away from but recognizes the historical catastrophe and the personal trauma undergone.

Memory, we have learned from Maurice Halbwachs, and again from Pierre Nora, always has a milieu. How do you photograph a memory, then, how do you give it

visibility, when that milieu has been destroyed by Holocaust violence as well as the passage of time? But experiences are often imprinted on the mind, and set off by the very absence of what inhabited the original space. Our foreknowledge of mortality may even enhance what has vanished. The quiescent or subdued memory-image endows photos with a physical aura. The effect is that of a still life (even when the camera is in motion): a spectral presence emerges, which demands to be integrated, or, as Kracauer might say, "redeemed."

Holocaust videography, of course, to achieve a return of memory through photographed testimonial speech, can place the victims back in what is left of their milieu of suffering, as Claude Lanzmann tends to do. It shows, for example, a field or grove of trees, now quite innocent, and which defeats the camera-eye as in Antonioni's *Blow Up*. Lanzmann even arranges a remarkable mise-en-scène by placing a barber, whose duty in the camps was removing the prisoners' hair, into an ordinary barber shop. However effective this device may be, we sense its artifice. It is best to resuscitate memories by simply raising the internal pressure with the assistance of maieutic interviewers.

Ideally, these interviewers become more than questioners: they comprise a new "affective community" that substitutes, however inadequately, for the original and tragically decimated milieu. But here an unresolved contradiction casts its shadow over the video-testimony project in the dot com era. Can memory retrieval and its communitarian aspect withstand the "imperturbable camera," its cold, objectifying focus, and now, in addition, the impersonal, market forces of electronic recall and dissemination?

I have suggested that survivor videography counteracts the glossy or ghostly unreality of seemingly realistic yet increasingly surrealistic TV programs. In part this is because the testimonial words do not fade out, or into a cinematic simulacrum of the events being described. Although the testimonies range over time and space, the camera's mobility, as well as its visual field, remains restricted to a person speaking in a particular place, at a particular time. While presenting testimonies in audiovisual format may add an expressive dimension, that is not an essential feature—since the speaker's bearing and gestures could also distract from the story being told. What *is* essential is the mental space such minimal visuality ("I see a voice!") allows. Witnesses can "see" better into, or listen more effectively to, themselves; and viewers, similarly, respond to that intimacy.

All of our efforts at Yale were directed, then, toward capturing the personal story; and to maximize the witnesses' autonomy during the taping process, we did not limit the time of the interview or impose any conditions whatsoever. Yet our decision in this regard was based less on sophisticated thinking about TV than on the fact that victims of the Shoah had been brutally deprived of precisely their personal autonomy. The camera, also, because it focused on the face and gestures of the witnesses, was anything but cold: in fact, it "reembodied" those who had been denied their free and human body-image in the camps.

I am less sure, however, about the success we will have in taming post-production procedures. As distance learning becomes standard, and machine-readable cataloguing takes over, archives of conscience like ours may not be able to resist being turned into gigabytes of information, electronic warehouses of knowledge that marginalize the other values I have mentioned. This greed for more and more information, for positivities, which has already accumulated an extraordinary and melancholy record on the Holocaust, has not yielded appreciable ethical lessons. The heaping up of factual detail may even be an excuse to evade the issue of what can be learned. It is not enough to say "nothing" can be learned; that no lesson can stand up to the enormity and contrariety of what happened. If only because such a position neglects the testimonial act as such, and the gulf that appears, in the aftermath of Auschwitz, between the possibility of testimony—which extends to visual and verbal representation generally—and Sarah Koffman's axiom: "Speak one must, without being able to."

Having described the communal frame of memory retrieval and the potential impact of survivor videography on the medium, I am tempted to make a final and very broad generalization. It shifts the focus from the survivors to those who look at their testimony, and ultimately to the quality of our gaze. What others suffer, we behold, Terrence Des Pres once said of the modern condition—with reference, in particular, to the increased technical power of optical transmission. We become, through the media, impotent involuntary spectators: it was so with the events in Bosnia, and then in Kosovo. It is no longer possible not to know. But the effects of this traumatic knowledge, this tele-suffering—Luc Boltanski, a French sociologist, has named it *souffrance à distance*—are beginning to be felt.

One difficult effect is that of secondary traumatization, through a guilt, perhaps shame, which the knowledge of evil, or simply of such suffering, implants. We know more about identification with the aggressor than identification with the victim: a bond sometimes grows between persecuted and persecutor, between the kidnapping victim, for instance, and the abductor. The strong effects of a sympathetic identification with the victim have drawn less attention. In the humanities, where the subject of trauma is beginning to be recognized, we still spend more energy criticizing psychoanalysis than dealing with what is fruitful in trauma theory.

That we learn through our own suffering is a cliché that targets abstract or book knowledge: the real issue, however, is whether we can learn from the suffering of others without overidentifying. To overidentify with the victim may have consequences as grave as to identify with the aggressor. Indeed, I suspect there may be some convertibility in the form of a movement toward coldness or cruelty when it becomes too hard to take in something which so intensely wants to be forgotten or mastered. We fear not just the image of suffering itself but also

the sense of powerlessness that accompanies it—the obsessive thoughts and a drift toward desensitization. Without empathy there can be no art, especially no fiction; yet the management of empathy is not easily taught.

The Holocaust testimony project, an active if belated response, relays terrible stories, yet in a bearable way, most of the time. In the telling, the psychologist Judith Herman has remarked, the trauma story becomes a testimony; and in the hearing of it the listener, who as interviewer enables the telling, is a partner in an act of *remembering forward* that obliges us to receive rather than repress inhuman events.

So the worst returns to haunt later generations. But it also gives them a chance to work it through. That is still a crude way of putting it, however. We know from Primo Levi's *The Drowned and the Saved* that the "ocean of pain" for the survivors rose instead of ebbing from year to year, and that the just among them were afflicted with a shame that could not be cleansed. In fact, as these stories circulate, in the form of video-testimonies, and generally as written memoirs or fictionalized accounts—as they gradually, and not always in a conscious manner, reach the public, we see the beginning of a rather astonishing phenomenon.

————————

I call it memory-envy. An extreme case may be that of Binjamin Wilkomirski, whose *Fragments* was hailed as the most authentic depiction so far of a child survivor of the Holocaust. Yet the chances are that Wilkomirski was brought up in Switzerland and never saw the inside of a concentration camp. His identification, nevertheless, with survivor experiences is quite convincing. The author internalizes what he has heard, read, or seen in movies and photos, and it emerges as his own experience. Here the creative and the pathogenic are hard to tell apart. Some deep envy may be at work, particularly in those who have no strong memories themselves—"strong" also in the sense that they bestow social recognition. The pressure to own a distinctive identity, however painful, plays into this: better to recover false memories than none, or only weak ones.

An equally interesting although very different case is Harold Pinter's play, *Ashes to Ashes* (1996). It depicts a woman who is being interrogated by her husband about the sadistic practices of a former lover. Rebecca seems to have tolerated or been hypnotized by them. Perhaps she is still under their spell. The Holocaust is never mentioned, but her mind, like Sylvia Plath's, lives in its penumbra—in a memory, perhaps a fantasy, dominated by male violence, the loss of babies, and of the innocence they evoke. Her husband is unable to bring her back; his very questioning becomes another kind of violence. As in the setting for survivor testimony, the stage is bare of props and the only action is a (tormented) interview. It comes as a shock to hear Rebecca repeat, at the end and climax of the play, the words of a woman who had her baby taken away (I quote verbatim here but leave out the "Echo" which, in the play, repeats the last words of each phrase):

They took us to the trains
They were taking the babies away
I took my baby and wrapped it in my shawl
And I made it into a bundle
And I held it under my left arm
And I went through with my baby
But the baby cried out
And the man called me back
And he said what do you have there
He stretched out his hand for the bundle
And I gave him the bundle
And that's the last time I held the bundle
And we arrived at this place
And I met a woman I knew
And she said what happened to your baby
Where is your baby
And I said what baby
I don't have a baby
I don't know of any baby[7]

The words were a shock because they reproduce with slight changes and omissions those of a survivor in a Yale testimony.[8] I read them first in a 1998 *New Yorker* review of Pinter's play after it was staged in America. We glimpse here how diffusion occurs: how Holocaust memory influences *affectively* a wider public. For it is improbable that Pinter could have seen the Yale testimony in question. It is far more likely that he saw those words in a book by Lawrence Langer, who was the first to study the Yale archive in *Holocaust Testimonies: The Ruins of Memory*. That book did not quote these particular words, but a later book by Langer, *Admitting the Holocaust* (1995), does—in a chapter, interestingly enough, on Cythnia Ozick's "The Shawl."[9]

In Pinter the original memory-milieu of the survivor's words is elided. No one could guess that "Echo" is, in a sense, a real person, namely, Pinter, whose mind has played back, almost verbatim, a description of the trauma of deportation. We pick up clues about the Holocaust context earlier in the play, but this final monologue clinches the matter. Yet what is remarkable is less that context than its resonance: the Holocaust has invaded Rebecca's (and the dramatist's) consciousness to such an extent that no further historical specificity is needed—indeed, to be more explicit might limit the power and pathos of this short play.

We have no technical term, that I know of, to describe the playwright's symbolic method, although Aharon Appelfeld too, in some novels, allows the setting of the action to be at once recognizable and unspecific. (The kind of denial depicted in Albert Camus's *The Plague*, whose context certainly includes the wartime persecution of the Jews in France, is conventionally, though effectively, allegorical.)[10] However unique the contextualizing event, Pinter wishes to make the woman's narrative express a general aspect of the human condition. One is

left wondering how often this occurs in literature—how often we fail to identify the elided circumstance. Perhaps this is what Aristotle meant when he said that poetry is more philosophical than history. In Greek tragedy, moreover, with its moments of highly condensed dialogue, the framing legend is so well known that it does not have to be emphasized. A powerful abstraction, or simplification, takes over. In this sense, and this sense only, the Holocaust is on the way to becoming a legendary event.

In Pinter's case we can trace how the historical referent almost elides itself. The very resonance of the event both broadens it and makes it vanish—a pattern similar to waves caused by a pebble thrown into water. Key phrases have migrated from a videotaped testimony to a scholarly book to a popular play to an influential magazine's review of the play. *Ashes to Ashes,* however, is an unusually conscious case of memory-envy. Holocaust imagery has been adapted rather than appropriated, and Rebecca's passion narrative suggests a sympathetic rather than total identification. Her repetition of the survivor's account is a self-redeeming, if nonconsoling, reenactment.

Two concerns remain. At what point does diffusion become commodification and banalize, rather than universalize, a new representational genre (the video-testimony), or Holocaust memory itself? Will everything end up, not even in a scholarly book, or as the climax to an enigmatic and moving play, but as a series of conventionalized iconic episodes variously packaged? A further concern, more distinctly ethical, is Pinter's use of this incident. Imagery from the historical Holocaust is made to fuse with a very private and precarious mental condition. Some might characterize this as exploitation. Yet it may be, as I have suggested, an inevitable and even appropriate development. For the pathos of the testimony moment loses its specific context precisely because it arouses a widespread anxiety: here concerning the loss of a child and the traumatic repression of that memory. What others suffer, we should suffer.

Try to suffer, that is. The entire problematic of how we can feel for others—and continue to feel for them—surfaces here. The pressure to respond with empathy (not an unlimited resource) is enormous, and it produces what has been called compassion fatigue. But it could also incite anger and hate: first, perhaps, turned inward as a form of self-disgust (and leading to depression should we deem ourselves insufficiently responsive), then turned outward as a sadistic or callous action, and completing in this manner a vicious cycle. This cycle is inevitable if we overidentify, in the very name of morality, with the victims, or do not respect the difference between their suffering and our own. As Primo Levi and Charlotte Delbo have observed, even the words that seem to describe that suffering become false tokens when it comes to the Shoah. "Hunger" and "tomorrow" do not mean in everyday language what they meant in the camps.

At this point art discloses its truest reason. Art expands the sympathetic

imagination while teaching us about the limits of sympathy. Such teaching hopes to bring the cognitive and the emotional into alignment. There is no formula, however, for aesthetic education of this kind: it must start early and continue beyond the university, perhaps for a lifetime. It is rarely prescriptive, and, although it may schematize itself as a set of rules (as a poetics or a hermeneutics), the type of thinking involved seems to import a structural moment of indeterminacy that escapes the brain's binary wiring. A sort of unframed perception becomes possible, a suspension or confusion of personal identity as at the end of Pinter's play, one that touches on what Keats named "negative capability."

Because to think suffering is different than to think about suffering, it is not the absence of meaning that disturbs Maurice Blanchot, for example, but its presence: more precisely, what disturbs him is the temptation to foreclose "the writing of disaster" by assigning meaning too quickly. "Danger that the disaster take on meaning rather than body." "Watch over absent meaning." "Try to think with grief." Visual literacy is even further behind in recognizing this challenge than literary study. While Kracauer's axiom that the cinema "aims at transforming the agitated witness into a conscious observer"[11] recognizes how important a human resource film can be, it understates the moral problematic: the guilt or shame accompanying sight, and the vicissitudes of empathy.

Today the dominance of the video-visual has become a fact of life as clear as other global influences. It has a bearing on both morality and mentality. However difficult it is to disenchant the medium of TV, we must find a way to approach it as more than a source of entertainment or information. Above all, "useless violence" (a phrase coined by Primo Levi to describe Nazi brutality), when routinely transmitted by TV in fantasy form or real-time reportage, should lead to intense self-reflection. The hyperreality of the image in contemporary modes of cultural production not only makes critical thinking more difficult but at once incites and nullifies a healthy illusion: that reality could be an object of desire rather than of an aversion overcome.

NOTES

1. Stanley's Cavell's *The World Viewed: Reflections on the Ontology of Film* (New York: Viking, 1971) discusses in chapter 2 the way the photographic medium achieves its effect of "presentness" by "automatism" or (seemingly) "removing the human agent from the task of reproduction."

2. For the issues raised in this paragraph, see Pierre Bourdieu, *Sur la télévision: suivi de L'emprise du journalisme* (Paris: Raisons d'agir, 1996). Also see "Ces grands patrons qui tiennent les médias," *Le Nouvel Observateur* no. 1808, July 1–7, 1999: 8–18.

3. The tension that what we know about the world comes primarily from the mass media, even while we are haunted by the suspicion that all we are given to see is manipulated, has been explored by Niklas Luhman. A striking example of what he calls *Manipulations-Verdacht* is the assertion of Goran Matic, a minister in Milosevic's government, who claimed "that what the world had assumed were refugees—driven from their homes by Serbian police and paramilitary units—were in fact 3,000 or so ethnic Albanian 'actors,' paid $5.50 each . . . by the CIA to take part in a NATO 'screenplay.' *New Republic*, May 31, 1999: 12.

4. Siegfried Kracauer, *Theory of Film* (New York: Oxford University Press, 1960), 300.

5. Kracauer 1960: 1x.

6. *Final Harvest: Emily Dickinson's Poems*, ed. Thomas H. Johnson (Boston: Little, Brown, 1961), 234 (1039 in Johnston's numbering).

7. Harold Pinter, *Ashes to Ashes* (London: Faber and Faber, 1996).

8. Bessie K., Holocaust Testimony (HVT 205), Fortunoff Video Archive for Holocaust Testimonies, Yale University.

9. Lawrence Langer, *Admitting the Holocaust: Collected Essays* (New York: Oxford University Press, 1995), 142–43.

10. A related technique, which elides, however, a fictional rather than documentary source, is found in E. L. Doctorow's novel *Ragtime*. The novel's hero, Coalhouse Walker Jr., and its basic theme of an irrationally stubborn pursuit of justice, are based on a famous novella by Heinrich Kleist, *Michael Kolhaas*. But in Doctorow the historical sixteenth-century setting of the story is transposed to a new, clearly defined contemporary milieu.

11. Kracauer 1960:58.

Film

Miriam Bratu Hansen

Schindler's List Is Not *Shoah:* Second Commandment, Popular Modernism, and Public Memory

If there were a Richter scale to measure the extent to which commercial films cause reverberations in the traditional public sphere, the effect of *Schindler's List* might come close to, or at least fall into the general range of D. W. Griffith's racist blockbuster of 1915, *The Birth of a Nation.* If we bracket obvious differences between the films (which are perhaps not quite as obvious as they may seem), as well as eight decades of media history, the comparison is tempting because a similar seismic intensity characterizes both Spielberg's ambition and the film's public reception.[1] Each film demonstratively takes on a trauma of collective historical dimensions; and each reworks this trauma in the name of memory and national identity, inscribed with particular notions of race, sexuality, and family. Each film participates in the contested discourse of fiftieth-year commemorations, marking the eventual surrender of survivor- (or veteran-) based memory to the vicissitudes of public history. While *Birth of a Nation* was not the first film to deal with the Civil War and its aftermath (there were in fact dozens of Civil War films between 1911 and 1915), the film did lay unprecedented claim to the construction of national history and thus demonstrated the stakes of national memory for the history of the present. And while *Schindler's List* is certainly not the first film to deal with the German Judeocide, Spielberg's story about a Sudeten-German Catholic entrepreneur who saved the lives of 1,100 Polish Jews asserts a similar place of centrality in contemporary U.S. culture and politics.

On the level of reception, both *Birth* and *Schindler's List* provoked responses from far beyond the pale of industrial-commercial culture, getting attention from writers, activists, and politicians who usually don't take films seriously; it thus temporarily linked the respective media publics (emergent in the case of *Birth,* all-inclusive in the case of *Schindler's List*) with the publics of traditional politics and critical intellectuals.[2] What is extraordinary about these two films is not just how they managed to catalyze contesting points of view but also how they make visible the contestation among various and unequal discursive arenas in their effort to lay claim to what and how a nation remembers—not an identical nation, to be

From *Critical Inquiry* 22, Winter 1996: 292–312. Reprinted by permission of the author and the University of Chicago Press.

sure, but distinctly different formations of a national public. As is well known, *Birth* was the first film to be given a screening at the White House (after which President Wilson's comment, "It is like writing history in lightning," became part of the legend), but it was also the first film to galvanize intellectual and political opposition in an alliance of Progressive reformers and the newly formed NAACP. As is likewise known, not all intellectuals protested: *Birth* became the founding text for an apologetic discourse on "film art" that for decades tried to relativize the film's racist infraction.[3]

Here, at the latest, my comparison turns into disanalogy. For can we compare the violent and persistent damage done to African Americans by *Birth* to the damage done, as some critics claim, by *Schindler's List* to the victims in whose name it pretends to speak? And can we compare the white and black, liberal and radical engagement for a disenfranchised community to the contemporary intellectual stance that holds all representations of the Shoah accountable to the task of an anamnestic solidarity with the dead? To what extent is the disjunction of the two films a matter of the different histories they engage and to what extent does it illustrate the profound transformation of public memory in contemporary media culture? What do we make, in each case, of the ambivalent effects of popular success? And how, finally, does popularity as such shape the critical accounts we get of the films?

In the following, I will try to trace some of the dynamics at work in the reception of *Schindler's List*. I regard the controversies over the film as symptomatic of larger issues, in particular the ongoing problematic of Holocaust remembrance and the so-called Americanization of the Holocaust, but also the more general issue of the relationship of intellectuals to mass culture, specifically to the media publics of cinema and television. I see both these issues encapsulated in the pervasive polarization of critical argument into the opposition of *Schindler's List* versus Claude Lanzmann's documentary *Shoah* (1985), as two mutually exclusive paradigms of cinematically representing or not-representing the Holocaust. This opposition, I will argue, does not yield a productive way of dealing with either the films or the larger issues involved.

I distinguish, roughly, among three major strands or levels in the reception of *Schindler's List*. First, there is the level of official publicity. Under this term I lump together a whole variety of channels and discourses, ranging from Spielberg's self-promotion and the usual Hollywood hype (culminating in the Oscar Award ceremony) to presidential endorsements at home and abroad as well as government bannings of the film in some Near Eastern and Asian countries; from subsidized and mandatory screenings for high school students and youth groups to the largely adulatory coverage in the trade papers, the daily press, and TV talk shows.

The second, though by no means secondary, level of reception is the mercurial factor of popular reception. While this reception is no doubt produced and shaped by official publicity, it cannot be totally reduced to intended response. The

distinct dynamics of popular reception comes to the fore in precisely those moments when an audience diverges or goes away from the film, when reception takes on a momentum of its own, that is, becomes public in the emphatic sense of the word.[4] This includes moments of failure, such as the much publicized irreverent reaction of black students at Castlemont High in Oakland.[5] It also includes the film's enormous success in Germany, which prompted endless discussions, letters to the editor, and the discovery of local Schindlers everywhere—a development one cannot but view with amazement and ambivalence. Methodologically, this aspect of reception is the most difficult to represent, for it eludes both ethnographic audience research and textually based constructions of possible spectatorial effects; yet it requires an approach that is capable of mediating empirical and theoretical levels of argument.

The third level of reception, on which I will focus here, is the vehement rejection of the film on the part of critical intellectuals. This includes both academics and journalists, avant-garde artists and filmmakers (among others, Art Spiegelman and Ken Jacobs in a symposium printed in the *Village Voice*), but also a fair number of liberal publicists (for example, Frank Rich, Leon Wieseltier, Philip Gourevitch, Ilene Rosenzweig) who voiced their dissent in middle-brow papers such as the *New York Times*, the *New Republic*, the *New York Review of Books* as well as Jewish publications such as *Forward*, *Tikkun*, and *Commentary*. Most of these critical comments position themselves as minority opinion against the film's allegedly overwhelming endorsement in the media, if not as martyrs in the "resistance" against popular taste ("there is little pleasure in being troubled by what so many have found deeply moving").[6] Accordingly, critical dissent is directed as much against the larger impact of the film—which Michael André Bernstein has dubbed "the *Schindler's List* effect"[7]—as against the film itself.

This response is no doubt legitimate and, in print at least, highly persuasive. For all I know, I might well have joined in, that is, had I seen the film in this country rather than in Germany. The kind of work the film did there, in light of a hopelessly overdetermined and yet rapidly changing "politics of memory," may arguably present a special case.[8] Seeing the film outside the context of American publicity, however, made me consider the film's textual work, if not independently of its intentions and public effects, yet still from a slightly displaced location in relation to both Hollywood globality and its intellectual critics. Let me say at the outset that it is not my intention to vindicate *Schindler's List* as a masterpiece (which would mean reverting to the *Birth of a Nation* debate). I think there are serious problems with the film's conception, and I could have done without much of the last third, when Oskar Schindler (Liam Neeson), the opportunist, gambler, and philanderer, turns into Schindler, the heroic rescuer. But seen from a perspective of displacement, and considered from an interstitial space between distinct critical discourses and between disjunctive political legacies, the film did seem to have an important function, not only for empirically diverse audiences, but also for thinking through key issues involved in the representation of the

Shoah and the problem of "public memory."[9] Moreover, in the way the film polarized, or was assumed to have polarized, critical and popular responses, the reception of *Schindler's List* threw into relief a particular pattern in the intellectuals' reactions to the film: they seemed to rehearse familiar tropes of the old debate on modernism versus mass culture.

Before I elaborate on this pattern, and on what it occludes in the public as well as textual workings of the film, I will first outline the intellectual critique in its key points. The following summary distinguishes, roughly, among arguments pertaining to (a) the *culture industry* (in Horkheimer and Adorno's sense); (b) the problem of *narrative*; (c) the question of *cinematic subjectivity*; and (d) the question of *representation.*

(a) The first and obvious argument is that *Schindler's List* is and remains a Hollywood product. As such it is circumscribed by the economic and ideological tenets of the culture industry, with its unquestioned and supreme values of entertainment and spectacle; its fetishism of style and glamour; its penchant for superlatives and historicist grasp at any and all experience ("the greatest Holocaust film ever made"); and its reifying, leveling, and trivializing effect on everything it touches. In this argument, *Schindler's List* is usually aligned with Spielberg's previous mega-spectacles, especially *Jurassic Park,* and is accused of having turned the Holocaust into a theme park. Since the business of Hollywood is entertainment, preferably in the key of sentimental optimism, there is something intrinsically and profoundly incommensurable about "re-creating" the traumatic events of the Shoah "for the sake of an audience's recreation" (Spiegelman).[10] Or, as J. Hoberman puts it so eloquently: "Is it possible to make a feel-good entertainment about the ultimate feel-bad experience of the twentieth century?"[11]

This critique of *Schindler's List* links the film to the larger problem of the Holocaust's dubious mass-media currency, recalling the ugly pun of "Shoahbusiness." The interesting question here is whether Spielberg's film is merely the latest culmination of what Saul Friedlander discerned, in films and novels of the 1970s, as a "new discourse about Nazism on the right as well as on the left," a discourse that thrived on the spectacular fusion of kitsch and death.[12] Or does *Schindler's List,* along with the success of the Holocaust Memorial Museum in Washington, D.C., mark the emergence of yet another new discourse? If the latter is the case, this new discourse, whose different dynamics the film might help us understand, will have to be situated in relation to other struggles over public memorializing concerning more specifically U.S. American traumata such as slavery, the genocide of Native Americans, and Vietnam.

(b) The second and more local argument made about the film's inadequacy to the topic it engages is that it does so in the form of a fictional narrative. One emphasis in this argument is on the choice of fiction (notwithstanding the film's pretensions to historical "authenticity") over nonfiction or documentary, a form of film practice that would have allowed for a different organization of space and temporality, different sound/image relations, and therefore different possibilities

of approaching the events portrayed. Attendant upon the film's fictional form—with its (nineteenth-century) novelistic and historicist underpinnings—is the claim, supported by the publicity and Spielberg's complicity with it, that *Schindler's List* does not just represent one story from the Shoah but that it does so in a *representative* manner—that it encapsulates the totality of the Holocaust experience.[13] If that were the case, the film's focus on the heroic exception, the Gentile rescuer and the miracle of survival, would indeed distort the proportions and thus end up falsifying the record.

Related to this charge is the condemnation of the film's choice of a particular type of narrative, specifically, the *classical* mode that governed Hollywood products until about 1960 and beyond.[14] In a technical sense, this term refers to a type of narrative that requires thorough causal motivation centering on the actions and goals of individual characters (as opposed to the "anonymous" Jewish masses who were the object of extermination); a type of narrative in which character psychology and relations among characters tend to be predicated on masculinist hierarchies of gender and sexuality (in the case of *Schindler's List*, the reassertion of certain "styles of manhood" and the sadistic-voyeuristic fascination with the female body, in particular the staging of Amon Goeth's [Ralph Fiennes] desire and his violence toward Helen Hirsch, the Jewish housemaid [Embeth Davidtz]);[15] a type of narrative in which the resolution of larger-order problems tends to hinge upon the formation of a couple or family and on the restoration of familial forms of subjectivity (Schindler as a super father figure who has to renounce his promiscuity and return to marriage in order to accomplish his historic mission, the rescue of Jewish families).[16]

A fundamental limitation of classical narrative in relation to history, and to the historical event of the Shoah in particular, is that it relies on neoclassicist principles of compositional unity, motivation, linearity, equilibrium, and closure—principles singularly inadequate in the face of an event that by its very nature defies our narrative urge to make sense of, to impose order on the discontinuity and otherness of historical experience. Likewise, the deadly teleology of the Shoah represents a temporal trajectory that gives the lie to any classical dramaturgy of deadlines, suspense, and rescues in the nick of time, to moments of melodramatic intensity and relief. There are at least three last-minute rescues in *Schindler's List*, leading up to the compulsory Hollywood happy ending. This radically exacerbates the general problem of narrative film, which Alexander Kluge has succinctly described as the problem of "how to get to a happy ending without lying."[17] The rescue of the Schindler Jews is a matter of luck and gamble rather than melodramatic coincidence; and although the story is historically "authentic," it cannot but remain a fairy tale in the face of the overwhelming facticity of "man-made mass death" (Edith Wyschogrod).[18] Critics of the film, notably Claude Lanzmann and Gertrud Koch, have observed that *Schindler's List* (like Agnieszka Holland's 1991 *Europa, Europa*) marks a shift in the public commemoration of the Shoah: the film is concerned with *survival*, the survival of individuals, rather than the

fact of death, the death of an entire people or peoples.[19] If the possibility of *passing through Auschwitz* is the film's central historical trope, the implications are indeed exorbitant—although not necessarily, in my opinion, that self-evident and unequivocal.

Finally, as a classical narrative, *Schindler's List* inscribes itself in a particular tradition of "realist" film. This is not just a matter of Spielberg's declared efforts to ensure "authenticity" (by using authentic locations, by following Thomas Keneally's novel, which is based on survivor testimony); nor is it simply a matter of the use of black-and-white film stock and the imitation of a particular 1940s style. The film's "reality effect," to use Roland Barthes's phrase, has as much to do with the way it recycles images and tropes from other Holocaust films, especially European ones; but as a classical narrative, it does so without quotation marks, pretending to be telling the story for the first time.[20] As Koch argues, there is something authoritarian in the way *Schindler's List* subsumes all these earlier films, using them to assert its own truth claims for history ("MMM," 25–26). The question that poses itself is whether the film's citational practice merely follows the well-worn path of nineteenth-century realist fiction, or whether it does so in the context of a postmodern aesthetics that has rehabilitated such syncretistic procedures in the name of popular resonance and success. The more interesting question, though, may be to what extent this distinction actually matters, or in which ways the event of the Shoah could be said to trouble, if not challenge postmodernist assumptions about representation, temporality, and history.

(c) The third objection raised against *Schindler's List* pertains to the way it allocates subjectivity among its characters and engages the viewer's subjectivity in that process. The charge here is that the film narrates the history of 1,100 rescued Jews from the perspective of the perpetrators, the German Gentile Nazi turned resister and his alter ego, Amon Goeth, the psychotic SS commandant. As Philip Gourevitch asserts, "*Schindler's List* depicts the Nazis' slaughter of Polish Jewry almost entirely through German eyes."[21] By contrast, the argument goes, the Jewish characters are reduced to pasteboard figures, to generic types incapable of eliciting identification and empathy. Or worse, some critics contend, they come to life only to embody anti-Semitic stereotypes (money-grubbing Jews, Jew-as-eternal-victim, the association of Jewish women with dangerous sexuality, the characterization of Itzhak Stern [Ben Kingsley], Schindler's accountant, as "king of the Jewish wimps").[22] This argument not only refers to the degree to which characters are fleshed out, individualized by means of casting, acting, cinematography, and narrative action; the argument also pertains to the level of filmic narration or enunciation, the level at which characters function to mediate the film's sights and sounds, events and meanings to the spectator, as for instance through flashbacks, voice-over, or optical point of view. As psychoanalytic film theorists have argued in the 1970s and early 1980s, it is on this level that cinematic subjectivity is formed most effectively because unconsciously.[23] If that is so (and let's for the moment, for the sake of argument, assume it is), what does it mean that

point-of-view shots are clustered not only around Schindler but also around Goeth, making us participate in one of his killing sprees in shots showing the victim through the telescope of his gun? Does this mean that, even though he is marked as evil on the level of the diegesis or fictional world of the film, the viewer is nonetheless urged to identify with Goeth's murderous desire on the unconscious level of cinematic discourse?

(d) The fourth, and most difficult, objection to *Schindler's List* is that it violates the taboo on representation *(Bilderverbot)*, that it tries to give an "image of the unimaginable."[24] If the criticisms summarized up to this point imply by and large that the film is not "realistic" enough, this critique involves the exact opposite charge, that the film is too "realistic." So, by offering us an "authentic" reconstruction of events of the Shoah, the film enhances the fallacy of an immediate and unmediated access to the past (the fallacy of historical films from *Birth of a Nation* to *JFK*)—by posing as the "real thing" the film usurps the place of the actual event. What is worse, it does so with an event that defies depiction, whose horror renders any attempt at direct representation obscene. Spielberg transgresses the boundaries of representability most notoriously, critics agree, when he takes the camera across the threshold of what we, and the women in the film "mistakenly" deported to Auschwitz, believe to be a gas chamber. Thus *Schindler's List,* like the TV miniseries *Holocaust,* ends up both trivializing and sensationalizing the Shoah.

The most radical proponent of this critique, Lanzmann, accuses *Schindler's List* of not respecting the unique and absolute status of the Holocaust: "unique in the sense that it erects around itself, in a circle of flames, a boundary which cannot be breached because a certain absolute degree of horror is intransmissable: to pretend it can be done is to make oneself guilty of the most serious sort of transgression."[25] The counterexample of a film that respects that boundary and succeeds in an aesthetic figuration of the very impossibility of representation is, for both Lanzmann and other critics of Spielberg, his own film *Shoah* (1985). Lanzmann's film, as has often been pointed out, strictly refuses any direct representation of the past, whether by means of fictional reenactment or archival footage. Instead, the film combines interviews featuring various types of witnesses (survivors, perpetrators, bystanders, historians) to give testimony at once to the physical, sense-defying details of mass extermination and to the *"historical crisis of witnessing"* presented by the Shoah.[26] This crisis threatens not merely the project of a retrospective, anamnestic account, but the very possibility and concept of eyewitnessing and, by extension, the recording capacity of the photographic media. (This is why Lanzmann so radically distrusts Spielberg's untroubled accessing—or, as Lanzmann calls it, "fabrication"—of a visual archive: "If I had found an actual film—a secret film, since that was strictly forbidden—made by an SS man and showing how 3000 Jews, men, women, and children, died together, asphyxiated in a gas chamber of the crematorium 2 in Auschwitz—if I had found that, not only would I not have shown it but I would have destroyed it.")[27]

Lanzmann's argument, like the critique of *Schindler's List* in the name of *Shoah,* is bound up with a complex philosophical debate surrounding the Holocaust to which I cannot do justice here. Suffice it to say that the moral argument about the impossibility of representation—of mimetic doubling—is linked, via a quasi-theological invocation of the Second Commandment, to the issue of the singularity of the Shoah, its status as an event that is totally and irrevocably Other, an event that ruptures and is ultimately outside history. What matters in this context is the further linkage, often made concurrently, between the claim to singularity and the type of aesthetic practice that alone is thought to be capable of engaging the problematic of representation without disfiguring the memory of the dead. For the breach inflicted by the Shoah has not only put into question, irrevocably, the status of culture as an autonomous and superior domain (to invoke an often misquoted statement by Adorno);[28] it has also radicalized the case for a type of aesthetic expression that is aware of its problematic status—the nonrepresentational, singular, and hermetic *écriture* to be found in works of high modernism. *Shoah* has rightly been praised for its uniqueness, its rigorous and uncompromising invention of a filmic language capable of rendering "imageless images" of annihilation (Koch paraphrasing Adorno's *Aesthetic Theory*).[29] *Schindler's List,* by contrast, does not seek to negate the representational, iconic power of filmic images, but rather banks on this power. Nor does it develop a unique filmic idiom to capture the unprecedented and unassimilable fact of mass extermination; rather, it relies on familiar tropes and common techniques to narrate the extraordinary rescue of a group of individuals.

The critique of *Schindler's List* in high-modernist terms, however, especially in Lanzmann's version, reduces the dialectics of the problem of representing the unrepresentable to a binary opposition of showing or not showing—rather than casting it, as one might, as an issue of competing representations and competing modes of representation. This binary argument also reinscribes, paradoxically, a high-modernist fixation on vision and the visual, whether simply assumed as the epistemological master sense or critically negated as illusory and affirmative. What gets left out is the dimension of the other senses and of sensory experience, that is, the aesthetic in the more comprehensive, Greek sense of the word, and its fate in a history of modernity that encompasses both mass production and mass extermination.[30] What gets left out in particular is the dimension of the acoustic, the role of sound in the production of visuality, especially in the technical media where sound has come to compensate for the historical marginalization of the more bodily senses. Yet, if we understand the Shoah's challenge to representation to be as much one of affect as one of epistemology, the specific sensory means of engaging this challenge cannot be ignored. The sound track, for example, is neither the seat of a superior truth (as Lanzmann seems to claim for *Shoah*) nor merely a masked accomplice for the untruths of the image track (as assumed in summary critiques of the classical Hollywood film), but rather the material site of particular and competing aesthetic practices.[31]

It is no coincidence that none of the critics of *Schindler's List* have commented on the film's use of sound (except for complaints about the sentimental and melodramatic music)—not to mention how few have actually granted the film a closer look. Although I share some of the reservations paraphrased above, I still would argue that *Schindler's List* is a more sophisticated, elliptical, and self-conscious film than its critics acknowledge (and the self-consciousness is not limited to the epilogue in which we see the actors together with the survivors they play file past Schindler's Jerusalem grave). Let me cite a few, brief examples that suggest that we might imagine this film differently, examples pertaining to both the film's complex use of sound and its structuring of narration and cinematic subjectivity.

To begin with the latter point, the complaint that the film is narrated from the point of view of the perpetrators ignores the crucial function of Itzhak Stern (Ben Kingsley), the Jewish accountant, in the enunciative structure of the film. Throughout the film, Stern is the focus of point-of-view edits and reaction shots, just as he repeatedly motivates camera movements and shot changes. Stern is the only character who gets to authorize a flashback, in the sequence in which he responds to Schindler's attempt to defend Goeth ("a wonderful crook") by evoking a scene of Goeth's close-range shooting of twenty-five men in a work detail in retribution for one man's escape; closer framing within the flashback in turn foregrounds, as mute witness, the prisoner to whom Stern attributes the account. The sequence is remarkable also in that it contains the film's only flashforward, prompted by Schindler's exasperated question, "What do you want me to do about it?" Notwithstanding Stern's disavowing gesture ("nothing, nothing—it's just talking"), his flashback narration translates into action on Schindler's part, resulting in the requisitioning of the Pearlmans as workers, which is shown proleptically even before Schindler hands Stern his watch to be used as bribe. This moment not only marks, on the diegetic level of the film, Schindler's first conscious engagement in bartering for Jewish lives; it also inscribes the absolute difference in power between Gentiles and Jews on the level of cinematic discourse, as a disjunction of filmic temporality. Stern is deprived of his ability, his right to act, that is, to produce a future, but he can narrate the past and pass on testimony, hoping to produce action in the listener/viewer.

More often, temporal displacement is a function of the sound track, in particular an abundance of sound bridges and other forms of nonmatching (such as a character's speech or reading turning into documentary-style voice-over); and there are numerous moments when the formal disjunction of sound and image subtends rhetorical relations of irony and even counterpoint. This disjunctive style occurs primarily on the level of diegetic sound, in particular, speech. (The use of nondiegetic music in *Schindler's List* is indeed another matter, inasmuch as it functions more like the "glue" that traditionally covers over any discontinuity and sutures the viewer into the film.)[32] But the persistent splitting of the image track by means of displaced diegetic sound still undercuts the effect of an

immediate and totalitarian grasp on reality—such as that produced by perfect sound/image matching in numerous World War II films or, to use a more recent example, Stone's *JFK*.

In the sequence that initiates the liquidation of the Kraków ghetto (figures 1–16), disjunctive sound/image relations combine with camera narration that foregrounds Stern's point of view. The sequence is defined by the duration of an acoustic event, Goeth's speech that begins and ends with the phrase "today is history." The speech starts in the middle of a series of four shots alternating between Schindler and Goeth shaving, which briefly makes it an acoustic flashforward. Only in the fifth shot is the voice grounded in the speaking character, Goeth now dressed in a uniform, addressing his men who stand around him in a wide circle. In the shots that follow, the speech appears to function as a kind of voice-over, speaking the history of the ghetto's inhabitants and the imminent erasure of this history and its subjects. But the images of the living people we see—a rabbi praying, a family having breakfast, a man and a woman exchanging loving looks—also resist this predication. So does the voice of the rabbi that competes with Goeth's voice even before we see him pray, and it continues, as an undertone to Goeth's voice, into the subsequent shots of ghetto inhabitants (so that in one shot, in which we hear the subdued synchronic voices of the family at breakfast, there are actually three different layers of sound); the praying voice fades out just before the last sentence of Goeth's speech. Not coincidentally, all the Jewish characters shown in this sequence will survive, that is, they will, as individuals, give the lie to Goeth's project. What is more, nested into this sequence is a pronounced point-of-view pattern that centers on Stern and makes him the first to witness the ominous preparations. The act of looking is emphasized by a close-up of him putting on his glasses and turning to the window, and by the answering extreme high-angle shot that frames window and curtain from his vantage point. This shot is repeated, after two objective, almost emblematic shots (closely framed and violating screen direction) of rows of chairs and tables being set up by uniformed arms and hands, and then bookended by a medium shot of Stern watching and turning away from the window. The whole sequence is symmetrically closed by reattaching Goeth's voice to his body, thus sealing the fate of the majority of the ghetto population, the people *not* shown on the image track.

To be sure, the film's hierarchy of physicality and masculinity would never allow Stern to be seen shaving (as Schindler and Goeth are in the beginning of the sequence). But the structuring of vision on the level of enunciation establishes Stern as a *witness* for the narration, for the viewer, for posterity. By contrast, moments of subjective vision ascribed to Schindler, most notably the point-of-view shots that stage his two sightings of the little girl in the red coat, serve quite a different function, stressing character psychology rather than narrational authority. Stern's role as enunciative witness is particularly interesting in a sequence that does *not* involve optical point of view—the sequence in which Goeth kills Lisiek (Wojciech Klata), the boy whom he has made his personal servant (figures 17–22). What is

Figure 1. Today is history;

Figure 2. —today will be remembered.

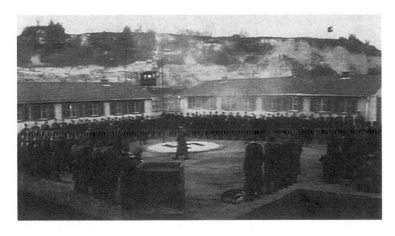

Figure 3. —Years from now the young will ask with wonder about

Figure 4. —this day. Today is history and you are part of it. Six hundred years ago,

Rabbi's voice praying

Figure 5. —when elsewhere they were put in the blame for the black death, Casimir the Great

Figure 6. —so-called, told the Jews they could come to

Figure 7. —*Kraków. They came, they trundled their belongings into the city; they*

Mrs. Dresner's voice: a bit less

Figure 8. —*settled, they took hold, they*

Figure 9. —*prospered; and business*

Figure 10a. —science, education, the arts.

Figure 10b.

Figure 11. They came here with nothing,

Figure 12. —nothing,

Figure 13. —and they flourished.

Figure 14. —For six centuries, there has been a

Figure 15. –Jewish Kraków; think about that. By this evening, those six centuries are a rumor;

Rabbi's voice fades

Figure 16. –they never happened. Today is history.

remarkable about this sequence is the oblique, elliptical rendering of the killing: we neither see Goeth shooting nor do we see the boy being hit; we only see his body lying in the background as Stern walks across the yard, and it is Stern's movement that motivates that of the camera. Even Stern's registering of the killing is rendered only obliquely, stressing the split between seeing and meaning, seeing and feeling characteristic of the concentration camp universe. Compared to the systematic way *Shoah* (in Shoshana Felman's reading) foregrounds the problematic of witnessing, such moments are perhaps marginal in *Schindler's List*, but they nonetheless deserve to be discussed in similar terms—as an aesthetic attempt to engage the extreme difficulty (although not absolute impossibility) of giving sensory expression to an experience that radically defies sense.[33]

Important as the close attention to the film's textual work is, it can only provide a weak answer to the fundamental objections raised by the film's intellectual opponents. Let me repeat that I am not interested in defending *Schindler's List* on aesthetic grounds (the aesthetic narrowly understood as relating to the institution of art and its mass-mediated afterlives). Nor am I suggesting that the film's use of sound and its overall narrational strategies are radical, unique, or original; on the contrary, most of these textual devices belong to the inventory of classical Hollywood cinema, from the mid-teens through the 1950s. Seen in light of the history of that institution up to and including commercial film production of the present, however, *Schindler's List* makes use of these devices in a relatively more intelligent, responsible, and interesting manner than one might have expected, for instance, on the basis of Spielberg's earlier work. The wholesale attack on the film not only erases these distinctions; it also misses the film's diagnostic significance in relation to other discourses, junctures, and disjunctures in contemporary American culture.

The point I'm trying to make is that the lack of attention to the film's material and textual specificity is itself a symptom of the impasse produced by the intellectual critique, an impasse that I find epitomized in the binary opposition of *Schindler's List* and *Shoah*. (Lanzmann's position in this regard is only the most extreme version of this opposition: "In [Spielberg's] film there is no reflection, no thought, about what is the Holocaust and no thought about what is cinema. Because if he would have thought, he would not have made it—or he would have made "*Shoah*.'")[34] It is one thing to use *Shoah* for the purpose of spelling out the philosophical and ethical issues of cinematic representation in relation to the Shoah; it is another to accuse *Schindler's List* of not being the same kind of film. For while *Shoah* has indeed changed the parameters of Holocaust representation, it is not without problems, aesthetic as well as political, nor is it sacrosanct.

More important, the attack on *Schindler's List* in the name of *Shoah* reinscribes the debate on filmic representation with the old debate of modernism versus mass culture, and thus with binary oppositions of "high" versus "low," "art" versus "kitsch," "esoteric" versus "popular." However, Adorno's insight that, to use Andreas Huyssen's paraphrase, ever since the mid-nineteenth century "modernism

and mass culture have been engaged in a compulsive *pas-de-deux*" has become exponentially more pertinent in postmodern media culture.[35] "High" and "low" are inextricably part of the same culture, part of the same public sphere, part of the ongoing negotiation of how forms of social difference are both represented and produced in late capitalism. This is not to say that *Shoah* did not have to compete for funding in an unequal struggle with commercial cinema; nor that it did not have to fight for distribution and access. But once the film was released, especially in the United States, it entered the commercial circuit of the art film market and was praised by the same critics and in the same hyperbolic terms that celebrated *Schindler's List.*

Ironically, it could be argued, *Schindler's List* itself participates in the modernism/mass culture dichotomy even as it tries to overcome it. Here is where I would like to insert the concept of popular modernism (which I elaborate in greater detail elsewhere).[36] If we want to grasp the plurality and complexity of twentieth-century modernity, it is important to note the extent to which modernism was not just the creation of individual artists and intellectuals or, for that matter, avant-garde coteries, but also, especially during the interwar period, a popular and mass movement. I am thinking in particular of formations usually subsumed under labels such as Americanism and Fordism, but more specifically referring to a new culture of leisure, distraction, and consumption that absorbed a number of artistic innovations into a modern vernacular of its own (especially by way of design) and vice versa. It seems to me that Spielberg would like to go back to that moment—that he is trying to make a case for a capitalist aesthetics and culture which is at once modernist and popular, which would be capable of reflecting upon the shocks and scars inflicted by modernization on people's lives in a generally accessible, public horizon.

The reason I believe that something of that order is at stake has to do with the way *Schindler's List* refers itself to that great monument of cinematic modernism, *Citizen Kane.*[37] This argument is primarily based on striking affinities of film style—the self-conscious use of sound, low-key lighting, particular angles and compositions in frame, montage sequences, as well as the comic use of still photography early on in the film. If Spielberg tries to inscribe himself into an American film history pivoting around *Citizen Kane,* he also tries to revise the message—if one can speak of a message—of Welles's film. *Citizen Kane* traces the disintegration of its protagonist from a young man of lofty ideals to a monstrous figure of the specular, two-dimensional, and fragmented media culture he helped create. *Schindler's List* reverses the direction of this development. It presents us with an enigmatic character who starts out in the world of dazzling surfaces and glamour and who is repeatedly identified with the aesthetics of fashion, advertising, and consumption. (In the scene in which Schindler proposes to Stern what is basically a highly exploitative scheme, Stern asks: "They [the Jewish 'investors'] put up all the money; I do all the work. What, if you don't mind my asking, would you do?" And Schindler replies: "I'd make sure it's known the company's in business. I'd see

Figure 17. —Lisiek: *I have to report, sir: I've been unable to remove the stains from the bathtub.* Goeth: *Go ahead, go on, leave. I pardon you.*

Figure 18.

Figure 19. —I pardon you.

Figure 20.

Figure 21.

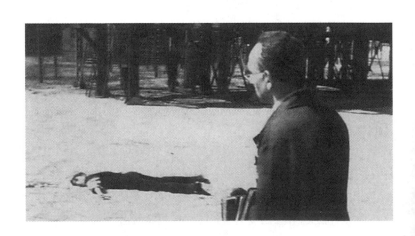

Figure 22.

that it had a certain panache. That's what I'm good at. Not the work, not the work: the presentation!") But out of that cypher of a grifter-conman-gambler develops an "authentic" person, an integrated and intelligible character, a morally responsible agent. No doubt Spielberg himself has an investment in this redemptive trajectory; and if, as a number of critics have pointed out, the director strongly identifies with his protagonist, he does so in defense of a capitalist culture, of an aesthetics that fuses modernist style, popular storytelling, and an ethos of individual responsibility. Whether he succeeds in reversing *Citizen Kane*'s pessimistic trajectory, that is, in disentangling Schindler—and the story of the Schindler Jews—from the reifying effects of mass-mediated, spectacular consumer culture, is an open question, depending as much on the film's long-term public effects as on textual critique.

But perhaps this question is beside the point, as is treating the opposition of *Shoah* versus *Schindler's List* as if it were a practical alternative, a real option. For whether we like it or not, the predominant vehicles of public memory *are* the media of technical re/production and mass consumption. This issue is especially exacerbated for the remembrance of the Shoah in light of the specific crisis posed by the Nazis' destruction of the very basis and structures of collective remembering. (In contrast with most of the "ordinary massacres" committed in the course of the German genocidal war all over Europe, the Shoah did not leave any communities of survivors, widows and children, not even burial sites that would have provided a link with a more "organic" tradition of oral and collective memory.)[38] In a significant way, even before the passing of the last survivors, the remembrance of the Shoah, to the extent that it was public and collective, has always been more dependent on mass-mediated forms of memory—on what Alison Landsberg calls "prosthetic memory."[39]

Much has been written about the changing fabric of memory in postmodern media society, in particular the emergence of new cultural practices (new types of exhibits, the museum boom) that allow the beholders to *experience* the past—any past, not necessarily their own—with greater intensity and sensuous immediacy (for example, at the U.S. Holocaust Memorial Museum).[40] We need to understand the place of *Schindler's List* in the contemporary culture of memory and memorializing; and the film in turn may help us understand that culture. This might also shed light on how the popular American fascination with the Holocaust may function as a "screen memory" *(Deckerinnerung)* in the Freudian sense, covering up a traumatic event—another traumatic event—that cannot be approached directly. More than just an ideological displacement (which it is no doubt as well), the fascination with the Holocaust could be read as a kind of screen allegory behind/through which the nation is struggling to find a proper mode of memorializing traumata closer to home. The displaced referents of such memorializing may extend to events as distant as the genocide of Native Americans or as recent as the Vietnam War. It is no coincidence that African American historians have begun using concepts developed in the attempt to theorize the Shoah, such as the notion of a "breach" or "rupture," to talk about the Middle Passage.[41]

Likewise, the screen memories of the Holocaust could be read as part of an American discourse on modernity, in which Weimar and Nazi Germany figure as an allegory of a modernity gone wrong.[42] The continued currency of these mythical topoi in the popular media may indicate a need for Americans to externalize and project modernity's catastrophic features onto another nation's failure and defeat—so as to salvage modernity the American way. This would give the American public's penchant for allegories of heroic rescue (elaborated in cinematic form by D. W. Griffith) a particular historical and political twist in that it couples the memory/fantasy of having won the war with the failure to save the Jews. In any case, if *Schindler's List* functions as a screen memory in this or other ways, the pasts that it may at once cover and traverse cannot be reduced to the singular, just as the Americanization of the Holocaust cannot be explained by fixating exclusively on its ideological functions.[43] That the film touches on more than one nerve, appeals to more constituencies than a narrowly defined identity politics would have it, could be dismissed as an effect of Hollywood's marketing strategies in the blockbuster era. But it could also be taken as a measure of the film's ability to engender a public space, a horizon of at once sensory experience and discursive contestation.

No doubt *Schindler's List* could have been a different film, or many different films, even as based on Keneally's novel. And different stories relating to the most traumatic and central event of the twentieth century will be and will have to be told, in a variety of media and genres, within an irrevocably multiple and hybrid public sphere. If *The Birth of a Nation* remains important to American history, it is not only for its racist inscription of the Civil War and Reconstruction periods; it is just as important for what it tells us about 1915, about the new medium's role in creating a national public, about the dynamics of cultural memory and public memorializing in a volatile immigrant society. *Schindler's List* comes at a radically different moment—in national and global history, in film history, in the history of the public sphere. To dismiss the film because of the a priori established unrepresentability of what it purports to represent may be justified on ethical and epistemological grounds, but it means missing a chance to understand the significance of the Shoah in the present, in the ongoing and undecided struggles over which past gets remembered and how. Unless we take all aspects—omissions and distortions, displacements and possibilities—of public, mass-mediated memory culture seriously, we will remain caught in the "compulsive *pas-de-deux*" of (not just) intellectual history.

NOTES

1. The comparison was first suggested, in a somewhat different spirit, by Terrence Rafferty in *The New Yorker* 69 (December 20, 1993), 132. Rafferty praises the epic significance and "visionary clarity" of *Schindler's List* by invoking James Agee's reverie about *Birth* as "a perfect realization of a collective dream of what the Civil War was like, as veterans might remember it fifty years later, or as children, fifty years later might imagine it." Obviously, such a compari-

son asks to be turned against itself: see Philip Gourevitch, "A Dissent on 'Schindler's List,'" *Commentary* 97.2 (February 1994): 52.

For astute readings and suggestions on this essay, I wish to thank Homi Bhabha, Bill Brown, Michael Geyer, Alison Landsberg, and audiences at the University of Chicago, Harvard University, and the annual conference of the Society for Cinema Studies, March 1995.

2. Another example of such boundary-crossing publicity in the recent past is Oliver Stone's *JFK* (1992). My use of the term "public," like the distinction among various types of publicness, is indebted to Oskar Negt and Alexander Kluge, *Public Sphere and Experience* (1972), tr. P. Labanyi, J. O. Daniel, and A. Oksiloff (Minneapolis: University of Minnesota Press, 1993).

3. See Janet Staiger, "*The Birth of a Nation:* Reconsidering Its Reception," in Robert Land, ed., *THE BIRTH OF A NATION: D. W. Griffith, Director* (New Brunswick, N.J.: Rutgers University Press, 1994), 195–213. For an earlier account, see Thomas Cripps, *Slow Fade to Black: The Negro in American Film, 1900–1942* (London: Oxford University Press, 1977), chap. 2. On the film's intervention in the contemporary political and ideological context, see Michael Rogin's excellent essay, "'The Sword Became a Flashing Vision': D. W. Griffith's *The Birth of a Nation*," *Representations* 9 (Winter 1985): 150–95. On the film's devastating and lasting effects on African Americans' cinematic representation and relation to film practice, see Manthia Diawara, ed., *Black American Cinema* (New York: Routledge, 1993).

4. See Alexander Kluge, "On Film and the Public Sphere," tr. Th. Y. Levin and M. Hansen, *New German Critique* 24–25 (Fall–Winter 1981–82): 206–20.

5. Frank Rich, "Journal: 'Schindler's' Dissed," *New York Times*, February 6, 1994, sec. 4, 17; see also "Laughter at Film Brings Spielberg Visit," *New York Times*, April 13, 1994, B11.

6. Michael André Bernstein, "The *Schindler's List* Effect," *American Scholar* 63 (Summer 1994): 429–32; p. 429.

7. Ibid.

8. Michael Geyer, "The Politics of Memory in Contemporary Germany," in Joan Copjec, ed., *Radical Evil* (London: Verso, 1996), 169–200. See also Michael Geyer and Miriam Hansen, "German-Jewish Memory and National Consciousness," in Geoffrey Hartman, ed., *Holocaust Remembrance: The Shapes of Memory* (Oxford: Blackwell, 1994), 175–90.

9. See Geoffrey H. Hartman, "Public Memory and Its Discontents," *Raritan* 13.4 (Spring 1994): 24–40. Hartman defines contemporary "*public* memory" in contradistinction to traditional "*collective* memory" (33). I am using the term in a more general and less pessimistic sense indebted to Negt and Kluge's theory of the public sphere (see note 2, above).

10. Art Spiegelman, in J. Hoberman et al., "SCHINDLER'S LIST: Myth, Movie, and Memory," *Village Voice*, March 29, 1994, 27; hereafter abbreviated "MMM." See also Sean Mitchell's profile of Spiegelman, "Now, for a Little Hedonism," *Los Angeles Times, Calendar* section, December 18, 1994, 7, 97–98; on *Schindler's List*, p. 98.

11. J. Hoberman, "Spielberg's Oskar," *Village Voice*, December 21, 1993, 65. See also Frank Rich, "Extras in the Shadows," *New York Times*, January 2, 1994, 4; and Leon Wieseltier, "Close Encounters of the Nazi Kind," *New Republic* (January 24, 1994), 42.

12. See Saul Friedlander's introduction to the volume of essays, edited by him, *Probing the Limits of Representation: Nazism and the "Final Solution"* (Cambridge, Mass.: Harvard University Press, 1992), and *Reflections of Nazism: An Essay on Kitsch and Death* (1982), tr. Thomas Weyr (New York: Harper & Row, 1984), 13.

13. See Ora Gelley, "Point of View and the Narrativization of History in Steven Spielberg's *Schindler's List*," paper delivered at the Society for Cinema Studies annual conference, New York, March 1995.

14. David Bordwell, Janet Staiger, and Kristin Thompson, *The Classical Hollywood Cinema: Film Style and Mode of Production to 1960* (New York: Columbia University Press, 1985); David Bordwell, *Narration in the Fiction Film* (Madison: University of Wisconsin Press, 1985), chap. 9. The concept of classical cinema owes much to psychoanalytic-semiotic and feminist film theory of the 1970s; see Philip Rosen, ed., *Narrative, Apparatus, Ideology* (New York: Columbia University Press, 1986).

15. Ken Jacobs and Gertrud Koch, in "MMM," 27–28.

16. Bernstein, "The *Schindler's List* Effect," 430; Geoff Eley and Atina Grossmann, "Watching *Schindler's List:* Not the Last Word," *New German Critique*, 71 (Spring–Summer 1997): 41–62.

17. Kluge, *Die Macht der Gefühle* (The Power of Emotion, 1983), film script and other materials published under the same title (Frankfurt a.M.: Zweitausendeins, 1984); see also Miriam Hansen, "The Stubborn Discourse: History and Story-Telling in the Films of Alexander Kluge," *Persistence of Vision* 2 (Fall 1985): 26. On the Hollywood convention of the always-happy ending, see David Bordwell, "Happily Ever After, Part Two," *The Velvet Light Trap* 19 (1982–83): 2–7.

18. Edith Wyschogrod, *Spirit in Ashes: Hegel, Heidegger, and Man-Made Mass Death* (New Haven: Yale University Press, 1985).

19. Claude Lanzmann, "Holocauste, la représentation impossible," *Le Monde,* March 3, 1994, I, VII; "Why Spielberg Has Distorted the Truth," *Guardian Weekly,* April 9, 1994, 14; and Koch, in "MMM," 26.

20. Roland Barthes, "L'Effet de réel," *Communications* 11 (1968): 84–89, tr. Gerald Mead, "The Realistic Effect," *Film Reader* 3 (1978): 131–35. See also Barthes, *S/Z,* tr. Richard Miller (New York: Hill and Wang, 1974).

21. Gourevitch, "Dissent," 51. See also Jonathan Rosenbaum, "Gentile Persuasion," *Chicago Reader,* December 17, 1993, 10 and 26–27; and Gelley, "Point of View."

22. Ilene Rosenzweig, *The Forward,* quoted in Frank Rich, "Extras in the Shadows," *New York Times,* January 2, 1994, 4; Donald Kuspit, "Director's Guilt," *Artforum* 32 (February 1994): 11–12. Also see "MMM," 26.

23. See, for instance, articles by Christian Metz, Raymond Bellour, Kaja Silverman, Stephen Heath, and Laura Mulvey reprinted in Rosen, *Narrative, Apparatus, Ideology.* For a critique of the cine-semiotic concept of "enunciation," see Bordwell, *Narration and the Fiction Film,* 21–26.

24. Gertrud Koch, "The Aesthetic Transformation of the Image of the Unimaginable: Notes on Claude Lanzmann's *Shoah*" (1986), tr. Jamie Owen Daniel and Miriam Hansen, *October* 48 (Spring 1989): 15–24. Also, see Koch, *Die Einstellung ist die Einstellung: Visuelle Konstruktionen des Judentums* (Frankfurt a.M.: Suhrkamp, 1992), especially part 2: "Film und Faktizität: Zur filmischen Repräsentation der Judenvernichtung."

25. Lanzmann, "Holocauste, la représentation impossible," 7. Lanzmann makes the same argument in his critique of the TV miniseries, *Holocaust,* "From the Holocaust to the *Holocaust,*" tr. Simon Srebrny, *Telos* 42 (Winter 1979–80): 137–43.

26. Shoshana Felman, "The Return of the Voice: Claude Lanzmann's *Shoah,*" in Felman and Dori Laub, M.D., *Testimony: Crises of Witnessing in Literature, Psychoanalysis, and History* (New York: Routledge, 1992), 204–83.

27. Lanzmann, "Holocauste, la représentation impossible," 7.

28. Theodor W. Adorno, "Cultural Criticism and Society," *Prisms* (German ed., 1955), tr. Samuel and Shierry Weber ([1967] Cambridge: MIT Press, 1988): "Cultural criticism finds itself faced with the final stage of the dialectic of culture and barbarism[:] to write poetry after Auschwitz is barbaric, and this corrodes even the knowledge of why it has become impossible to write poetry today" (one sentence in the original, three in the translation). See also Adorno's revision of this statement in *Negative Dialectics* (1966), tr. E. B. Ashton (New York: Seabury, 1973), 362–63.

29. Gertrud Koch, "Mimesis and *Bilderverbot,*" *Screen* 34.3 (Autumn 1993): 211–22. See also Koch, *Die Einstellung ist die Einstellung,* 16ff., 123ff., and "The Aesthetic Transformation of the Image of the Unimaginable."

30. It is this sense of the aesthetic which Benjamin tries to recover against and in view of the decline and perversion of the institution of art. See Susan Buck-Morss, "Aesthetics and Anaesthetics: Walter Benjamin's Artwork Essay Reconsidered," *October* 62 (Fall 1992): pp. 3–41.

31. James F. Lastra, *Technology and the American Cinema: Perception, Representation, Modernity* (New York: Columbia University Press, 2000). See also Rick Altman, ed., *Sound Theory/Sound Practice* (New York: Routledge, 1992).

32. Cf. Claudia Gorbman, *Unheard Melodies: Narrative Film Music* (Bloomington: Indiana University Press, 1987); Hanns Eisler [and Theodor W. Adorno], *Composing for the Films* (New York: Oxford University Press, 1947).

33. Felman, "Return of the Voice."

34. Reported in Robert Sklar, "Lanzmann's Latest: After '*Shoah*,' Jewish Power," *Forward,* September 30, 1994, 10.

35. Andreas Huyssen, *After the Great Divide: Modernism, Mass Culture, Postmodernism* (Bloomington: Indiana University Press, 1986), 24.

36. Miriam Bratu Hansen, "America, Paris, The Alps: Kracauer (and Benjamin) on Cinema and Modernity," in Leo Charney and Vanessa Schwartz, eds., *Cinema and the Invention of Modern Life* (Berkeley: University of California Press, 1995).

37. Spielberg himself claims that he was neither inspired nor influenced by any fiction film when he was working on *Schindler's List* but only watched innumerable documentaries and sifted through piles of photographs. See Hellmuth Karasek, "Die ganze Wahrheit schwarz auf weiß: Regisseur Steven Spielberg über seinen Film 'Schindlers Liste,'" *Der Spiegel* 8 (1994): 183–86; p. 185. In the same interview, however, he acknowledges having thought of "Rosebud" to capture the enigmatic distance, the lack of clear, intelligible motivation, with which he conceived of the Schindler character. See also Annette Insdorf, in "MMM," 28. Whether or not inspired by Welles, the relative restraint and withholding of interiority in Spielberg's construction of the Schindler character, at least during the film's first half, is in my opinion much preferable to the omniscient, unrestricted access we get to Schindler's feelings and thoughts in Thomas Keneally's novel on which the film is based.

38. "Per una memoria Europea dei crimi Nazisti," International Conference to Commemorate the 50th Anniversary of the 1944 Massacres Around Arezzo, June 22–24, 1994.

39. Alison Landsberg, "Prosthetic Memory: The Logics and Politics of Memory in Modern American Culture," Ph.D. diss., University of Chicago, 1996, especially chap. 4.

40. Andreas Huyssen, *Twilight Memories: Marking Time in a Culture of Amnesia* (New York: Routledge, 1995), especially chaps. 1 and 12. See also Alison Landsberg, "The 'Waning of Historicity'?: A Closer Look at the New Media of Experience," paper delivered at the Society for Cinema Studies annual conference, New York, March 1995. For a brief survey of issues involved in American memorial culture, see Michael Kammen, *Mystic Chords of Memory: The Transformation of Tradition in American Culture* (New York: Knopf, 1991), 3–14.

41. For a recent example, see Saidya Hartman, "Redressing the Pained Body," paper delivered at the Chicago Humanities Institute, February 1995. The term "breach" or "rupture" refers to Dan Diner, ed., *Zivilisationsbruch: Denken nach Auschwitz* (Frankfurt a.M.: Fischer, 1988). The first, quite controversial, attempt to conceptualize the trauma of slavery in terms of the Shoah is Stanley M. Elkins, *Slavery: A Problem in American Institutional and Intellectual Life* (1959; 2nd ed., Chicago: University of Chicago Press, 1968). More recently, see Paul Gilroy, *The Black Atlantic: Modernity and Double Consciousness* (Cambridge, Mass.: Harvard University Press, 1993), 213ff. Laurence Mordekhai Thomas, *Vessels of Evil: American Slavery and the Holocaust* (Philadelphia: Temple University Press, 1993) is a useful starting point but does not really engage with issues of representation and memory.

42. Michael Geyer and Konrad Jarausch, "The Future of the German Past: Transatlantic Reflections for the 1990s," *Central European History* 22 (September–December 1989): 229–59. See also Zygmunt Bauman, *Modernity and the Holocaust* (Ithaca: Cornell University Press, 1989).

43. In the manner of, for instance, Peter Novick, "Holocaust Memory in America," in James E. Young, ed., *The Art of Memory: Holocaust Memorials in History* (Munich: Prestel, 1995), 157–63.

Yosefa Loshitzky

Hybrid Victims:
Second Generation Israelis
Screen the Holocaust

The memory of the Holocaust and its victims has always been a locus of contro-
versy in the Israeli public sphere. As Israeli historian of the Holocaust Yechiam
Weitz observes, it was "accompanied by unending political strife. These debates
were always harsh, bitter, full of tension and emotional. Occasionally, they were
violent and even deadly."[1] The Zionist view of the Holocaust is predicated on the
perception of the State of Israel as the most suitable monument to the memory of
European Jewry, the secular redemption.[2] Indeed, the United Nations' decision in
1947 to divide Palestine into two states, one Arab and one Jewish, was directly
connected to Western guilt regarding the extermination of Europe's Jewish popu-
lation. It was also an attempt to solve the Jewish refugee problem. Ben-Gurion's
statist ideology regarded the Holocaust as the logical culmination of Jewish life in
exile. Consequently, during the 1950s the Holocaust occupied a marginal place in
Israeli public discourse and survivors were subject to alienation, latent repression,
and self-suppression.[3] Zahava Solomon claims that in a fragile Israel after the war,
when survival, economic growth, and military heroism were the priority and weak-
ness was shunned, Holocaust survivors were not encouraged to recount their
experiences, turning them into "immigrants in their own land."[4] A turning point
in Israel's attitude toward the Holocaust occurred as a result of Adolf Eichmann's
trial in 1960. As Haim Gouri observes, "Holocaust survivors were finally given the
chance to speak" and overnight "they became the focus of national attention."
The Eichmann trial, says Gouri, "'historic' in the fullest sense of the term, com-
pelled an entire nation to undergo a process of self-reckoning and overwhelmed it
with a painful search for its identity."[5]

The June 1967 War opened a new phase in the perception of the Shoah,
followed by an ideological polarization that reached its peak with the rise to power
of the right-wing Likud Party in 1977. Since the early 1980s the memory of the
Shoah has been institutionalized and ritualized in Israeli official discourse on the
Holocaust, with a growing awareness of what came to be known as the "second
generation." Organized visits of Israeli and diaspora Jewish youth (known as the

March of the Living) to the death camps in Poland, and the appropriation of the symbols of the Holocaust (such as the yellow Star of David) by racist ultra right-wing movements (*Kach* and *Kahana Hai*) have become a part of Israeli civil religion.[6]

Recently, Israeli public discourse on the Holocaust has shown greater openness toward the more contradictory and disturbing aspects of the Holocaust. The emergence of the Israeli "new historians"[7] and their revisionist reading of the history of the Israeli-Palestinian conflict, the corrosive effect of the Intifada (the Palestinian popular uprising) on the Israeli public, and the start of the peace process with the Palestinians and Israel's Arab neighbors have synthesized the concerns of Israel's artistic, intellectual, and academic communities, encouraging the Israeli public at large to reexamine the space occupied by the Shoah in the grand narrative of Zionism. In an age that has been called "post-Zionist" by some Israeli scholars and intellectuals,[8] it is only natural that the contradictory "lessons" of the Shoah (if one can talk at all about the "lessons" of this catastrophe), such as Israeli attitudes toward the Palestinian "Other," the disturbing charges of collaboration between Zionism and Nazism,[9] as well as the traditionally arrogant and patronizing attitude of Israelis toward the Jewish diaspora, have had to be publicly discussed and debated.

In Israel as in Germany—where most of the discussions on Nazi crimes against the Jews took place in the cultural and aesthetic spheres—art preceded purely political debate. Films such as Orna Ben-Dor's *Because of That War* (1988), as well as the music of Yehuda Poliker, have opened a new space in Israeli public discourse to the formerly suppressed plight of the diaspora survivors and to the effect of their lived experience on their sons and daughters, the "second generation." In a play such as *Arbeit Macht Frei vom Toitland Europa* (Work Frees from the Death-Land of Europe) the Israeli and the survivor's self are disturbingly mirrored in their Palestinian "Other." Moti Lerner's controversial play *Kasztner* was recently adapted into a television drama, *The Kasztner Trial* (1995), by filmmaker Uri Barbash—the director of *Behind the Walls* (1984)—and scandalized the Israeli public even prior to its actual broadcasting due to its revisionist post-Zionist reading of the affair, particularly its demythification of the heroic figure of the Hungarian/Palestinian parachutist Hannah Senesh.[10]

The blossoming of Holocaust memoirs in Israel in the past ten to fifteen years is further evidence of the country's changing culture of memorialization. Dina Porat delineates three stages in the evolution of this culture.[11] In the early years of the state, Israeli society perceived the survivors as an amorphous mass composed of an incomprehensible number of "six million" who were commemorated by state ceremonies. Later, she points out, those "six million" were conceived in terms of communities, which are more defined publics. They were memorialized by schools and by the "Yizkor" books of the destroyed communities. In contrast, the current, third stage of memorialization, is characterized by a personal attitude, and joined by the understanding that "each person has a name" and that each of the six million has his or her own story. The emerging memoir culture of

the survivors is part of the process that places the individual and her or his story at the center. Porat's observation of the personalization of Holocaust Remembrance Day is one example. The gradual change in the attitude of Israeli society to the Shoah and the survivors, as Porat and others have observed, includes also a more complex view of the notions of heroism, survival, and resistance. This view is more receptive to the survivors' voice and the complexities and multiplicities of their experiences. The survivors' voice found its most sensitive response among what came to be known "the second generation."

What Is the Second Generation?

Second-generation "issues" have been detailed in psychological studies, principally in the U.S. and Israel.[12] According to Israeli psychotherapist Dina Wardi, the children born immediately after the Holocaust were not perceived by their survivor parents as separate individuals but "as symbols of everything the parents had lost in the course of their lives."[13] The survivor parent tries to reconstruct feelings of identity through her or his children. "By relating to the children as a kind of offshoot of themselves, the parents satisfy their inner need for identity and identification, but this prevents the children from being able to individuate themselves and to create a unique identity."[14] These children, the memorial candles of the Holocaust, as Wardi calls them, "have been given the lifework of establishing intergenerational continuity." As the successors of the survivors, behind whom there are "ruin and death and infinite emotional emptiness," it is the obligation and privilege of the second generation "to maintain the nation, to re-establish the vanished family and to fill the enormous physical and emotional void left by the Holocaust" in their survivor parents' "surroundings and hearts."[15]

Indeed, one of the more interesting aspects of the second-generation phenomenon is related to the complex ways in which the memory of the Holocaust is transmitted through generational dynamics. The fact that some of the survivors are still alive provides us with a rare opportunity to observe the operation of memory in flux, its transmission from one generation to the next: from the survivors, to the second and third generations, with each generation creating and shaping a different kind of memory, as well as institutionalized forms of memorialization and commemoration. The generational aspect of the memory of the Holocaust becomes even more significant given the abnormality of the family structure in survivor families. As most survivors lost their parents in the Holocaust, their children, the second generation, do not have grandparents. In fact, only the third generation, the children of the second generation, enjoy full generational continuity. They are, so to speak, the first "normal" generation.

If we expand the narrow, psychological definition of who is entitled to inclusion within the category of the second-generation, then we may as well talk

about a second generation "sensibility" that transcends the empirical status of the "real" children of Holocaust survivors and refugees. Thus Steven Spielberg can be understood as a second-generation director, since *Schindler's List,* an anxiety-induced film motivated by fears of disappearance and consequent oblivion and denial, marks a shift in Holocaust generational sensibilities. *Schindler's List* symbolically passes the torch from one generation to the next, reaffirming the role of generational identity in the symbolic memory culture of the Holocaust.[16] A very similar generational sensibility can also be detected in French philosopher Allan Finkielkraut's own confession that he began to reject his status as an "imaginary" Jew; that is, one who avoids "a negation that was difficult to face: the eradication of Diaspora Jewishness as an integral Jewish culture."[17] For Finkielkraut, this was not as a result of political change or the disappointment of Marxism, but when he realized that his Holocaust survivor parents would one day die, and "with them, the knowledge of pre-war Jewish civilization he would never be able to possess."[18] Behind what Finkielkraut regards as the imaginary states of post—World War II Jewish identity is the Holocaust, "the event that, despite its determining status, 'has no heirs.' An absence that haunts the rhetoric of postwar Jewish identity."[19] And indeed, the second generation, which, through intergenerational transmission has inherited the role of guilty survivor, is now beginning to make its voice heard in an attempt to explore if not fill this haunting absence.[20]

Israeli Cinema and the Holocaust

When Finkielkraut discusses "second generation imaginary Jews," he does not forget to remind his readers that his generation is also the generation of May 1968, born at the same time as television. "We grew up with the media age," he stresses, "from tender youth, the world as audiovisual spectacle has been our daily fare. Our coming of age was doubly transfixed, both by the century's grand struggles and by the incessant broadcast of images across the small screen."[21] The centrality of images in second-generation consciousness explains why film has become for many second-generation Israelis the main vehicle through which they articulate their Holocaust postmemory. Postmemory films work against the attempt to standardize and routinize an official monolithic memory of the Holocaust. They privatize memory rather than nationalize it, reflecting the current schism of Israeli society and its conflicts of identities. Israeli postmemory films, thus, constitute an identity formation mechanism.

As both a mirror and complicit participant in the construction and perpetuation of dominant Israeli ideology, Israeli cinema, for many years, ignored the topic of the Holocaust. Although, as Roni Perchak observes,[22] many Israeli filmmakers come from survivors' families, the Holocaust occupied a marginal space in Israeli cinema. Most documentaries on the Holocaust that were produced for

Israeli television were "educational" and designed for use as illustrative material in schools. Except for indirect allusions to Jewish refugees, and three feature films that directly deal with the Holocaust—*HaMartef* (The Cellar, 1963) by Nathan Gros, *Tel Aviv-Berlin* (1986) by Tzipi Trope, and *Me'Ever Layam* (Beyond the Sea)—Israeli cinema has ignored this traumatic event in Jewish history. As Judd Ne'eman points out,[23] Holocaust representations in Israeli cinema appear in two historically separate stages, an early post—World War II stage and a late 1980s stage marked by the production of Ilan Moshenzon's *Wooden Gun* in 1978. What Ne'eman calls the "new wave" Holocaust cinema consists of a small number of films, such as *Tel Aviv-Berlin, Because of That War, The Summer of Aviya* (Eli Cohen, 1988), and *New Land* (Orna Ben-Dor, 1994). The silence of Israeli cinema with regard to the Holocaust can be explained by the association of the Holocaust with diasporic consciousness and the "negation of exile"[24] practiced by Israeli Zionist ideology. An additional explanation might be that because cinema has traditionally been categorized as entertainment, it was not regarded by some as a suitable medium to deal with this topic.

The attitude of Israeli cinema to the Holocaust began to change in the late 1980s. The documentaries *Hugo* (1989) by Yair Lev and *Because of That War* by Orna Ben-Dor, and the feature fiction film *The Summer of Aviya* by Eli Cohen, began to deal with the trauma of the survivors and their children. This tendency has intensified in recent years with new documentaries. In three of them—*Choice and Destiny* (1994) by Tzipi Reibenbach, *Will My Mother Go Back to Berlin?* (1993) by Micha Peled, and *Daddy Come to the Amusement Park* (1994) by Nitza Gonen—the second generation explored and investigated their parents and the memory of the Holocaust through the movie camera. In a fourth documentary, *Don't Touch My Holocaust* (1994), the director Asher Tlalim explored both the process of the production and performance of *Arbeit Macht Frei*, directed by Dudi Maayan and performed by the Acre Theater Group, and the roots and origins of the creators of this performance, as well as his own and Maayan's Moroccan roots.

In Israeli second-generation films the filmmakers focus both the camera and their own gaze toward their survivor parents.[25] Similar to the different manifestations in the contemporary drama and fiction of the second generation, which, as Yael Feldman observes, "share one common feature—a rejection of the collective model of representation that they inherited from their parents and cultural mentors," they seek "a close subjective encounter with the experiences that the ideology of that model of necessity suppressed."[26] Author David Grossman, for example, "emplotting this long journey into the heart of the death camps as an intensely personal odyssey, triggered by a writer's block and traced to the particular pathology of (single) children of survivors has attempted to release the Shoah from the shackles of the collective and reclaim it as a subjective experience." In a similar (post-Zionist?) spirit, second-generation documentary films express rebellion against Israel's nationalization of the Holocaust and its appropriation as collective property. These films attempt to denationalize the Holocaust by retrieving

the private and expressing it as unique and personal. Eventually, however, their attempt to "privatize" memory results in a reconciliatory compromise between the private and the historical, the intimate and the collective. In a style reminiscent of the cinema verité tradition, the movie camera is used in these films as a valuable catalytic agent, a revealer of inner truth, which begins with the return to the private only to find out that the intimate is ultimately the collective. The camera in these films, as Perchak perceptively observes, is the instrument that shapes the family, the speech, the intergenerational encounter, and which finally expands the definition of the second generation by including the spectators in this shared destiny, as well as in their role as witnesses.[27]

Hugo, made in 1989 as a graduation film in the Department of Film and Television at Tel Aviv University, transcended the status of student film and became the first documentary in the new genre of second-generation films to explore survivor parents. Hugo, the name of Lev's father as well as the name of the film, deals with the problematic relationship between father and son—the protagonists of the film. This film made manifest a tendency which was to become typical of the second-generation films that followed it: the creation of a linkage between the crisis in the child-parent relationships and the parents' silence, which is rooted in the horror of the Holocaust. This silence is shattered through the power and mediation of the movie camera. The linkage is most evident in *Choice and Destiny*, which is shaped like a dialogue between the father's speech—created by the movie camera—and the mother's silence which the camera aims to break. The camera focuses for a long time on the empty chair where the mother sits while the father is telling his story and which she leaves from time to time. This empty chair, like the empty chair left by Jan Karski in Claude Lanzmann's *Shoah* (1985), becomes a metaphor of silence, a visual articulation of the impossibility of verbal articulation. The camera, which constitutes the speech and the images, ultimately breaks the mother's silence toward the end of the film.

The presence of the camera in these films thus becomes an active presence that shapes the events and the protagonists' behavior. This has been most powerfully expressed in Gonen's film *Daddy Come to the Amusement Park*, which documents the actor Shmuel Vilojni, and his sister's and father's trip to Poland, his father's birthplace, and to the extermination camp where his grandfather (whose name the actor Vilojni, known as "the memorial candle," bears) was murdered. The documentation of the visit is juxtaposed with clips of Vilojni performing stand-up comedy before a Tel Aviv audience, in which he satirizes his trip to Poland and his Jewish/Polish background. The fact that Vilojni is an actor was fully exploited in the film in a self-reflexive fashion. The camera continuously activated the actor, and encouraged him to externalize his moods, from his silliest moments (like making fun of a Polish soldier and marching along with him in a grotesque manner) to the more dramatic scenes such as his emotional outbreak in Auschwitz, which was joined by his admission that he does not know who is indeed crying—he himself, or the actor within him. Vilojni's trip to Poland is consciously presented

in this film as a roots journey, aimed not only at exploring the origins of his Jewish Polish family and its journey to death, but also at getting to know his father and himself better. At the end of the journey the father confesses to his children that he has discovered that he has "two wonderful children," and the son confesses to finding a new father and a new "self." Old family tensions, in particular between the son and the father, end in a family reconciliation. The journey to Poland, the land of the murdered Jews thus, becomes in Gonen's/Vilojni's film, an Oedipal journey that assumes healing therapeutic qualities. Gonen's, Riebenbach's, Lev's, and Peled's films, express, as Perchack observes, an attempt to escape from the superficial effect of collective memory, and to return to the private, personal experience, through the witnessing of its singular and unique existence.[28] Yet the personal experience brings memory back into the all-engulfing bosom of the collective, leading toward a renewed recognition that what was experienced as private memory is ultimately shaped and mediated through film, which along with architecture, is the most public art.

The recent tendency in Israel to privatize and ethnicize the memory of the Holocaust is most evident in the wave of documentaries on the Holocaust made by Israeli second-generation filmmakers in the late 1980s and early 1990s, particularly in Orna Ben-Dor's *Because of That War* (1988), Asher Tlalim's *Don't Touch My Holocaust* (1994), and Tzipi Reibenbach *Choice and Destiny* (1994). Two of these films (*Because of That War* and *Choice and Destiny*) were made by daughters of survivors, while *Don't Touch My Holocaust* was made by an Oriental Israeli. Despite differences in background and country of origin (Ben-Dor was born in Israel, Reibenbach in Poland, and Tlalim in Morocco) the three directors belong to the same age-group and have lived most of their lives in Israel. Hence their films, despite being firmly rooted in their particular familial and ethnic milieus, transcend those differences and together constitute a form of social and cultural document on Israeli society with its multiplicity of views on the Holocaust. Among other themes, the films project and screen Israeli society's struggle with Holocaust memory and, in turn, survivors' and their children's struggle with Israeli society. These films, therefore, both construct and reflect the sociocultural phenomenon of participating in the process of negotiating and contesting Israeli identity. What Marianne Hirsch calls the aesthetics of postmemory, a diasporic aesthetics of temporal and spatial exile that needs simultaneously to rebuild and to mourn, is at the center of these films. The films are constructed by an imagined collectivity of ghosts and shadows, and express loss and ambivalence toward their creators' "home" (both their real Israeli home and their imagined loved/hated diasporic home). These films not only insist on the significance of recovering memory but also on the acknowledgment that the very act of memory pays tribute to their parents' culture, which was destroyed by the Nazis, and further rejected and repressed by Israel's statist and antidiasporic ideology.

Don't Touch My Holocaust assigns another task to the medium of film. It links the discussion of the Holocaust to the Mizrahim and the Palestinians.

Making Oriental Israelis and Palestinians part of the Holocaust "experience" challenges Israeli identity politics that distinguishes between those who experienced themselves, or through their families, the horrors of the Holocaust, and those who remained outside it. The highly charged locus of the film is a cluster of seemingly unrelated and insignificant scenes, in which Tlalim's camera, while freely floating in the streets of Casablanca, lingers on a film board of *Casablanca* the film, and later on a small movie theater in Tangier, where Tlalim was born. In this way Tlalim's camera testifies that cinema is not only the global producer of images, fantasy, and fiction, but also the projection of conflictual identities that on the surface seem disparate and disconnected.

Don't Touch My Holocaust (1994), Asher Tlalim

Asher Tlalim's documentary *Don't Touch My Holocaust* is about the play *Arbeit Macht Frei*, which was performed by the Acre Theatre in Acre Israel for three years (from 1993 to 1996) and traveled in Germany.[29] The film is a mélange of direct presentation of some scenes from the theatrical performance, interviews conducted with the actors, a reenactment of the actors' encounters with people from their past, and a documentation of the group's visit to Germany. The theatrical performance itself was a participatory journey through seven installations and tableaux. Part museum tour, part coach trip, part school play, part confession, part concert recital, part reconstructed ghetto, and part testimonial, and using an intimacy conceivable only in live performance, it led its audience through an overwhelming five-hour experience of total theater.

The performance exploited all the senses and made its audience involuntarily complicit in the disturbing theatrical experience by making it an uncomfortable participant-observer. The actors who made this performance are "total" people who mingle life with art, pushing both to the extremes. Their encounters with the audience affected the performance and were assimilated into each individual show. Political and current events were continuously integrated into the play as well, thus making it more relevant and responsive to Israel's stormy political life. For example, in one of the scenes, an Independence Day dinner, the actor Muni Yosef, who only a few minutes before had been a crazy beggar, plays a typically supermacho Israeli male who boasts about screwing women and hunting "Arabushim" (a deregatory name for Arabs) while silencing his submissive wife. A day after the peace treaty with Jordan was signed, Muni updated his performance, describing how he had just returned from the ceremony after screwing Queen Noor and harrassing Bill's (Bill Clinton) security guards.

The personal journey of Smadar (Madi) Yalon-Maayan (the principal actress and then the wife of playwright Dudi Maayan) into her past as part of the work on the play epitomizes the totality of the performance and its blurring of the

boundaries between life and art, reality and performance. Her self-training for this role involved working through her private mourning for her father, a Holocaust survivor who after his liberation from the camps immigrated to Israel (where, according to Madi, "he wasted his life"). In Tlalim's film, Madi speaks about her experiments with self-starvation as a preparation for her role in the play as a Musslman,[30] during which she lost so much weight that she had to be hospitalized. She also tatooed a number on her arm, a significant number which indicated the date of her father's death. In the first scene in the theater space she touches this tattoo, either caressing it or trying to erase it.

The group members worked on the performance for six years. They collected materials for three years and performed the play for another three. *Arbeit Macht Frei* ran for three consecutive years, twice a week in the theater in Acre. Only thirty people were admitted to each performance and tickets had to be reserved a year in advance. At three o'clock in the afternoon the thirty lucky spectators were driven in a luxury bus to the Holocaust museum of Kibbutz Lohamei HaGetaot (literally "The Ghetto Fighters Kibbutz"). Dudi Maayan, the head of the Acre group, said that it was essential for the audience to visit the museum first because the museum functioned as a transitory, preparatory stop for their imminent entrance into the unknown labyrinthic space of the theater, which recalled the sewage system of the Warsaw ghetto.[31]

Madi Yalon-Maayan, in the role of Zelma, a Holocaust survivor, guided the spectators among the "works" *(avodot)*, the word she uses to refer to the museum's exhibits. In a fake and wearily didactic tone, and in a mixed language composed of broken Hebrew, German, Yiddish, and English, she discussed the exhibits and made comments about the genius of the process of extermination, the destruction of trust between people, and the rise of fascism. "It is not a new invention," she says, "we too know a chosen people, Yes? Who can give me a contemporary example of a ghetto?" she asks the audience. "There is no need to be shy, nobody can see us here" she adds. "Soweto," somebody says. "Gaza,"[32] says another. "Very interesting," Zelma says, and comments, "Once in one of the groups I had a child, who said that here, in my heart, I have a ghetto."

Later Zelma takes the spectators to another hall where they can see wood sculptures of Musslmans. "This Musslmanchik," she says (in broken, funny Hebrew), "whose stomach is glued to his back, I would have given a fortune to know where he hides a piece of bread. I'll give millions to know where his scream comes from." Hours later, toward the end of a typically Israeli dinner shared by the actors and the audience as part of the performance, the audience sees the actress Madi Maayan (Zelma in the museum), lying naked in a Musslman-like position on the dinner table and pulling a piece of bread out of her vagina. Then Khaled (the Israeli Palestinian actor Khaled Abu-Ali) takes over the role of the tour guide from Zelma and explains what happened in Treblinka using a wooden model of the camp. "I," he says, "did not know about the Holocaust until four years ago. Only after visiting Yad Vashem did I begin to believe that it really happened. That

people can indeed kill like that. I wish you could see me once guiding [Arab] youth from the surrounding villages, who are not familiar with the Shoah." The text that Khaled is performing is in fact not a fictional one. Khaled indeed became aware of the Holocaust only a few years before joining the cast, when he began leading groups of young people from Arab villages in the Galilee around the museum. One of his guided tours is documented in Tlalim's film. The Arab youth in the tour say to the camera that the Jews suffered less than the Palestinians. They [the Jews] at least were exterminated immediately, while the Palestinians are being slowly tortured.

The film *Don't Touch My Holocaust* begins with twenty minutes in which Tlalim tries to explore the meaning of the memory of the Holocaust for Israelis. He creates in this introduction what he calls "an inventory of the memory of the Holocaust." It is a sort of a retrospective tour de force of the lexicon of the Holocaust as it has been shaped by Israeli collective memory and is composed of the exploration of some key words, such as "Arbeit Macht Frei," that have come to symbolize the Holocaust.[33] Yet, as Tlalim insists, this inventory of institutionalized memory is represented "with love, from within," not in order to criticize and satirize Israeli society but in order to place it before a critical mirror. The film, as Tlalim explains, is structured like a psychoanalytic journey. "It is a journey deep into the soul."[34]

The significance of Tlalim's documentary is that it is not a simple documentation of the theater performance, but a film on memory and identity. As the director himself acknowledges: "all the films that I make are about memory." Tlalim perceives *Don't Touch My Holocaust* as a continuation of his series of six films on the 1973 War. In these films, as he said, he tried to examine the trauma of war. In *Don't Touch My Holocaust* he confronts the question of how Israelis deal with memory, how they remember and how they forget. These questions, as Tlalim explained, were triggered by a personal trauma which he went through during the 1973 War, in part related to the loss of his brother in the war. His film *Missing Picture* (1989) explores the notion of war trauma, and its influence on its victims' daily lives. After Tlalim confronted the 1973 War trauma he felt that the time was ripe for him to touch "the ultimate trauma which overshadows all the static memories of our daily life: the Holocaust."

Tlalim himself has no direct relationship with the Holocaust. He was born in Tangier and raised in Spain. Yet he always felt that the division between children of survivors and nonsurvivors, as well as between Ashkenazim and Mizrahaim, is unjustified and in relation to the third generation is no longer significant. Significantly, the shared diasporic roots of Casablanca-born Dudi Maayan, the playwright, and Tlalim born in Tangier, turned them immediately into close friends.[35] In the film *Don't Touch My Holocaust* the seeming paradox of Maayan and Tlalim, two Oriental Jews, commemorating the extermination of Ashkenazi Jews, is formulated as the question, "What does a Moroccan have to do with the Holocaust?" which introduces Tlalim's documentation of his visit to his hometown

of Tangier. The whole attempt "to penetrate deeper and deeper into memory in order to extract the beginning of it all" led, as Tlalim explains, "in unexpected directions." Tlalim traveled to Morocco to visit and shoot his and Maayan's childhood homes for the film.[36] Additionally, in the section that opens the film, he introduces the story of Muni Yosef, one of the actors, who was born in Iraq and was not familiar at the beginning of the production with the phrase "Arbeit Macht Frei." Yet during the research period some of Muni's repressions disappeared and he recalled that his childhood on Moshav Mazor was spent among survivors who founded the Moshav. Tlalim's film documents his visit to Mazor and his meeting with one of the neighbors, who tells him that she can still see Mengele performing a selection.[37]

The whole film *Don't Touch My Holocaust,* according to Tlalim, "is about looking at ourselves in the mirror. We look in the mirror and see ourselves as we are without putting the blame on the Germans and without adopting a victim's perspective. It is a film without Germans. We look at ourselves and try to see what we really look like. What is behind this film and all the other films that I have made is the belief that we are all ill, we all suffer from dark dreams. We all suffer from some childhood trauma and the only way to face it is to examine it. To look at ourselves and to make fun of ourselves. This is the way in which Madi who plays a survivor is looking at us, cruelly and yet lovingly. This is the way we look at our perversions and disturbances, painfully yet laughingly. I tried in this film to observe Israeli society mercilessly yet affectionately in an effort to understand what we are made of."

The dilemma behind the film, Tlalim said, is how to remember, both personally and collectively. Perhaps, he asserted, it would be better to live in amnesia. But this is impossible because the past always creeps into our life. "I have a problem with institutionalized ways of memorialization but the question is: what is the alternative? I see my children, the third generation, and the ways they are touched by the Holocaust. We need to relate to memory here and now, see ourselves as we live it now and not as it really happened. The film is structured like an internal journey and each spectator is invited to look at his own life. I call it 'The Mirror Way.'"

During *Arbeit Macht Frei'*s trip to Germany, Tlalim, the documentor, himself became an actor in the performance. *Arbeit Macht Frei* was a theater of process: once "I became an actor myself another dimension was added to this complex process. People wanted to see both the theatrical performance and the film, and a kind of dialogue was created between the two." In Germany the group used the Wannsee Villa, the place where the decision to implement the Final Solution was made, as a substitute for the guided tour in the Lohamei HaGetaot Holocaust Museum in Israel. The group was surprised by the salient absence of exhibits in the Wannsee museum that represented the actual catastrophe. They also discovered that the German "second generation" also wants to talk about the Holocaust, more than the Israeli group was willing to listen. One member of the audience

told them his secret anxiety: to find a picture of his father in Nazi uniform in one of the museums. In one of the more cathartic journeys of the theater process, the actors are seen urinating on the site of Hitler's bunker and singing patriotic Israeli songs. While the Israeli Jews succeeded in exorcising some of their anxieties, Khaled, the Palestinian, felt constantly persecuted. According to Tlalim, the reactions to the performance in Germany were mixed. The Jewish audience was upset because the Germans as perpetrators were absent. The young non-Jewish Germans, on the other hand, were enthusiastic, and very interesting relationships developed between some of them and the actors.

One of the problems of Israeli society, according to Tlalim, is that it deals with the Holocaust only on the ceremonial level. This has brought about the trivialization and banalization of the memory of the Holocaust. In addition, assimilation of the Holocaust into modern Israeli society fails to assign a role to Jewish-Palestinian relations. Arabs living in Israel have been excluded from the memory of the Holocaust.[38] This attempt at division is also related to the division between Ashkenazim and Mizrahim, and according to Tlalim, has resulted in a monopolization of the memory of the Holocaust by the children of survivors. This exclusionist attitude damaged the Arabs in particular. The message of Tlalim's film is that "the memory of the Holocaust belongs to us all." It was therefore very important for Tlalim to document through his film a guided tour in Arabic in the Lohamei HaGetaot Museum conducted especially for Arab youth from the surrounding area. "I was shocked," Tlalim said, "by their reactions. Yet it is not them I blame, but the educational system that does not understand that every Israeli citizen has to confront this issue. Only when the system changes will people not make these silly comparisons between Israeli and Nazi soldiers and the Intifada and the Holocaust."[39]

According to historian Amnon Raz-Krakotzkin, the uniqueness of the performance of *Arbeit Macht Frei*, which was "one of the most overwhelming experiences provided by Israeli culture in recent years,"[40] is that it subverts and challenges the established memory of the Holocaust, while acknowledging that the Holocaust is the primary formative factor in the shaping of Jewish-Zionist consciousness. Furthermore, its point of departure is the creation of a sense of responsibility toward this memory. *Arbeit Macht Frei* enables its Israeli spectators to have a different kind of memory, one that is critically shaped against the existing one, and yet which grows out of it. The unique use of the theatrical medium enables the creation of a dialogic relationship between the repressing present and the repressed past, turning the memory of the Holocaust into a basis for a completely different ethics.

Memory in *Arbeit Macht Frei* is "performed" by the characters of Zelma and Khaled who lead the narrative, while constantly changing and transforming in the course of the performance. Zelma, with a middle European accent and "broken" language, represents the victim, the one who came from "there" and whose memory has been absent from the traditional Israeli ideological framework that

refers to the murder but not to the victims. Her "broken" language signifies a cultural positioning and not just the linguistic fact that her Hebrew speech is neither standard nor correct. Her cultural positioning as "marginal" is linked to the way in which her interpretation of the different exhibits in the museum leads into new and provoking insights regarding the Israeli/Palestinian conflict.

Zelma is later replaced by Khaled, who guides the spectators through a model of the Treblinka extermination camp. The identification of the Palestinian actor with the suffering of the Jews challenges the monopoly claimed by Zionism on the memory of the Holocaust and on the particularist Jewish lessons that it draws from it. The inclusion of Khaled in the ritual of remembrance assigns to the ritual a broad meaning, and gives the spectator a new and fresh perspective with which to understand some of the ideological assumptions of Israeli society.

The scene, which develops out of a torture scene in which Khaled is dancing completely naked on the wooden table based on the Treblinka model, unites Khaled and Zelma into one image of memory. It is described by Israeli journalist Tzvi Gilat as "the closest thing to a nightmare which I have ever experienced in relation to any work of art."[41] The final scene of the play, located also at the end of Tlalim's film, serves as the ultimate expression of Maayan's and Tlalim's primal protest against exclusionist Holocaust memory.

The scene begins after the audience, along with the actors, have finished a very rich dinner, and enjoyed wine and Baklawa (a sweet Oriental pastry) as refreshments. They have descended one by one through a very narrow door that has been opened in the ceiling of the room where most of the performance takes place, to another space. It is a hybrid space evoking associations of both discotheque and gas chamber. An "Israeli folk dance festival" is projected on huge video screens, with Israeli singer Shoshana Damari who in Israeli public consciousness is known as "the singer of the wars." Surrounding the video screens are various photographs and exhibits related to the Holocaust. At the corner of this space, one of the actresses, completely naked, is obsessively eating the remains of the dinner to the point of vomiting. Madi Maayan, completely naked, is crouching in another corner in a Mussulman posture and Khaled, also naked, is dancing on a wooden table in another corner of the hall. It was only a few hours before on a similar table in the Lohamei HaGetaot Museum that Khaled explained to the audience that Jews were beaten to death every day in Treblinka. Now Khaled is beating himself with a club similar to the one that was used by the Ukrainians to beat the Jews in Treblinka, and invites members of the audience to come to the table and join the beating. Horrifying as it is, there are people (both in Israel and in Germany) who accept his "invitation" and beat him. Others use the bottle opener which hangs from Khaled's neck in order to open bottles of beer.

The horrific party culminates with a slowly rising high-pitched sound emanating from the loudspeakers and changing respectively from wild drum beats, to Israeli popular songs of the 1950s that celebrate the Zionist project of settling the land; all this while the eyes of Holocaust victims and of Herzl, the founder of

Zionism, stare at the audience from images hanging on the walls. A tough attendant leads the audience to the exit (or entrance?) gate bearing the words "Arbeit Macht Frei," the famous slogan that welcomed the victims to Auschwitz. Khaled is still frantically dancing and beating himself, his naked body flooded with strong beams of blinding light thrown by powerful projectors. On the way to the exit the members of the audience see Khaled, exhausted from the physical and mental effort, collapse and cry cathartically,[42] while Madi Maayan, still naked, hugs and calms him down in a *Pieta*-like posture.

The *Pieta* image leads the spectators to acknowledge the victimhood and self-flagellation of Khaled, the Palestinian, as well as that of Zelma, the survivor, whose repression in Israeli culture derives from his or her epitomizing the ultimate icon of the diasporic Jew, a mythic figure rejected by the ideology of the "negation of exile" which is at the core of Zionism. Thus the memory of the victim, as Raz-Krakotzkin observes, becomes a focus for Jewish identity, which paradoxically enables the opening up of the memory of the Palestinian past. Yet no memory, neither Jewish nor Palestinian, can retrieve the past. The common memory of victimhood, which this last scene so powerfully establishes, creates the conditions for a change of consciousness regarding the boundaries of discourse on and of memory.

The last scene of *Arbeit Macht Frei* also reestablishes a mirror effect, echoed by Tlalim's "mirror way" in *Don't Touch My Holocaust*. To look at one's self in the mirror is also to look at the other. And this act of looking is precisely the junction where the survivor and the Palestinian merge into what I call a "hybrid survivor." However, it is important to remember, as Raz-Krakotzkin reminds us, that the Palestinian actor does not represent an indigenous "Palestinian consciousness" but constitutes part of a play that was written by Jews and deals with Jewish consciousness (despite the dialogism and openness toward the "other" that characterizes this work of theater). Although the actor presents his point of view, its importance is that it shows the consciousness of the Jew from the point of view of the other. The distinction here is not between a "particularistic" versus "universal" memory, but between two patterns of memory that the language of Israeli culture creates. The Palestinian actor points out an essential observation: it is the fate of the Palestinians—more than other nations, excluding the Jews and the Germans, and in a different way, the Poles—that the Holocaust occupies such a significant role in their collective consciousness. And that is because the memory of the Holocaust is "forced" upon them not only to justify Jewish settlement in Palestine, but to explain expulsion of the Palestinians and the negation of their right to freedom and self-determination. This dialectic process, based upon a diasporic consciousness, opens up the possibility of seeing the extermination of the Jews as the point of departure in forging a new attitude toward the continuous oppression of the Palestinians, without reverting to the simplistic and senseless comparison between two kinds of national catastrophes ("holocausts") made by the Arab youth in Tlalim's film. The rupture in the existing

Jewish consciousness, as Raz-Krakotzkin observes, makes room for a new defini-
tion of Jewish existence in Israel/Palestine. It is a definition that not only acknowl-
edges the Arab existence but assigns to it a "surplus value." It is a definition that
assumes full responsibility by acknowledging the wrongs done to the other and
identifying with the repressed.[43]

As the Israeli critic Michael Handelzaltz claims, the final scene of the play,
in which the naked Khaled is beaten by "volunteers" from the audience (Tlalim's
film shows the beating in Germany), creates a reality of humiliation. The specta-
tor who does not interfere to stop the suffering is as indifferent as the bystanders
in the Holocaust. But had the spectator interfered he would have collaborated in
the activity of the theater. The spectator, thus, is both an innocent and complicit
observer. You (the spectator), Handelzaltz concludes his review, "are both observer
and collaborator, there is no way out."[44]

The Acre theater group left Tel Aviv, the cultural center of Israel, for Acre,
an originally Arab town which today has become an Arab ghetto. Khaled claims
that the theater experience helps him in his personal choice: beyond being an Arab,
an Israeli, and a Palestinian, he has decided to be a human being. And over and over
again he realizes what this means. From time to time people who beat him on the
wooden table call him and ask for forgiveness. Only now, they explain, have they
realized what they have done. "What kind of forgiveness are you asking for?"
Khaled asks them. "You have become Nazis yourselves." "But you gave us a club
and asked to be beaten," they respond. "And if I had given you a knife?" he replies.[45]

The actor Muni Yosef explained that the show gave him relief from his
trauma. The performers collected materials for the show during the Gulf War. He
and Madi experienced severe anxiety and were afraid that that it could be the end
of Israel.[46] Dudi Maayan said that he would like the Holocaust to be perceived as
"another planet," to use Ka-Tzetnik's phrase. Yet, according to Maayan, this planet
should be viewed slightly differently from Ka-Tzetnik's. It is one among many plan-
ets. "This planet," Maayan says, is here, it was a part of our lives and yet life goes
on. Even the prime minister,"[47] Maayan emphasizes, "says that we are no longer a
lonely people *(am levadad yishkon).* This is a revolution in the way Israel perceives
itself, and it is only the beginning of a revolution that we are going through."

One of the scenes of the play is a satire on the institutionalized ceremonies
conducted in Israeli schools to commemorate Holocaust Memorial Day. While the
actors perform making a parody in the form of a mock ceremony, the background
walls of the performance space are filled by video projections. One of them shows
selection, another Israeli folk dances, and on the other two we see kibbutz chil-
dren respond to a question about what they know of the Holocaust, while famous
Israeli television broadcasters report the daily news. "Replace your television with
a mirror," suggests Dudi Maayan in a flier that is distributed to the audience when
they leave the theater. But as Gilat perceptively observes, "all those televisions
are mirrors on which we are screened, and everything is difficult to watch: funny,
saddening, comforting and disturbing at the same time."[48]

Viewing both *Arbeit Macht Frei* and *Don't Touch My Holocaust* is an unsettling, disturbing experience, especially for an Israeli audience.[49] Both these works create a moral dilemma for the ideal imaginary (and imagined) Israeli identity by using pornography, invoking Palestinian victimhood and Israeli racism in conjunction with the Holocaust, and making the audience complicit in the theatrical performance. In this way both the play and the film capture one of the confusing contradictions embedded in Israel's struggle with the memory of the Holocaust. This experience may be too offensive for survivors. Despite the fact that Tlalim claimed that survivors were grateful to him for making this film,[50] my own (though limited) experience is different. At the Twelfth World Congress of Jewish Studies, where I presented a short version of this study, I illustrated my paper with an excerpt from the ending of the film which documents a performance of the *Pieta* scene in Germany. As the audience in my session was composed of survivors and academics (a very common mixture in Holocaust-related conferences that take place in Israel) I warned everybody, and in particular the survivors, that they might find the material offensive and therefore they should feel free to leave. Despite my warning, and despite the fact that I never suggested any comparison between the oppression of the Palestinians and the Holocaust, I was still bitterly attacked by one survivor for the sheer fact that I brought together the Holocaust and the Palestinian issue. The film was also attacked by the survivors in my audience for being pornographic, sensationalist, and scandalous.[51] Although I do not accept the survivors' judgment I can fully understand their point of view. Indeed, after experiencing *Arbeit Macht Frei*, I told everybody how overwhelming this performance was and how important for understanding Israeli identity. Yet, I have always maintained that this performance was suitable for the second generation only. It should be emphasized time and again that both *Arbeit Macht Frei* and *Don't Touch My Holocaust* reflect a second-generation sensibility and are primarily aimed at a second-generation audience. The second-generation sensibility, after all, is based on the desire to fill a void, to imagine what David Grossman in *See Under Love* calls "Eretz Sham" (the country over there) or to repeat Ka-Tzetnik's phrase, "the other planet." Spatially and temporally distant from the historical Holocaust, the second generation has its own Holocaust that, not unlike "Grossman's Holocaust" and consciously so, exists in the realm of the imaginary, which does not strive to explore what really happened "there," but how what happened "there" affects us here and now—how our imagined and fantasized Holocaust has been assimilated into our consciousness.

Distance and Proximity

Second-generation Holocaust films made in Israel have contributed not only to the emergence of the survivors' voice but also to the emergence of the second

generation's voice and their acceptance by themselves as secondary victims (both direct "victims" of their survivor parents, as well as indirect victims of the Holocaust). This acceptance indicates changes in Israeli society, which has shifted from a society that prizes heroism to one that prizes victimhood. Paradoxically and tragically, however, the identification with the Jewish victims increases as the identification with the victims of Israel, the Palestinians, wanes. This contemporary Israeli dialectic of victimhood, perceptively captured by *Arbeit Macht Frei*, recalls the American elevation of the Holocaust into a master moral paradigm that replaces confrontation with America's victims, Native Americans and African Americans, with an "easier" identification with the Jewish Holocaust.[52]

Second-generation Holocaust films counter the attempt to standardize and routinize an official monolithic memory of the Holocaust. They privatize memory rather than nationalize it. These processes are part of the current schism within Israeli society and its conflicts of identity, in which the Holocaust functions as an identity-formation mechanism. Yet the collective spirit of the "Israeli tribe" is stronger than any attempt at individuation. To borrow from the famous slogan of the feminist revolution, in Israel the private is always public. Consequently, the phenomenon of second-generation Israelis going back to Poland (in most cases with their survivor parents) to visit the death camps in order to perform a "secular ritual" of "Holocaust tourism"[53] has become part of Israeli civil religion. Similar journeys in search of lost diasporic identity are practiced by Moroccan second-generation youth who travel to Morocco to find their roots. The close relationships of the two trends is expressed in Tlalim's *Don't Touch My Holocaust*, which explores the complex issues of identity, memory, and ethnicity through the conjunction of the Holocaust with both Jewish and Arab "Orientals."

Israeli second-generation films can also be seen as manifestations of a healing process, in particular with regard to the second generation, but also with regard to the Israeli collective as a whole. This is most evident in *Because of That War*, and even more so in *Don't Touch My Holocaust*, which is dominated by the second-generation voice and completely ignores the survivors' voice. The survivors' voice in this film is transmitted through the sometimes perverse prism of their ventriloquist children whose "Holocaust" remains in the realm of morbid fantasy. In contrast, the realistic style adopted by *Because of That War* gives an equal voice to the survivors and their children. It respects the survivors' memories, but nevertheless shows compassion toward their children, who to a certain extent became their "victims." Indeed, *Because of That War* was the first Israeli documentary that used the children of survivors as protagonists in a Holocaust film and consequently helped to establish the second generation as an identity group. Obviously, the status that Poliker and Gilead enjoy in Israeli youth culture aided identification with them as protagonists. Similarly, Vilojni's status as a popular actor and stand-up comedian helped his home-movie-style roots journey to Poland to receive larger public exposure. *Choice and Destiny*, on the other hand, is mainly

a film about the survivor parents. The survivors' child (Reibenbach) never says anything about herself. She is always in the background playing the role of a very unintrusive interviewer. Yet despite its intimate, familial character, the film transcends the genre of a home-movie and becomes a fascinating documentary on Israeli society and identity.

The play of distance and proximity in these films is also evident in their gender/parenting economy. It is fascinating to examine in these films who speaks and who keeps silent, who is absent and who is present, who is visible and who is invisible as an indication of how removed or enmeshed the film is from the Holocaust. In *Because of That War* Gilead's father is absent. We see him briefly at a family dinner before the mother goes to Poland. We only know that he is also a Holocaust survivor. Poliker's mother, on the other hand, is always present in the frame, although she remains a silent presence. All we know about her is that she is also a survivor from Greece. In *Daddy Come to the Amusement Park* the mother is completely absent. We have no idea who she is and even if she is alive. The whole film concerns the Oedipal axis of father/son, and even the sister is used only to provide emotional support for her father and brother. *Choice and Destiny* is the most interesting film from the point of view of family dynamics. The silent mother erupts toward the end, creating a shift of narrative focus. Of all the major Israeli documentaries, *Don't Touch My Holocaust* is the most "remote" from the Holocaust. In this film Madi's father is the ghost behind it all, occupying the "space" of a structuring absence since there are no other fathers or mothers in the film. Both Tlalim and Maayan were initially attracted to the subject through their first wives, who happened to be daughters of survivors. Both used the Holocaust as a "tool" in their search for their own repressed Oriental identity, and both focused on a phantasmagoric Holocaust based on imagination rather than on testimonies or fact-oriented evidence. *Because of That War* is less remote due to its involvement with both the survivors and their children. Yet the film focuses on the second generation, whose identity is perceived as shaped by their relationships with their survivor parents. In terms of distance from the world of the Holocaust and the survivors, *Choice and Destiny* is the closest. The survivor parents are the unquestionable protagonists of the film and the "curious" camera accords their faces, their silences, and their talk the respect and dignity that they deserve.

By ethnicizing and privatizing the Holocaust second-generation Holocaust documentaries made in Israel during the 1980s and the 1990s express the fragmentation of the Israeli Zionist narrative of the Holocaust into "small narratives" reflecting the struggle over hegemony in Israel's identity politics. Moreover, as most of these films express a leftist perspective, they manifest an attempt to expropriate the discourse on the Holocaust from the Israeli right, which elevated it to the level of myth identified with right wing-style of ultranationalism. These processes of ethnicization, privatization, and expropriation signify that the memory of the Holocaust has become one of the most contested arenas over identity in Israel today.[54]

NOTES

1. Yechiam Weitz, "Political Dimensions of Holocaust Memory in Israel," in Robert Wistrich and David Ohana (eds.), *The Shaping of Israeli Identity: Myth, Memory and Trauma* (London: Frank Cass, 1995), 130.

2. For a further discussion of the memory of the Holocaust in Israel, see James Young, "Israel: Holocaust, Heroism, and National Redemption," in *The Texture of Memory: Holocaust Memorials and Meaning* (New Haven and London: Yale University Press, 1993), 209–18; Saul Friedlander, "Memory of the Shoah in Israel," in James E. Young (ed.), *The Art of Memory: Holocaust Memorials in History* (New York: The Jewish Museum, Prestel, 1994), 149–58; Haim Gouri, "Facing the Glass Booth," in Geoffrey H. Hartman (ed.), *Holocaust Remembrance: The Shapes of Memory* (Oxford, U.K., and Cambridge, Mass.: Blackwell, 1994), 153–60; Yael Zerubavel, "The Death of Memory and the Memory of Death: Masada and the Holocaust as Historical Metaphors," *Representations* 45 (Winter 1994): 72–100; Yael S. Feldman, "Whose Story Is It, Anyway? Ideology and Psychology in the Representation of the Shoah in Israeli Literature," in Saul Friedlander (ed.), *Probing the Limits of Representation: Nazism and the "Final Solution"* (Cambridge, Mass., and London: Harvard University Press, 1992), 223–39; Tom Segev, *The Seventh Million: The Israelis and the Holocaust* (New York: Hill & Wang, 1993); Anita Shapira, the section on "Zionism and the Holocaust," in "Politics and Collective Memory: The Debate over the 'New Historians' in Israel," *History and Memory* 7, no. 1 (Spring—Summer 1995), special issue entitled "Israeli Historiography Revisited," edited by Gulie Ne'eman Arad, pp. 17–23; Haim Bresheeth, "The Great Taboo is Broken: Reflections on the Israeli Reception of *Schindler's List*," in Yosefa Loshitzky (ed.), *Spielberg's Holocaust: Critical Perspectives on Schindler's List* (Bloomington and Indianapolis: Indiana University Press, 1997), 193–212; Robert S. Wistrich, "Israel and the Holocaust Trauma," *Jewish History* 11, no. 2 (Fall 1997); Omer Bartov, "Defining Enemies, Making Victims: Germans, Jews, and the Holocaust," *American Historical Review* 103, no. 3 (June 1998): 771–816. For an analysis of the Israeli case, see pp. 800–808; Moshe Zuckerman, *Shoah in the Sealed Room: The "Holocaust" in the Israeli Press During the Gulf War* (Tel Aviv: Hotzaat HaMehaber, 1993) (in Hebrew); Oz Almog, "The Sabra and the Holocaust" (HaTzabar VeHashoah), in *The Sabra—A Profile* (HaTzabar—Dyokan) (Tel Aviv: Am Oved Publishers, 1998), 137–47 (in Hebrew); Efraim Sicher (ed.), *Breaking Crystal: Writing and Memory after Auschwitz* (Urbana and Chicago: University of Illinois Press, 1998). See in particular Part 2: "The View from Israel," pp. 91–181; Yoel Rappel (ed.), *Memory and Awareness of the Holocaust in Israel* (Tel Aviv: Mod-Publishing House Co., 1998) (in Hebrew). On the relationship between the Holocaust and post-Zionist debates, see *Post-Zionism and the Holocaust: The Role of the Holocaust in the Public Debate on Post-Zionism in Israel (1993–1996)*, a collection of clippings collected and edited and with a foreword by Dan Michman, Bar Ilan University, Faculty of Jewish Studies, The Abraham and Eta Spiegel Family Chair in Holocaust Research, The Institute for Research on Diaspora Jewry in Modern Times, "Research Aids" series no. 8, January 1997 (in Hebrew). For further reading on the attitude of the Yishuv, and in particular Mapai (the historical "mother" of the current Labor Party), see Hava Eshkoli (Vagman), *Elem: Mapai LeNochach HaShoah 1939–1942* (Silence: Mapai Confronting the Holocaust between 1939 and 1942), (Jerusalem: Yad Yitzhak Ben Tzvi, 1994); and Yechiam Weitz, *Mudaut VeHoser Onim: Mapai LeNochach HaShoah 1943–1945* (Awareness and Helplessness: Mapai Confronting the Shoah 1943–1945), (Jerusalem: Yad Yitzhak Ben Tzvi, 1994).

3. In recent years the question has repeatedly arisen whether the survivors could have told their stories immediately after the Holocaust. The prevailing view today, inspired by growing criticism of the reception and absorption of the immigrants (from both Europe and the Arab countries) by the young Israeli State, maintains that the survivors faced indifference and contempt that kept them silent. The attitude toward the survivors has recently become a focus of heated debates in Israel.

4. Zahava Solomon, "From Denial to Recognition: Attitudes to Holocaust Survivors," *Journal of Traumatic Stress* 8, no. 2 (April 1995): 215–28. Solomon claims that the survivors met a conspiracy of silence and an attitude that implicitly and explicitly blamed them for what happened to them and for surviving. In the first twenty years after the war, the psychiatric community failed to connect the emotional distress and physical problems of the Holocaust survivors to their previous experiences of terror and loss. When they did start to treat Holocaust survivors,

therapists found themselves overwhelmed by their patients' suffering, and sometimes resentful of their demand for attention. Tragically, to this very day eight hundred Holocaust survivors who were institutionalized in insane asylums when they immigrated to Israel are still there. Only recently was it discovered that some of them were placed in asylums because they were found socially "unfit." In one publicized case it was clear that there was no psychiatric justification for institutionalization. Due to the intervention of the television crew who interviewed him, the person was released and sent to a regular home for the elderly. Solomon argues that only after the Eichmann trial and the 1967 War was there a marked turnaround in attitudes both generally and in the clinical field. She suggests that the views of mental health professionals have mirrored rather than led those of the general public.

5. Haim Gouri, "Facing the Glass Booth," in Geoffrey H. Hartman (ed.), *Holocaust Remembrance: The Shapes of Memory* (Oxford and Cambridge, Mass.: Blackwell, 1994), 154.

6. On the appropriation of the Holocaust by the right wing, see Laurence J. Silberstein, "Others Within and Others Without: Rethinking Jewish Identity and Culture," in Laurence J. Silberstein and Robert L. Cohn, *The Other in Jewish Thought and History: Constructions of Jewish Culture and Identity* (New York and London: New York University Press, 1994), 1–34. This appropriation reached its tragic climax with the incitement campaign that preceded Yitzhak Rabin's assassination.

7. For a further discussion of this issue see *History and Memory* 7, no. 1 (Spring–Summer 1995). See in particular Anita Shapira's section on "Zionism and the Holocaust" in "Politics and Collective Memory: The Debate over the 'New Historians' in Israel."

8. It is important to emphasize that the trendy term "post-Zionism" was coined by the academic/intellectual community. Most Israelis still see themselves and their State as Zionist. In fact, one could claim that Zionism has never thrived so powerfully as in contemporary Israel with its growing ultranationalism and the Zionization of the formerly anti-Zionist and ultra orthodox community.

9. For a new publication on this issue, which has generated heated debate in Israel, see Daniel Frenkel, *Al Pi Tehom: HaMediniyut HaTziyonit VeShe'elat Yehudei Germanya, 1933–1938* (On the Abyss: Zionist Policy and the Question of the German Jews, 1933–1938) (Jerusalem: Magnes, 1994).

10. Giyora Senesh appealed to the Israeli Supreme Court because of one line spoken in Lerner and Barabash's drama about Kasztner, in which he claims that Hannah Senesh broke under torture and informed the Nazis about the two other parachutists. His appeal was dismissed by the judges. However, the creators of the television drama eventually decided to remove the controversial line from the broadcast version. It is interesting to note at this point that Spielberg replaced "Jerusalem of Gold" with Senesh's "To Caesaria" (known in Israel as "Eli, Eli") in the Israeli version of the film. For a discussion of this replacement and its ideological implications, see Bresheeth, "The Great Taboo is Broken," and Omer Bartov, "Spielberg's Oskar: Hollywood Tries Evil," in Loshitzky, *Spielberg's Holocaust.*

11. Dina Porat, "L'Oolam lo Darki HaAharona," (It Is Never My Last Road) *Ha'aretz* (January 15, 1997), 5. This is a review of Felix Zandman's *Darki MeVichy le Vichy: MeNeourim BaShoah LeBagrut shel Mada VeTa'asiya* (My Way from Vichy to Vichy: From Adolescence in the Holocaust to an Adulthood of Science and Industry), tr. Amos Karmel (Tel Aviv: Keter, 1997).

12. See, among others, Dina Wardi, *Memorial Candles: Children of the Holocaust*, tr. Naomi Goldblum (London and New York: Routledge, 1992); Helen Epstein, *Children of the Holocaust: Conversations with Sons and Daughters of Survivors* (London: Penguin Books, 1988, ca. 1979); Rafael Moses (ed.), *Persistent Shadows of the Holocaust* (International Universities Press, Inc.), (proceedings of the 1988 conference at Hebrew University's Sigmund Freud's Center); Martin S. Bergmann and Milton E. Jucovy (eds.), *Generations of the Holocaust* (New York: Basic Books, 1982) and/or (New York: Columbia University Press, 1990); Yael Danieli, "Families of the Nazi-Holocaust: Some Short- and Long-Term Effects," in C. D. Spielberger and I. G. Sarson (eds), *Stress and Anxiety*, vol. 8, chap. 46 (New York: Wiley & Son, 1982); Howard Cooper, "The 'Second Generation' Syndrome," *Journal of Holocaust Education* 4, no. 2 (Winter 1995): 131–46; Gaby Glassman, "The Holocaust and Its Aftermath: How Have the Survivors Fared During the Last Fifty Years?" *European Judaism* 29, no. 1 (Spring 1996): 52–63. For a very interesting discussion on Israeli female writers and film directors and Holocaust second-generation consciousness, see Ronit Lentin, "Likhbosh MeHadash et Teritoryot HaShtika: Sofrot VeKolnoaniyot Yisraeliyot

KeBanot LeNitzolei Shoah," (To Reconquer the Territories of Silence: Israeli Female Writers and Film Directors as Daughters of Holocaust Survivors), in *Memory and Awareness of the Holocaust in Israel,* 169–95. In her study, which attempts to break what she calls the three territories of silence related to the Holocaust—sociology, gender, and self-reflexive acknowledgment of the researcher in his or her own personal involvement in the object of his (but mainly *her*) research— Lentin argues that the construction of male-dominated Zionist identity not only suppressed, discriminated against, and stigmatized Holocaust survivors but also feminized them.

13. Wardi, *Memorial Candles,* 27.

14. Ibid.

15. Ibid., 35.

16. See Loshitzky, *Spielberg's Holocaust.*

17. David Suchoff, "Introduction," in Alain Finkielkraut, *The Imaginary Jew,* tr. David Suchoff (Lincoln and London: University of Nebraska Press), xvii.

18. Ibid., xvii.

19. Ibid., viii—ix.

20. In this study I do not include the more institutionalized expressions of the second generation that have emerged in the past decade in the form of special organizations, conferences, therapy and support groups, and so on. One of the more interesting (and in my opinion disturbing) phenomena related to the growing institutionalization of the second generation is the creation of forums between second-generation Jews and Germans (mainly the sons and daughters of high-ranking Nazis). Thus, for example, on Sunday, June 2, 1996, at the Royal Geographical Society in London the Second Generation Trust presented a symposium entitled "Opposite Sides of a Shared History." The speakers were Samson Munn, the son of Holocaust survivors, and Kirk Kuhl, son of a high-ranking Nazi. Each year since 1992, as the brochure distributed to the participants revealed, "with others from similar backgrounds, they have been meeting in a group created by the Israeli psychologist, Professor Dan Bar-On. Together, they have reflected on the impact of the Holocaust on their lives, how it has affected them and how their parents' experiences were communicated to them." One of their meetings was documented in a remarkable BBC documentary *Children of the Third Reich* (1993), produced by Katherine Clay. The London meeting was attended by five hundred people. See also Dan Bar-On, *Fear and Hope: Three Generations of the Holocaust* (Cambridge: Mass.: Harvard University Press, 1995) and Dan Bar-On, *Legacy of Silence: Encounters with Children of the Third Reich* (Cambridge, Mass.: Harvard University Press, 1991). See also Bjorn Krondorffer, *Remembrance and Reconciliation: Encounters Between Young Jews and Germans* (New Haven: Yale University Press, 1995).

21. Finkielkraut, *The Imaginary Jew,* 23.

22. Roni Perchak, "HaIntimi Hu HaKolektivi: Al Kolnoa Yisraeli VeNose HaShoah," (The Intimate and the Collective: On Israeli Cinema and the Holocaust) *Dimui* 13A (Summer 1997): 38–41. For an analysis of the Holocaust in Israeli cinema (viewed from a right-wing perspective), see Ilan Avisar, "Personal Fears and National Nightmares: The Holocaust Complex in Israeli Cinema," in *Breaking Crystal,* 137–59.

23. Judd Ne'eman, "The Empty Tomb in the Postmodern Pyramid: Israeli Cinema in the 1980s and 1990s," in Charles Berlin (ed.), *Documenting Israel* (Cambridge, Mass.: Harvard College Library, 1995), 130.

24. The notion of the "negation of exile" is crucial to the conceptualization of Zionism. "Negation of exile," as Amnon Raz-Krakotzkin explains, refers to a mental attitude and ideological position that sees the present Jewish settlement in, and sovereignty over Palestine/Eretz Israel, as the "return" of the Jews to a land considered to be their homeland and described as empty. "Negation of exile" seems, according to him, "to be the 'normalization' of Jewish existence, the fulfillment of and 'solution' to Jewish history, whereas 'exile' is interpreted as an unsatisfactory political reality that concerns only the Jews. According to this point of view, the cultural framework that Zionists wished to 'actualize' was an 'authentic' Jewish culture, one that could not develop under exilic circumstances, and which was also considered to be in direct continuity to the ancient 'pre-exilic' past. This conception also shaped the image of the 'new Jew,' defined in contrast of the rejected 'exilic Jew.' As such, the 'negation of exile' demanded cultural uniformity and the abandonment of the different cultural traditions through which Jewish identity had previously been determined." Amnon Raz-Krakotzkin, "Galut betoch Ribonut: LeBikoret Shlilat HaGalut BaTarbut HaYisraelit" (Exile within Sovereignty: Toward a Critique

of the 'Negation of Exile' in Israeli Culture), *Teoria VeBikoret* (Theory and Criticism) 4 (Autumn 1993): 23–56, and 5 (Autumn 1994): 113–32 (in Hebrew).

25. Alongside the official genre there has developed another unofficial "amateur" second-generation film genre. Many children of survivors document on video their visits to their parents' lost world.

26. Feldman, "Whose Story Is It, Anyway? Ideology and Psychology in the Representation of the Shoah in Israeli Literature," 238.

27. Perchak, "The Intimate and the Collective."

28. Ibid.

29. For other discussions of *Don't Touch My Holocaust*, see Regine-Michal Friedman, "Generation of the Aftermath: The Parodic Mode," *Kolnoa: Studies in Cinema and Television*, Assaph sec. D, no. 1 (1998): 71–82, and Moshe Zimerman, "HaShoah VehaAherut,' o Erko HaMusaf Shel HaSeret Al Tigou li BaShoah," (The Holocaust and "Otherness," Or the Surplus Value of the Film *Don't Touch My Holocaust*), in Nurith Gertz, Orly Lubin, and Judd Ne'eman (eds.), *Fictive Looks—On Israeli Cinema* (Tel Aviv: The Open University of Israel, 1998), 135–59 (in Hebrew). Another film, entitled *Balagan* (1994)—*balagan* is slang for disorder—was made on *Arbeit Macht Frei* by German filmmaker Andres Weiel. Tlalim claimed that the making of this film was based on dishonest and shameful conduct on the part of ZDF, which promised to support his film but instead sent its own director to make a documentary about *Arbeit Macht Frei*. Tlalim felt both cheated and victimized by the German station and the title of his film (among other things) refers to this experience. It is as if he warns the Germans to keep their hands off the Holocaust and his own film.

30. *Musslman* is a German term meaning "Muslim," widely used by concentration camp prisoners to refer to inmates who were on the verge of death from starvation, exhaustion, and despair. A person who had reached the Musslman stage had little, if any, chance for survival and usually died within weeks. The origin of the term is unclear.

31. Tzvi Gilat, "Mesibat HaZva'a," (The Horror Party), 7 *Yamim* (*Yediot Ha'aronot* weekly supplement), (November 4, 1994), 47. Among the testimonies that were collected by the group during their research for documentary materials was one by a woman who hid for two years in the sewage canals of the Warsaw ghetto, where her son was born in the dark. When the city was liberated and she saw the light of sun the baby cried because he wanted to return to the dark. Darkness was familiar to him, light was threatening.

32. In Tlalim's film Madi Maayan discusses visual similarities between Arab Acre and the ghetto, in particular the Warsaw ghetto.

33. All the citations from Tlalim are taken from a lecture that he gave to my class, "Identity Politics in Israeli Cinema" at The Hebrew University on January 8, 1997.

34. Ibid.

35. Tlalim heard through a friend about the performance in Acre and called Dudi Maayan. Madi Maayan answered the phone and when Tlalim introduced himself she said: "I just cannot believe it. We had a meeting yesterday and decided that we wanted someone to film us and you were suggested as the director."

36. Another example of "marriage" between Mizrahim and children of survivors is the novel of Eli Amir, *Ahavat Shaul* (Shaul's Love) (Tel Aviv: Am Oved, 1998), in which the protagonist, Shaul Bar Adon, a pure Sepharadi ("Samech Tet" in Hebrew) falls in love with Haya, a daughter of Holocaust survivors, who under the pressure of her Polish parents marries Gershon, a Sabra pilot. As a result, the sterility of Shaul (who never marries and has no children) assumes a deep symbolic meaning. Gilead Ovadia, a clinical psychotherapist of Oriental Jewish descent, claims that the suffering of the Oriental immigrants was dwarfed compared to the survivors' suffering. Consequently, the Mizrahim suffered from unconscious feelings of guilt toward the survivors with whom they competed for resources during the 1950s, the days of mass immigration from Europe and North Africa. Their attraction to the Right and especially to the figure of Menahem Begin, according to Ovadia, can be explained against this background. Begin symbolized a father figure whose diasporic personality, along with the centrality of the Holocaust in his rhetoric, freed them from their unconscious guilt. At the same time Begin provided for them a non-Sabra, anti-hero role model with whom they could identify. See Gilead Ovadia, "HaKoah ShebaHulsha" (The Strength in Weakness), *Ha'aretz* (Monday, November 3, 1997), 2B.

37. Mengele, she tells Muni, ordered her to leave her little son in the hands of an old woman

who was behind her and since then she has not seen him. The survivor's daughter who joins her mother tells her "second-generation story." After giving birth to her boy she suffered from depression. Her boy was born with a defect in his heart. One day she found out that the boy had disappeared. In fact he was taken for an examination. But the daughter experienced her mother's trauma: the loss of her little boy. After this trauma she was unable for a long time to take care of her little boy and her survivor mother had to take care of both her daughter and grandson.

38. On the ideologically laden terms "Israeli Arabs," "Israeli Palestinians," and the like, see Dani Rabinowitch, "Oriental Fantasy: How the Palestinians Have Become Israeli Arabs," *Theory and Criticism* 4 (Autumn 1993): 141–51 (in Hebrew). For a very interesting article that explores the highly complex relationships between the Arabs (including the Palestinians) and the Holocaust, see Azmi Bishara, "HaAravim VehaShoah: Nituah Beayatiyuta Shel Ot Hibur" (The Arabs and the Holocaust: An Analysis of the Problematics of Conjunction), *Zemanim* 53 (Summer 1995): 54–71 (in Hebrew).

39. Tlalim, lecture.

40. Raz-Krakotzkin, "Exile within Sovereignty," 121–22.

41. Gilat, "The Horror Party," 44.

42. Khaled, the representative of the oppressed, used to stand twice a week in front of the model of Treblinka at the Lohamei HaGetaot Museum and cry over the Holocaust, which is not his people's "holocaust." Three days after experiencing the show, and still unable to digest its disturbing impact, the Israeli journalist Tzvi Gilat called Khaled and asked him what he was crying about. "I always have something to cry about," Khaled said. "And the Holocaust belongs to everybody. Even an Arab who lives here lives under its shadow." In one year, he told Gilat, three of his brothers died as a result of illness. His father died and his people are still suffering. That week, he told Gilat, he caught himself crying over the [Jewish] people who died from a terrorist bomb that exploded on bus number five in Tel Aviv. Gilat, "The Horror Party," 44.

43. Raz-Krakotzkin, "Exile within Sovereignty," 121–22.

44. Michael Handelzaltz, "Tzofim VeMeshatfim Peula," (Observing as Collaborating), *Ha'aretz*, Literary Supplement (April 19, 1991), B2.

45. Nobody from Sakhnin, Khaled's small village in the Galilee, saw the show although it ran for three years. Nobody also knew that Khaled performed naked. Khaled does not know what would have happened had they known about it, but he made his choice. The Lohamei HaGetaot Museum founded a new project to teach the Holocaust to the Arab and Druze population. The director of the museum said that at first the Palestinian students tend to compare the situation of the Palestinians in the occupied territories to that of the Jews in the Holocaust. The project is modeled on a similar program for African American youth organized by the Washington Museum. Recently there has been a growth of interest in the Holocaust in Palestinian circles. Some major Palestinian intellectuals, like Edward Said, Mahmud Darwish, and others, have appealed for the recognition of the Jewish Holocaust and for the withdrawal of analogies made by some Arabs and Palestinians between the Holocaust and the Palestinian "Nakba" (catastrophe), the name adopted by the Palestinians to describe the tragedy of 1948. In return they asked that Israelis recognize the Palestinian "Nakba." In a closed meeting at the Jerusalem Van Leer Institute on November 16, 1998, Said (in response to Adi Ophir's question) appealed for the mutual recognition of the irrecoverable loss of both people.

46. For further reading on this anxiety, see Zuckerman, *Shoah in the Sealed Room*, and Brenda Danet, Yosefa Loshitzky, and Haya Bechar-Israeli, "Masking the Mask: An Israeli Response to the Threat of Chemical Warfare," *Visual Anthropology* 6, no. 3 (1993): 229–70.

47. Maayan refers here to Yitzhak Rabin.

48. Gilat, "The Horror Party," 47.

49. Madi Maayan's pronunciations regarding what she regards as the "arousing" pornographic power of the Holocaust are highly disturbing. Her unsettling confessions were given more salience in the German film *Balagan*, a fact that makes this film even more disturbing and ethically problematic than *Don't Touch My Holocaust*. Similar sets of concerns about the use of pornographic imagery in conjunction with the Holocaust were raised with regard to Ram Katzir's (a grandson of survivors) exhibition, "Within the Line," which opened at the Israel Museum on January 21, 1997, and became the focus of controversy and survivors' protests, as well as to the even more scandalous exhibition of Roi Rosen (also a son of survivors), "Live and

Die Like Eva Braun," which opened at the same museum in December 1997 and provoked a stormy public debate.

50. The survivors in the audience, he told my class, felt that the film expressed something very truthful about themselves. One of the students in my class commented: "I find it hard to see my parents who are 'Auschwitz graduates' in this performance." Tlalim responded: "I saw 'Auschwitz graduates' in the performance," thus implying that his film is meaningful and acceptable for survivors.

51. The reactions to my paper and the same film clip at the May 15–18, 1997 SCS Conference in Ottawa, Canada, were, by contrast, very enthusiastic. Many of the audience were American Jews and some of them second generation and they thanked me after the session. I raise this point to show that response to the film varies, depending on different cultural and generational sensibilities.

52. For a further discussion of the place of the Holocaust in American culture, see James Young, *The Texture of Memory: Holocaust Memorials and Meaning* (New Haven: Yale University Press, 1993). See in particular the chapters on the United States. See also Peter Novick, "Holocaust Memory in America," in James Young (ed.), *The Art of Memory: Holocaust Memorials in History* (New York: Prestel, 1994), 159–65; and Jeffrey Shandler, "Schindler's Discourse: America Discusses the Holocaust and Its Mediation, from NBC's Miniseries to Spielberg's Film," in Loshitzky, *Spielberg's Holocaust.*

53. Jack Kugelmass, "Why We Go to Poland: Holocaust Tourism as Secular Ritual," in Young, *Holocaust Memorials*, 175–84.

54. In the political arena this process is most evident in the mobilization of the Holocaust by the Shas Sepharadi-religious party, particularly during the trial of its leader Aryeh Derei, which was compared in one of the party's propaganda video films to the Eichmann trial.

Artifacts

James E. Young

Daniel Libeskind's Jewish Museum in Berlin: The Uncanny Arts of Memorial Architecture

"[According to Schelling], the uncanny [is] something which ought to have remained hidden but has come to light."

–Sigmund Freud[1]

How does a city "house" the memory of a people no longer at "home" there? How does a city like Berlin invite a people like the Jews back into its official past after having driven them so murderously from it? Such questions may suggest their own, uncanny answers: a "Jewish Museum" in the capital city of a nation that not so long ago voided itself of Jews, making them alien strangers in a land they had considered "home," will not by definition be *heimlich* but must be regarded as *unheimlich*—or, as our translation would have it, uncanny. The dilemma facing the designer of such a museum thus becomes: How then to embody this sense of *unheimlichkeit*, or uncanniness, in a medium like architecture, which has its own long tradition of *heimlichkeit*, or homeliness? Moreover, can the construction of a contemporary architecture remain entirely distinct from, even oblivious to, the history it shelters? Is its spatial existence ever really independent of its contents?

In their initial conception of what they then regarded as a Jewish Museum "extension" to the Berlin Museum, city planners hoped to recognize both the role Jews had once played as co-creators of Berlin's history and culture and that the city was fundamentally haunted by its Jewish absence. At the same time, the very notion of an "autonomous" Jewish Museum struck them as problematic: the museum wanted to show the importance and far-reaching effect of Jewish culture on the city's history, to give it the prominence it deserved. But many also feared dividing German from Jewish history, inadvertently recapitulating the Nazis' own segregation of Jewish culture from German. This would have reimposed a distinct line between the history and cultures of two people—Germans and Jews—whose fates had been inextricably mingled for centuries in Berlin. From the beginning, planners realized that this would be no mere reintroduction of Jewish memory into Berlin's civic landscape but an excavation of memory already there, but long suppressed.

Freud may have described such a phenomenon best: "This uncanny is in reality nothing new or alien, but something which is familiar and old-established in the mind and which has become alienated from it only through the process of repression. . . . The uncanny [is] something which ought to have remained hidden but has come to light" (241). Thus would Berlin's Jewish Museum generate its own sense of a disquieting return, the sudden revelation of a previously buried past. Indeed, if the very idea of the uncanny arises, as Freud suggests, from the transformation of something that once seemed familiar and homely into something strange and "unhomely," then how better to describe the larger plight of Jewish memory in Germany today? Moreover, if "unhomeliness" for Freud was, as Anthony Vidler suggests, "the fundamental propensity of the familiar to turn on its owners, suddenly to become defamiliarized, derealized, as if in a dream," then how better to describe contemporary Germany's relationship with its own Jewish past?[2] At least part of the uncanniness in such a project stems from the sense that at any moment the "familiar alien" will burst forth, even when it never does, thus leaving one always ill-at-ease, even a little frightened with anticipation—hence, the constant, free-floating anxiety that seems to accompany every act of Jewish memorialization in Germany today.

After Anthony Vidler's magnificent reading of the "architectural uncanny," I would also approach what I am calling an "uncanny memorial architecture" as "a metaphor for a fundamentally unlivable modern condition" (x). But rather than looking for uncanny memory per se, or uncanny memorials or architecture, we might (after Vidler) look only for those uncanny qualities in memorial architecture. In fact, what Robin Lydenberg aptly sees in "uncanny narrative" might be applied here to a particular kind of uncanny memorial architecture as well: the stabilizing function of architecture, by which the familiar is made to appear part of a naturally ordered landscape, will be subverted by the antithetical effects of the unfamiliar.[3] It is a memorial architecture that invites us into its seemingly hospitable environs only to estrange itself from us immediately on entering.

By extension, the memorial uncanny might be regarded as that which is necessarily antiredemptive. It is that memory of historical events which never domesticates such events, never makes us at home with them, never brings them into the reassuring house of redemptory meaning. It is to leave such events unredeemable yet still memorable, unjustifiable yet still graspable in their causes and effects.

In designing a museum for such memory, the architect is charged with housing memory that is neither at home with itself nor necessarily housable at all. It is memory redolent with images of the formerly familiar, but which now seems to defamiliarize and estrange the present moment and the site of its former home. Whether found in Shimon Attie's estrangement of contemporary sites with the images of their past, or Renata Stih and Frieder Schnock's reintroduction of anti-Jewish laws into formerly Jewish neighborhoods emptied of Jews by these very

laws, such memory marks the fraught relationship between present-day Germany and its Jewish past.

In the pages that follow, I tell the story of architect Daniel Libeskind's extraordinary response to the nearly paralyzing dilemma Berlin faces in trying to reintegrate its lost Jewish past. Since this story is necessarily part of a larger history of the Jewish Museum in Berlin, I begin with a brief history of this museum's own genesis in prewar Berlin in order to contextualize the museum's place in the mind of Libeskind himself. From here I follow with the city planners' more contemporary conceptualization of the museum, its impossible questions, and then conclude with Libeskind's nearly impossible-to-build architectural response. The aim here will not be merely to explain Libeskind's startling design, but to show how as a process, it articulates the dilemma Germany faces whenever it attempts to formalize the self-inflicted void at its center—the void of its lost and murdered Jews.

I. The Jewish Museum and the Berlin Museum

It was with catastrophic timing that Berlin's first Jewish Museum opened in January 1933, one week before Adolf Hitler was installed as chancellor. Housed in a refurbished series of exhibition halls at the Oranienburger Strasse complex already home to the spectacular synagogue there, as well as to the Jewish community center and library, Berlin's first Jewish Museum opened quite deliberately in the face of the Nazi rise to power with an exhibition of work by artists of the Berlin Secessionists, led by the German Jewish artist Max Liebermann.[4] It is almost as if the museum had hoped to establish the institutional fact of an inextricably linked German Jewish culture, each a permutation of the other, as a kind of challenge to the Nazis' assumption of an essential hostility between German and Jewish cultures.

But even here, the very notion of what constituted a "Jewish Museum" would be a matter of contention for the community itself: Would the museum show art on Jewish religious themes by both Jewish and non-Jewish artists? Or would it show anything by Jewish artists? The question of what constituted "Jewish art" had now been broached. Indeed, from its origins, questions of "Jewishness," "Germanness," and even "Europeanness" in art exhibited by the museum began to undercut the case for something called a "Jewish Museum" in Berlin. So when the museum opened with a show of Max Liebermann's work in 1933, the very idea of a taxonomy of religious communities and their art seemed an affront to the most assimilated of Berlin's Jews. The Jewish art historian and director of the Berlin Library of Arts, Curt Glaser, attacked both the idea of a "Jewish Museum" in Berlin and the presumption that Liebermann's work was, by dint of his Jewish birth only, somehow essentially Jewish—even though there was nothing thematically Jewish in the work itself. Such a show, Glaser wrote at the time, "leads to a split, which

is totally undesirable and from an academic point of view in no way justifiable. Liebermann, for example, is a European. He is a German, a Berlin artist. The fact that he belongs to a Jewish family is totally irrelevant with regards to the form and essence of his art."[5] Thus was an integrationist model for the Jewish Museum in Berlin first proposed and first challenged within days of the museum's official opening.[6]

Despite constant pressure by the Nazis over the next five years, the Jewish Museum went on to mount several more exhibitions of German Jewish artists and their milieu. But with the advent of the Nuremberg laws defining "the Jew" as essentially "un-German," the Nazis suddenly forbade all but Jews to visit the museum, and all but Jewish artists to exhibit there. With this sleight of legislative hand, the Nazis thus transformed the institutional "fact" of an inextricably linked German Jewish culture into a segregated ghetto of art and culture by Jews for Jews. Moreover, as "Jewish art," all that was shown there was officially classified as *entartete*, or decadent. Just as the Nazis would eventually collect Jewish artifacts to exhibit in a planned museum "to the extinct Jewish race," they turned the Jewish Museum in a de jure museum for *entartete Kunst*.

Whether assimilated to Nazi law or not, like the other Jewish institutions in its complex on Oranienburger Strasse and across the Reich, the Jewish Museum was first damaged, then plundered during the pogrom on *Kristallnacht*, November 10, 1938. Its new director, Franz Landsberger, was arrested and sent to Sachsenhausen, before eventually emigrating to England and then the United States. The museum itself was dismantled, and its entire collection of art and artifacts was confiscated by Nazi authorities. Some four hundred paintings from the collection were eventually found in the cellars of the former Ministry for Culture of the Reich on Schlüterstrasse after the war. According to Weinland and Winkler, the entire cache of paintings was seized by the Jewish Relief Organization (JRSO) and handed over to the Bezalel National Museum in Jerusalem, which would later become the Israel Museum.[7]

Meanwhile, Berlin's Märkische Museum, which had been established in 1876 to tell the story of the city's rise from a provincial hub to the capital of a reunified German Reich in 1876, continued to thrive. Like the exhibitions of any official institution, those at the Märkishe Museum reflected the kinds of self-understanding dominant in any given era—from the Weimar period to the Nazi Reich, from postwar Berlin to the communist takeover of the East. But when the Berlin Wall was erected in August 1961, West Berliners suddenly found themselves cut off from the Markische Museum, now located behind the wall in the East. Hoping to preserve the memory of single, unified Berlin as bulwark against its permanent division and unwilling to cede control of the city's "official history" to the party apparatchiks of the East, a citizens committee proposed a Berlin Museum for the western sector, which the Berlin Senate approved and founded in 1962.

Thus founded in direct response to the violent rending of the city by the Berlin Wall in August 1961, the Berlin Museum moved from one improvised home

to another in the western sector of the city. Only in 1969 did it finally find a permanent home under the roof of what had been the *Colliegenhaus*—a baroque administrative building designed and built by Philipp Gerlach for the "Soldier King" Friedrich Wilhelm I in 1735—located on Lindenstrasse in what had once been the center of southern Friedrichstadt. Gutted and nearly destroyed during Allied bombing raids during the war, the *Colliegenhaus* had been carefully restored during the 1960s and would now provide some 2,500 square meters of exhibition space for the new Berlin Museum. The aim of the museum would be to represent and document both the cultural and historical legacies of the city—through an ever-growing collection of art, maps, artifacts, plans, models, and urban designs—all intended to show the long evolution of Berlin from a regional Prussian outpost to capital of the German Reich between 1876 and 1945. But due to a chronic lack of space, a large part of its holdings, including its departments of Theatrical History and Judaica, among others, had been more or less permanently consigned to the museological purgatory of storage and was scattered in depots throughout the city.

Even as the Berlin Museum searched for a permanent home during the 1960s, Heinz Galinski, then-head of West Berlin's Jewish community, publicly declared that the city was also obligated to build a Jewish Museum to replace the one destroyed by the Nazis in 1938. Since all but the main building of the Oranienburger Strasse Synagogue complex had been damaged beyond repair during the war and so was demolished in 1958, the museum could not be rebuilt on its original site. Moreover, because it was located in the eastern sector of the city, it would be as inaccessible to the West as the Märkische Museum. According to social historian Robin Ostow, Galinski told the Berlin *Stadtverwaltung* that he didn't want a mere replication of the ghetto at the higher level of a cultural institution. But rather, he wanted the history of Berlin's Jews to be exhibited in the Berlin Museum as part of the city's own history.[8] Here the laudable, if nearly impossible to execute, "integrationist model" of Jewish and Berlin history once again found its voice.

With this mandate added to its own, the Berlin Museum began to collect materials and artifacts on Jewish history for what they hoped would be an autonomous Jewish department within the Berlin Museum. In 1971, two years after opening in the *Colliegenhaus* on Lindenstrasse, the Berlin Museum mounted its first exhibition devoted to Jewish life in Berlin, a gigantic show entitled "Contribution and Fate: 300 Years of the Jewish Community in Berlin, 1671–1971." Although it focused primarily on famous Jewish Berliners from the 1920s and seemed to embody an intense nostalgia for the *heile Welt* of pre-Nazi Germany, according to Robin Ostow, this exhibit also inspired further public discussion about the need for an autonomous Jewish Museum within the Berlin Museum.

Four years later, in 1975, the Berlin Senate established a Jewish "department" within the Berlin Museum. In consultation with Heinz Galinski, the Senate announced that "close association with the Berlin Museum in the shape of one of its departments protects the Jewish Museum from isolation and conveys an interwoven relationship with the whole [of] Berlin cultural history."[9] At this

point, the "Society for a Jewish Museum" was established with Galinski as its chair, its express mandate to promote the Jewish Museum "as a department of the Berlin Museum." But by this time, Frankfurt had already built an independent Jewish Museum, and a Berlin citizens' group calling itself "Friends of the Jewish Museum" continued to agitate for a separate building for the Jewish Museum in Berlin. And once again, the debate was joined around an irresolvable paradox, articulated in a 1985 op-ed article in *Die Welt:* "Nowhere else was the image of the successful German-Jewish symbiosis regarded with more conviction than in pre-1933 Berlin; yet Berlin was also the chief starting point for the years of terror, 1933 to 1945. The history of Berlin will always be interwoven with the history of the Berlin Jews."[10] The writer of this article concludes that because an autonomous Jewish Museum could never compensate for the terrible loss of Berlin's Jewish community, the "establishment of a Jewish Museum in the Berlin of today is neither meaningful nor necessary" (28). His solution, like the Senate's and Galinski's, would be to locate the remaining Jewish collections in the Berlin Museum proper, to reintegrate them into Berlin's own story of itself.

Between 1982 and 1987, the debate around the Jewish Museum assumed two parallel tracks: one over whether to locate it outside the Berlin Museum, the other over where it would be sited *if* located outside the Berlin Museum. A number of venues were proposed by various groups and opposed by others, including the Moritzplatz and Hollmannstrasse; others, like the Ephraim Palais, became politically and logistically untenable. In 1986, while various sites for the Jewish Museum were still being debated, the Prinz-Albrecht Palais was even suggested to the Society for the Jewish Museum, to which the society responded indignantly: "Should this of all palaces become a symbol of Berlin Judaism? The culture of the murdered in the house of the murderers? No more needs to be said" (30). Indeed, no more was said on locating the Jewish Museum in the former Berlin home of the Nazi Party.

In November of that same year, the Jewish Museum Department of the Berlin Museum was moved temporarily to the Martin Gropius Bau, where it could exhibit a portion of its holdings. The status of its new home was best described by Volker Hassemer, senator for culture, at its opening. "The new display rooms [at the Gropius Bau] are a milestone in the gradual process to reconstruct and extend the Jewish department of the Berlin Museum," he said, before continuing:

> They remain, nonetheless—and this must be stated quite frankly to the public—a temporary solution on the path to the ideal solution desired by us all. That is, a Jewish department as a recognizable component of the Berlin Museum. . . . We must make it quite clear that the creators and the products of this culture were not something "exotic," not something alienated from this city and its cultural life, but that they were and still are a part of its history. . . . In view of this obligation . . . , I am convinced it is both correct and justified not to develop the Jewish department of the Berlin Museum as the core of an independent Jewish Museum in Berlin, but as an independent department within the Berlin Museum.[11]

This view was corroborated by Hanns-Peter Herz, chair of the Society for a Jewish Museum, who also stated plainly, "We do not want a special museum for the Berlin Jews, but a Jewish department within the Berlin Museum." (32).

In 1988, the Senate agreed to approve financing for a "Jewish Museum Department" that would remain administratively under the roof of the Berlin Museum but would have its own, autonomous building. A prestigious international competition was called in December 1988 for a building design that would both "extend" the Berlin Museum and give the "Jewish Museum Department" its own space. But because this was also a time when city planners were extremely sensitive to the destructive divisiveness of the Berlin Wall, which the Berlin Museum had been founded to overcome, they remained wary of any kind of spatial demarcation between the museum and its "Jewish Museum Department"—hence, the unwieldy name with which they hoped to finesse the connection between the two: "Extension of the Berlin Museum with the Jewish Museum Department."

According to planners, the Jewish wing would be both autonomous and integrative, the difficulty being to link a museum of civic history with the altogether uncivil treatment of that city's Jews. The questions such a museum raises are as daunting as they are potentially paralyzing: How to do this in a form that would not suggest reconciliation and continuity? How to reunite Berlin and its Jewish part without suggesting a seamless rapprochement? How to show Jewish history and culture as part of German history without subsuming it altogether? How to show Jewish culture as part of *and* separate from German culture without recirculating all the old canards of "a people apart"?

Rather than skirting these impossible questions, the planners confronted them unflinchingly in an extraordinary conceptual brief for the competition that put such questions at the heart of the design process. According to the text by Rolf Bothe (then director of the Berlin Museum) and Vera Bendt (then director of the Jewish Department of the Berlin Museum), a Jewish Museum in Berlin would have to cover three primary areas of consideration: (1) the Jewish religion, customs, and ritual objects; (2) the history of the Jewish community in Germany, its rise and terrible destruction at the hands of the Nazis; and (3) the lives and works of Jews who left their mark on the face and the history of Berlin over the centuries.[12] But in elaborating these areas, the authors of the conceptual brief also challenged potential designers to acknowledge the terrible void that made this museum necessary. If part of the aim here had been the reinscription of Jewish memory and the memory of the Jews' murder into Berlin's otherwise indifferent civic culture, another part would be to reveal the absence in postwar German culture demanding this reinscription

Most notably, in describing the history of Berlin's Jewish community, the authors made clear that not only were the city's history and Jews' history inseparable from each other, but that nothing (not even this museum) could redeem the expulsion and murder of Berlin's Jews—"a fate whose terrible significance should not be lost through any form of atonement or even through the otherwise effective

healing power of time. *Nothing in Berlin's history ever changed the city more than the persecution, expulsion, and murder of its own Jewish citizens. This change worked inwardly, affecting the very heart of the city.*"[13] In thus suggesting that the murder of Berlin's Jews was the single greatest influence on the shape of this city, the planners also seem to imply that the new Jewish extension of the Berlin Museum may even constitute the hidden center of Berlin's own civic culture, a focal point for Berlin's own historical self-understanding.

II. Daniel Libeskind's Uncanny Design

Guided by this conceptual brief, city planners issued an open invitation to all architects of the Federal Republic of Germany in December 1988. In addition, they invited another twelve architects from outside Germany, among them the American architect Daniel Libeskind, then living in Milan. Born in Lodz in 1946 to the survivors of a Polish Jewish family almost decimated in the Holocaust, Libeskind had long wrestled with many of the brief's questions, finding them nearly insoluble at the architectural level. Trained first as a virtuoso keyboardist who came to the United States with violinist Yitzchak Perlman in 1960 on an American-Israeli Cultural Foundation Fellowship, Libeskind says he gave up music when, in his words, there was no more technique to learn. From there, he turned to architecture and its seemingly inexhaustible reserve of technique. He studied at Cooper Union in New York under the tutelage of John Hejduk and Peter Eisenman, two of the founders and practitioners of "deconstructivist architecture." Thus, in his design for a Jewish Museum in Berlin, Libeskind proposed not so much a solution to the planners' conceptual conundrum as he did its architectural articulation. The series of drawings he submitted to the committee in mid-1989 have come to be regarded as masterpieces of process art as well as architectural design.

Of the 165 designs submitted from around the world for the competition that closed in June 1989, Daniel Libeskind's struck the jury as the most brilliant and complex, possibly as unbuildable. It was awarded first prize and thereby became the first work of Libeskind's ever to be commissioned.[14] Whereas the other finalists had concerned themselves primarily with the technical feat of reconciling this building to its surroundings in a way that met the IBA's criteria, and to establishing a separate but equal parity between the Berlin Museum and its Jewish Museum Department, Libeskind had devoted himself to the spatial enactment of a philosophical problem. As Kurt Forster had once described another design in this vein, this would be "all process rather than product."[15] And as an example of process-architecture, according to Libeskind, this building "is always on the verge of Becoming—no longer suggestive of a final solution."[16] In its series of complex trajectories, irregular linear structures, fragments, and displacements, this building

is also on the verge of unbecoming—a breaking down of architectural assumptions, conventions, and expectations.

Libeskind's drawings for the museum thus look more like the sketches of the museum's ruins, a house whose wings have been scrambled and reshaped by the jolt of genocide. It is a devastated site that would now enshrine its broken forms. In this work, Libeskind asks, If architecture can be representative of historical meaning, can it also represent unmeaning and the search for meaning? The result is an extended building broken in several places. The straight void-line running through the plan violates every space through which it passes, turning otherwise uniform rooms and halls into misshapen anomalies, some too small to hold anything, others so oblique as to estrange anything housed within them. The original design also included inclining walls, at angles too sharp for hanging exhibitions.

From Libeskind's earliest conceptual brief, the essential drama of mutually exclusive aims and irreconcilable means was given full, unapologetic play. For him, it was the impossible questions that mattered most: How to give voice to an absent Jewish culture without presuming to speak for it? How to bridge an open wound without mending it? How to house under a single roof a panoply of essential oppositions and contradictions? (166). He thus allowed his drawings to work through the essential paradoxes at the heart of his project: How to give a void form without filling it in? How to give architectural form to the formless and to challenge the very attempt to house such memory?

Before beginning, Libeskind replaced the very name of the project—"Extension of the Berlin Museum with the Jewish Museum Department"—with his own more poetic rendition, "Between the Lines." "I call it [Between the Lines] because it is a project about two lines of thinking, organization, and relationship," Libeskind says. "One is a straight line, but broken into many fragments; the other is a tortuous line, but continuing indefinitely. These two lines develop architecturally and programmatically through a limited but definite dialogue. They also fall apart, become disengaged, and are seen as separated. In this way, they expose a void that runs through this museum and through architecture, a discontinuous void."[17] Through a twisting and jagged lightning bolt of a building, Libeskind has run a straight-cut void, slicing through it and even extending outside it: an empty, unused space bisecting the entire building. According to Libeskind, "The new extension is conceived as an emblem where the not visible has made itself apparent as a void, an invisible. . . . The idea is very simple: to build the museum around a void that runs through it, a void that is to be experienced by the public."[18] As he makes clear, this void is indeed the building's structural rib, its main axis, a central bearing wall that bears only its own absence.

Indeed, it is not the building itself that constitutes his architecture but the spaces inside the building, the voids and absence embodied by empty spaces: that which is constituted not by the lines of his drawings, but those spaces between the lines. By building voids into the heart of his design, Libeskind thus highlights

the spaces between walls as the primary element of his architecture. The walls themselves are important only insofar as they lend shape to these spaces and define their borders. It is the void "between the lines" that Libeskind seeks to capture here, a void so real, so palpable, and so elemental to Jewish history in Berlin as to be its focal point after the Holocaust—a negative center of gravity around which Jewish memory now assembles.[19]

In fact, as we see from a glance at his earlier series entitled "Micromegas," Libeskind's preoccupation with absences, voids, and silences predates by several years his design for the Jewish Museum. In this series of drawings from 1978, Libeskind attempts to sever the connection between form and function altogether. If until then, architecture had taught that form was function, he hoped to show that form could be much more than merely functional—by being much less. Here he has exploded geometrical shapes into their components, rearranging them in ways to show affinities and dissimilarities between their parts and other shapes.

Unable to disregard the musical compositions of Weber, Schoenberg, and Cage already so deeply embedded in his consciousness, he added a series called "Chamber Works" in 1983, subtitled "Meditations on a Theme from Heraclitus." Music, art, architecture, and history all formed the interstices of these compositions. In these drawings, a complex of lines gives way to empty space, which comes into view as the subject of these drawings, meant only to circumscribe spaces and show spaces as contained by lines. In "Chamber Works," the last in these experimental series, Eisenman finds that Libeskind leaves only traces of the journey of his process behind. Although as traces, these too almost seem to evaporate, so that by the end of this series, there is a gradual collapse of structure back into the elemental line, thin and drawn out, more space than ink, which is almost gone. In his 1988 work "Line of Fire," Libeskind takes this single line, folds and breaks it—and thereby transforms it from not-architecture to the buildable.

As Kurt Forster points out, Libeskind's 1989 design for the Jewish Museum descends not only from "Line of Fire," but from a myriad of sources poetic, artistic, musical, and architectural,[20] from Paul Klee's enigmatic sketches of Berlin as site of "Destruction and Hope" to Jakob G. Tscernikow's studies of multiple fold and intercalated shapes in his *Foundations of Modern Architecture* (1930), to Paul Celan's "Gesprach im Gerbirg" (1959). In its compressed and zigzagging folds, as Forster shows, Libeskind's design echoes both exercises and disruptions of architecture and art from before the war. Forster thus highlights the striking parallels between Paul Klee's post–World War I sketches of Berlin as a site of "Destruction and Hope" and Libeskind's own idiosyncratic site-location map of Berlin.

Before designing the physical building itself, Libeskind began by situating the museum in what might be called his own metaphysical map of Berlin, constituted not so much by urban topography as it was by the former residences of its composers, writers, and poets—that is, the cultural matrix of their lives in Berlin. In Libeskind's words, "great figures in the drama of Berlin who have acted as bearers of a great hope and anguish are traced into the lineaments of this

museum. . . . Tragic premonition (Kleist), sublimated assimilation (Varnhagen), inadequate ideology (Benjamin), mad science (Hoffmann), displaced understanding (Schleiermacher), inaudible music (Schoenberg), last words (Celan): these constitute the critical dimensions which this work as discourse seeks to transgress."[21] All were transgressors of the received order, and out of these transgressions, culture was born. In Libeskind's view, the only true extension of the culture Berlin's Jews helped to generate would also have to transgress it.

Little of this, it must be said, was readily apparent to jurors on their first encounter with Libeskind's proposal. Indeed, as one juror admitted, this was not a case of "love at first sight." The entire group had to work hard to decipher Libeskind's complex series of multilayered drawings: a daunting maze of lines broken and reconnected, interpenetrations, self-enclosed wedges, superimposed overlaps. But as they did, the difficulty of the project itself began to come into view along with its articulation in Libeskind's brief. On peeling away each layer from the one under it, jurors found that the project's deeper concept came into startling relief. It was almost as if the true dilemma at the heart of their project was not apparent to them until revealed in Libeskind's design. The further they probed, the richer and more complex the design's significance became until only it seemed to embody— in all of its difficulty—the essential challenge of the project itself.

At the same time, there was some concern among jurors that in the face of such a stupendously monumental piece of architecture, one that wears its significance and symbolic import openly and unashamedly, the contents of the museum itself would wither in comparison. As a work of art in its own right, worried the museum's director, Rolf Bothe, "The museum building might seem to make its contents subordinate and insignificant" (166). Indeed, given the early design, which included walls slanted at angles too oblique for mounting and corners too tight for installations, this museum seemed to forbid showing much else beside itself: it would be its own content. Others worried that such a radical design would in the end generate just too much resistance among traditional preservationists and urban planners. Was it wise, they wondered, to choose a design that might not actually get built?

Only the mayor of Kreuzberg, the district of Berlin in which the museum would be built, continued to resist the design. In his words, "a design was expected which would relate to the proportions of the existing building, fit in inconspicuously into the green ribbon and leave space for the mundane needs of the local people for green spaces and playgrounds" (168). For both the mayor and the borough's official architect, Libeskind's provocative vision seemed to be at direct odds with their desire to preserve the green spaces and playgrounds there. This was a pleasant place for the people to come relax and, it seems, to forget their troubles, both present and past. But in the end, even city-architect Franziska Eichstadt-Bohlig agreed that perhaps it was time to "face up to the interpentration of German and Jewish history after having repressed it for 40 years" (168).

Other doubts centered on Libeskind himself. Falkk Jaeger, an architectural

critic and guest of the commission who sat in on the deliberations, reminded the jurors that to this point, Libeskind had never actually built anything, even though he had won several prestigious design competitions. In Jaeger's eyes, Libeskind was not so much a practicing architect as he was an architectural philosopher and poet. His buildings, according to Jaeger, were extremely complex structures consisting equally of "beams, axes, fragments, imagination and fantasies, which can usually never be built" (168). At the same time, Jaeger continued, "this building-sculpture, which seems to lie beside the existing building like a petrified flash of lightning, cannot be called deconstructivist." That is to say, it was eminently buildable, even as it would retain signs of fragments and voids. It is a working through, a form of mourning that reaches its climax "in the experience of a melancholy which has been made material." In this way, the critic believes this to be a *Gesamtkunstwerk* (complete artwork) that need not fulfill any other function to justify its existence. Whatever is finally housed here, no matter what it is, Jaeger concludes, will thus never be conventional, never boring.

III. Inside the Museum: Voids and Broken Narrative

After accepting Libeskind's museum design in the summer of 1989, the Berlin Senate allotted some 87 million DM (nearly $50 million) for its construction. In 1990, Libeskind submitted a cost analysis for his design (170 million DM) that nearly doubled the government's allotted budget. But even his revised budget of 115 million DM was deemed politically unthinkable at a time when the breaching of the Berlin Wall had forced all to begin focusing on the looming, unimaginable costs of reunification. All government building plans were put on hold as Berlin and Germany came to grips with a shocking new political topography—no dividing wall between East and West, but a country divided nevertheless between the prosperous and the desperate.

In fact, on July 4, 1991, the government summarily announced that planning for the Jewish Museum was being suspended altogether, only to have it reinstated by the Berlin Senate in September. Despite continuing calls for the museum's suspension, the Berlin Senate voted unanimously in October to build the museum, however altered it might be by the new realities on the ground—both economic and topographical. It is significant, perhaps, that in the minds of civic leaders, Berlin's reunification could not proceed until the city had begun to be reunited with its missing Jewish past.

To trim the museum's costs, city planners ordered the angles of its walls to be straightened, among dozens of other changes, which helped keep it within its newly allotted 117 million DM budget. In addition, a hall intended for outside the main building was absorbed into the ground floor, several of the outer "voids" were themselves voided, and the complex plan for the lower floor was vastly sim-

plified so that it would come into line with the main building. At first, the architect resisted those changes that seemed to neutralize the very difficulty of his design, especially those that removed the museum's estranging properties. Later, however, Libeskind offered a different, more philosophical explanation for what would be necessary changes. What was designed while the Berlin Wall was standing would now be built in a newly reunified city. "As soon as Berlin was unified, I straightened all the walls," Libeskind has written. "My enemies told me I was no longer a deconstructivist, that I had chickened out, because I had straightened the walls. But I did it because I felt the project was no longer protected by the kind of schizophrenia developed out of the bilateral nature of the city. . . ."[22] The museum has to stand and open itself in a different way in a united and wall-less city."[23]

In fact, as Bernhard Schneider forcefully reminds us, no one who enters the building will experience it as a zigzag, or as a jagged bolt of lightning. These are only its drawn resemblances as seen from above, and they will have virtually nothing to do with the volumes of space located inside.[24] The building's radical design is barely apparent as one approaches it from the street. Although its untempered zinc plating is startlingly bright in its metallic sheen, when viewed from the entrance of the Berlin Museum on Lindenstrasse, the new building also strikes one as a proportionately modest neighbor to the older baroque façade next door. Indeed, over time, the untempered zinc will weather into the same sky-blue shade as the untempered zinc window frames on the Berlin Museum next door. The echo of materials and hue between these buildings is thus subtle but distinct, the only apparent link between them at first sight.[25]

Moreover, Libeskind's museum is lower and narrower than the Berlin Museum, and its zinc-plated façade seems relatively self-effacing next to the ochre hues of its baroque neighbor. Although outwardly untouched, the stolid baroque façade of the Berlin Museum itself is now recontextualized in its new setting adjacent to the Jewish Museum. For as designed by Libeskind, the connection between the Berlin Museum and Jewish Museum Extension remains subterranean, a remembered nexus that is also no longer visible in the landscape, but buried in memory. The Berlin Museum and Jewish Museum are thus "bound together in depth," as Libeskind says. "The existing building is tied to the extension underground, preserving the contradictory autonomy of both on the surface, while binding the two together in depth. Under-Over-Ground Museum. Like Berlin and its Jews, the common burden—this insupportable, immeasurable, unshareable burden—is outlined in the exchanges between two architectures and forms which are not reciprocal: cannot be exchanged for each other."[26]

"The entrance to the new building is very deep, more than ten meters under the foundations of the Baroque building," Libeskind tells us. "From the entrance, one is faced with three roads: the road leading to the Holocaust tower which . . . has no entrance except from the underground level; the road leading to the garden; and the road leading to the main circulation stair and the void. The

entire plane of the museum is tilted toward the void of the superstructure. The building is as complex as the history of Berlin."[27] As we enter the museum, in fact, the very plane of the ground on which we stand seems to slope slightly. It is an illusion created in part by the diagonal slant of narrow, turret-like windows, cut at 35-degree angles across the ground-line itself. For on the "ground floor," we are actually standing just below ground level, which is literally visible through the window at about eye level. Only the earth line in the half-buried window establishes a stable horizon, a plumb line of dirt. Because the upper-floor windows are similarly angled, our view of Berlin itself is skewed, its skyline broken into disorienting slices of sky and buildings.

The exhibition halls are spacious but so irregular in their shapes, cut through by enclosed voids and concrete trusses, that one never gains a sense of continuous passage. "I have introduced the idea of the void as a physical interference with chronology," Libeskind has said. "It is the one element of continuity throughout the complex form of the building. It is 27 meters high and runs the entire length of the building over 150 meters. It is a straight line whose impenetrability forms the central axis. The void is traversed by bridges which connect the various parts of the museum to each other" (35). In fact, a total of six voids cut through the museum on both horizontal and vertical planes. Of these six voids, the first two are accessible to visitors entering from the sacred and religious exhibition spaces. According to the architect's specifications, nothing is to be mounted on the walls of these first two voids, which may contain only freestanding vitrines or pedestals.

The third and fourth voids cut through the building at angles that traverse several floors, but these are otherwise inaccessible. Occasionally, a window opens into these voids, and they may be viewed from some thirty bridges cutting through them at different angles; but otherwise, they are to remain sealed off and so completely "unusable space" jutting throughout the structure and outside it. The fifth and sixth voids run vertically the height of the building. Of these, the fifth void mirrors the geometry of sixth void, an external space enclosed by a tower: this is the Holocaust void, a negative space created by the Holocaust, an architectural model for absence. This concrete structure itself has no name, Libeskind says, because its subject is not its walls but the space enveloped by them, what is "between the lines." Although connected to the museum by an underground passageway, it appears to rise autonomously outside the walls of the museum and has no doors leading into it from outside. It is lighted only indirectly by natural light that comes through an acutely slanted window up high in the structure, barely visible from inside.

The spaces inside the museum are to be construed as "open narratives," Libeskind says, "which in their architecture seek to provide the museum-goer with new insights into the collection, and in particular, the relation and significance of the Jewish Department to the Museum as a whole."[28] Instead of merely housing the collection, in other words, this building seeks to estrange it from the

viewers' own preconceptions. Such walls and oblique angles, he hopes, will defamiliarize the all-too-familiar ritual objects and historical chronologies, and cause museumgoers to see into these relations between the Jewish and German departments as if for the first time.

The interior of the building is thus interrupted by smaller, individual structures, shells housing the voids running throughout the structure, each painted graphite-black. They completely alter any sense of continuity or narrative flow and suggest instead architectural, spatial, and thematic gaps in the presentation of Jewish history in Berlin. The absence of Berlin's Jews, as embodied by these voids, is meant to haunt any retrospective presentation of their past here. Moreover, curators of both permanent and temporary exhibitions will be reminded not to use these voids as "natural" boundaries or walls in their exhibitions, or as markers within their exhibition narratives. Instead, they are to design exhibitions that integrate these voids into any story being told, so that when mounted, the exhibition narrative is interrupted wherever a void happens to intersect it. The walls of the voids facing the exhibition walls will thus remain untouched, unusable, outside healing and suturing narrative.

Implied in any museum's collection is that what one sees is all there is to see, all that there ever was. By placing architectural "voids" throughout the museum, Libeskind has tried to puncture this museological illusion. What one sees here, he seems to say, is actually only a mask for all that is missing, for the great absence of life that now makes a presentation of these artifacts a necessity. The voids make palpable a sense that much more is missing here than can ever be shown. As Vera Bendt has aptly noted, it was the destruction itself that caused the collection here shown to come into being. Otherwise, these objects would all be part of living, breathing homes—unavailable as museum objects. This is then an aggressively antiredemptory design, built literally around an absence of meaning in history, an absence of the people who would have given meaning to their history.

The only way out of the new building is through the Garden of Exile. "This road of exile and emigration leads to a very special garden which I call the E.T.A. Hoffmann Garden," Libeskind has said. "Hoffmann was the romantic writer of incredible tales, and I dedicated this garden to him because he was a lawyer working in a building adjacent to the site" (33). The Garden of Exile consists of forty-nine concrete columns filled with earth, each 7 meters high, 1.3 × 1.5 meters square, spaced a meter apart. Forty-eight of these columns are filled with earth from Berlin, their number referring to the year of Israel's independence, 1948; the forty-nineth column stands for Berlin and is filled with earth from Jerusalem. They are planted with willow oaks that will spread out over the entire garden of columns into a great, green canopy overhead. While the columns stand at 90-degree angles to the ground plate, the ground plate itself is tilted in two different angles, so that one stumbles about as if in the dark, at sea without sealegs. We are sheltered in exile, on the one hand, but still somehow thrown off balance by it and disoriented at the same time.

IV. Conclusion

At one point, before eventually rejecting it, Freud cites Jentsch's contention that "the central factor in the production of the feeling of uncanniness [is] intellectual uncertainty; so that the uncanny would always, as it were, be something one does not know one's way about in. The better oriented in his environment a person is, the less readily will he get the impression of something uncanny in regard to the objects and events in it."[29] If we allow our sense of uncanniness to include this sense of uncertainty after all, we might then ask how a building accomplishes this disorientation. In Libeskind's case, he has simply built into it any number of voided spaces, so that visitors are never where they think they are. Neither are these voids wholly didactic. They are not meant to instruct, per se, but to throw previously received instruction into question. Their aim is not to reassure or console but to haunt visitors with the unpleasant—uncanny—sensation of calling into consciousness that which has been previously—even happily—repressed. The voids are reminders of the abyss into which this culture once sank and from which it never really emerges.

If modern architecture has embodied the attempt to erase the traces of history from its forms, postmodern architecture like Libeskind's would make the traces of history its infrastructure, the voids of lost civilizations literally part of the building's foundation, now haunted by history, even emblematic of it. The architecture of what Libeskind calls "decomposition" derives its power not from a sense of unity but from what Anthony Vidler has called the "intimation of the fragmentary, the morselated, the broken."[30] Rather than suggesting wholeness and mending, salvation or redemption, such forms represent the breach itself, the ongoing need for *tikkun ha'olam* and its impossibility.

As Reinhart Koselleck has brilliantly intimated, even the notion of history as a "singular collective"—that is, an overarching and singularly meaningful History—is a relatively modern concept.[31] Alois M. Muller has elaborated: "Until the 18th century the word had been a plural form in German, comprising the various histories which accounted for all that had happened in the world. History as a singular noun had a loftier intent. In future, not only individual minor historical episodes were to be told. History suddenly acquired the duty to comprehend reality as a continuous whole and to portray the entire history of humankind as a path to freedom and independence. History was no longer to be 'just' the embodiment of many histories. History as a unity sought to make them comprehensible."[32] And as Muller also makes quite clear, this project of historical unification had distinctly redemptive, even salvational aims, the kind of history that its tellers hoped would lead to a "better world."

Libeskind's project, by contrast, promises no such relief. His work is not, as Muller reminds us, intended to serve as a "revelatory monument to the 'good' in history, but to open a shaft for a historical crime perpetrated in the name of

history" (117). By resisting continuous, homogeneous history-housing, Libeskind never allows memory of this time to congeal into singular, salvational meaning. His is partly integrationist and partly disintegrationist architecture. His is a project that allows for the attempt at integration as an ongoing, if impossible project, even as it formalizes disintegration as its architectural motif. Libeskind would deunify such history, atomize it, allow its seams to show, plant doubt in any single version, even his own. All of this suggests an antiredemptory housing of history, one that expresses what Muller has called a systematic doubt, a lack of certainty in any attempt that makes it all process, never result.

From the beginning, this project seemed to be defined as that which would be extremely difficult to complete. Planners initiated a nearly impossible project, selected a nearly unbuildable design, and have now succeeded in building a public edifice that embodies the paralyzing questions of contemporary German culture. The result leaves all questions intact, all doubts and difficulties in place. This museum extension is an architectural interrogation of the culture and civilization that built it, an almost unheard of achievement.

But with its thirty connecting bridges, its 7,000 square meters of permanent exhibition space, 450 square meters of temporary exhibition space, and 4,000 square meters of storage, office, and auditorium spaces, the Jewish Museum will have roughly three times the space of the Berlin Museum next door. Some have suggested that the Berlin Museum be allowed to spill into most of the newly available space, leaving the Jewish Museum department on the bottom floor only; others have suggested that the building in itself be designated the national "memorial to Europe's murdered Jews."[33] In any case, all the attention this design has received, both laudatory and skeptical, will generate a final historical irony. Where the city planners had hoped to return Jewish memory to the house of Berlin history, it now seems certain that Berlin history will have to find its place in the larger haunted house of Jewish memory. The Jewish wing of the Berlin Museum will now be the prism through which the rest of the world will come to know Berlin's own past.

If "estrangement from the world is a moment of art," as Adorno would have it, after Freud, then we might say that the uncanniness of a museum like Libeskind's crystallizes this moment of art.[34] But if the "uncanny is uncanny only because it is secretly all too familiar, which is why it is repressed," as Freud himself would have it, then perhaps no better term describes the condition of a contemporary German culture coming to terms with the self-inflicted void at its center—a terrible void that is at once all too secretly familiar and unrecognizable, a void that at once defines a national identity, even as it threatens to cause such identity to implode.

<div align="center">NOTES</div>

1. Sigmund Freud, "The Uncanny," in *The Standard Edition of the Complete Psychological Works of Sigmund Freud*, tr. James Strachey, vol. XVII (London, 1955), 225, 241.

2. Anthony Vidler, *The Architectural Uncanny: Essays in the Modern Unhomely* (Cambridge, Mass., and London: The MIT Press, 1996), 7.

3. See Robin Lydenberg, "Freud's Uncanny Narratives," *PMLA* 112, no. 5 (October 1997): 1076. Here she also shows how the *unheimlich* (alien and threatening) contains within it its own lexical opposite (*heimlich*—familiar and agreeable). That is, part of uncanny's power to affect us is just its familiarity, which is all the more disturbing when estranged.

4. See Vera Bendt, "Das Jüdische Museum," in *Wegweiser durch das jüdische Berlin: Geschichte und Gegenwart* (Berlin: Nicolai Verlag, 1987), 200–209.

5. Hermann Simon, *Das Berlin Jüdische Museum in der Oranienburger Strasse*, 34. Quoted in Martina Weinland and Kurt Winkler, *Das Jüdische Museum im Stadtmuseum Berlin: Eine Dokumentation*, 10.

6. The issue of what constitutes Jewish art remains as fraught as ever in contemporary discussions of national and ethnic art. Among others, see Joseph Gutmann, "Is There a Jewish Art?" in *The Visual Dimension: Aspects of Jewish Art*, ed. Claire Moore (Boulder, Colo.: Westview Press, 1993), 1–20.

7. Martina Weinland and Kurt Winkler, *Das Jüdische Museum im Stadtmuseum Berlin: Eine Dokumentation*, 10.

8. From an interview Robin Ostow held with Reiner Gunzer, the Museumsreferant who negotiated with Galinski at this time. I am grateful to Robin Ostow for sharing with me her essay, "(Is It) a Jewish Museum: Six Models of Jewish Cultural Integration in Germany," in *Jewish Communities in Postwar Berlin and New York*, ed. Jeffrey Peck and Claus Leggewie (forthcoming), where these details are cited.

9. From *Berlinische Notizen*, nos. 1–2 (1975): 11. As cited in Weinland and Winkler, *Das Jüdische Museum im Stadtmuseum Berlin*, 17.

10. "Palais auf dem Prufstein. Braucht das jüdische Kulturgut Berlins ein Museum?" in *Die Welt*, October 19, 1985. Quoted in Weinland and Winkler, *Das Jüdische Museum im Stadtmuseum Berlin*, 28.

11. *Berlinische Notizen*, no. 4 (1987): 120ff. As cited in Weinland and Winkler, *Das Jüdische Museum im Stadtmuseum Berlin*, 32.

12. See Rolf Bothe and Vera Bendt, "Ein eigenstandiges Jüdisches Museum als Abteilung des Berlin Museums," in *Realisierungswettbewerb: Erweiterung Berlin Museum mit Abteilung Jüdisches Museum* (Berlin: Senatsverwaltung fur Bau- und Wohnungswesen, 1990), 12.

13. *"Nichts in Berlins Geschichte hat die Stadt jemals mehr verandert als die Verfolgung, Verteibung und Ermordung ihrer judischen Burger—dies war eine Veranderung nach Innen, die ins Herz der Stadt traf,"* from *Realisierung*, 12.

14. Although this was Libeskind's first full commission, it was not his first completed building, which is the Felix Nussbaum Museum in Osnabruck.

15. As cited by Anthony Vidler, *The Architectural Uncanny*, 135.

16. *Realisierungs Wettbewerb*, 169.

17. Daniel Libeskind, *Between the Lines: Extension to the Berlin Museum with the Jewish Museum* (Amsterdam: Joods Historisch Museum, 1991), 3.

18. Daniel Libeskind, "Between the Lines," in *Daniel Libeskind: Erweiterung des Berlin Museums mit Abteilung Jüdisches Museum*, ed. Kristin Feireiss (Berlin: Ernst & Sohn, 1992), 63.

19. For further insightful reflection on the role these voids play in Berlin generally and in Libeskind's design in particular, see Andreas Huyssen, "The Voids of Berlin," *Critical Inquiry* 24, no. 1 (Fall 1997): 57–81.

20. Kurt Forster, "Monstrum Mirabile et Audax," in *Erweiterung des Berlin Museums mit Abteilung Jüdisches Museum*, ed. Kristin Feireiss (Berlin: Ernst & Sohn, 1992), 19.

21. *Realisierungs Wettbewerb*, 169.

22. Daniel Libeskind, *Radix-Matrix: Architecture and Writings* (Munich and New York: Prestel Verlag, 1997), 113.

23. Daniel Libeskind, "Between the Lines," *Erweiterung des Berlin Museums mit Abteilung Jüdisches Museum*, ed. Kristin Feireiss, 65.

24. Bernhard Schneider, "Daniel Libeskind's Architecture in the Context of Urban Space," in Daniel Libeskind, *Radix-Matrix: Architecture and Writings*, 120.

25. "I got the idea of using Zinc from Schinkel," Libeskind has said. "Before his very early death, he recommended that any young architect in Berlin should use as much zinc as possible. . . .

In Berlin, untreated zinc turns to a beautiful blue-gray. Many of Schinkel's Berlin buildings, particularly at the Kleinglienicke Park, are built of zinc which has been painted white. When you knock them, you can tell that they are just covers. That is very Berlin-like." From Daniel Libeskind, "1995 Raoul Wallenberg Lecture" (Ann Arbor: College of Architecture & Urban Planning, University of Michigan, 1995): 40.

26. *Realisierungs Wettbewerb*, 169.

27. "1995 Raoul Wallenberg Lecture," 34.

28. *Realisierungs Wettbewerb*, 169.

29. Sigmund Freud, "The Uncanny," 221.

30. Anthony Vidler, *The Architectural Uncanny*, 70.

31. See Reinhard Koselleck, *Futures Past: On the Semantics of Historical Time* (Cambridge, Mass., and London: The MIT Press, 1985), 92–93.

32. Alois M. Muller, "Daniel Libeskind's Muses," in Daniel Libeskind, *Radix-Matrix*, 117.

33. See James E. Young, *At Memory's Edge: After-Images of the Holocaust in Contemporary Art and Architecture* (New Haven and London: Yale University Press, 2000), from which this essay is drawn and in which I tell the entire story of Germany's national "Memorial for the Murdered Jews of Europe," including Libeskind's preliminary design. In submitting a design for this memorial, the architect made clear that he did not want his design for a Jewish Museum to be turned into a Holocaust memorial.

34. Theodor Adorno, *Aesthetic Theory*, tr. C. Lenhardt (New York and London: Routledge and Kegan Paul, 1984), 262.

Tamar Katriel

"From Shore to Shore": The Holocaust, Clandestine Immigration, and Israeli Heritage Museums

I. Israeli Heritage Museums: Locating the Clandestine Immigration Story

Documenting the impressive growth of the local heritage industry in Israel since the late 1960s, the preface to an English-language museum guide states that "there is a passion for museums in Israel, a passion for preserving and interpreting the past" (Rosovsky & Ungerleider-Mayerson 1990, 6). My interest here is in the manifestations of this passionate concern with the past—specifically, as it is articulated in the interweaving of Holocaust and Zionist themes in two Israeli clandestine immigration museums. These museums are devoted to the collective memory of the struggle against the British blockade on the shores of Palestine in pre-state years, just before, during, and after World War II (1934–48). The British restriction on Jewish immigration was designed to block the flow of Jewish refugees, who were fleeing Nazi persecution in Europe, and later of Holocaust survivors, who were looking for a new home. The story of the heroic journey and desperate struggle undertaken by dozens of ships filled to overflowing with Jewish refugees, a majority of whom were Holocaust survivors and were led by Jewish underground soldiers and seamen from Palestine, is told in these museums against the background of the Holocaust story. More elaborate versions of the Holocaust story itself are inscribed and enshrined on the Israeli public landscape in the distinctive enclaves of Holocaust museums and memorial sites (notably, Yad Vashem and Beit Lochamei Hagetaot museums).

While clandestine immigration museums are historically grounded in the cataclysmic events of the Holocaust, they nevertheless underscore the centrality of the Land of Israel as a cultural theme. This is a theme they share with the many other museums and sites that sacralize the Zionist project. Clandestine immi-

gration museums thus combine the memory of the destruction of Jewish life in the diaspora with the place-centered and utopian vision encapsulated in the Zionist agenda. This agenda is encapsulated in three main Zionist themes: the ingathering of the Jews through immigration to the Land of Israel (*aliyah*, literally 'ascendance'); place-making, as epitomized in agricultural settlement (*hityashvut*); and security/defense (*bitachon/haganah*), which involves the country's ability to defend itself against external enemies. Taken together, these themes have been constructed as culturally focal collective values expressing attachment and commitment to Israel as a Jewish homeland; as such, they have profoundly shaped the Zionist nation-building enterprise from its early stages of implementation. Currently, these themes continue to be central in terms of the country's hotly contested political agenda and in terms of the cultural conversation surrounding it.

In most Israeli museum settings, the theme of the Holocaust and the theme of Zionist revival are kept apart, symbolically charting disparate Jewish trajectories, the one dealing with the destruction of Jewish life in the diaspora, the other with its renewal in the Land of Israel. Within the context of clandestine immigration museums, however, themes related to the Zionist agenda gain greater complexity through their explicit and implicit association with the theme of the Holocaust. The prospect of immigration to the Land of Israel, its settlement and defense—all become more significant and more poignant given the power of Holocaust memory. And the theme of the Holocaust is colored by the possibility of struggle and survival. This was expressed by one of the guides in the following words: "We must understand that clandestine immigration was not just a matter of rescuing a few Jews, or some humanitarian act of bringing in some Jews. It was the very heart of the struggle against the British" (Atlit, May 3, 1991). The two master-narratives of twentieth-century Jewish life—the narrative of destruction in the Holocaust and of redemption in Zionism—rub against each other in clandestine immigration museums, combining the core themes of victimage and heroism in their own distinctive ways.

The cultural representations constructed and promulgated in the context of heritage museums (as well as other forms of mass dissemination, such as print and electronic media) are important shared symbolic resources for the shaping of contemporary identities. Therefore, it is important to consider the ideological and pedagogical work performed by heritage museums in constructing collective images of the past. In Israel, since the late 1960s, there has been a sharp increase in the number and diversity of heritage museums, and they have clearly emerged as important sites for domestic and, to some extent, international cultural tourism. The dozens of heritage museums that now dot the Israeli landscape maintain close ties with the educational establishment, especially through the Ministries of Education and Culture, and this assures a steady flow of visitors. In fact, about two-thirds of the patronage of heritage museums is comprised of "captive audiences" of schoolchildren and youth for whom the themes encapsulated in the Zionist agenda and in Holocaust memory are reiterated again and again (see Azoulay 1993,

1994; Dominguez 1986, 1990; Golden 1996; Inbar 1999; Katriel 1997 for studies that address the Israeli heritage museum scene).

Elsewhere, I have attended to the ways in which the Zionist project of settling the Land of Israel is represented in pioneer settlement museums (Katriel 1997). In these museums, it is the image of the early settlers or *chalutzim* (pioneers) that is thematized and celebrated. Here, I focus on the use of Holocaust memory to thematize the history of Jewish immigration to the land in another branch of Israeli museums. The particular version of the Israeli immigration story told in these museums combines the theme of the ingathering of the Jews and the theme of armed struggle in its own distinctive way. It is neither the story of diaspora nor strictly the story of the Land of Israel—yet in some ways it is the story of both. It is a story of Jewish survival, of a journey away from catastrophe and toward a land of promise—the story of a movement "from shore to shore."

In what follows I offer a reading of the representational practices—both verbal and visual—that I have observed and recorded in two heritage museums: The Clandestine Immigration and Naval Museum in downtown Haifa (established in 1969 under the auspices of the Ministry of Defense) and the Ma'apilim Atlit Camp (established in 1989 under the auspices of the Council for Historic Preservation, known as *Hamo'atza Leshimur Mivnim V'atarim*). The latter is a site-museum constructed on the grounds of the illegal immigrant detention camp established by the British Mandatory authorities in 1938 in Atlit (some 10 miles south of Haifa). (The fieldwork for this reading was conducted from 1990 to 1992.)

At first glance, the two museums tell essentially similar stories. Both museums see their mission as primarily an educational one, and both narrate the heroic saga of the struggle for Jewish immigration to the Land of Israel during the British Mandate against the background of the Holocaust and its images. Both emphasize the fact that during the 1930s and 1940s, many Jews were attempting to flee Nazi persecution or its aftermath in Europe, and for many of them Palestine was the only feasible destination. The museum in Haifa seems to stress the theme of the struggle against the British, perhaps because of its link with Israeli naval history. Rather than attempting to cover the whole history of the clandestine immigration, the site-museum in Atlit tells a more localized story, focusing on the hardships experienced by the clandestine immigrants in the detention camp itself. The differences in the pedagogical orientations of the two museums can probably be explained by the twenty-year span that separated their establishment, and the changes that have taken place in the museological field. The site-museum in Atlit is constructed around a more overtly pedagogical idiom; it is somewhat more playful and less filled with pathos, emphasizing activities such as simulations and computer games rather than relying mainly on the standard guided tour.

In both museums, the term used for this chapter of the Jews' immigration to Israel is *ha'apala,* referring to a strenuous upward climbing movement. The upward movement implied here denotes a ritualized ascendance in space, and the particular strain associated with this immigration movement relates to the

embattled stance of the defenseless refugees vis-à-vis the British state-based power. These refugees have been given the distinctive name of *ma'apilim* rather than the usual *olim* (a term specifically used for Jewish newcomers of all times who are said to "ascend" to the Land of Israel). The neutral term *mehagrim* (immigrants) is never used in speaking of Jewish newcomers to Israel. The story of *ha'apala* is considered to be a central chapter in Israeli pre-state history because the British blockade of Israeli shores severely restricted the feasibility of the refugees' arrival in Palestine. It is considered a heroic saga despite the fact that most refugee ships were intercepted before they could land, and the majority of Holocaust survivors huddling in them were sent to detention camps in Palestine or Cyprus. It is considered a tragic tale because of the terrible plight of the survivors, who had such a history of suffering behind them and the loss of human life some of the journeys on these rickety ships entailed.

As the story is told in clandestine immigration museums, the Holocaust survivors are not the only protagonists in this tale. It is no less the tale of the underground Jewish organizations whose members—the fighters—took part in the struggle to smuggle ships filled beyond capacity with European refugees past the British blockade. This double-layered narrative of the Holocaust survivors' "homecoming" and the heroics of the clandestine immigration operation provides the core of the museum story. The story of Holocaust survivors is thus refracted through the story of national struggle and the heroic saga of nation-building.

As noted, in the museum in Haifa, the struggle dimension of the survivors' immigration story is amplified by the double representational mission of the museum as a whole: it represents both clandestine immigration and naval history. A direct link is drawn between these two story lines as visitors are told that the first ships of the Israeli navy were the same rickety refugee ships that came into disuse in 1948 once the State of Israel was established and the British blockade ended. In the Atlit camp, the element of struggle associated with the clandestine immigration narrative appears in the story of the dramatic escape attempt organized and perpetrated by the underground military units of the *Palmach* that resulted in the freeing of many refugees who were in the detention camp at the time. The late Prime Minister Rabin was one of the commanders in that escape operation, so that his name has become linked to the site and his picture now adorns the Atlit museum wall. Thus, in both these museums, the pathos of the story of Holocaust survivors who were denied entrance to the Land of Israel comes together with the heroics of the relentless struggle of the small-scale Jewish population of Palestine at the time, presenting a gripping, multifaceted tale of nation-building.

Both clandestine immigration museums specifically celebrate the moment of arrival in the Land of Israel and the struggle to make that moment possible. Indeed, their discourse is dominated by the "homeland" and "haven" metaphors, and it never goes beyond that moment. Even though the survivors are said to have blended into the Jewish population of Palestine, their story is never told in the

celebratory idiom reserved for settler-pioneers. In this, as in other contexts, the story of Jewish salvage and the utopian tale of Zionist pioneering mark mutually exclusive narrative trajectories. The only point of contact between the story of victimage and the story of heroic enterprise can be found in the image of the Jewish underground activists—some of whom were pioneers-turned-fighters, and whose arrival in the Land of Israel (often just a few years earlier) came under the heading of conquest, not survival. Thus, clandestine immigration museums tell little about the refugees' process of settlement and acculturation in the Land of Israel.

The narrative focus on the moment of arrival is spatially reflected in the Haifa museum's location on the shore near the Haifa port, where many immigrant ships landed. The Atlit site-museum is also located just off the shore. The museums' location and layout authenticate the story they tell. In fact, the Clandestine Immigration and Naval Museum is constructed around one refugee ship that was used in the clandestine immigration operation. The ship stands out as an architectural landmark and has become a visual emblem of the museum, even though most of the exhibition area, and the main entrance to the museum, are located in the building below the ship.

The interweaving of the tale of clandestine immigration and of naval history is spatially reflected in the organization of the museum's main floor. The tour usually opens with a short historical introduction about World War II and the Holocaust accompanied by an enlarged map with small electric bulbs marking the European ports of departure for refugee ships. Another favorite display is a model of the famous survivors' ship, the *Exodus*. The next portion of the display takes visitors to the story of naval history, told through an array of material and pictorial display items, including miniature ship models and parts. Some of the stories told about Israeli naval history involve disasters such as ships sunk in battle and the mysterious disappearance of the submarine *Dakar*. While incidents of this kind populate the narratives of naval museums in other countries as well, in this context the theme of disaster and loss resonates with the pathos of the Holocaust narratives that frame the museum display. Visitors then return to the story of clandestine immigration, either by stepping down to a lower level, or by stepping up to the upper level, where they enter the clandestine immigration ship perched on top of the museum's main floor.

The lower-level display area is lined with pictorial exhibits and artifacts used by the clandestine immigrants and items of art and craft they produced in the detention camps; it also includes audiovisual displays that depict the refugees' journey and their stay in the detention camp in Cyprus, where many of them were expelled by the British. Images of life in Cyprus stress the productive social and cultural environment the survivors created with the help of educators and other messengers sent to them by the Zionist agencies in Palestine.

The climb into the ship and the encounter with the pictures and documents lining its walls and, particularly, with the reconstructed refugees' sleeping bunks in the front area constitute the climax of the museum visit. The ship enclosure

and its display provide a backdrop to a highly emotional audiovisual presentation of the ship's history, which is entitled "From Shore to Shore." The story of that particular ship, dramatically told in these authentic surroundings, is designed to enhance visitors' identification with both the plight and the tenacity of the refugees, as well as with the heroic endeavors of those pre-state fighters who came to their rescue. The experience of moving inside the narrow quarters of the ship and of hearing its story in these surroundings is moving. As visitors step back onto the ship's open-air dock, the sense of congestion and containment experienced in the ship is further, retrospectively highlighted.

A similar token reenactment of the survivors' experience is found in the Atlit site-museum, where visitors are taken through reconstructed cabins of the one-time detention camp. The visual display at the Atlit detention camp site is not very imposing in and of itself. The few cabins reconstructed there are a small fraction of the camp as it looked during its operation, as visitors visually experience by inspecting the enlarged photographs that hang along some of the museum walls. These cabins bring to life the detainees' experience of confinement through the foregrounding of images usually associated with the Holocaust: the barbed wire surrounding the detention camp, the reconstructed wooden watchtowers, where British soldiers stood on guard, erected at the corners, the several elongated wooden cabins—all invoke a Holocaust iconography. These historically loaded visual images are reinforced by the shower and disinfection machine displayed in the centrally located cabin, which was the detainees' point of entry into the camp.

Stories accompanying these exhibits dramatize the new arrivals' horror at finding themselves again entrapped in a camp that looked so similar to the Nazi camps they had just left behind. The enlarged photographs on the walls and the audiovisual display about the clandestine immigration period are also infused with Holocaust images, and both interpret and amplify the somewhat sparse exhibits by giving some sense of the historical context of events occurring in both Europe and Palestine at the time. The pictures also indicate the vastness of the detention camp and the magnitude of human suffering it encompassed. Another cabin reconstructs the overcrowded living quarters, using mannequins to display the typical activities of the detainees. This exhibit is used as a trigger for many of the anecdotes told on the site about everyday life in the detention camp. The pictures, exhibits, and stories all help visitors to imagine the terrible physical and psychological state of the Holocaust survivors who found themselves behind barbed wire once again.

Through both verbal and visual means, these museums present a vision of the Land of Israel as a land of promise, a haven for persecuted and homeless Jews. The museums' celebration of the nation's commitment to the ingathering of Jews, and to the struggle for immigration, constructs Zionism as an ongoing project, repeatedly revitalized by new immigration waves. The telling and retelling of the story of clandestine immigration to contemporary audiences thus becomes a narrative site in which *aliyah* as a political goal and cultural project becomes

rearticulated and reaffirmed. The museum story is thus underwritten by a rhetoric of justification for the State of Israel, which is presented as the only viable socio-political framework for the survival of the Jewish people.

While the clandestine immigration story is mythologized as a unique chapter in Zionist immigration history, it is at the same time discursively incorporated into the larger "ingathering of the Jews" theme and made continuous with other chapters in Jewish history in which Jews were impelled toward the Land of Israel. *Ha'apala* is at once said to be another term for *aliyah* and yet to constitute a very unique instance of it. Its uniqueness stems from the singular sense of urgency and tragedy attending the particular historical background of the Holocaust. Its continuity with Jewish historical experience has to do with the centrality of the Land of Israel in Jewish imagination through the ages.

II. The Rhetoric of Jewish Struggle and Survival

Whereas the museums' locales and visual displays authenticate their story, their narrative speaks not only in a language of facticity but also in an idiom of historical legitimation. Consider the framing remark one hears when sitting in the reconstructed refugee ship in the Clandestine Immigration Museum, watching the museum's central audiovisual display. The commentary is spoken in a pathos-filled voice-over, which comes closest to articulating the museum's standardized narrative line, while the visitors' gaze is fixed on the game of the light-and-shadow that is played on the exhibit of the refugees' sleeping bunkers. It goes as follows:

> These refugees wanted to disengage themselves from the continent where their people was annihilated. The Holocaust proved that they had nothing to look for in the countries of others. Their one and only desire was to reach the Land of Israel. . . . There is no precedent in human history for a people who seeks to sneak into its own homeland. Large ships carrying thousands of refugees began to move along the seas. It was the Jewish people's obstinate desire to return to its homeland.

Several themes emerge from this excerpt and the narrative line it establishes. First of all, the lesson drawn from the Holocaust is the standard, exclusive Zionist interpretation given, that is, the conclusion that the Land of Israel is the only safe place the Jews have in the world. Second, the statement that the Jewish refugees craved to disengage themselves from Europe legitimizes a stance whereby their past can be discarded so that their arrival in the Land of Israel is recast as a new beginning, a miraculous moment of rebirth. Third, the moment of arrival is foregrounded not only in relation to the past but in relation to the future as well. Nothing is said about the survivors' life after their landing or after their release from the British detention camps. Beyond their vague statement about their absorp-

tion in the local scene, the refugees are not narratively incorporated into the story of later struggles to establish the state, be it on the battlefield or in other life scenes. Indeed, the museum offers a highly circumscribed view of the survivors' life trajectory. It is spoken—quite tellingly—as a movement "from shore to shore" rather than as a journey from one land to another, or as a passage from a life before to a life after the moment of survival by immigration.

A fourth theme relates to the implication that the Jews have always craved to come to the Land of Israel. This formulation works to incorporate the clandestine immigration saga into an ongoing cultural theme of yearning for Zion, blurring the radical, secular, and activist nature of the Zionist project, which was discontinuous with the traditional religious stance toward the Jews' return to the Land of Israel. This comes to the fore with particular force when the museum story is told to Orthodox Jewish visitors, who frequent the museum in increasing numbers, as for them the clandestine immigration story is but one chapter in a long chain of Jewish immigrations-pilgrimages to the Land of Israel over the ages.

Finally, this excerpt gives voice to a major tenet of Zionist ideology—the theme of return. Unlike the case of any other immigrants anywhere in the world, the Jews' immigration to the Land of Israel is conceptualized as a "homecoming" rather than as a move from home to a foreign land. The acceptability of this formulation is grounded in the aforementioned, religiously based view of the Land of Israel as a Jewish homeland. In this view, the Jews' historical right to the land transcends historical political realities and international arrangements. Hence, the claim to uniqueness, reiterated again and again, legitimates the tendency to ignore objectionable international arrangements in defiance of the British blockade. The claim to Jewish exceptionalism in this case also helps overlook the history of the plight of Palestinian refugees whose problem was being created just as that of the Jewish refugees was being solved. In the early years of Israeli statehood, many Palestinians who fled from their homes tried to sneak back across the newly established Israeli borders, but they were called infiltrators rather than returnees (Morris 1989).

All in all, the clandestine immigration story told in these museums tends to focus on Jewish-British relations and to ignore Jewish-Palestinian ones. It remains, in a sense, largely a Eurocentric story, with the British said to exacerbate the Nazis' atrocities by heartlessly ignoring the plight of Jewish Holocaust survivors. The Palestinians are only rarely mentioned in passing as having put pressure on the British to curb Jewish immigration to Palestine. In this rendition of the Jewish immigration story, they are not only ignored as the majority of the population in pre-state Palestine but even as relevant enemies. Little historical explanation is given for the blockade, and the Palestinian point of view is never offered. In clandestine immigration museums, the us-against-them theme combines with the theme of the few against the many, the weak but rightful against the strong and wicked—Jewish Holocaust survivors against the mighty British Empire.

As we have seen, the rhetoric of struggle framing the clandestine immigration story underscores the Jewish people's willpower and tenacity, but it is not always clear who the real heroes of the story are. The following excerpt from an interview with a museum guide in Atlit illustrates this point:

GUIDE: It is very important to us to convey the message that clandestine immigration was the *Yishuv's* [pre-state Jewish population] battle against the British regulations and that its purpose was to establish a Jewish state.

INTERVIEWER: The struggle of the immigrants?

GUIDE: The struggle of the *Yishuv.*

INTERVIEWER: That is, you focus more on the *yishuv?*

GUIDE: No, that is, struggle, let's say a decision of the Yishuv, when the so-called fighters are actually the clandestine immigrants, with all the problematic of it. That is, where's the borderline? That is, are the immigrants really fighters in the battlefield? (Haifa, November 4, 1991)

Clearly, the guide finds it difficult to conceptualize the Jewish refugees as fighters. The struggle metaphor seems to fit the *Yishuv* much better than the immigrants themselves. This is commensurate with popular representations of the clandestine immigration effort as resting on the shoulders—both literal and figurative—of the young Israeli underground fighters. Their praises were sung by the popular poet, Nathan Alterman, who dedicated a poem to a non-Jewish captain of one of these clandestine immigration ships and to the Jewish underground fighters, whom he described as literally carrying their people to shore on their shoulders. This well-known poem is part and parcel of mainstream Israeli school lore and is reproduced in full in a prominent place as part of the ship display in the clandestine immigration museum in Haifa. According to this account, the survivor-refugees are presented as powerless and passive, as victims of their circumstances rather than as makers of history. In this poem, the immigrants are "allowed" to be powerless refugees while the underground fighters and ship crew are the ones who are celebrated. In other parts of the display, such as the ship's audiovisual presentation, the refugees are recast in the image of Zionist enthusiasts who were willing to brace the sea and the British in undertaking their journey to the Land of Israel, and are celebrated for what most of them were probably not. All in all, the museum display reproduces an ambivalent tale that supports the dichotomy of passive Holocaust victims versus active Israeli freedom fighters.

Thus, while in most museum encounters the story of Jewish victimage predominates and the refugees are presented as largely passive participants in the clandestine immigration operation, dependent in many ways on the fighters sent out to them by pre-state Jewish organizations in Palestine, here and there one hears comments that contradict this picture. This is important since clandestine immigration museums are major participants in the construction and inscription of the image of Holocaust survivors in Israeli collective memory, and the cultural

conversation surrounding the image of Holocaust survivors touches on fundamental themes and concerns such as the nature and meaning of victimhood, struggle, power, and personal and collective agency. The earlier Israeli view of Holocaust victims as passive "sheep who went to the slaughter" (a phrase still disseminated in schools in the early 1960s when I was a high school student) has come to epitomize the image of Holocaust victims and survivors as too weak and passive to resist Nazi persecution, too hesitant and calculating to leave Europe on time, not strong and daring enough to fight back. This view was also implied by the phrase *Hashoa veHagvura* (The Holocaust and Heroism), which was used in a variety of public and commemorative contexts to denote the destruction of the mass of European Jewry but also to highlight the heroic resistance of the few who did fight back in the ghettos and as partisans.

This view of Holocaust victims was fueled by the Israeli cultural focus on fighters and heroes, on gaining power and control in all circumstances, on cultivating an active orientation toward life events. In a context where the Sabra, the New Jew, the fighter and doer, was held up as a cultural model, the image of the Holocaust survivors as passive victims of brutal persecution drew more condemnation than sympathy. Over the years, probably beginning in the early 1960s in the wake of the Eichmann trial, these cultural images became interrogated and publicly debated. By now, marked changes have taken place in notions of victimhood, in conceptions of courage, and in images of struggle. The Jews' everyday struggle for survival in the ghettos, the camps, the hiding places has come to be recognized as meaningful and daring no less than the open resistance of the ghetto fighters and the partisans. Rather than stressing Jewish passivity during the Holocaust, the Jews' persistent struggles to cope with impossible everyday situations are stressed. The appealing aura of open resistance and fighting is complemented by a recognition of the incredible fortitude and courage required daily for sheer survival during the Holocaust.

This change of attitude has seeped into clandestine immigration museums as well, complicating the original story line of the passive survivor-refugees who were carried to the shore on the shoulders of Jewish underground fighters. In their interpretive activities, the guides also dwell on anecdotes that highlight the survivors' struggle to resist the British efforts to deport them, presenting them as active partners in shaping their own fate. This narrative line is especially elaborated in narrating the story of the famous ship *Exodus*, which is told in such a way as to underscore the survivors' powers of both active and passive resistance: their bare-handed struggle against the British soldiers; their refusal to disembark the ship in the French port where it docked; their rejection of French citizenship in exchange for surrender. In this as in other cases, the stories that emphasize the clandestine immigrants' courage and tenacity seem to be consciously told so as to attenuate the sense of victimage and passivity associated with their Holocaust experience. This was explicitly attested to by one of the guides interviewed at the Atlit site, who expressed his dissatisfaction with the use of the clandestine immigration story

as a narrative site for highlighting the theme of Jewish victimization, passivity, and helplessness. Rather, he stressed the story's far-reaching moral implications as a universal narrative about human efficacy, about people as doers and shapers of their fate:

> I'd say that the most general message I'd like to convey is that people can take their fate in their own hands and do things for themselves. That is, in my opinion, clandestine immigration and all that operation just serves as a model for how people can do things for themselves. . . . There were circumstances, things happened, but they decided for themselves. They faced the dilemma of whether to get on the ship or wait, whether to cross the border or wait in the detention camp. . . . I would like to convey the message of the survivors, not of the ship commanders, or of the organizers of clandestine immigration, but the human story of the immigrants, their heroism, which usually remains blurred, shapeless, let's not get into the reasons for this, because naturally they [the survivors] weren't the ones who wrote the history, they were the pieces of straw that were floating on the water (Atlit, November 4, 1991).

This guide is obviously aware of the cultural conversation in and through which the image of Holocaust survivors has been renegotiated in contemporary Israel. His view is informed by the cultural shift in ways of depicting the Holocaust and the foregrounding of the survivors' own perspective, their own sense of struggle, perhaps to the point of exaggerating the sense of self-efficacy he attributes to their postwar situation. Yet, at the same time, the metaphor he employs in describing Holocaust survivors is a giveaway—it takes him right back to the image of the survivor-refugees as passively moved about in the stream of life, like "the pieces of straw that were floating on the water." The vehemence with which these words were spoken rules out an ironical stance on his part. Inadvertently, this metaphorical phrasing undermines the self-conscious statement that preceded it, giving voice to the profound ambivalence that still attends the Holocaust survivor image in Israeli collective memory and in clandestine immigration museum representations.

III. Concluding Remarks

Clandestine immigration museums provide a version of the Zionist tale that highlights the story of Jewish victimization as an idiom that legitimates the central place accorded to the Land of Israel in Jewish life. At the same time, however, they also underwrite the themes of struggle, choice, and human agency that are central values in Zionist ideology. Another way of putting this is to say that they combine themes that find their quintessential place in other Israeli heritage museums: Jewish victimization (Holocaust museums), activist Zionist endeavors (the hallmark of settlement museums), and heroic struggle against the enemy (at the

core of museums devoted to the history of military combat). Much of the effectiveness of the story told in clandestine immigration museums lies in their focus on survival rather than victimage and destruction. The Holocaust, as an epitome of the persecution of Jews in the diaspora, is presented as the main historical legitimation for the establishment of the Jewish State, and this ideological position is reinforced by occasional side comments regarding the lack of safety Jews have experienced in the diaspora through the ages and to this day. At the same time, visitors are not required to identify with the helplessness of the Jewish victims' position. Rather, they are invited to identify with the heroic struggle associated with the survivors' arrival in the Land of Israel (and, by extension, the new life they sought to build there).

The saga of clandestine immigration holds a special position in the ongoing narrative construction of Israeli collective memory, mediating the often troubled conjunction of victimhood (as epitomized by the Holocaust) and of active struggle (as epitomized in the Israeli cult of war). Museums addressing clandestine immigration depict past events as action-filled dramas of living, and in so doing they point to the visitors' present and future potential, seeking to enlist their commitment to the national cause. They weave together a tale of personal and collective struggle through nostalgic invocations of a heroic and sacrifice-filled past. These depictions are often coupled with a depreciation of the contemporary social scene. Thus, some of the side comments I have heard guides insert into their interpretive activities or interviews suggest that they view their role as partly designed to counteract prevailing attitudes in a social scene populated by veteran Israelis and youngsters who are not duly appreciative of the founders' heroic struggle and by newcomers to the land who are ungrateful for the State's efforts on their behalf.

Furthermore, the telling and retelling of this particular chapter in Israeli/Jewish history provides a context for the negotiation of the themes of continuity and change associated with Jewish national revival. On the one hand, the narrative construction of the clandestine immigration story, set against the story of the Holocaust, becomes incorporated within an ongoing tale of Jewish persecution through the centuries, which is claimed to manifest the Jews' collective predicament and to underwrite their unwavering attachment to the idea of an ancestral homeland. The clandestine immigration story, therefore, both marks the inevitability of Jewish suffering and victimhood and celebrates the continuity of Jewish survival and national sentiment over the generations. The incorporation of the clandestine immigration story in this essentially religion-based version of Jewish continuity serves to blur the secular nature of much of the Zionist enterprise of nationhood, which is reflected in the meager attention paid to religious ritual, traditional Jewish artifacts, and associated themes in clandestine immigration museums.

In this and in other ways, the story of clandestine immigration differs from other immigration stories, such as those told in ethnographic museums devoted to the collective tales of ethnic Jewish communities (Iraqi Jews, Yemenite Jews,

German Jews, and so on). Indeed, ethnographic museums and clandestine immigration museums both construct their stories in relation to the newcomers' past, but they do so in very different ways. The clandestine immigration is presented first and foremost as a direct historical outcome of the Holocaust and as part of the struggle for national autonomy waged against the British colonialist rule in pre-state years. Ethnographic museum representations are mainly a memorial to the vanished diaspora life of newcomers to the Land of Israel, Holocaust victims among them. Ethnographic museums are chiefly oriented to the past and to the diaspora as a spatiotemporally defined state of being. They sacralize the vanished fabric of social and cultural life in diasporic communities through the enshrinement of some of their material and symbolic traces. Life in these communities is depicted as highly tradition-bound—hence, the emphasis placed on life-cycle and calendrical religious rituals. They tell a story of communal immersion rather than one of the human agency that propels individual actions and historical events. In the clandestine immigration narrative, the survivors' diaspora past is presented as a highly traumatic yet shapeless collective experience, and the narrative focuses on their eventful journey to and arrival in the Land of Israel in active defiance of their destiny. It is a story anchored in a particular diasporic situation, spatially located off the shores of the Land of Israel, in places whose particular contours have been blurred by the overwhelming, leveling effect of Jewish suffering. In a fundamental, if ambivalent, sense it is a story concerned with human victimage, human agency, and the promise of human powers of survival.

Notably, neither the version of immigration narratives presented in ethnographic museums nor the one presented in clandestine immigration museums has anything to say about the new immigrants' experiences in the new land, beyond the moment of arrival or their release from the British detention camps. The hardships Holocaust survivors or other newcomers faced during the process of acculturation to the new land as well as their lifework and accomplishments in later years are left unsung. In clandestine immigration museums, the narrow focus on the theme of survival, on the moment of history that stretches through the clandestine immigrants' journey "from shore to shore," fixes their image in Israeli collective memory within the confines of their Holocaust survivor role. In this version of their story, the survivors' redemptive journey out of Europe has taken them to the Israeli shores, but it has not really brought them inland. In this respect, these collective immigration narratives stand in stark contrast to the story of pioneering settlement museums, whose spatial focus is the Land of Israel as a site of cultivation and self-transformation. Their point of departure is the pioneers' moment of arrival, when they embark on the project of actively shaping the new world they and their children will inhabit.

This narrative contrast in the stories told about newcomers to the land in different heritage museums came to life for me on one of my trips to the Atlit site-museum. Having attentively listened to the narrative crafting of the tale of clandestine immigration in many guides' formal interpretive activities, I was somewhat

startled to hear the poignant, personal inflection given to that same story by an elderly visitor, a one-time clandestine immigrant, in a moment of autobiographical reconstruction.

It was a rather early, beautiful Saturday morning and we found ourselves at the Atlit camp with one other family group, which included an elderly couple, young parents, and their two children. I fell into conversation with the older woman, and she told me that she and her husband had met during the months they spent as inmates in the Atlit detention camp. For a short moment she became my guide and reminisced about her experiences in the place. But as we continued to talk, I realized that most of the stories she wanted to tell were about the life they led in the years following arrival, after they had left the detention camp. She spoke mainly of deeds and accomplishments, her own and those of many friends and acquaintances, all Holocaust survivors, whom she mentioned by name one after the other: one was an accomplished lawyer, another a wonderful physician, a third had established a factory single-handedly, and so on. They all had children and grandchildren. They had made good of life, she reassured me and herself, vindicating the present rather than reminiscing about the painful past, and subtly shifting the temporal trajectory charted by the museum's official narrative in a voice more intimate than the museum setting usually invites. Dwelling on these fragments of memory shared in a moment of fleeting encounter, her story resounded for me as an alternative, even subversive version of the clandestine immigration museum official story line as I had heard it reiterated by its ordained storytellers.

REFERENCES

Azoulay, A. 1993. With Open Doors: Museums of History in the Israeli Public Space. *Theory and Criticism* 4:79–95 (in Hebrew).

———. 1994. Museums and Historical Narratives in Israel's Public Space. In *Museum Culture: History, Discourses, Spectacles,* ed. D. Sherman & I. Rogoff, 85–109. London: Routledge.

Dominguez, V. 1986. The Marketing of Heritage. *American Ethnologist* 13(3): 546–55.

———. 1990. The Politics of Heritage in Contemporary Israel. In *Nationalist Ideologies and the Production of National Culture,* ed. R. G. Fox, 130–47. Washington, D.C.: American Ethnological Society.

Golden, D. 1996. The Museum of Jewish Diaspora Tells a Story. In *The Tourist Image: Myth and Mythmaking in Tourism,* ed. T. Selwyn, 223–50. New York: John Wiley.

Inbar, Y. 1999. Require a Long Breath: Israeli Museums from Constructing a Future to Preserving the Past. *Panim* 10:82–86 (in Hebrew).

Katriel, T. 1997. *Performing the Past: A Study of Israeli Settlement Museums.* Mahwah, N.J.: Lawrence Erlbaum Associates.

Morris, B. 1989. *The Birth of the Palestinian Refugee Problem, 1947–1949.* Cambridge: Cambridge University Press.

Rosovsky, N., & J. Ungerleider-Mayerson. 1990. *The Museums of Israel.* Tel Aviv: Steimatzky.

Photographs

Figure 1. Cäcilie Rubel Gottfried, Czerno-witz, Austria-Hungary, ca. 1910. Hirsch-Spitzer family collection.

Marianne Hirsch

Surviving Images:
Holocaust Photographs
and the Work of Postmemory

One's first encounter with the photographic inventory of ultimate horror is a kind of revelation, the prototypically modern revelation: a negative epiphany. For me, it was photographs of Bergen-Belsen and Dachau which I came across by chance in a bookstore in Santa Monica in July 1945. Nothing I have seen— in photographs or in real life—ever cut me as sharply, deeply, instantaneously. Indeed, it seems plausible to me to divide my life into two parts, before I saw those photographs (I was twelve) and after, though it was several years before I understood fully what they were about. What good was served by seeing them? They were only photographs—of an event I had scarcely heard of and could do nothing to affect, of suffering I could hardly imagine and could do nothing to relieve. When I looked at those photographs, something broke. Some limit had been reached, and not only that of horror; I felt irrevocably grieved, wounded, but a part of my feelings started to tighten; something went dead, something is still crying.[1]

I made a thorough search of my father's desk. I opened every pad and every box in every drawer. . . . In the right bottom drawer I found gray cardboard boxes. There were black and white photographs of dead bodies in them. In several photographs hundreds of bony corpses were piled on top of one another in bony heaps. I had never seen a dead body, not even in a photograph. . . . This is what death looked like.

Not every body in the photographs was dead. People were standing up, but they didn't look human. Their bones stuck out too much. You could see the sockets where one bone connected to the next. Some were naked, some wore striped pajamas that fell off their bones. One man tried to smile. His face was more frightening than the expressionless faces—he was reaching for life, but it was too late. . . . 'U.S. army' and a series of numbers was stamped on the back of each photograph.

My mother told me that the photographs were taken by Mr. Newman. He was a photographer for the Army when they liberated the concentration camps at the end of the war. His photographs were evidence at Nuremberg for what the Nazis did.

I took the photos to class to show the other third-graders what had happened in the camps. My mother had gone through the photos to remove the

*ones she thought were too upsetting, but I wanted to take all of them, espe-
cially the upsetting ones. . . . I believed my friends had no right to live without
knowing about these pictures, how could they look so pleased when they were
so ignorant. None of them knew what I know, I thought. I hated them for it.*[2]

1. Rupture

Two encounters, one described by Susan Sontag in 1973 in *On Photography,* the
other by Alice Kaplan in *French Lessons* in 1993, twenty years later. Sontag was
12 in 1945 when she first saw those pictures, Kaplan was in third grade, 8 or 9, in
1962 when she found them, in the desk of her father who had been a prosecutor
at Nuremberg and who had recently died of heart failure.

Both of these encounters with what Sontag calls "the photographic inven-
tory of ultimate horror" occurred in childhood. Although one of these writers is
a contemporary of the Holocaust and the other a member of the second genera-
tion, both encounters are marked by the same rupture, the same child realization
of death, inconceivable violence, incomprehensible evil. The same sense that the
world will never again be whole. That "something broke." In both texts, the
descriptions of these encounters are carefully dated and situated: they serve to
position the authorial subject in a generational space defined by its visual culture,
one in which images such as those found in the privacy of the desk drawer or even
the public space of the bookstore are the mark of a limit of what can and should
be seen. Although these two generations share the same visual landscape and live
in it with the same sense of shock, that shock has different effects for witnesses
and survivors than it does for their children and grandchildren.

Thus, if Sontag describes this radical interruption through seeing, it is
only to show how easily we can become inured to its visual impact: "Photographs
shock insofar as they show something novel. . . . Once one has seen such images,
one has started down the road of seeing more—and more. Images transfix. Images
anesthetize. . . . At the time of the first photographs of the Nazi camps, there was
nothing banal about these images. After thirty years, a saturation point may have
been reached" (21).

We do not have to look at the images Sontag and Kaplan describe. Now,
after fifty years, they have become all too familiar. The saturation point that "may
have been reached" for Sontag twenty-five years ago has certainly been surpassed
by now, causing many commentators on the representation and memorialization
of the Holocaust to express serious concerns and warnings. "Is our capacity for
sympathy finite and soon exhausted?" worries Geoffrey Hartman in *The Longest
Shadow.* The surfeit of violent imagery that constitutes our present visual land-
scape, he insists, has desensitized us to horror, evacuating the capacity for the
shocked child vision of Sontag or Kaplan. Hartman fears that we will try to go ever
further, surpassing all representational limits to "seek to 'cut' ourselves, like psy-

chotics who ascertain in this way that they exist."[3] And in a recent extensive study of Holocaust atrocity photos taken by the liberating armies, Barbie Zelizer worries that through this surfeit of imagery we are, as her title indicates, "remembering to forget," that the photographs have become no more than decontextualized memory cues, energized by an already coded memory, no longer the vehicles that can themselves energize memory.[4]

Hartman and Zelizer voice a fear that has become pervasive among scholars and writers concerned about the transmission of Holocaust memory. And yet what we find in the contemporary scholarly and popular representation and memorialization of the Holocaust is not the multiplication and escalation of imagery that Hartman's fear might lead us to expect, but a striking repetition of the same very few images, used over and over again iconically and emblematically to signal this event.

This is despite the fact that the Holocaust is one of the visually best-documented events in the history of an era marked by a plenitude of visual documentation. The Nazis were masterful at recording visually their own rise to power as well as the atrocities they committed, immortalizing both victims and perpetrators.[5] Guards often officially photographed inmates at the time of their imprisonment and recorded their destruction. Even individual soldiers frequently traveled with cameras and documented the ghettos and camps in which they served. At the liberation, the Allies photographed and filmed the opening of the camps; postwar interrogations and trials were meticulously filmed as well. It is ironic that although the Nazis intended to exterminate not only all Jews but also their entire culture, down to the very records and documents of their existence, they should themselves have been so anxious to add images to those that would, nevertheless, survive the death of their subjects.

Very few of these images were taken by victims: the astounding clandestine photographs Mendel Grossman succeeded in taking in the Łódź ghetto, hiding the negatives which were found after his death, are a rare exception, as are the blurred, virtually unrecognizable, photos of burnings and executions taken by members of the resistance in Auschwitz, and also the images of the Warsaw ghetto taken at his own risk by the German anti-Nazi photographer Joe Heydecker. The images of perpetrators, resisters, and victims together yield an enormous archive of diverse representations, many of which appeared frequently in the two decades after the war, in Alain Resnais's important 1956 film *Night and Fog*, which is largely composed of this gruesome archival material, and in Gerhard Schönberger's 1960 volume *The Yellow Star*.[6] As new archives and museums open, more imagery has become available, and yet, as the historian Sybil Milton has written, "although more than two million photos exist in the public archives of more than twenty nations, the quality, scope and content of the images reproduced in scholarly and popular literature has been very repetitive."[7] The repetition of the same few images has disturbingly brought with it their radical decontextualization from their original context of production and reception.[8] Why, with so much imagery

available from the time, has the visual landscape of the Holocaust and thus our opportunity for historical understanding been so radically delimited?

In what follows I try to understand this repetition from the vantage point of a historical and generational moment that is fully cognizant of the mediated and media-driven scene of representation that shapes both knowledge and memory of the Holocaust. If these images, in their obsessive repetition, delimit our available archive of trauma, can they enable a responsible and ethical discourse in its aftermath? How can we read them? Do they act like clichés, empty signifiers that distance and protect us from the event?[9] Or, on the contrary, does their repetition in itself retraumatize, making distant viewers into surrogate victims who, having seen the images so often, have adopted them into their own narratives and memories, and have thus become all the more vulnerable to their effects? If they cut and wound, do they enable memory, mourning, and working through?[10] Or is their repetition an effect of melancholy replay, appropriative identification?

In my study and teaching of Holocaust representation, I have found this repetition puzzling and disturbing. Yet, I have also found that in different contexts the effects of this repetition are different, ranging across all of the possibilities I have just named. It is certainly important to study the specific contextual use of these images. What I attempt here, however, is a more general reading that locates repetition itself in a specifically generational response to memory and trauma, in what I call *postmemory*—the response of the second generation to the trauma of the first. Postmemory offers us a model for reading both the striking fact of repetition and the particular canonized images themselves. I will argue that for us in the second generation, cognizant that our memory consists not of events but of representations, repetition does not have the effect of desensitizing us to horror, or shielding us from shock, thus demanding an endless escalation of disturbing imagery, as the first generation might fear. On the contrary, compulsive and traumatic repetition connects the second generation to the first, *producing* rather than *screening* the effect of trauma that was lived so much more directly *as compulsive repetition* by survivors and contemporary witnesses. Thus, I would suggest that while the reduction of the archive of images and their endless repetition might seem problematic in the abstract, the postmemorial generation, in displacing and recontextualizing these well-known images in their artistic work, has been able to make repetition not an instrument of fixity or paralysis or simple retraumatization, as it often is for survivors of trauma, but a *mostly* helpful vehicle of working through a traumatic past.[11]

2. Postmemory

Postmemory most specifically describes the relationship of children of survivors of cultural or collective trauma to the experiences of their parents, experiences

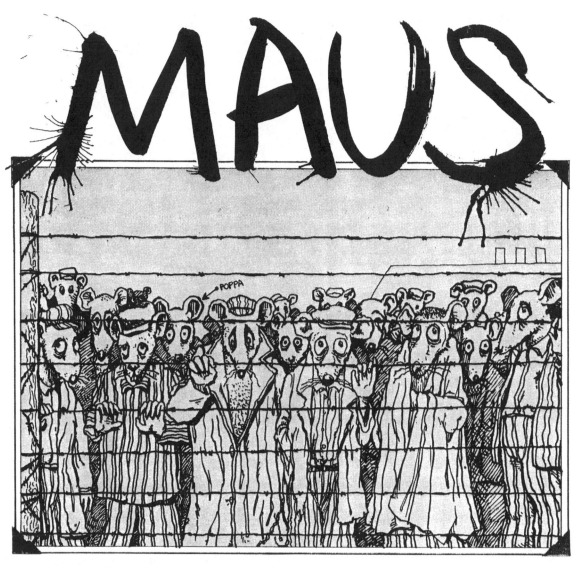

Figure 2. The first Maus. Art Spiegelman © 1972.

that they "remember" only as the narratives and images with which they grew up, but that are so powerful, so monumental, as to constitute memories in their own right. I first came to this notion in reading Art Spiegelman's representations of his parents' story of survival in *Maus*.[12] The original three-page "Maus," published in *Funny Animals* in 1972, begins with a cartoon redrawing of the famous Margaret Bourke-White photograph of liberated prisoners in Buchenwald. The photo corners at the edges clearly indicate not only the double mediation of this image but also its inscription into the family photo album. The small arrow marked "Poppa" pointing to one of the prisoners in the back row shows, moreover, the son's inability to imagine his own father's past other than by way of repeatedly

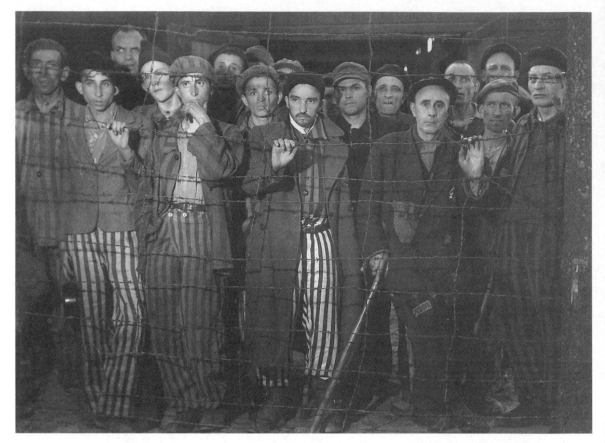

Figure 3. Buchenwald, April 1945. Margaret Bourke-White, Life Magazine © Time, Inc.

circulated and already emblematic cultural images, images that have become part of his own consciousness and his family album.[13]

The term "postmemory" is meant to convey its temporal and qualitative difference from survivor memory, its secondary, or second-generation memory quality, its basis in displacement, its vicariousness and belatedness. Postmemory is a powerful form of memory precisely because its connection to its object or source is mediated not through recollection but through representation, projection, and creation—often based on silence rather than speech, on the invisible rather than the visible. That is not, of course, to say that survivor memory itself is unmediated, but that it is more directly—chronologically—connected to the past.

The work of postmemory defines the familial inheritance and transmission of cultural trauma. The children of victims, survivors, witnesses, or perpetrators have different experiences of postmemory, even though they share the familial ties that facilitate intergenerational identification. Still, this form of remembrance need not be restricted to the family, or even to a group that shares an ethnic or national identity marking: through particular forms of identification, adoption, and projection, it can be more broadly available. When Art Spiegelman represents the young Artie as identifying the prisoner in the photograph as "Poppa," he sees

the anonymous image through the lens of his own familial drama. But the young Alice, the child of a witness, needs to show the images to her class so that others will know what she knows and so that they can reconstitute their identities accordingly: "my friends had no right to live without knowing about these pictures, how could they look so pleased when they were so ignorant." Thus, although familial inheritance offers the clearest model for it, postmemory need not be *strictly* an identity position. Instead, I prefer to see it as an intersubjective transgenerational space of remembrance, linked specifically to cultural or collective trauma. It is defined through an identification with the victim or witness of trauma, modulated by the unbridgeable distance that separates the participant from the one born after. Geoffrey Hartman has written about "witnesses by adoption" and I like the connection to and enlargement of family that this term implies. Postmemory thus would be *retrospective witnessing by adoption.* It is a question of adopting the traumatic experiences—and thus also the memories—of others as experiences one might oneself have had, and of inscribing them into one's own life story. It is a question, more specifically, of an *ethical* relation to the oppressed or persecuted other for which postmemory can serve as a model: as I can "remember" my parents' memories, I can also "remember" the suffering of others. These lines of relation and identification need to be theorized more closely, however—how the familial and intergenerational identification with one's parents can extend to the identification among individuals of different generations and circumstances and also perhaps to other, less proximate groups. And how, more important, identification can resist appropriation and incorporation, resist annihilating the distance between self and other, the otherness of the other.[14]

Nor do I want to restrict the notion of postmemory to the remembrance of the Holocaust, or to privilege the Holocaust as a unique or limit experience beyond all others: the Holocaust is the space where I am drawn into the discussion. Although it might be generalizable to other contexts, however, the specificity of the Holocaust as an exemplary site of postmemory deserves notice and comment; it is due to more than my own autobiographical connection to it. I am speaking of a historical, generational moment—hence postmemory's connection to the postmodern with its many "posts"—a cultural and intellectual moment that is shaped by the traumas of the first half of the twentieth century and that understands its own fundamentally mediated relationship to this painful history, even while considering it as absolutely determinative.[15]

Thus postmemory characterizes the experience of those who, like me, have grown up dominated by narratives that preceded their birth, whose own belated stories are displaced by the powerful stories of the previous generation, shaped by monumental traumatic events that resist understanding and integration. It describes as well the relationship of the second generation to the experiences of the first—their curiosity and desire, as well as their ambivalences about wanting to own their parents' knowledge. Alice Kaplan's relentless search through her father's desk drawers, her exposure of the images he carefully saved, and her insistence that

her classmates must join her in the act of looking at what her father saw, illustrate the act of postmemory. Her description clarifies the textual nature of postmemory—its reliance on images, stories, and documents passed down from one generation to the next.

The notion of postmemory derives from the recognition of the belated nature of traumatic memory itself. If indeed one of the signs of trauma is its delayed recognition, if trauma is recognizable only through its aftereffects, then it is not surprising that it is transmitted across generations. Perhaps it is *only* in subsequent generations that trauma can be witnessed and worked through, by those who were not there to live it but who received its effects, belatedly, through the narratives, actions, and symptoms of the previous generation. Cathy Caruth suggests that trauma is an encounter with another, an act of telling and listening, a listening to another's wound, recognizable in its intersubjective relation.[16] Trauma may also be a way of seeing through another's eyes, of remembering another's memories through the experience of their effects. Caruth makes space for this elaboration when she cites, as an epigram, the following quote from Michael Herr's *Dispatches:* "It took the war to teach it, that you were as responsible for everything you saw as you were for everything you did. The problem was that you didn't always know what you were seeing until later, maybe years later, that a lot of it never made it in at all, it just stayed stored there in your eyes" (cited in *Unclaimed Experience,* 10). My reading of Holocaust images attempts to explore the implications of Herr's notion of visual response and responsibility as it is reconceived by the artists and writers of the postmemorial generation.

The repeated images of the Holocaust need to be read from within the discourse of trauma, not for what they reveal but for how they reveal it, or fail to do so: thus they can be seen as *figures* for memory and forgetting. They are part of an intergenerational effort at reconstitution and repair that Robert Jay Lifton describes on an individual level: "In the case of severe trauma we can say that there has been an important break in the lifeline that can leave one permanently engaged in either repair or the acquisition of new twine. And here we come to the survivor's overall task, that of formulation, evolving new inner forms that include the traumatic event."[17] As much for the generations following the Shoah as for survivors, the work of postmemory is such a work of "formulation" and attempted repair. The repetitive visual landscape we construct and reconstruct in our postmemorial generation is a central aspect of that work. To understand it, we must begin by reading the images themselves.[18]

3. Traces

Ida Fink's short story "Traces" from her 1987 collection *A Scrap of Time* stages a conversation between a survivor and some unnamed "they" who use a photo-

graph to ask her questions about the liquidation of the ghetto in which she was interned.[19]

> Yes, of course she recognizes it. Why shouldn't she? That was their last ghetto.
>
> The photograph, a copy of a clumsy amateur snapshot, is blurred. There's a lot of white in it, that's snow. The picture was taken in February. The snow is high, piled up in deep drifts. In the foreground are traces of footprints, along the edges, two rows of wooden stalls. That is all.

As the woman tries to tell what she remembers, her narrative is arrested, time and again, by the details she can make out in the photo:

> "That's the ghetto," she says again, bending over the photograph. Her voice sounds amazed.
>
> . . . she reaches for the photograph, raises it to her nearsighted eyes, looks at it for a long time, and says, "You can still see traces of footprints." And a moment later, "That's very strange." . . .
>
> "I wonder who photographed it? And when? Probably right afterwards: the footprints are clear here, but when they shot them in the afternoon it was snowing again."
>
> The people are gone—their footprints remain. Very strange.

This image in Fink's story is a kind of metapicture illustrating the complicated issues that are raised in the seemingly simple attempt to use a photograph as an instrument of historical evidence, or even, simply, as a memory cue for the witness. I'd like to use this fictional photograph to explore *the privileged status of photography as a medium of postmemory.* What does Fink gain for her story by adding this fictional photograph to the witness's narrative?

Art historians and semioticians have discussed the photograph as a *trace.* The notion of trace, or index, describes a material, physical, and thus extremely potent connection between image and referent. In Charles Sanders Peirce's tripartite definition of the sign—symbol, icon, and index—the photograph is defined as an index based on a relationship of contiguity, of cause and effect, like a *footprint.* Thus a photograph of footprints in the snow is a trace of a trace. At the same time, it is also an icon, based on physical resemblance or similarity between the sign and the referent. In his *Camera Lucida,* Roland Barthes goes beyond Peirce when he insists that photography holds a *uniquely* referential relation to the real, defined not through the discourse of artistic representation, but that of magic, alchemy, indexicality:

> I call 'photographic referent' not the *optionally* real thing to which an image or a sign refers but the *necessarily* real thing which has been placed before the lens, without which there would be no photograph. . . . The photograph is literally an emanation of the referent. From a real body, which was there, proceed radiations which ultimately touch me, who am here. . . . A sort of umbilical cord links the body of the photographed thing to my gaze: light,

though impalpable, is here a carnal medium, a skin I share with anyone who has been photographed.[20]

The woman in Fink's story underscores what Barthes calls the photograph's "ça-a-été" with her first repeated spoken statement: "'That's the ghetto,' she says again, bending over the photo. Her voice sounds amazed." She points to the trace (the photo)—which is in itself of a trace (the footprints)—and, amazed, she finds there an unequivocal presence ("that's the ghetto").

Oral or written testimony, like photography, leaves a trace, but, unlike writing, the photograph of the footprint is the index par excellence, pointing to the presence, the having-been-there, of the past—here is why Fink needed the description of the photograph to underscore the material connection between past and present that is embodied in the photograph and underscored by the witness who recognizes it. The photo—even the fictional photo—has, as Barthes would say, evidential force. It thus illustrates the integral link photographs provide for the second generation, those who in their desire for memory and knowledge, are left to track the traces of what has been there and no longer is. Pictures, as Barbie Zelizer argues, "materialize" memory.

"The photograph . . . is blurred. There's a lot of white in it." In spite of their evidential force and their material connection to an event that was there before the lens, photographs can be extremely frustrating, as fleeting in their certainty as footprints in the snow. They affirm the past's existence, its "having-been there"; yet, in their flat two-dimensionality, in the frustrating limitation of their frames, they also signal its insurmountable distance and unreality. What ultimately can we read as we read an image? Does it not, like the white picture of footprints in the snow, conceal as much as it reveals?

When was the picture taken, the witness wonders, and concludes that it was "probably right afterwards: the footprints are clear here, but when they shot them, it was snowing again." The still picture captures, refers to, an instant in time which, when we look at the picture, is over, irrecoverable. Yet the photograph testifies to that past instant's reality. If the photograph has evidential force, Barthes argues, it testifies not as much to the object as to time, but because time is stopped in the photograph, one might say, it gives us only a partial and thus perhaps a misleading knowledge about the past. Even as it freezes time, however, the image shows that time cannot be frozen: in the case of Holocaust photos such as this one, the impossibility of stopping time, or of averting death is already announced by the shrinking of the ghetto, the roundup, the footprints pointing toward the site of execution. In this case, these footprints in the snow are the visible evidence not of the inevitable, non-negotiable march of time, but of its murderous interruption.

Those who question the witness have only representations such as this photograph and the woman's halting narrative to go on. The story does not tell of their response, cites only one of their questions. But it describes the picture they are looking at and images such as this one, art historian Jill Bennett has argued,

do more than *represent* scenes and experiences of the past: they can communicate an emotional or bodily experience by evoking the viewer's own emotional and bodily memories.[21] They *produce* affect in the viewer, speaking *from* the body's sensations, rather than speaking *of*, or *representing* the past. These postmemorial viewers do more than listen to the witness; they gaze at the image with her and thus they can reenact, recall in the very sensations of the body, that fateful walk in the snow. This connection between photography and bodily or sense memory can perhaps account for the power of photographs to connect first- and second-generation subjects in an unsettling mutuality that crosses the gap of genocidal destruction.

On the one hand, a blurred picture with a lot of white in it, depicting footprints and some wooden stalls in the snow. On the other, a narrative about the massacre of the children and their parents, the last in their ghetto. The two are incommensurable, illustrating the incommensurability of the crime and the instruments of representation and even conceptualization available to us—the absolute limits of representation. If the photograph is a trace, then it cannot ultimately refer to its incomprehensible, inconceivable referent that is the extermination of European Jewry, or even just the murder of the last eighty Jews in the town. "The people are gone—their footprints remain. Very strange." Equally strange that the photo, a "copy of a clumsy amateur snapshot," should remain. As horrific as any Holocaust photograph may be, it cannot in any way claim to represent, in the sense of being commensurate with, the crime it purportedly depicts.

More than just evocative and representational power, images also quickly assume symbolic power—the *trace* in the story becomes not just a footprint in the snow but a *trace* of the children who were killed. "But suddenly she changes her mind and asks that what she is going to say be written down and preserved forever, because she wants a trace to remain." And thus she tells the story of the hidden children who were brought out by the SS to identify their parents but who refused to move or to speak. "'So I wanted some trace of them to be left behind.'" She alone can connect the two presents of the photograph because she alone survived. But the photograph she uses to tell her story moves her testimony to a figurative level. Barbie Zelizer discusses the symbolic and interpretive power of images, arguing that "the photo's significance . . . evolved from the ability not only to depict a real-life event but to position that depiction within a broader interpretive framework." Photos are "markers of both truth-value and symbolism."[22]

4. Figures

As a figure for the relationship of photography, memory, and postmemory, Fink's photo enables us to read some of the emblematic images used in Holocaust representation and memorialization, images repeated in textbooks and museums, on

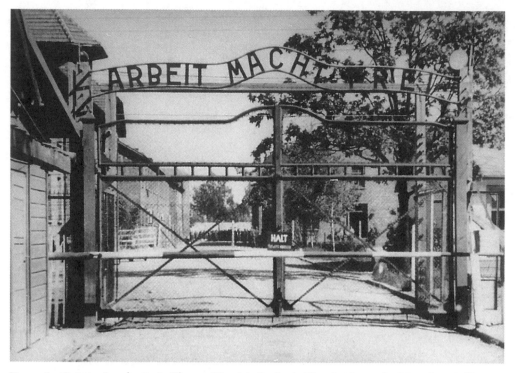

Figure 4. Gate to Auschwitz I, Glowna Komisja Badania Zbrodni Preciwko Narodowi Polkiemu. Courtesy USHMM Photo Archives.

book covers and in films: (1) the entrance to Auschwitz I with its ironic "Arbeit macht frei" sign, its massive iron gate in whose center is the small sign "Halt! Ausweise vorzeigen" (show documents!); (2) the main guard house to Auschwitz II-Birkenau depicted from a slight distance with three train lines leading into it and with snow-covered pots, pans, and other belongings in the foreground; (3) the camp watchtowers connected by electric barbed wire fences, poles, and spotlights [in some images the signs saying "Halt/Stop" or "Halt/Lebensgefahr" are visible]; and (4) the bulldozers moving corpses into enormous mass graves—clearly one of the images that so struck Sontag and Kaplan.[23]

The specific context of these images has certainly been lost in their incessant reproduction. The gate of Auschwitz I and the tower could be either perpetrator or liberator images; the liberator's signature can clearly be found in the objects in front of the Birkenau gate, and the bulldozer image reveals its production most explicitly at the moment of liberation, although its provenance from Bergen-Belsen is immaterial to the uses to which the image has been put. I would like to suggest, not without some hesitation, that more than simply "icons of destruction," these images have come to function as tropes for Holocaust memory itself. And they are also tropes for photography, referring to the act of looking itself. It is as such tropes, and not only for their informational value about the Holocaust, whether denotative or connotative, that they are incorporated into the visual dis-

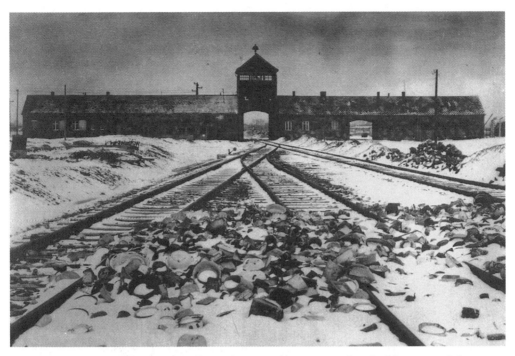

Figure 5. The main rail entrance of Auschwitz-Birkenau just after the liberation of the camp.
Yivo Institute for Jewish Research, courtesy USHMM Photo Archives.

course of postmemory as pervasively as they are. And, at the same time, the rep-
etition also underscores their metaphoric role.[24]

The two gates are the thresholds that represent the difficult access to the
narratives of dehumanization and extermination. As Debórah Dwork and Robert
Jan van Pelt say of the gate of Auschwitz I, "For the post-Auschwitz generation,
that gate symbolizes the threshold that separates the oikomene (the human
community) from the planet Auschwitz. It is a fixed point in our collective mem-
ory, and therefore the canonical beginning of the tour through the camp. . . . In
fact, however, the inscribed arch did not have a central position in the history of
Auschwitz." Most Jewish prisoners, they show, never went through the gate since
they were taken by truck directly to Birkenau to be gassed. The expansion of the
camp in 1942, moreover, placed the gate in the interior of the camp, not at its
threshold.[25]

In the pictures, the gate of Auschwitz I is always closed; its warning "halt"
further signals the dangers of opening the door on memory. For the victims,
"Arbeit macht frei" remains perhaps the greatest trick of National Socialism,
enabling the killers to lure their victims willingly and cooperatively into the camp
and later into the gas chamber. It is a lie, but also a diabolical truth: freedom is
both the very small possibility of survival though work, and the freedom of death.
It is only in retrospect, knowing what lies beyond the closed gate, that one fully
appreciates the extent of the trick.

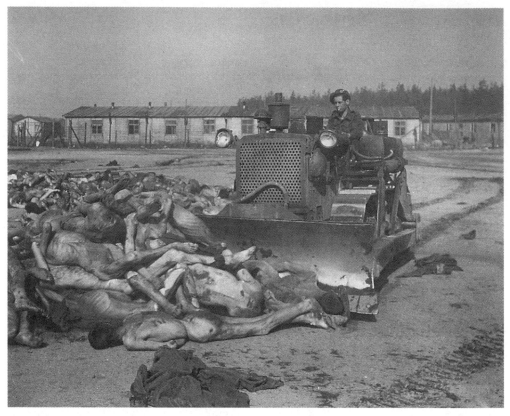

Figure 6. A British soldier clearing corpses at Bergen-Belsen. Courtesy USHMM Photo Archives.

But could "Arbeit macht frei" not also be read, by and for us, in the second generation, as a reference to the tricks played by memory itself, the illusory promise that "Trauerarbeit macht frei," that one could become free if one could only do the work of memory and mourning that would open the gate, allow one to enter back into the past and then, through work, out again into a new freedom? The closed gate would thus be the figure for the ambivalences, the risks of memory and postmemory themselves—"Halt/Lebensgefahr." The obsessively repeated encounter with this picture thus would seem to repeat the lure of remembrance and its deadly dangers—the promise of freedom and its impossibility. At the same time, its emblematic status has made the gate into a screen memory. For instance, Art Spiegelman in *Maus* draws Vladek's arrival and departure from Auschwitz through the main gate, which could not have been true in 1944–45 when the gate was no longer used in this way. For Spiegelman, as for all of us in his generation, the gate is the visual image we share of the arrival in the camp. The artist needs it not only to make the narrative immediate and "authentic": he needs it as a point of access (a gate) for himself and for his postmemorial readers.[26]

The same could be said of the "Gate of Death" to Birkenau with the multiple tracks leading into it. Those who read and study about the Holocaust encounter this image obsessively, in every book, on every poster. Like the gate of Auschwitz

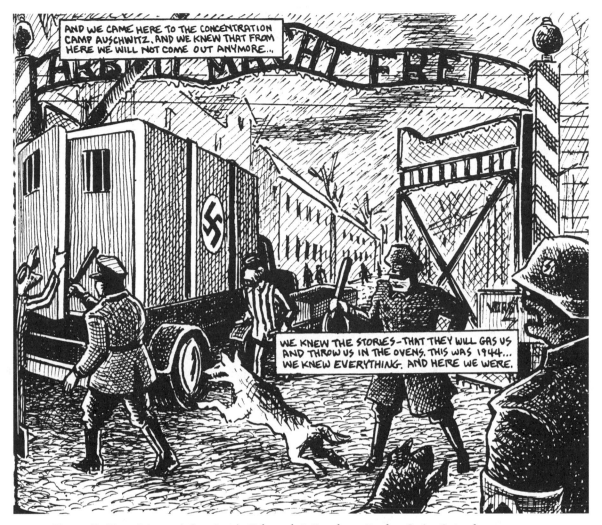

Figure 7. From Maus: A Survivor's Tale, *vol. I, Pantheon Books,* © *Art Spiegelman.*

I, it is the threshold of remembrance, an invitation to enter and, at the same time, a foreclosure. The electric fences, towers, and lights, the forbidding warning signs, repeat cultural defenses against recollection, and, especially, against looking beyond the fence, inside the gate of death, at death itself. The postmemorial generation, largely limited to these images, replays, obsessively, this oscillation between opening and closing the door to the memory and the experiences of the victims and survivors.[27] The closed gates and the bright lights are also figures for photography, however—for its frustrating flatness, the inability to transcend the limit of its frame, the partial and superficial view, the lack of illumination it offers, leaving the viewer always at a threshold and withholding entrance.

But when we confront—as we repeatedly do in the texts of Holocaust remembrance—the liberators' pictures of the innumerable bodies being buried or cleared by bulldozers, we come as close as we can in an image to looking into the

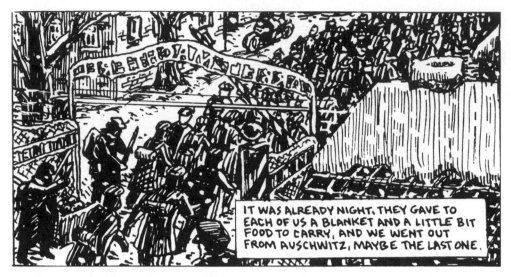

Figure 8. From Maus: A Survivor's Tale, *vol. II, Pantheon Books,* © *Art Spiegelman.*

pits of destruction. On the one hand, these images are the epitome of dehumanization, the inability, even after the liberation to give victims an individual human burial. They show, perhaps better than any statistics can, the extent of the destruction, the multiplication of victims that transforms corpses into what the Nazis called *Stücke* (pieces) even by the liberating armies. They lead us back to the pre-war images of individuals, families, and groups, such as the ones in the Tower of Faces in the U.S. Holocaust Memorial Museum, and as we project these two kinds of images unto each other, seeing them as mutually implying each other, we come to appreciate the extremity of the outrage and the incomprehension with which they leave anyone who looks.[28]

But, on the other hand, can we not see in the pictures of mass graves too a figuration of memory and forgetting that might also be involved in their canonization? The earth is open, the wound is open, we stare at the picture in the shock, amazement, and disbelief that Sontag and Kaplan express. This is the image that ruptures all viewing relations. But, at the same time, the opposite is also taking place: the bodies are being buried, the traces are being concealed, forgetting has begun. Every time we look at this image, we repeat the encounter between memory and forgetting, between shock and self-protection. We look into the pit of death but we know that it is in the process of being covered, just as, in Fink's story, the afternoon snow covered the traces of the crime. The work of postmemory, in fact, is to uncover the pits again, to unearth the layers of forgetting, to go beneath the screen surfaces that disguise the crimes and try to see what these images—the family pictures and the images of destruction—both expose and foreclose.

But the bulldozer image disturbs in a different way as well. It inscribes another confrontation, that between the camera and the bulldozer, perhaps mirror images of one another. In this specific context, one could say that these two

machines, worked by humans, do a similar job of burial that represents forgetting. That they recall, however obliquely, another machine, the weapon. And that, when it comes to images of genocidal murder, the postmemorial act of looking performs this unwanted and discomforting mutual implication.

5. A Double Dying

The bulldozer image, like the photo in Ida Fink's story, records a fleeting moment, just after and just before—in this case, after killing and before burial. Theorists of photography have often pointed out the simultaneous presence of death and life in the photograph: "Photographs state the innocence, the vulnerability of lives heading toward their own destruction and this link between photography and death haunts all photos of people," says Susan Sontag in *On Photography* (70). The indexical nature of the photo intensifies its status as harbinger of death and, at the same time, its capacity to signify life. Life is the presence of the object before the camera; death is the "having-been-there" of the object—the radical break, the finality introduced by the past tense. The "ça-a-été" of the photograph creates the retrospective scene of looking shared by those who survive.

In its relation to loss and death, photography does not mediate the process of individual and collective memory but brings the past back in the form of a ghostly revenant, emphasizing, at the same time, its immutable and irreversible pastness and irretrievability. The encounter with the photograph is the encounter between two presents, one of which, already past, can be reanimated in the act of looking.

In order to elaborate on what she calls the photograph's "posthumous irony," Sontag describes Roman Vishniac's pictures of the vanished world of Eastern European Jewish life which are particularly affecting, she argues, because as we look at them we know how soon these people are going to die (70). "Strictly speaking," writes Christian Metz, "the person *who has been photographed*— . . . is dead. . . . The snapshot, like death, is an instantaneous abduction of the object out of the world into another world, into another kind of time. . . . The photographic *take* is immediate and definitive, like death. . . . Not by chance, the photographic art . . . has been frequently compared with shooting, and the camera with a gun."[29] In the years since Sontag's 1973 book and Metz's 1985 essay, the equation between the camera and the gun, and the concomitant view of the photographic gaze as monolithic and potentially lethal, has been significantly qualified as theorists have stressed the multiplicity of looks structuring a photographic image.

For example, the giant opening image that faces the visitor who enters the permanent exhibition at the U.S. Holocaust Memorial Museum places the viewer in the position of the unbelieving onlooker or retrospective witness, who confronts

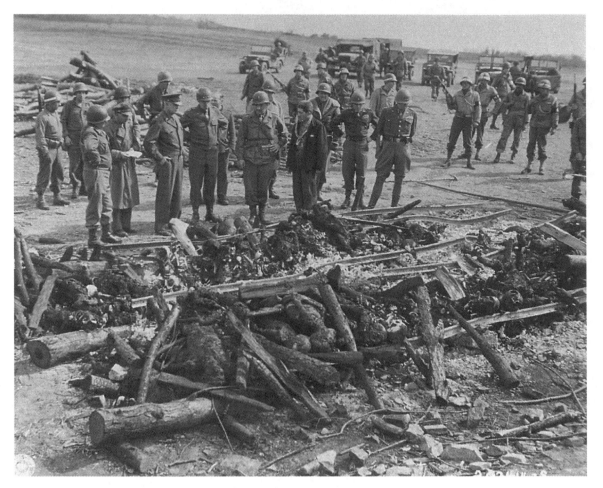

Figure 9. U.S. forces at Ohrdruf concentration camp. Harold Royall, courtesy USHMM Photo Archives.

the contemporary witnesses and sees *both* them in the act of looking *and* what they saw. These multiple and fractured lines of sight among the dead victims, the liberating U.S. army, and the retrospective witness confirm some recent work that complicates the assumption that a monocular perspective represented by the camera rules the field of vision, as Metz suggests.[30]

In my own work on the distinction between the familial gaze and look in *Family Frames*, I have tried to extricate us from the monocular seeing that conflates the camera with a weapon. Thus I have argued that while the *gaze* is external to human subjects, situating them authoritatively in ideology, constituting them in their subjectivity, the *look* is located at a specific point; it is local and contingent, mutual and reversible, traversed by desire and defined by lack. While the look is returned, the gaze turns the subject into a spectacle. "In the scopic field," Lacan says, "the gaze is outside, I am looked at, that is to say, I am a picture. . . . What determines me, at the most profound level, in the visible, is the gaze

that is outside." But looking and being looked at are interrelated processes; when you look you are also seen; when you are the object of the look you return it, even if only to reflect light back to its source: "things look at me and yet I see them," Lacan says. These looks are exchanged through the *screen* that filters vision through the mediations of cultural conventions and codes that make the seen visible. The gaze is mediated by the screen, contested and interrupted by the look. Vision is multiple and power is shared. I believe that we can use photographs to study these complex visual relations. Interpellated by the photograph, its viewers become part of the network of looks exchanged within the image and beyond it. The viewer both participates in and observes the photograph's inscription in the gazes and looks that structure it.

But is this multiplicity of vision sustained in the images of total death that have survived the destruction of the Holocaust, like the image of the bodies in the mass grave? In the images of burial and execution, the bulldozer burying the innumerable bodies repeats the act of the gun that has shot those bodies before they are buried, or the gas that has choked them. And the camera recording this violent destruction for posterity cannot stand ouside this coimplication. In its staggering multiplication, the triple act of shooting overwhelms all viewing relations.[31]

Several images that have been frequently reproduced in recent exhibits make this troubling equation uncompromisingly clear. These reverse the temporal sequence of the mass grave picture. They are images from the mass executions in Russia, Latvia, and Lithuania that depict victims facing the camera moments before they are to be put to death. I am thinking in particular of an image of four women, in their undergarments. In the brutally frontal image, the camera is in the exact same position as the gun and the photographer in the place of the executioner who remains unseen. The victims are already undressed; the graves have been dug. Displayed in their full vulnerability and humiliation they are doubly exposed in their nakedness and their powerlessness. They are shot before they are shot.[32]

How are postmemorial viewers to look at this picture and others like it? Where are the lines of transgenerational identification and empathy? Unbearably, the viewer is positioned in the place identical with the weapon of destruction: our look, like the photographer's, is in the place of the executioner. Steven Spielberg makes that utterly plain when he photographs Amon Goeth's random executions through the viewfinder of his gun in *Schindler's List*. Is it possible to escape the touch of death and the implication in murder that these images perform? To regain a form of witnessing that is not so radically tainted?

Perhaps the most haunting, arresting moment in Ida Fink's "Traces" is the witness's question, "I wonder who photographed it?" Fink's story reminds us that every image also represents, more or less visibly or readably, the context of its production and a very specific embodied gaze of a photographer. And, she reminds us as well, that for photographs associated with the Holocaust in particular, the very fact of their existence may be the most astounding, disturbing, incriminating thing about them. Perpetrator images, in particular, are taken by perpetrators for their

Figure 10. German soldiers examine photographs after executing a group of Jews and Serbs in a reprisal action, Serbia, 1941. Courtesy ECPA Photo Cinéma Video des Armées.

own consumption. Recently I have come across a set of thirty-eight images that bring this home with shocking force. These are pictures of a reprisal action against Jewish and non-Jewish partisans in Serbia, gruesomely detailing a roundup, confiscation of valuables, a lineup, the digging of graves, the shootings, and, also, the soldiers' act of looking intently at images. The pictures they are holding are clearly too large to be images confiscated from the prisoners; they must be images of this or of other *Aktionen* they or others have performed. Or they could be images of German victims, and thus supposed justifications for reprisal actions. It is not clear whether the soldiers are looking at these pictures before or after the execution depicted. How is the act of looking connected to the act of shooting: Is it a form of justification, indoctrination and instruction, or a retrospective debriefing?[33] No matter. These images illustrate the quality of the perpetrator's look as well as its connection to the perpetrator's deed. When we confront perpetrator images, we cannot look independently of the look of the perpetrator.[34]

The images of executions and burials are ruled by what we might term a murderous National Socialist gaze that violates the viewing relations under which we normally operate. The lethal power of the gaze that acts through the machine gun and the gas chamber, that reduces humans to "pieces" and ashes, creates a visual field in which the look can no longer be returned, multiplied, or displaced. All is touched by the death that is the precondition of the image. When looking and photographing have become coextensive with mechanized mass death, and the subject looking at the camera is also the victim looking at the executioner, those of us left to look at the picture are deeply touched by that death.[35]

The Nazi gaze is so all-encompassing that even for those in the post-memorial generation, available screens seem to falter, and any possible resistant potential of the look is severely impaired. The retrospective irony that Sontag identifies with photography has ceased being ironic as we feel ourselves in the position of both killer and victim, inextricably entwined in a circle from which, even for those of us analyzing the images in the postmemorial generation, it is difficult to find an escape through ironic insight. Too late to help, utterly impotent, we nevertheless search for ways to take responsibility for what we are seeing, as Michael Herr suggested, to experience, from a distance, even as we try to redefine, if not repair, these ruptures. This is the difficult work of postmemory.[36]

In *Camera Lucida* Barthes discusses the picture of the young Lewis Payne who is waiting to be hanged. "The *punctum* is," Barthes says, "*he is going to die.* I read at the same time: *This will be* and *this has been*; I observe with horror an anterior future of which death is the stake. By giving me the absolute past of the pose . . . , the photograph tells me death in the future. What *pricks* me is the discovery of this equivalence. In front of the photograph of my mother as a child I tell myself: she is going to die: I shudder . . . *over a catastrophe which has already occurred*. Whether or not the subject is already dead, every photograph is this catastrophe" (96). The images from the Holocaust, whether pictures of executions of even prewar images, are different. It is not that these women, or these men, were alive when the photo was taken and that we know that they were killed after. Barthes's retrospective irony works in such a way that, as viewers, we reanimate the subjects—his mother or Lewis Payne—trying to give them life again, to protect them from the death we know must occur, has already occurred. Here is the pathos, the punctum of the picture. But the victims of the *Einsatztruppen* were already killed by the murderous Nazi gaze that condemned them without even looking at them. This lethal gaze reflects back on images of European Jews that precede the war, removing from them the loss and nostalgia, the irony and longing that structure such photographs from a bygone era. It is the determining force of the identity pictures Jews had to place on the identification cards the Nazis issued and which were marked with an enormous J in gothic script. Those pictures had to show the full face and uncover the left ear as a telltale identity marker. In these documents, identity is identification, visibility, and surveillance, not for life but for the death machine that had already condemned all of those thus marked.

Figure 11. Rose Spitzer J-Pass, Vienna, 1939. Hirsch-Spitzer family collection.

The notion of the pervasive murderous gaze of National Socialism brings me to another obsessively repeated set of images, those of survivors at liberation, like the famous picture of Elie Wiesel in the bunks in Buchenwald, or the liberation pictures of Margaret Bourke-White. For some, these photographs of survivors looking at the liberating photographers might not seem to be so radically different from the images of executions. As Alice Kaplan observes, "people were standing up, but they didn't look human. . . . he was reaching for life, but it was too late." For her they elicit the same broken look and the same sense of belatedness. They are marked by a lack of recognition and mutuality, a sense of disbelief, a decided disidentification.[37] But Artie, in *The First Maus*, reanimates the image as he tries to find his father among those who "didn't look human." His indexical gesture "Poppa" is also the resistant one of the child who is alive because survival was indeed possible.

These photos—even the images of survivors, even the prewar images—are not about death but about genocidal murder. They resist the work of mourning. They make it difficult to go back to a moment before death, or to recognize survival. They cannot be redeemed by irony, insight, or understanding. They can only be confronted again and again, with the same pain, the same incomprehension, the same distortion of the look, the same mortification. And thus, in their repetition, they no longer *represent* Nazi genocide, but they *provoke* the traumatic effect that this history has had on all who grew up under its shadow.

6. Screens

Those who have grown up in the generation of postmemory have had to live with these broken, forestalled, viewing relations. The break preceded us, but each of us relives it when, like Alice Kaplan, we first find those images in a desk drawer or in a book. Through repetition, displacement, and recontextualization, postmemorial viewers attempt to live with, and at the same time to reenvision and redirect, the mortifying gaze of these surviving images.

In her extensive interviews with children of Holocaust survivors, Nadine Fresco describes the silences that separate them from their parents. The stories never get told; instead they are expressed symptomatically, acted out between parents and children: "the forbidden memory of death manifested itself only in the form of incomprehensible attacks of pain. . . . The silence was all the more implacable in that it was often concealed behind a screen of words, again, always the same words, an unchanging story, a tale repeated over and over again, made up of selections from the war."[38] When Fresco describes what she calls the "black hole" of silence, she insists on the repetition of the words that shield us from that silence, "again, always the same, unchanging, repeated over and over." The images that are used to memorialize the Holocaust by the postmemorial generation, in their obsessive repetition, constitute a similar shield of unchanging trauma fragments, congealed in a memory with unchanging content. They can thus approximate the shape of narrative testimonies, *producing* rather than *shielding* the effect of trauma. Rather than desensitizing us to the "cut" of recollection they have the effect of cutting and shocking in the ways that fragmented and congealed traumatic memory reenacts the traumatic encounter. The repeated images make us relive the broken looking relations occasioned by the murderous gaze of National Socialism.

Their repetition in books and exhibitions can be seen as a form of protection and a refusal to confront the trauma of the past. In Eric Santner's terms they would thus function as a kind of *Reizschutz*—"a protective shield or psychic skin that normally regulates the flow of stimuli and information across the boundaries of self" (151). As Santner, in this reading of Freud's *Beyond the Pleasure Principle* insists, the shield that allows individual and collective identities to reconstitute themselves in the wake of trauma has a textual quality which has to include a certain "homeopathic procedure," illustrated by the "fort/da" game through which Freud's grandson masters loss. "In a homeopathic procedure the controlled introduction of a negative element—a symbolic, or in medical contexts, real poison—helps to heal a system infected by a similar poisonous substance" (146). But if the "fort/da" game is about integrating trauma and about healing, the repetitions of these images do not have the same effect.

In my reading, repetition is not a homeopathic protective shield that screens out the black hole; it is not an anesthetic, but a traumatic fixation. Hal Foster

defines this paradox in his analysis of Andy Warhol's repetitions which, he argues, are neither restorative nor anesthetizing: "the Warhols not only *re*produce traumatic effects, they also *produce* them. Somehow, in these repetitions, several contradictory things occur at the same time: a warding away of traumatic significance *and* an opening out to it, a defending against traumatic affect *and* a producing of it."[39] This is how we can see the closed gates of Auschwitz: the gate is closed, acting as a screen, but it is in itself so real as to disable the screen's protective power.

The repeated Holocaust photographs connect past and present through the "having-been-there" of the photographic image. They are messengers from a horrific time that is not distant enough. In repeatedly exposing themselves to the same pictures, postmemorial viewers can produce in themselves the effects of traumatic repetition that plague the victims of trauma. Even as the images repeat the trauma of looking, they disable, in themselves, any restorative attempts. It is only when they are redeployed, in new texts and new contexts, that they regain a capacity to enable a postmemorial working through. The aesthetic strategies of postmemory are specifically about such an attempted, and yet an always postponed, repositioning and reintegration.

7. Night and Fog

I would like to conclude these reflections with two postmemorial texts that illustrate the more enabling functions of repetition. The first, Art Spiegelman's *Maus*, has already constituted a theme in these pages. Almost all of the frequently repeated images of the Holocaust have found their way into this work: the two gates of Auschwitz, the guard towers, the liberator images, the mass graves. Often several of these are on the same page. Spiegelman's use of these repeated images reminds us how much we may need and rely on canonization and repetition in our postmemorial discourse. In his text they have the function of memory itself. His graphic versions recall the photographs we have all seen, reinforcing a common canon of shared images that will extend into the next generations. In participating in the repetition, Spiegelman reminds us that memory also depends on forgetting, that reduction and canonization, and also figuration, are indeed crucial to the work of postmemory. And in translating the photographs into a new graphic idiom he unhinges them from the effects of traumatic repetition, without entirely disabling the functions of sense memory that they contain.

But *Maus* contains a contrary impulse, as well. Based on extensive and meticulous visual research, *Maus* also reproduces an number of less available images, calling our attention to the enormous archive of photographs, drawings, documents, and maps both by basing his drawings on them and by reproducing them in the CD-ROM edition of *Maus*. Readers of the CD-ROM can click on a frame to make different archival images appear, showing how numerous less visible images

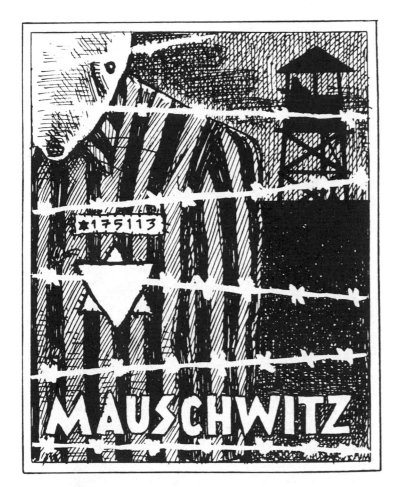

Figure 12. From Maus: A Survivor's Tale, *vol. II, Pantheon Books,* © *Art Spiegelman.*

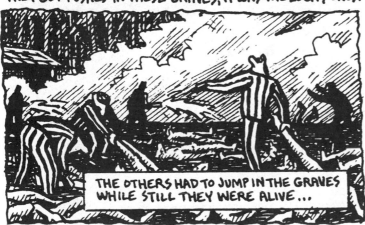

Figure 13. From Maus: A Survivor's Tale, *vol. II, Pantheon Books,* © *Art Spiegelman.*

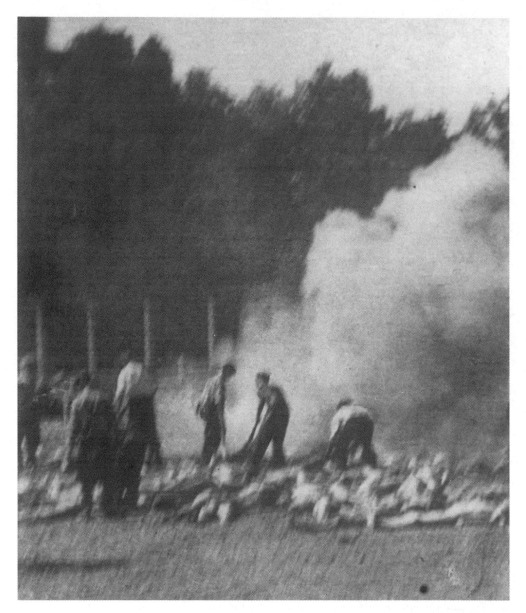

Figure 14. Clandestine image of Sonderkommando *forced to burn bodies in Birkenau.* Archiwum Panstwowego w Oswiecimiu-Brzezince, courtesy USHMM Photo Archives.

are actually hiding behind the more visible ones. The technology of the CD-ROM is well suited to this revelation. In figure 13, for example, Spiegelman highlights the astounding clandestine images taken by resistance members in Auschwitz. Spiegelman's multiplication is a necessary corrective which counteracts the canonization of a small number of images.

The second text, Lorie Novak's photograph "Night and Fog" also resituates archival images in a new frame. The title refers to Alain Resnais's film and the source of this generation's encounter with the documentary images of the

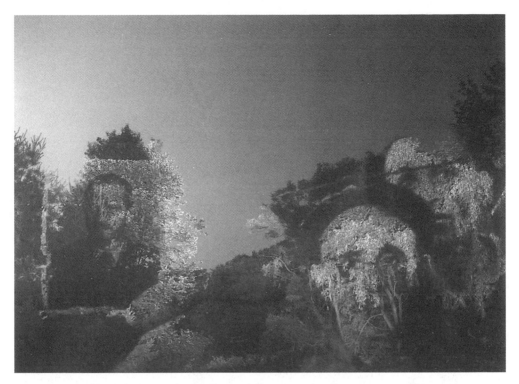

Figure 15. Night and Fog. *Color photograph.* © Lorie Novak 1991.

Holocaust. The image itself is a composite projection onto a nighttime scene: on the right there is a fragment of Margaret Bourke-White's famous picture of the Buchenwald survivors behind the barbed wire fence (figure 3). On the left we can just barely see a hand holding an old torn photograph. This is a found image from the New York Public Library of someone's relative lost in the concentration camps. The two pictures are projected onto trees: the ghosts have become part of our landscape, they have reconfigured our domestic and public spaces. Projecting photographs unto trees enables us to see memory as constructed, as cultural rather than natural.

Novak's is a stunning, haunting picture that contains but is not dominated by the repeated trauma fragments of Holocaust imagery. Their appearance illustrates Michael Rothberg's notion of "traumatic realism": "a realism in which the scars that mark the relationship of discourse to the real are not fetishistically denied, but exposed; a realism in which claims to reference live on, but so does the traumatic extremity that disables realist representation as usual."[40] The hand in Novak's image introduces a viewer, someone who holds, listens, and responds. That postmemorial artist/viewer can intervene and connect the public and private images that have survived the Shoah, introducing them into a landscape in which they have an afterlife. And although her powerful projectors and her title "Night and Fog" recall the most fearful moments of the Nazi death machinery, her multiple images, taken at different moments and brought together here, can,

like Spiegelman's, succeed in disconnecting the camera from the weapon of mass destruction and thus in refocusing our look.

Looking at this image of a projection is very different from looking at the documentary images from the Holocaust. If we recognize its content, however, it is because we have seen those other pictures during all our lives. But in these projections, as in Spiegelman's drawings, we can begin to move beyond the shock of seeing them for the first time, again and again. We can also move out of their obsessive repetition, for they are both familiar and estranged. And thus they reconstitute a viewing relation that cannot be repaired, but that can perhaps be reenvisioned in ways that do not negate the rupture at its source.[41]

NOTES

1. Susan Sontag, *On Photography* (New York: Anchor Doubleday, 1989), 19, 20.

2. Alice Kaplan, *French Lessons* (Chicago: University of Chicago Press, 1993), 29, 30.

3. Geoffrey Hartman, *The Longest Shadow: In the Aftermath of the Holocaust* (Bloomington: Indiana University Press, 1996), 152.

4. Barbie Zelizer, *Remembering to Forget: Holocaust Memory Through the Camera's Eye* (Chicago: University of Chicago Press, 1998).

5. See, for example, the photographs collected in the controversial exhibition and catalogue *The German Army and Genocide: Crimes Against War Prisoners, Jews and Other Civilians, 1939–1944*, tr. Scott Abott (New York: The New Press, 1999), which documents not only the atrocities committed but the passion for documenting atrocities photographically.

6. See Mendel Grossman, *With a Camera in the Ghetto [Lódź]*, tr. Mendel Kohansky (Hakibutz Hameuchad: Ghetto Fighters' House, Lohame HaGetaot, 1970); Peter Hellman, ed., *The Auschwitz Album: A Book Based on an Album Discovered by a Concentration Camp Survivor, Lili Meier* (New York, 1981); Joe Julius Heydecker, *Where Is Thy Brother Abel?: Documentary Photographs of the Warsaw Ghetto* (Sao Paolo: Atlantis Livros, 1981); Ulrich Keller, ed., *The Warsaw Ghetto in Photographs: 206 Views Made in 1941* (New York: Dover Publications, 1984); Jürgen Stroop, *The Stroop Report: The Jewish Quarter of Warsaw Is No More!*, tr. Sybil Milton (New York: Pantheon, 1979); Gerhard Schönberger, *Der gelbe Stern: Die Judenverfolgung in Europa 1933–1945*, 2nd rev. ed. (Frankfurt: Fischer, 1993); Teresa Swiebicka, ed., *Auschwitz: A History in Photographs* (Oswiecim, Bloomington, Warsaw: Auschwitz-Birkenau State Museum and Indiana University Press, 1990).

7. Sybil Milton, "Photographs of the Warsaw Ghetto," *Simon Wiesenthal Center Annual* vol. 3 (1986): 307. Milton's judgment has recently been repeated by two scholars who have attempted to historicize and thus to demystify the "atrocity photos" taken by the liberators in 1945. In her rich *Remembering to Forget*, Barbie Zelizer says: "Certain atrocity photos resurfaced time and again, reducing what was known about the camps to familiar visual cues that would become overused with time" (158). See also Cornelia Brink, *Ikonen der Vernichtung: Öffentlicher Gebrauch von Fotografien aus nationalsozialistischen Konzentrationslagern nach 1945* (Berlin: Akademie Verlag, 1998): "The number of images that spontaneously come to mind when one speaks of concentration and death camps, is limited, and the impression imposes itself that since 1945 the very same images have repeatedly been reproduced" (my translation), (9).

8. In *Remembering to Forget*, Zelizer traces in detail how certain liberator images, some of which were originally associated with specific dates and individual camps, eventually get mislabeled and associated with other camps, or come to signal more and more general and abstract images of "death camps," or "the Holocaust," or become unspecific "signifiers of horror." Even at the time of their production, most of these images were not carefully labeled or situated, but now the credits identify neither the photographers nor the original photo agencies for which they worked, but merely the contemporary ownership of the images. Attribution and content are even more difficult to determine when it comes to perpetrator images. The controversy that tem-

porarily closed the Wehrmacht exhibition concerned eight or nine photographs that depicted German soldiers standing next to civilian victims: what is not readable from the images themselves is whether the corpses were the victims of documented Wehrmacht and SS killings or of the Soviet NKVD massacres that preceded those killings. See *The German Army and Genocide*, 82–83.

9. See Eric Santner's useful notion of "narrative fetishism" in "History Beyond the Pleasure Principle: Some Thoughts on the Representation of Trauma," in *Probing the Limits of Representation: Nazism and the "Final Solution,"* ed. Saul Friedlander (Cambridge, Mass.: Harvard University Press, 1992), 144ff.

10. See Dominick LaCapra's useful notions of "muted trauma" and "empathic unsettlement" as well as his distinction between "acting out" and "working through" in *Representing the Holocaust: History, Theory, Trauma* (Ithaca: Cornell University Press, 1994) and *History and Memory After Auschwitz* (Ithaca: Cornell University Press, 1998).

11. It is important to note that, as my initial quotations from Sontag and Kaplan indicate, my inquiry is restricted to the memory and postmemory of victims and bystanders, not of perpetrators. For an appreciation for the different issues raised by German encounters with Holocaust photographs, see Cornelia Brink, *Ikonen der Vernichtung*, and Dagmar Barnouw, *Germany 1945: Views of War and Violence* (Bloomington: Indiana University Press, 1996). Both focus specifically on liberator images and their use in Germany in 1945 and after. The Alice Kaplan passage illustrates what happens when images migrate from one context to another, in this case, from their juridical use at Nuremberg to the childhood drama of a third-grader in Ohio. See also Bernd Hüppauf, "Emptying the Gaze: Framing Violence through the Viewfinder," *New German Critique* 72 (Fall 1997): 19: "There is no simultaneity and hardly any exchange of ideas between the U.S. discourse on representations of the Holocaust and the German discourse on the subject."

For a discussion of the redeployment of Holocaust photographs in the representations of contemporary artists, see Andrea Liss, *Trespassing Through Shadows: Memory, Photography and the Holocaust* (Minneapolis: University Press of Minnesota, 1998) and James Young, *At Memory's Edge: After-Images of the Holocaust in Contemporary Art and Architecture* (New Haven: Yale University Press, 2000).

12. See "Family Pictures: *Maus*, Mourning and Post-Memory," *Discourse* 15, no. 2 (Winter 1992–93): 3–29 and *Family Frames: Photography, Narrative and Postmemory* (Cambridge, Mass.: Harvard University Press, 1997), esp. chaps. 1 and 8.

13. Appendix, *The Complete Maus* on CD-ROM (New York: Voyager, 1994).

14. For a companion essay to this one, which examines more closely the relationship between postmemory and identification, see my "Projected Memory: Holocaust Photographs in Personal and Public Fantasy," in *Acts of Memory: Cultural Recall in the Present*, ed. Mieke Bal, Jonathan Crewe, and Leo Spitzer (Hanover: University Press of New England, 1999) and also *Public Fantasy*, ed. Lee Edelman and Joe Roach (New York: Routledge, forthcoming). There I discuss postmemory in relation to Kaja Silverman's notion of "heteropathic" memory and identification in her *Threshold of the Visible World* (New York: Routledge, 1996).

15. We cannot understand the workings of Holocaust postmemory without also considering the particularities of a Jewish memorial tradition that is based on identification and ritual reenactment, the sense that "we are all as slaves coming out of Egypt." Yet the experiences of the Holocaust also pose particular challenges to this tradition, since the identification of Holocaust postmemory, I believe, must be marked by the distance that characterizes the second generation's incapacity ultimately to comprehend and thus to internalize the extremity of parental trauma. It can never be even a ritual reenactment like that of the Passover seder, for example.

16. Cathy Caruth, *Unclaimed Experience: Trauma, Narrative and History* (Baltimore: Johns Hopkins University Press, 1996).

17. Robert Jay Lifton, *The Broken Connection: On Death and the Continuity of Life* (New York: Simon and Schuster, 1979), 176, cited in Santner, 152.

18. Hüppauf stresses the necessity of just such a reading: "Theories of perception and visuality have hardly made an inroad into discourse on the Holocaust, and, in more general terms, the violent practices of the Third Reich." "Emptying the Gaze," 14.

19. Ida Fink, "Traces," in *A Scrap of Time*, tr. Madeline Levine and Francine Prose (New York: Schocken, 1987), 135–37.

20. Roland Barthes, *Camera Lucida: Reflections on Photography*, tr. Richard Howard (New York: Hill and Wang, 1981), 76, 77, 80, 81.

21. Jill Bennet, "Within Living Memory," in *Telling Tales*, exhibition catalogue (Sydney, Australia: Ivan Dougherty Gallery and Graz, Austria: Neue Galerie am Landesmuseum Joanneum, 1998), 10–11.

22. Zelizer, *Remembering to Forget*, 9, 10.

23. I discuss several other emblematic images, particularly those of children—the little boy with raised hands from the Warsaw ghetto and Anne Frank's face—in "Projected Memory."

24. Patricia Yaeger's "Consuming Trauma; or, the Pleasures of Merely Circulating," *Journal* x (1997) 2, 225–51, serves as the most powerful cautionary note against textualizing and theorizing on the basis of the dead bodies of others. I am painfully aware of the risks I take in discussing as figures images that are as uncompromisingly literal, present, and pervasive as these. And yet, I am also convinced that their power need not be undermined by a discussion of the metaphoric roles that they have come to play.

As arresting as they are, these emblematic images have undoubtedly reduced our ability to understand or envision the multifaceted reality of concentration camps. As Dan Stone has said in his "Chaos and Continuity: Representations of Auschwitz," "ever since the first photos of Auschwitz, the meaning imputed to it has been encompassed in the symbolic framework of the barbed wire, the ramp, or the famous entrance gate. These things are of course important parts of the camp, yet they are not the camp *but only how we wish to keep seeing it*" (emphasis added). In *Representations of Auschwitz: Fifty Years of Photographs, Paintings and Graphics*, ed. Yasmin Doosry (Oswiecim: Auschwitz-Birkenau State Museum, 1995), 27.

25. Dwork and van Pelt even suggest that the part of Auschwitz I that was preserved as a museum was determined by the place of the gate. See "Reclaiming Auschwitz," in *Holocaust Remembrance: The Shapes of Memory*, ed. Geoffrey Hartman (Cambridge, England: Basil Blackwell, 1994), 236–37.

26. The centrality of this image in *Maus* is underscored by the introduction to the CD-ROM edition in which Spiegelman uses it to illustrate his construction of a page: "The size of the panel gives weight, gives importance," he says. "This is the largest panel in the book, too big to be contained by the book—the entrance into Auschwitz."

27. Jacques Lacan's discussion of the simultaneously literal and figural functioning of doors and gates might be useful in explaining the importance these two images have assumed in Holocaust representation: see "Psychoanalysis and Cybernetics, or on the Nature of Language," in *The Seminar of Jacques Lacan, Book II*, ed. Jacques-Alain Miller, tr. Sylvana Tomaselli (New York: W. W. Norton, 1988). Just in the way that doors can only be open because they can also be closed, things can be remembered only because they can also be forgotten. In the cultural remembrance of the Holocaust, the gate is both memory and a defense against memory.

28. See my discussion of the co-implication of these two kinds of Holocaust photographs in *Family Frames*, 20, 21. See also Cornelia Brink's response and elaboration of my argument, "'How to Bridge the Gap:' Überlegungen zu einer fotographischen Sprache des Gedenkens," in *Die Sprache des Gedenkens: Zur Geschichte der Gedenkstätte Ravensbück*, ed. Insa Eschebach, Sigrid Jacobeit, and Susanne Lanwerd (Berlin: Edition Hentrich, 1999). Gerhard Schönberger implicitly makes a similar point in *Der gelbe Stern* when he juxtaposes, on facing pages (280 and 281), the bulldozer image from Bergen Belsen with a poster that Louis Lazar from Nyons, France, has made of images of his lost relatives.

29. Christian Metz, "Photography and Fetish," in *The Critical Image: Essays on Contemporary Photography*, ed. Carol Squiers (Seattle: Bay Press, 1990), 158.

30. See especially Jacques Lacan, *Four Fundamental Concepts of Psychoanalysis*, tr. Alan Sheridan (New York: Norton, 1978), Jonathan Crary, *Techniques of the Observer: On Vision and Modernity in the Nineteenth Century* (Cambridge, Mass.: The MIT Press, 1990), and Kaja Silverman, *Threshold of the Visible World*.

31. Interestingly, some contemporary German theories of visuality, especially feminist theories, continue to stress the violence of photographic technology and thus of the photographic act. See, for example, the work of Christina von Braun and Silke Wenk.

32. This image is widely reproduced; see, for example, Michael Berenbaum, ed., *The World Must Know: The History of the Holocaust as Told in the Holocaust Memorial Museum* (Boston:

Little, Brown and Company, 1993), 98. The recent controversy in Israel's Yad Vashem illustrates the particular issues facing Jewish viewers of these images. Citing the taboo against female nudity, Orthodox Jews argued against the display of images of nude or scantily dressed women in the photographic exhibitions of the destruction of European Jews. For them the issue is the potential arousal of male viewers by the exposed female bodies. Although, in contrast to the Orthodox line, one might well argue that pedagogy demands that the worst be shown, one might also worry about the violation inherent in such displays: these women are doomed in perpetuity to be displayed in the most humiliating, demeaning, dehumanizing position. Given the invisibility many European Jews worked so hard to enjoy, perpetrator images are also fundamentally troubling in their hyperbolic identification of Jews as Jews and as victims. The act of looking, in these cases, is marked in complicated ways by power, religion, and gender.

33. I am grateful to James Young for bringing these images to my attention and to Alex Rossino for discussing them with me at length. These are clearly images of professional quality, indicating that they were taken by an official propaganda corps. Bernd Hüppauf explains this work: "Photos and descriptions inform us about groups of soldiers positioned at the edge of the killing sites, often in elevated positions that provided an unrestrained field of vision. . . . There they watched for an hour or more and sometimes took photographs." "Emptying the Gaze," 27. The angle of vision in this group of images does indeed indicate the photographers' elevated position.

34. For a suggestive discussion of perpetrator representations, see Gertrud Koch's analysis of some perpetrator images from the Lódź ghetto in the context of Nazi aesthetic in *Die Einstellung ist die Einstellung: Visuelle Konstruktionen des Judentums* (Frankfurt: Suhrkamp, 1992), 170–84. Koch looks specifically at devices like lighting and framing that clearly identify the subjects of the images as "Jews" and as "other," contrasting them distinctly with similar images of German subjects.

35. Bernd Hüppauf in "Emptying the Gaze" traces his own analysis of the alienated decorporealized technological gaze characterizing the Nazi regime back to Ernst Jünger's extensive writings on the photography of World War I in "Über den Schmerz," *Essays I, Werke 5* (Stuttgart: Klett-Cotta, 1963): "A photograph then is outside of the zone of sensibility. . . . It captures the flying bullet as well as the human being at the moment when he is torn to pieces by an explosion. And this has become our characteristic way of seeing; photography is nothing else but an instrument of this, our own character'" (Jünger in Hüppauf, 25). Hüppauf describes the images of perpetators as embodying an "empty gaze from no-where." For a dissenting interpretation of soldier's photographs, see Alexander B. Rossino, "Eastern Europe Through German Eyes: Soldiers' Photographs 1939–42," *History of Photography* 23, 4 (Winter 1999): 313–21.

36. See, for example, Kaja Silverman's discussion of the picture of a woman arriving in Auschwitz that is included in Haroum Farocki's film *Bilder der Welt und Inschrift des Krieges*. Silverman and Farocki perceive in the woman's look at the camera a resistant posture: it is a look one might use on the boulevard rather than in the concentration camp, she says. "The critical problem faced by the Auschwitz inmate is how to be 'photographed' differently—how to motivate the mobilization of another screen" (*Threshold*, 153). There are moments when this seems like an impossible task.

37. Barbie Zelizer comments on the frequency with which survivors are depicted from a straight frontal perspective, staring directly into the camera, as though "to signify frankness" (*Remembering to Forget*, 114). As other types of images, such as those of witnesses or images of perpetrators, have disappeared from view, these frontal shots of survivors, such as we see in figure 3, have become more common. Interestingly, this particular image by Margaret Bourke-White was not published at the time of the camps' liberation, leading Zelizer to conclude that "images can work better in memory . . . than as a tool of news relay" (183).

38. Nadine Fresco, "Remembering the Unknown," *International Review of Psychoanalysis* 11 (1984): 417–27.

39. Hal Foster, *The Return of the Real: The Avant-Garde at the End of the Century* (Cambridge, Mass.: The MIT Press, 1996), 132.

40. Michael Rothberg, *Traumatic Realism: The Demands of Holocaust Representation* (Minneapolis: University of Minnesota Press, 2000). See also Saul Friedlander's notion of "allusive or distanced realism" in *Probing the Limits*, 17.

Marianne Hirsch

41. I would like to thank the faculty, participants, and audience of the 1998 School of Criticism and Theory at Cornell University, as well as the audiences at the University of New Hampshire, the University of Pennsylvania, Princeton University, the University of Wisconsin at Milwaukee, and Boston University, for the helpful discussions following my presentation of this argument. Many thanks also for the probing readings of Elizabeth Abel, Jonathan Crewe, Susannah Heschel, Mary Jacobus, Nancy K. Miller, Rebecca Schneider, Leo Spitzer, and Susanne Zantop.

Barbie Zelizer

Gender and Atrocity:
Women in Holocaust Photographs

When confronted with evidence of the Nazi atrocities of World War II, it seems impossible to envision a way in which the phenomenon might be made more extreme. The words used to characterize Nazi brutality defy standardization: horrific, evil, beyond belief. This chapter, however, considers one aspect of Nazi atrocity where the supposed fragility and vulnerability of its victims wrap its consideration with a double dose of incomprehensibility—atrocities against women. While doing so by no means undercuts the centrality of ethnicity as the primary identity marker in Nazi consciousness, here I have elected to splice out the experience of women in the camps and their photographic depiction at the moment of liberation.[1]

Specifically, I examine here the photographic portrayal of women in the photos taken of the liberation of the concentration camps during the spring of 1945 and published in the U.S. and British daily and weekly press. While gender did not necessarily figure as an a priori representational category for the takers of these atrocity photos—largely members of the U.S. and British liberating forces who stumbled through the camps over a three-week period and randomly took pictures—its emphatic presence as a post-phenomenon category of analysis demands consideration. What, if anything, does gender tell us about the shape of atrocity in the public imagination? Additionally, how does the visual domain figure in the gendered representation of atrocity?

Photographing the Liberation

Photography of the liberation of the concentration camps of World War II is a record in need of attention. The horrors of the camps were photographically depicted in a vast array of circumstances by individuals with varying skills and agendas. From the U.S. Engineering Corps officer, numbed by a frenzied shuffle that transported him from camp to camp with a camera in his pocket, to the Signal Corps photographer, borrowed from *Life* magazine to bring home the camp

scenes first to the military pool and then to the homefront, the photographers of the camps were largely unaware of what they were about to see before they encountered it. The record of atrocity that they produced is therefore raw, harshly realistic, and alarming for its intrusive attentiveness to the details and nuances of evil.

The record, however, is also patterned and repetitive. Photos of Bergen-Belsen faded into depictions from Buchenwald or Dachau, as photographers with varying levels of expertise, experience, and authority took fundamentally similar shots of fundamentally similar scenes. Stick-like figures, gaping mounds of human bodies, stark death machinery—these shots and others tackled our senses with irreparable yet repeated horror, filling the pages of nearly every newspaper and journal in the United States and Britain for over a three-week period in 1945. Amply presented then and recycled with predictable regularity over the decades that followed, the photography of the camps' liberation became in many ways a visual memory of what we have come to call the Holocaust.[2] The long list of events, actions, policies, and stories that became the Holocaust was eventually reduced for many to a few stock shots, brought out every so often to visually remind the world of the mangled realities that produced them.

How was this visual record of Nazi atrocity produced? Significantly, the camps' liberation occurred at a time when the status of the photograph in daily news was somewhat uncertain, photojournalists were still called "pictorial reporters," and images were codified as adjuncts to the written word that needed the intervention of reporters to make sense.[3] The press had not thought how to make images into autonomous carriers of information, photographers interested in news had not organized standards of practice that all agreed on or carried out, and most photographs of the time did not contain delineating features that connected them with texts—features like captions, credits, and a precise relationship to the texts that they accompanied all lacked explicit form.

Additionally, the circumstances under which the atrocity photos were produced were difficult, if not untenable. British and U.S. forces entered the concentration camps of Europe over a three-week period in April and May 1945. Often in step with the frontline commanders went photographers and reporters, who documented what the liberating forces were seeing. As U.S. photographer Margaret Bourke-White later put it, "it was like a twilight of the gods. No time to think. No time to interpret. Just rush to photograph, write, or cable it. Record it now—think about it later. And history will form the judgments." The scenes of the camps were largely unexpected. The press had not sufficiently reported on the atrocities prior to liberation and was thus ill-prepared for the carnage that it found. The camps were so numerous that the U.S. and British forces often came upon them by accident, and photographers followed on their heels, stumbling onto the scenes of atrocity inside. Furthermore, faulty equipment, bad weather, and uneven training and experience all conspired to make photography difficult. Not surprisingly, then, much of the photographic response to the camps was a case of "making do,"

an improvisory response to a circumstance in need of recording without sufficient means or rules for recording and making sense of it.[4]

But with the liberation of the camps, the image became central. The press needed to establish an authoritative record of what it was seeing and help convince disbelieving publics that what was happening in the camps was real. Photographers were stationed across occupied Europe—serving with the U.S. Signal Corps, the British Film and Photographic Unit, the service associations, and as photojournalists. As professionals, semiprofessionals, and amateurs, these photographers took shots of all that they saw—stacks of corpses, open pits serving as makeshift graves, black and white skeletal figures angled like matchsticks across the camera's field of vision. For a three-week period in April and May 1945, their photographs filled the pages of the daily and weekly press in the United States and Britain, displaying gruesome shots the likes of which had rarely been seen before and dramatically altering the performance of photos in news. For one of the few times in history, the pictures became the main event of the record. And for many on the homefront, these photographs became the crowning proof of Nazi atrocity. Although "revolting" and "distasteful," one newspaper said at the time, the pictures "brought home a cold truth. . . . If anyone ever doubted the animal viciousness of the Nazi mind, he can no longer deny [it]."[5]

For reporters and photographers, the atrocities perhaps loomed larger than any other event they had been responsible for documenting. No surprise, then, that when faced with the atrocities of the camps, they not only documented what they saw but bore witness to its atrocities, using their reports and photographs as a way of taking responsibility for the horrors of Nazi Europe. Bearing witness meant that the press fulfilled a responsibility for documentation that went beyond mere journalistic coverage: it transmitted coverage in a way that would enable the outside world to see what had happened. Bearing witness forced the press to adjust its practices of newsmaking—pooling resources, portraying parts of the story repeatedly so as to confirm reports already tendered, ignoring scoops, and avoiding competition. It also set in place representations of the camps that quickly took on iconic status: readers began to receive photographic images resembling the photos that had appeared earlier. Heaps of corpses, emaciated bodies, women, men, and children behind barbed wire, and accoutrements of atrocity, such as the gas chambers, hanging rooms, and crematory ovens, all surfaced repeatedly as the press struggled to depict the atrocities of the camps.

These circumstances helped create two sets of expectations surrounding the atrocity photos. One expectation was that the photos would document the horrors wrought by the Nazis in a realistic and referential fashion. Here, the photograph's role was seen as accurate, fact-driven, and natural, providing verisimilitude and denotatively recording events "as they were."

A second expectation coopted the photographs as markers of a larger story, infused with broader cultural meanings that did not necessarily undercut the photos' referential force but contextualized it against a more general understanding

of what had happened. Here, the photograph's role was seen as symbolic, metaphoric, and universal, providing context to the grounded and concrete depictions that it displayed. This was accomplished by presenting photographs in nonreferential ways, without credits, with captions that bore generalized titles like "Nazi Atrocities," and without any definitive linkage to the texts at their side.[6]

The positioning of women within the atrocity photos echoed these larger representational impulses at the core of atrocity's visualization. These broad expectations that shaped the liberation photos—to reference reality and to serve as symbols of a larger atrocity story—thereby also shaped the representation of female gender in depictions of Nazi atrocity.

Issues of gender were everywhere inside the camps of Nazi Europe. To begin with, Nazi policy was one of the first to strategically sentence women to death rather than treat them as war spoils.[7] Thus, women were from the onset "given" their own gendered category as part of the broader concentration camp experience.

Women both ran the camps and were incarcerated inside; certain sites, like parts of Belsen or Ravensbrueck, were reserved particularly for women. Women also played an active part in documenting the Nazi atrocities, serving as both photographers and reporters. Photographers, such as Lee Miller and Margaret Bourke-White, later won acclaim for the photographs of carnage that they produced. Miller even declared herself tougher than many of the male medics around her; later she recounted how she was one of the few, among many male U.S. soldiers, who was able to stomach the scenes of the camps. Reporters like Marguerite Higgins, Martha Gelhorn, and Iris Carpenter braved the camps together with the first rush of military force; in fact, Higgins later claimed that she helped rush the gates of Dachau and inform the inmates inside that they were free. Women also served with the liberating forces, usually as nurses or aides in relief organizations; one such woman, a nurse at Mauthausen, wrote compellingly in later years of her time nursing the sick.[8] Women thus appeared liberally across the wartorn landscape, in nearly every kind of activity associated with the camps. In visual depiction, then, one could assume that they would turn up definitively across the landscape of representation as well. This, however, was not the case.

Women as Documents in the Atrocity Photos

Although women were to be found in nearly every setting of the concentration camps, their depiction was both strategic and contained. One of the first atrocity photos to appear with the liberation of the camps depicted a group of Russian women who had been victimized by the Germans. On April 9, 1945, three British newspapers—the *London Times, News Chronicle,* and *Daily Mirror*—printed pictures of the group, with the *Mirror* explaining that its staff "went out on this story deliberately in the belief that our readers ought to see these pictures."[9] The shots

depicted collective frontal shots, that were tame in comparison with what would later appear.

In that the need to particularize and uphold referential integrity, central to the atrocity photographs, was necessary to document the brutality which the Nazi regime waged against women, gender's recognition as a variable worthy of mention was evident already in the early coverage of the camps' liberation. Women were positioned as documents, both verbally and visually. When women were present in the story, their gender was clearly proclaimed. One article about Ravensbrueck's liberation that appeared in the *Daily Telegraph* declared that "Slave *Women* Lived Like Animals in Nazi Camp" [emphasis added]. The *Boston Globe* stated that at Bergen-Belsen the "Brutal *Nazi Girls* Danced as Victims Were Burned" [emphasis added]. And the *Daily Mail* ran an article announcing the composition of the official parliamentary delegation to the camps, that pronounced that there was "1 *Woman MP* On Terror Camp Mission" [emphasis added].[10] In each case, marking female gender highlighted even the headlines, necessitated partly by the fact that the discussed activities challenged expectations of female behavior in wartime.

No surprise, then, that the image's documentary role was an important feature of the initial photographs that circulated of women from the camps. Women appeared frequently in the early atrocity photos. When Bergen-Belsen was liberated, images of women filled the pages of the daily and weekly press. The *Illustrated London News* featured a five-page photographic spread of twenty-two images, many of which depicted women.[11] Evidence of gender literally leaked from the photographs. Due to their being defined as part of Hitler's plan for extermination, women seem to have been sprinkled across the war landscape in many ways.

Yet despite women's ubiquitous presence in the camps' liberation, women turned up visually in only highly strategic ways. When compared with words, images made it both easier and more difficult to mark the gender of the women at hand. It was easier because in most cases the mere visibility of women in the photos made it possible to identify them along gender lines. But it was more difficult because the images of women needed to be depicted in ways that supported the larger atrocity story being told. This meant that gender was sometimes emphasized in ways that did not necessarily match, support, or reflect the activities being depicted.

Women as Victims, Survivors, Perpetrators, and Witnesses

Women associated with the camps' liberation were photographically displayed in four linkages with atrocity, with women portrayed as victims, as survivors, as perpetrators of Nazi brutality, and as witnesses to what had been transpiring in the camps.[12] Each category displayed its own representational attributes. The

depiction of women thus had a distinct shape already at the time of the liberation's recording, and that recording impacted in turn on how women in the camps were remembered.

The victims of the concentration camps were primarily portrayed as the dead bodies of the atrocity photos. Images of female victims appeared less frequently than photographs of males, and they were contained by site, generally taken in the camps where women were specifically held, such as Bergen-Belsen and Ravensbrueck. Because the site, however, was not always made clear, images of female corpses were often appended to discussions of camps where no women were held.

Like their male counterparts, the female victims of Holocaust photographs were largely anonymous, unnamed, and stacked in unidentifiable masses. Atrocity photos displayed a marked preference for group or collective shots over pictures of the individual.[13] These group shots carried a particular significance, by which the collective embodying the status under question helped offset the public disbelief that greeted many of these images. This issue of number was instrumental for the act of bearing witness to the atrocities. Because victims were presented in heaps of corpses, in open graves, and littered across courtyards, they were often formless, making it difficult to discern which appendage belonged to which body.

Female survivors of the camps—those inmates of the camps who were portrayed alive—also appeared frequently. Survivors were portrayed both individually and in group shots. Individual survivors wore the faces of distress and agony. Nearly always portrayed in frontal gazes, these women usually looked directly into the photographer's eyes. Although their frontal gaze appeared to signify frankness, they seemed to look at the camera without really seeing. One such photo of women from Belsen showed two young adult survivors in a close shot that echoed their hollowed cheekbones and vacant eyes (figure 1). Gazing into the distance, they were seemingly oblivious to the fact that their photo was being taken. "Here's How Nazis Treat Their Captives . . . ," read the caption to this photograph in *PM*, and it implored readers to look at "the faces of these women."[14]

Depictions of the survivors' distressed and disoriented state were often matched by verbal testimonies from the liberators. As one photographer with the British Army Film and Photographic Unit later recounted, many women "were incapable of coherent thought. . . . It was a very silent, quiet business. They sat about, very little movement. Some of them were too far gone to move."[15]

Female perpetrators also frequented the photos. Harsh, angled, angry, and often maniacal, female perpetrators constituted the conscious underside to women's involvement in the atrocity story. Female perpetrators were the antithesis to all that was subjunctive and desired about women's gendered behavior in the camps.

A further category of representation was the female witnesses. Due to the broader aim of using coverage of the camps to bear witness, the depiction of witnesses was crucial. These shots of women—and men—who came to look, see,

Figure 1. Two survivors in Bergen-Belsen, April 30, 1945. Courtesy The Imperial War Museum, London.

pause, and contemplate made the moment of witnessing atrocities a central part of the representation of Holocaust atrocity. The action paused long enough for the camera to freeze the act of witnessing and separate it from the larger narrative of which it was a part. It was therefore an integral part of depicting the larger atrocity story; hence, shots of witnessing filled the pages of the daily and weekly press.

Witnesses were taken from all categories of persons—reporters, survivors, German civilians, officials, newspaper editors. In late April, General Dwight Eisenhower mandated that the sights of the camps should be seen by all, and he arranged for junkets of politicians, officials, and other public personalities to see for themselves what had happened. Female members of congressional delegations and British Parliament—notably, Claire Booth Luce and British MP Mavis Tate—were favored targets of depiction from these junkets.[16] Their act of bearing witness stood in for the absent witness during the long years of war.

German civilian women also appeared as witnesses in these depictions. Brought into the camps to pay heed to the mounds of corpses there, their depiction mirrored the complexity of the German response to atrocity. One such photo showed eight civilians, mostly women, walking gingerly around a dead body in their midst. The first woman looked at it and clutched her throat; the second put her hand over her mouth and looked directly at the camera; the woman behind her also looked at the photographer but in a way that suggested she was blinded by the camera. The varying responses not only mirrored Germany's collective discomfort as a nation but complicated the act of bearing witness in the public imagination.[17]

All of this is a long way of saying that women were featured in the atrocity photos, but in clearly strategic ways. For while the number of photographic depictions of women appears to suggest that women's experiences were reflected broadly, a closer examination reveals that this was not the case. Rather, women were depicted narrowly, in ways that upheld larger assumptions about what the atrocity photos were supposed to mean.

Women as Symbols of the Atrocity Story

It is here that the second expectation of the photographic image came into play. The need to universalize the depictions of those same photos and use them as broad symbols of atrocity made particular sense when it came to women, whose supposed fragility made the atrocious seem that much more so. In this light, we saw numerous photos with the expected universal markers—no caption, no credits, and appended to texts that did not address what the images depicted. For instance, *Time* displayed a picture of billowing smoke alongside a photo of SS guard Hilde Lobauer, portrayed as a maniacal opposite of fragility, in an article about Belsen. While the caption under both pictures asked "The End of Belsen?", in the accompanying text the U.S. newsmagazine transformed the specific images into symbolic markers of a story about human suffering and totalitarianism. "The meaning of Belsen," it declared, "was the meaning of all totalitarianism."[18]

Here, the representation of women followed larger patterns of representation, by which the contingent details of one specific photograph were generalized so as to accommodate a broader atrocity story. In a wide range of practices, both compositional and presentational, the photos were turned into iconic representations of atrocity. In composition, the photos reflected a story of wide-ranging Nazi brutality. They showed an emphasis on collectives rather than individuals and positioned the evidence of atrocity within a given shot in strategic ways. For instance, the evidence of atrocity was systematically placed either in the shot's foreground or background, forcing the public to attend both to the target of depiction and to the larger context of brutality into which it fit. One set of photos portrayed women in a series of domestic tasks related to personal hygiene or food preparation, dead corpses stacked behind them.[19]

In presentation—that is, practices involving credits, captions, and the linking of photos to texts—the photos communicated less the contingent details of a given photograph and more the broad atrocity story it invoked. Captions, for instance, routinely contextualized the target of depiction as a reflective representation of all Nazi atrocity, and pictures were often used to signal that broad context rather than illustrate what was being discussed. The picture thus rarely matched the text.

One such picture appeared in October 1941 and showed two weeping

elderly women, alongside a more general article entitled "The Terror in Europe." The picture's exact caption told readers little: "Horror! Their homes burnt. Their men killed. Their country crushed under the jackboot. These Polish women weep, as millions weep in the occupied territories."[20] What was significant was not only what was depicted but what was not: there was no identified photographer or photographic agency, no identified place in which the photograph was taken, no distinctive identity given to the women. The caption, which provided little referential information about what was being depicted, described the women in a passive voice that helped reinforce broader understandings of women as victims.

The representation of women in this scheme was crucial, for barbarism—as it was experienced, inflicted, and witnessed—did not fit fundamental assumptions about women. Rather, in altering conventional notions of wartime, it displayed the degree to which gendered expectations were out of synchronization with the reality that women experienced in the camps.

Thus, the emphasis on gender in the atrocity photos was enveloped by a broader thrust to use the photos as symbols both at the time and in the years that followed. Women's representation as part of the documentation of the Nazi atrocities played off of an ambivalence about the role of women in the barbarism at hand. Not only was the world made uncomfortable by the notion that women had participated in perpetrating the atrocities, but depictions of the female victims and survivors of the concentration camps raised the level of public discomfort by portraying a population that had suffered indignities of multiple proportions.

The documentation of women's experience in the camps was thereby shaped to fit dominant cultural assumptions about women in culture and society. Perhaps because women were presumed to be more vulnerable than men, the brutality both against women and by women was seen as doubly atrocious, challenging gender-based expectations of women and broader expectations of humanity. Not surprisingly, then, female gender was strategically emphasized in the photographic record of the camps that emerged.

The thrust toward universality, however, undermined the visual representation of women in the liberation photos. When used as universal and symbolic markers of atrocity, the photos were unable to document the full range of women's experience in the events being depicted. The broad narratives invoked to make sense of the larger story of atrocity had little place for attending to the specific experiences of women within that story. In effect, this thrust undercut a recognition of women at the time. The photos' ability to function as symbols of atrocity, then, was predicated on an inability to attend to gender as a way of lending differentiated meaning to those same symbols. Emphasizing gender, conversely, undid the ability to make sense of the photos through a larger story of atrocity. And so gender could only be admitted in ways that supported the larger atrocity story.

This is not to say that gender disappeared from the atrocity photos. After all, gender is an incontrovertible visible accoutrement of the visual depictions. Yet its inclusion, or lack thereof, raised questions about where one would find

gender, and what it would look like. How would it be textually anchored? Would there emerge categories of gender representation? And would representations of gender differ according to the type of woman represented?

Gender was thus represented in conjunction with two main impulses. In both, gender's presentation was laundered and simplified in ways that did not reflect realistically the gendered experiences at its core. Neither of these impulses was able to accommodate gender as a category of identity replete with complexities, nuances, and contradictions.

The impulses had an either-or quality about them: gender was either wholly absent or wholly present. In the first impulse, gender was overused in ways that simplistically upheld stereotypical notions of what "being a woman" could mean under the circumstances being depicted. In particular, these photos supported the visualization of women as nurturers, exemplified by both domestic and maternal markers. In the second impulse, gender was absent altogether from the visual representations. Here, women were depicted in the atrocity photos in ways that neutralized their gender. Neither mode of representation attended to womanhood in all of its complexities. Rather, gender was simplified and flattened, undermining the ability to depict women as they were more fully associated with the atrocities of World War II. Yet these representations fit larger agendas about using the photographic documentation of the camps of Nazi Europe as broad symbols of a larger story about atrocity, and that was why they persisted.

Women as Overgendered: The Surplus of Gender

The overgendering of women in the atrocity photos was a representational strategy evident already during the early years of the war. One typical photograph that appeared already in *Picture Post* in late 1941 declared that "Women Want to be Photographed."[21] The image showed five women, grouped together, hugging, and smiling broadly as they balanced small children on their knees. Taken following the group's rescue by the Eighth Army from a concentration camp in Italy, it was chilling for its posture of civility, domesticity, and sanity, all of which would be more difficult to find in later images of the camps.

The overgendering of women in the atrocity photos by definition produced explicit markers of a female gendered presence in the camps. Yet this gendered presence upheld stereotypes of women as nurturing, domesticated, fragile, and vulnerable. Overgendered representations tilted toward those categories that could be seen as weak and fragile—the victims, survivors, and in many cases witnesses.

Pictures of women victims and survivors, particularly the women of Bergen-Belsen, were splashed frequently across the front pages of the U.S. and British press, which used them to signal the depths to which Nazi barbarism had sunk. The photos stressed the women's vulnerability, their fragile bodies and vacant

eyes. Newspapers and journals underscored the fact that female U.S. congress-persons and British parliamentarians—notably, Clare Boothe Luce and Mavis Tate—froze or cried when they visited the camps.[22] As one headline in the *Daily Telegraph* proclaimed in reference to British parliamentarian Mavis Tate, *"Woman M.P. to See Horror Camps"* [emphasis added].[23] These simplified representations of gender were all that the larger atrocity narrative could accommodate, and the depictions flatted out the existences that they were supposed to represent, playing to predictable and conventional notions of gender behavior.

This meant that the depictions of women in the camps failed to reflect the full range of women's associations with the camps: for instance, activities of female resistance, heroism, and autonomy were rarely accounted for. Similarly, schematic discussions of women persisted in memory, too. In Holocaust museums, for instance, Claudia Koonz has shown that women's experiences in the camps were flattened beyond repair, despite the hundreds of documents that attest to the multidimensional existence of thousands of women prisoners. At Buchenwald, they have been forgotten; at Ravensbrueck, they "appear as enduring and noble victims. . . . heroic males resist and women (if depicted at all) persevere."[24] In photographs too, only certain types of representations persisted, highlighting a fundamental inability to visually accommodate the multidimensionality of women's existence in the camps.

Not surprisingly, marked gender appeared frequently in the representation of victims. The words of a British medical officer who confronted scenes of carnage at Belsen were reprinted widely on both continents: women's bodies, he said, "were piled to the height of a table. I saw four girls carrying a body which was thrown on a pile. And I saw a woman carry her dead baby to it."[25] The female victims of Belsen were pictured in heaps and open pits, often alongside the corpses of males.

In these images, bodies of women were strewn alongside those of children, in scenes depicting a kind of warped domesticity. One such image was taken at Belsen, and it appeared in the *Saturday Evening Post* and the British journal *Picture Post*.[26] Readers were told that it portrayed a brother and sister who had starved to death. But a corresponding shot, which extended from the children's bodies, revealed that of their naked mother lying on the ground nearby (figure 2). Womanhood was signified by the maternal embrace, even in death.

The corresponding photo was alarming: it showed a frontal shot of the naked woman's corpse, partially clad in a torn blanket. Her eyes were half-open in rigor mortis, her mouth posed as if to deliver a statement, a hand clasped across her protruding breast. Cascades of brunette ringlets showered across one shoulder, and she was nude from the waist down. The photo was arresting both for its graphic nudity and for the beauty of the woman portrayed therein. Yet it was not published at the time, but only later, after the liberation.

Why was one photo widely reproduced and the other accompanying it was not? It may have been that the woman of the latter shot—the mother of the dead

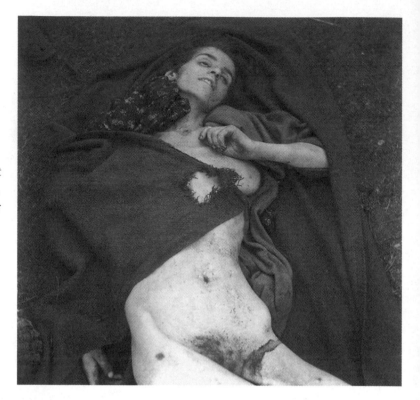

Figure 2. Corpse of mother at Bergen-Belsen, April 17, 1945. Courtesy The Imperial War Museum, London.

children—was considered both too beautiful and perhaps erotic to be shown. Her naked beauty, used years later by artist Robert Morris as the reality marker in his depiction of a beautiful woman innocently asleep under neon and strobe lights,[27] undermined the larger story of atrocity, which could accommodate depictions of her only as the victim of brutality. Her depiction, then, did not fit the unfolding story of Nazi barbarism.

Another category of representation that tended toward overgendered representation was the survivor. Women survivors were frequently portrayed in ways that underscored their ability to return to normalcy, signifying a warped extension of domestic and maternal roles alongside macabre scenes. In the group shots, women were portrayed in large, uniform groups that reflected their collective status. Numerous images showed the decrepit huts in Belsen, what one newspaper called a "filthy hut . . . [crowded] with women and children gaunt with hunger and dazed."[28]

Yet the same photos implied a return to normality, codified here as the resumption of practices reinstating the woman as nurturer. Returning to normalcy was seen as partly redeeming or mollifying the suffering of those who survived. Thus, group images of forced domesticity and collective intimacy reinstated the role of the woman as a provider of succor and consolation. Women were pictured combing lice out of each other's hair, scrubbing each other, washing pots and utensils, and cooking food. One caption told readers that the shot depicted "Where Women Had To Wash," implying that the resumption of hygienic routine would inevitably be woman's business.[29]

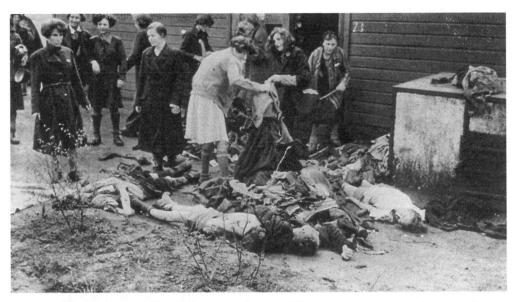

Figure 3. Survivors in Bergen-Belsen, April 29, 1945. Courtesy The Imperial War Museum, London.

No matter how macabre the circumstances, images reflected the capacity of women to carry on as nurturers. One British photographer who snapped shots of groups of women later recalled how odd the women had acted. "There were hundreds of bodies lying about, in many cases piled five or six high," he said. "Amongst them sat women peeling potatoes and cooking scraps of food. They were quite unconcerned when I lifted my camera to photograph them. They even smiled."[30] This was also the recollection of one of the women captured in the Belsen photos, Alice Lok Cahane. Cahane still recalls how bizarre it felt when she found herself smiling for the photographer, as if on automatic relay.[31]

Redeeming oneself through domestic routine was supported by most images, and in cases in which the photograph was not clear on this point, the caption underscored the expectation: one photo that appeared in the *Illustrated London News* showed women searching the clothes of other women who had died during the night (figure 3). The photograph was given different captions each time it was published. Readers were alternately told that the women were stripping the corpses of their clothes for fuel, so as to ready the bodies for burial, or to stop the spread of lice. Each caption suggested a slightly different anchoring to the same image; yet each also transformed what might have been an act of pilfering into an act of nurturing or concern.[32]

Domestic routine sometimes appeared in challenge to notions of what domesticity could mean under the circumstances. One series of photos showed a group of women at Belsen peeling potatoes in the foreground of the shot (figure 4).[33] Run as a front-page photo in the British *News Chronicle*, the shot was jarring precisely because of the juxtaposition between the shot's front and back; in the background appeared heaps of dead bodies, stacked across the horizon. The

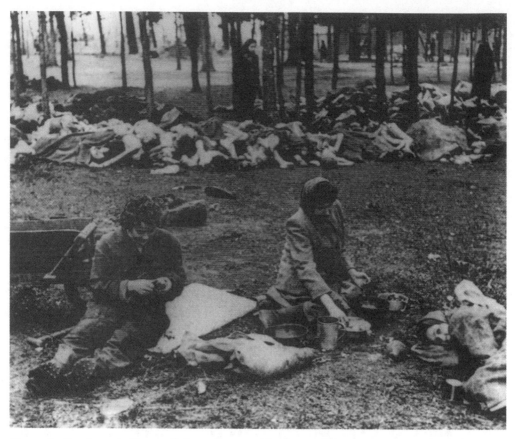

Figure 4. Survivors in Bergen-Belsen. Courtesy The Imperial War Museum, London.

juxtaposition of women doing women's work and evidence of carnage not only reinforced women as domesticated, but suggested again that women's work prevailed, regardless of the atrocities piling up alongside. The juxtaposition also stressed how survival—at least for women—came to be associated with a resumption of so-called normal or domestic routine.[34]

Overgendered representations of survivors were thereby doubly codified: both as portraits of horrible depravation and as attempts to maintain remnants of dignity in a world where dignity no longer prevailed. Collective perseverence and the ability to call upon one's role as nurturer in order to reinstate normalcy were key here.

Female witnesses were also represented in overgendered ways. As with the depiction of male witnesses, women were often portrayed looking at the atrocities without the atrocities depicted.[35] Such depictions were instrumental because they prolonged the act of witnessing and made it as newsworthy as the atrocities themselves. But unlike depictions of men, who primarily were depicted looking at dead bodies, female witnesses were also featured prominently talking with survivors. For instance, one photographic spread that appeared in the *Daily Mail* included one photograph each of Clare Boothe Luce and Mavis Tate talking to sur-

Figure 5. German civilians in Buchenwald, April 16, 1945. National Archives, courtesy of USHMM Photo Archives.

vivors, despite the fact that many men were on the delegation. The portrayal of women talking to live bodies rather than looking at dead ones again reinstated gendered expectations concerning women's traditional role as nurturer. Portrayals of women in this role again revealed fragility: one shot of the British parliamentary delegation to Buchenwald showed a group of a half-dozen parliamentarians overlooking a stack of corpses. All of the MPs looked impassive; only Mavis Tate covered her mouth with her hand.[36]

Here another kind of female witness surfaced frequently: the German civilian. Generally depicted on forced tours of the camps, mandated by Eisenhower's denazification campaign, collectives of anonymous female German civilians were often depicted together with their children, seemingly caught in the act of bearing witness. The women in these photos flinched, made faces, and appeared uncomfortable. Some fainted, cried, sneered. A few smiled. Some even looked away from the camera, in an act of refusing to bear witness.

One picture of German civilian females and children that appeared repeatedly portrayed middle-class Weimar residents brought into Buchenwald in the spring of 1945 (figure 5). Again, no atrocities were anywhere evident in the shot, and witnesses were portrayed but not that which was being witnessed. The civilians were in various stages of emotional disarray. One clutched a handkerchief to her chin, another looked as if she were about to cry, still another wore an expression

of disbelief. But each person conformed on one point: they looked to the left of the picture, staring at evidence of the atrocities beyond the camera frame. This aesthetic—showing witnesses without evidence of the atrocities—forced attention on the act of bearing witness. It froze the act of the women bearing witness in time and space, inviting readers to attend to what was being witnessed even if it was not shown. This aesthetic, again using women as witnesses, was repeated elsewhere, as in *Newsweek* under the caption "German women are unwilling witnesses."[37]

German women were also used as visual foils, sites of visual contrast to the emaciated figures of the survivors. One such picture was used in the *Picture Post* to lead into a six-page pictorial spread on the atrocities. The domesticity of the representation was clear: it showed a plump, well-dressed German woman holding a young blond boy, and the caption told readers that for this woman, "what happened inside meant nothing." The picture was juxtaposed with a second image of two stick-like survivors of the camps, and the titles to both photos extended the visual difference between them into verbal cues: one read "Inside the Wire," while the other proclaimed "And Outside."[38] Again, images of women, particularly with children, were used to signify the culpability of the entire German nation—an inverse case to the women and children pairs that appeared in representations of the victims and survivors.

After the liberation of the camps ended, one additional stage of representing the act of bearing witness took place, and it too displayed German women in the role of witness. Journals and newspapers printed numerous photographs of witnesses viewing photographs of the atrocities. Images that appeared in newspapers and newsmagazines again froze the act of witnessing in place,[39] but this time they underscored the centrality of photography as a primary documenter of the camp experience. Here, too, German women with children constituted a particularly memorable visual embodiment of the collective German response to the atrocities (figure 6).

These photos were significant because they showed collectives, in this case women with children, in the act of bearing witness to the photographic documentation. Like the earlier shots that portrayed groups viewing bodies, here we see groups viewing photos. The two women depicted in one shot from the *Daily Mirror* were typically angled toward the evidence of atrocity, the photos. Their backs were angled toward the camera, forcing the viewing audience to scrutinize the pictures at which the women themselves were looking. In its adjoining remarks, the *Daily Mirror* claimed that the photographs were a way of "holding the mirror up to the Huns," and it presented its own middle pages as the object of visual scrutiny.[40]

Women as Genderless: The Absence of Gender

The second gendering impulse behind the atrocity photos was to render gender invisible. In numerous cases of gendered representation, there was little or no visual

Figure 6. Civilians looking at pictures, April–May 1945. Courtesy The Imperial War Museum, London.

marker of gender itself. Such photos provided important markers of the boundaries of gendered expectations, for the point at which a woman was portrayed as genderless often underscored the boundary of what was seen as appropriate for members of that gendered group.

Λ genderless mode of representation involved all categories of women. To begin with, female victims, by virtue of their anonymity, often emerged as genderless. The gender of piles of human bodies or appendages depicted was typically indiscernable. The most striking example of such a presentation was Margaret Bourke-White's photo of a wagonload of corpses at Buchenwald.[41] Entitled simply "Victims of the Buchenwald Concentration Camp," the shot showed bodies that had been jumbled together in an indiscriminate heap, and it gave the impression that the piles of human feet and heads were about to spill over onto the photographer. Gender markers were virtually invisible. In fact, in most photos displaying nudity, the ability to distinguish between women and men was negligible. Only when some particularly female organ, such as a breast, protruded from the image, was it possible to detect a gender difference. In this respect, clothes assumed a bizarre role, taking on a referential power that the naked body lost in

many of these photographs. Seeing one clothed body atop a heap of naked ones often helped identify the body as that of a man or woman in a way not always made explicit by what should have been gender's most graphic state of display— that of nudity.

At times, genderless representation also characterized the visual depiction of survivors, whereby survivors lost gender specificity. One story frequently repeated involved a woman who insisted on being photographed in an upright position, looking alluringly at the camera, as she had been photographed before the war. Her postwar image, however, displayed an emaciated and marred body, with few signs of sexual appeal or even gender identity. Similarly, one liberator of Nordhausen was taken aback when he realized he had just encountered a young woman in the camp. He recounted that he thought he had been "talking to someone who looked just old and emaciated. It turned out to be a seventeen-year-old Jewish girl."[42]

However, the most frequently depicted category of genderless representation was the perpetrators. The female guards of the camps were shown in a highly codified fashion, as starch, rigid columns of women who were usually displayed in straight, forcibly arranged lines.[43] Largely portrayed as monsters who pushed the boundaries of female gendered behavior beyond the category itself, these women were presented without the expected gender markers, perhaps because their barbaric acts so directly challenged those expectations. Not surprisingly, then, they were also given labels like "fiendish," "monstrous," and "diabolical."

Women perpetrators signified the worst of Nazi barbarism. One article in *Time* juxtaposed a side view of an angry blond woman with a Belsen crowd scene. In the accompanying text readers were told that "these pictures are from the Belsen concentration camp. At left is Hilde Lobauer, known to the prisoners she terrified as 'the S.S. woman without a uniform.'"[44] Close shots of angry blond women were the norm.

The women perpetrators were almost always portrayed at harsh angles to the camera and in rigid and upright postures.[45] Shown with shaded faces, narrowed eyes, and lips that were pursed, their hair seemed to be the only feature in potential motion. In one such picture, women guards at Bergen-Belsen looked angry and cruel (figure 7). Only sometimes named, the derogatory labels they were given left little ambiguity concerning their identity. Called "the evil women of Belsen," "a study in evil," and the "female fiends of Buchenwald," they were characterized as "hatchet-faced," "fat," and "husky"—in a word, unwomanlike. Ilse Koch became the "Beast of Buchenwald," Irme Grese the "Bitch of Belsen." In most cases, their gender, skewed as it was, topped the titles they were given.

Sometimes perpetrators were shown with members of other groups—survivors and officials with the Allied forces who stared them down.[46] But in most cases these women looked only indirectly at the camera, their angry eyes portrayed at side angles to the camera lens, their faces averted. There were few attrib-

Figure 7. Former women guards at Bergen-Belsen, April 1945. Courtesy The Imperial War Museum, London.

utes that distinguished one body from another; rather, they presented as a uniform mass, bulky and rigid (figure 8). Interestingly, unlike the verbal representations of male guards, which seemed to focus more directly on character and human nature, the verbal descriptions attached to the photos of these women targeted their physical appearance—their husky build, blonde hair, harsh features. It was as if the behavior so violated expectations of women that the press sideswiped the issue of character by externalizing discussion of behavior on the women's appearance.

One of the few activities depicted in these shots was that of women perpetrators clearing out dead bodies and reburying them. As one newspaper saw it, the SS women "were unmoved by the grisliness of their task" and "one even smiled as she helped bundle the corpses into the pit." The article underscored the inappropriateness of the woman's reaction, recounting in bold, black print, "She Smiled." The *Boston Globe* captioned the shot in a way more general than what it depicted, marking the symbolic status of the women guards. The caption read, simply, "Terrible Scenes at Belsen."[47]

Gender as a Litmus Test of Atrocity

This analysis raises serious questions about atrocity and gender in the public imagination. It is worrisome not only for what it tells us about the limitations of

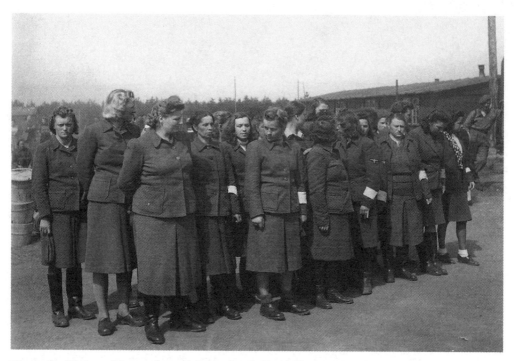

Figure 8. Women SS guards at Belsen, April 17, 1945. Courtesy The Imperial War Museum, London.

the ability to visually represent Nazi atrocity in a way that mirrors reality, but also for the doubts it sheds on the capacity of the visual to link atrocity with the indices of identity that presumably gave it its momentum. There are probably no instances of contemporary atrocity that have not been motivated by some aspect of identity held by the individuals being brutalized. Yet we seem hard-pressed to find a representational scheme that admits those indices of identity into its presentation. If the visualization of atrocity is able to produce only flattened versions of the identities associated with it, then it may be that we are undercutting a crucial dimension of atrocity's representation—and hence understanding—in all of its forms.

The visual can only go so far in representing the world to us. But these images offer a cautionary tale both about women's representation in Nazi atrocity photos and about the ability of the larger atrocity story to accommodate the inevitable complications of the circumstances from which its story takes hold. Images underscore the limitations of broad discourses about public life, telling us that when the representations of gender became too complicated for the larger surrounding story, the representations simply cease to reflect the complications at their core.

The lapse of these representations onto predictable, simplified, schematic, and conventionalized depictions of female experience is not surprising, yet it is troublesome. Women are neither overgendered—in the fragile, vulnerable, and

nurturing case—nor are they genderless. The persistent outrage surrounding a story about Nazi hunter Beate Klarsfeld slapping German Chancellor Kurt Georg Kiesinger in 1968 is a case in point. We are led too much by stereotypical notions of women's behavior, particularly when they are surrounded by a more generalized outrage about humanity. In order to communicate the extraordinary instances of barbarism and brutality at heart here, banal visual representations of women became necessary, even if they did not reflect the underlying gendered experience.

We saw this across all four categories of representational status, where women were presented as either not women or as providers of succor and nurturing, in much the way that the surrounding culture of the time needed to see them. Despite the fact that the enlightened world came to know of the acts of women in the resistance, as heroines, as gray figures, and as otherwise independent agents in the concentration camps of Nazi Europe,[48] rarely were these features of women's associations with the camps implied in photos. Rather, the flattened visual representations of women's experiences in the camps persist, even in recollections half a century later.

Although it is surely not their primary message, the atrocity photos of women in the concentration camps of Nazi Europe reflect both a fundamental discomfort about gender and a lack of sophistication in its understanding. While the often unnatural involvement of women pushed the atrocity story in ways that it could not easily accommodate, it may be that readers eased that discomfort by readily appropriating the images as symbols of atrocity, accomplices to the establishment of a leaky relationship between what the image depicted and how it was interpreted. Women's representation, in this sense, became one litmus test, among others, of the boundaries by which Nazi atrocity could be viably represented in the public imagination. And today, fifty-odd years later, it persists as a representational pattern. We need only confront the too broadly framed images of the women of Bosnia, whose rape and physical humiliation have at times overtaken the story, to see a renewal of those earlier depictions.

Thus, the U.S. and British publics responded to atrocity photographs of women not only because of what they found there but also because of how they could elaborate on what they saw. In the case of women, that elaboration took place in conjunction with broader codes about women and atrocity, that fastened women in places where the surrounding culture wanted them to be. The fact that the representations' content failed to complicate the resonant perceptions of women mattered less than the ability to use those representations to uphold a larger story of atrocity.

This raises questions about the ability of the visual to accommodate detail, particularly detail that complicates its master narrative. It suggests that the remembrance of the atrocities of World War II as broad, often universal narratives about large groups of people victimized by the Nazis was instituted already with photos taken at the time of the camps' liberation. The documentation of the atrocities failed to particularize the specific identities and statuses of the various

individuals and groups affected by the Nazis, helping to produce a faulty understanding of the ways in which Nazi brutality was brought to bear differently on different kinds of people. By representing gender in typical ways despite harshly atypical circumstances, the atrocity photos failed to display the extent to which the atrocities violated expectations of wartime behavior as it applied to women. Equally important, photography fell short of providing a critical visual discourse on Nazi brutality as it affected women in particular.

In 1957, Vera Brittain asked one small question in her rather large book, *Testament of Experience.* She asked: "Didn't women have their war as well?"[49] This chapter suggests that they did. It also suggests that the vagaries of their experience may not have been captured by the visual record that ensued. Although one needs to look closely to find patterns, the photographs of Nazi atrocity clearly imply that the war looked different for women than it did for men. But we have yet to discover how and what war meant to the women who were forced to make sense of its horrors in different ways than the men at their sides.

NOTES

Thanks to Liliane Weissberg for convincing me to examine the issue of gender in atrocity photographs. Thanks also to the John. H. Simon Guggenheim Memorial Foundation and the Freedom Forum Center for Media Studies at Columbia University for giving me fellowships that allowed me to pursue these ideas without interruption. Parts of this chapter were presented at a 1995 Conference on Women, Sexuality, and Violence at the University of Pennsylvania, a 1995 Conference on Articulations of History: Issues in Holocaust Representation at the Photographic Resource Center at Boston University, and a 2000 conference of the National Communication Association. Parts are also a reworking of material that originally appeared in my *Remembering to Forget: Holocaust Memory Through the Camera's Eye* (Chicago: University of Chicago Press, 1998). Thanks also to the Annenberg School for Communication at the University of Pennsylvania for helping me secure the permissions required to reproduce the photos accompanying this chapter.

1. In the words of Daniel Ofer and Lenore Weitzman, Nazism "targeted all Jews as Jews, and the primary status of Jews was their 'race' not their gender." See Daniel Ofer and Lenore Weitzman (eds.), *Women and the Holocaust* (New Haven: Yale University Press, 1998), 2.

2. This topic is dealt with extensively in Barbie Zelizer, *Remembering to Forget: Holocaust Memory Through the Camera's Eye* (Chicago: University of Chicago Press, 1998).

3. For more on this, see Barbie Zelizer, "Words Against Images: Positioning Newswork in the Age of Photography," in Hanno Hardt and Bonnie Brennen (eds.), *Newsworkers: Toward a History of the Rank and File* (Minneapolis: University of Minnesota Press, 1995).

4. Margaret Bourke-White, *Portrait of Myself* (New York: Simon and Schuster, 1963), 258. Deborah Lipstadt, *Beyond Belief: The American Press and the Coming of the Holocaust, 1933–1945* (New York: The Free Press, 1986).

5. "The Pictures Don't Lie," *Stars and Stripes*, April 26, 1945, 2.

6. See Zelizer, *Remembering to Forget*, for an extensive discussion of these issues.

7. J. Ringelheim, "The Split Between Gender and the Holocaust," in Ofer and Weitzman (eds.), *Women in the Holocaust*, 1998, 342.

8. Cited in Anthony Penrose (ed.), *Lee Miller's War* (Boston: Bullfinch Press, 1992), 187. Marguerite Higgins, *New York Herald Tribune*, May 1, 1945. Interview with Marie Ellifritz, File on 1981 International Liberators Conference, Witness to the Holocaust Project, Emory University. Ellifritz's testimony displayed a narrative style that was markedly different from many of the testimonies given by male liberators. Ellifritz discussed with great elaboration her search for

one prisoner she had tended during the war. She also recollected at great length the "beautiful wheat field" that surrounded the camp.

9. Discussed in "Press Exposure of German Horror Camps," *Newspaper World*, April 28, 1945, 1.

10. "Slave Women Lived Like Animals in Nazi Camp," *Daily Telegraph*, April 12, 1945, 5. William Frye, "Brutal Nazi Girls Danced as Victims Were Burned," *Boston Globe*, April 21, 1945, 1. "1 Woman MP On Terror Camp Mission," *Daily Mail*, April 20, 1945, 1.

11. "German Atrocities in Prison Camps," *Illustrated London News*, April 28, 1945, supplement.

12. This somewhat adapts Raul Hilberg's categories of witness—perpetrators, victims, and bystanders. See Raul Hilberg, *The Destruction of the European Jews* (New York: Holmes and Meier, 1985).

13. The preference for group shots over depictions of individuals somewhat characterized the time period, in that collective bodies in photos emerged as a visual response to fascism already in the late 1930s. See John Pulz, *The Body and the Lens: Photography 1839 to the Present* (New York: Harry N. Abrams, 1995), 97–100.

14. Picture appended to "Here's How Nazis Treat Their Captives . . . ," *PM*, May 1, 1945, 8.

15. Interview with Sergeant M. Lawrie. Cited in Martin Caiger-Smith, *The Face of the Enemy: British Photographers in Germany, 1944–1952* (Berlin: Nishen Publishing, 1988), 11.

16. See picture appended to "German Civilians Made To See For Themselves," *News Chronicle*, April 19, 1945, 4. Also see pictures entitled "M.P.s See Horror of Buchenwald," *Daily Mail*, April 24, 1945, 4, and "M.P.s View Hun Crimes," *Daily Mirror*, April 24, 1945, 5.

17. Photo by U.S. Signal Corps (Document #208-AA-207B-10, file "German Concentration Camps," Wobbelin, NA).

18. "The End of Belsen?" *Time*, June 11, 1945, 11.

19. "There Was Fuel in Plenty," *News Chronicle*, April 21, 1945, 1.

20. Picture appended to Patrick G. Walker, "The Terror in Europe," *Picture Post*, October 1941, 9.

21. Picture entitled "Women Want to Be Photographed," *Picture Post*, October 1943.

22. Percival Knauth, "Buchenwald," *Time*, April 30, 1945, 44; "There Is a Camp Worse Than Buchenwald," *News Chronicle*, April 23, 1945, 1. Few similar characterizations were made about their male counterparts.

23. "Woman M.P. To See Horror Camps," *Daily Telegraph*, April 20, 1945, 3.

24. Claudia Koonz, "Between Memory and Oblivion: Concentration Camps in German Memory," in John A. Gillis (ed.), *Commemorations: The Politics of National Identity* (Princeton: Princeton University Press, 1994), 267.

25. "Piles of Bodies Found in Camp," *Los Angeles Times*, April 19, 1945, pt. I, 2; also see "The Captives of Belsen," *London Times*, April 19, 1945, 4, and "30,000 Died in Prison Camp at Belsen," *Daily Telegraph*, April 19, 1945, 5.

26. Picture appended to Peter Furst, "Anti-Nazi Bavarias Helped to Seize Munich," *PM*, May 1, 1945, 12 and picture appended to Ben Hibbs, "Journey to a Shattered World," *Saturday Evening Post*, June 9, 1945, 21. The shot of the mother appeared at some delay in a commemorative volume issued by the *Daily Mail* [See *Lest We Forget* (London: Daily Mail, 1945), 73].

27. The installation, which was made in the late 1980s and entitled "Untitled," was set within colors of aqua and purple that gave the woman distinctively erotic overtones. See Ziva Amishai-Maisels, *Depiction and Interpretation: Visual Arts and the Holocaust* (Oxford and New York: Pergamon, 1993), 360.

28. Picture entitled "Belsen: A Horror Monument to Nazi Bestiality," *Daily Mirror*, April 21, 1945, 2.

29. See "There Was Fuel in Plenty," *News Chronicle*, April 21, 1945, 1. *Lest We Forget*, 19.

30. Letter from Sergeant Midgley, Imperial War Museum. Cited in Caiger-Smith, *The Face of the Enemy*, 14.

31. Personal communication with the author, May 23, 2000.

32. See picture appended to "Horror, Starvation, Death in German Concentration Camps Revealed by Allies' Advance," *Stars and Stripes*, April 30, 1945, 4; picture appended to "The Murder Gang of Belsen Spread This Horror in the Name of the Germans," *Sunday Express*, April

22, 1945, 9; picture as one of a set entitled "Like a Doré Drawing of Dante's Inferno: Scenes in Belsen," *Illustrated London News*, April 28, 1945, supplement, II.

33. Untitled picture appended to "There Was Fuel in Plenty," *News Chronicle*, April 21, 1945, 1.

34. Artist Alice Lok Cahane identified herself as one of the women in the photograph during a Holocaust conference that both she and I attended at Lehigh University in May 2000. According to Cahane, she had gone in search of potato peels to help her ailing sister and found herself posing for the photographer as he stopped to record the scene.

35. Picture appended to "To Look At Horror," *Newsweek*, May 28, 1945, 35.

36. Two pictures jointly entitled "MPs See Horrors of Buchenwald," *Daily Mail*, April 24, 1945, 4. Untitled picture appended to "150,000 Exterminated at Buchenwald," *Daily Telegraph*, April 24, 1945, 6.

37. See picture appended to "World Demands Justice," *Daily Mirror*, April 19, 1945, 4–5. Also see "These Germans Are Made To See the Horrors Done In Their Names," *Daily Mail*, April 19, 1945, 4. For more on this, see Zelizer, *Remembering to Forget*, 86–140. Also see *Newsweek*, May 7, 1945, 58.

38. See "The Problem That Makes All Europe Wonder," *Picture Post*, May 5, 1945, 7. It is also worth noting that the word "inside" here had a double meaning: both inside Nazi Germany and inside the journal.

39. Picture appended to Tania Long, "Goering's Home Town—Under American Rule," *New York Times*, June 3, 1945, sec. 6, 9. Also see "Holding the Mirror Up to the Huns," *Daily Mirror*, April 30, 1945, 5, and picture entitled "Exhibit A," appended to "Foreign News," *Newsweek*, June 4, 1945, 61.

40. Picture appended to "Holding the Mirror Up to the Huns," *Daily Mirror*, April 30, 1945, 5.

41. See, for instance, picture appended to "This Was Nazi Germany—Blood, Starvation, the Stench of Death," *Stars and Stripes*, April 23, 1945, 4–5. Also see picture appended to "Germany and Germans Did These Things," *PM*, April 26, 1945, 13.

42. The caption to the photo of the woman, Margit Schwartz, claimed that Schwartz was "almost completely mad . . . yet when a camera was produced before her . . . she not only climbed out of bed unaided, but managed to stand in a position approximating that taken formerly in the old photograph." Caption to print 208-AA-124G-3, British official photo. BU.6370/RN.

43. For example, see picture appended to "Study in Evil: The S.S. Women of Belsen," *Daily Mail*, April 23, 1945, 3. Also see picture appended to a set of pictures entitled "Like a Dore Drawing of Dante's Inferno," III.

44. "The End of Belsen?" *Time*, June 11, 1945, 36.

45. See, for instance, Frye, "Brutal Nazi Girls Danced," 1, and "Remains of Pure Aryan 'Civilization,'" *Daily Mirror*, April 29, 1945, 3.

46. See picture appended to a set of pictures entitled "Like a Dore Drawing of Dante's Inferno: Scenes in Belsen," *Illustrated London News*, April 28, 1945, supplement, III. Also see picture entitled "Study in Evil: The S.S. Women of Belsen," *Daily Mail*, April 23, 1945, 3.

47. Edwin Tetlow, "Belsen: The Final Horror," *Daily Mail*, April 20, 1945, 1. Picture entitled "Terrible Scenes at Belsen," *Boston Globe*, April 21, 1945, 1. See also picture appended to Harold Denny, "'The World Must Not Forget,'" *New York Times Magazine*, May 6, 1945, 8.

48. See, for instance, Carol Rittner and John K. Roth (eds.), *Different Voices: Women and the Holocaust* (New York: Paragon House, 1993) and Vera Laska (ed.), *Women in the Resistance and in the Holocaust: The Voices of Eyewitnesses* (Westport, Conn.: Greenwood Press, 1983).

49. Vera Brittain, *Testament of Experience* (New York: Macmillan, 1957).

SELECT BIBLIOGRAPHY

Amisha-Maisels, Ziva. 1993. *Depiction and Interpretation: Visual Arts and the Holocaust.* New York: Pergamon.

Bourke-White, Margaret. 1963. *Portrait of Myself.* New York: Simon and Schuster.

Bridenthal, Renate, Atina Grossman, and Marion Kaplan (eds.). 1984. *When Biology Became Destiny: Women in Weimar and Nazi Germany.* New York: New Feminist Library.

Brittain, Vera. *Testament of Experience.* 1957. New York: Macmillan.

Caiger-Smith, Martin. 1988. *The Face of the Enemy: British Photographers in Germany, 1944–1952.* Berlin: Nishen Publishing.

De Silva, C. (ed.). 1996. *In Memory's Kitchen: A Legacy from the Women of Terezin.* Northvale, N.J.: J. Aronson.

Heinemann, M. E. 1986. *Gender and Destiny: Women Writers and the Holocaust.* Westport, Conn.: Greenwood Press.

Hilber, Raul. 1985. *The Destruction of the European Jews.* New York: Holmes and Meier.

Koontz, Claudia. 1994. "Between Memory and Oblivion: Concentration Camps in German Memory," in John Gillis (ed.). *Commemorations: The Politics of National Identity.* Princeton: Princeton University Press.

Laska, Vera. (ed.). 1983. *Women in the Resistance and in the Holocaust: Voices of Eyewitnesses.* Westport, Conn.: Greenwood Press.

Lipstadt, Deborah. 1986. *Beyond Belief: The American Press and the Coming of the Holocaust, 1933–1945.* New York: The Free Press.

Ofer, Daniel, and Lenore Weitzman (eds.). 1998. *Women and the Holocaust.* New Haven: Yale University Press.

Penrose, Anthony (ed.). 1992. *Lee Miller's War.* Boston: Bullfinch Press, 187.

Pulz, John. 1995. *The Body and the Lens: Photography 1839 to the Present.* New York: Henry N. Abrams.

Reading, Anna. 1999. "Scarlet Lips in Belsen: Culture, Gender and Ethnicity in the Policies of the Holocaust." *Media, Culture and Society* 21, no. 4: 481–501.

Ringelheim, J. 1998. "The Split Between Gender and the Holocaust," in Ofer and Weitzman, *Women in the Holocaust,* 340–50.

Rittner, Carol, and John K. Roth (eds.). 1993. *Different Voices: Women and the Holocaust.* New York: Paragon House.

Zelizer, Barbie. 1998. *Remembering to Forget: Holocaust Memory Through the Camera's Eye.* Chicago: University of Chicago Press.

Zelizer, Barbie. 1995. "Words Against Images: Positioning Newswork in the Age of Photography," in Hanno Hardt and Bonnie Brennen (eds.), *Newsworkers: Toward a History of the Rank and File.* Minneapolis: University of Minnesota Press.

The Body

Lawrence Douglas

The Shrunken Head
of Buchenwald:
Icons of Atrocity at Nuremberg

Webster, says the poet, saw skull beneath the skin, but how much more terrible to see the skin without the skull.

–Richard Jenkins[1]

Overlooked in the celebrations of the fiftieth anniversary of the Nuremberg trial, the "most significant criminal action in history,"[2] was the proceeding's great tedium. Rebecca West, who reported on the trial for the *New Yorker*, described the courtroom as "a citadel of boredom."[3] The trial was long—eleven months would pass from the reading of the indictment on November 21, 1945, until the tribunal pronounced judgment on October 1, 1946—although perhaps not inordinately so: the O. J. Simpson murder trial took nearly as long as the entire Nuremberg trial, with its twenty-one defendants and complex indictment enumerating crimes committed over the course of a decade and the space of a continent.

The "savage impatience" that the trial aroused in its spectators was less a function of duration than of how the prosecution chose to present its evidence. Following the strategy of the chief counsel for the United States, Robert H. Jackson (on leave from his position as associate justice of the Supreme Court), the prosecution structured its case around captured documentary evidence, material considered "harder" and more reliable than eyewitness testimony.[4] As a result, much of the Nuremberg trial was devoted to the numbing recitation of thousands of documents, a process less suited to highlighting the malignancy of the defendants than the ingenuity of IBM, whose translation machine, specially designed for the Nuremberg courtroom, permitted the four-way simultaneous interpretation of material read into the court's record. And so, a trial many had feared would devolve into sensationalism came to assume all the drama of antitrust litigation.

But Nuremberg was not without its moments of spectacle. One of these came on December 13, 1945, near the end of the proceeding's first month. Thomas

From *Representations* 63, Summer 1998: 39–64. Copyright © 1998 by The Regents of the University of California. Reprinted by permission of the author and the University of California Press.

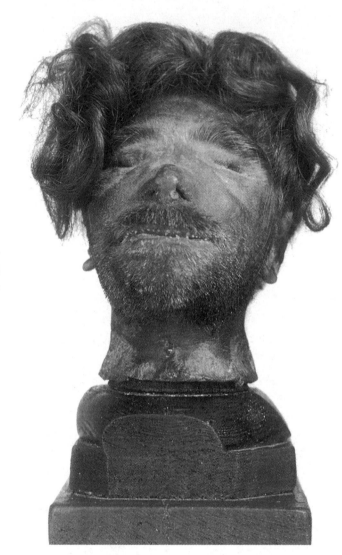

Figure 1. The shrunken head of Buchenwald. International Military Tribunal (IMT) Document no. 3422-PS (USA 254). Courtesy National Archives, College Park, Md.

J. Dodd, an assistant prosecutor (and future U.S. senator) who had spent much of the afternoon reading affidavits about the deplorable conditions in the concentration camps, brought the court's attention to an unusual exhibit: "We do not wish to dwell on this pathological phase of the Nazi culture," he announced, "but we do feel compelled to offer one additional exhibit, which we offer as Exhibit Number USA-254." Displayed on a table in the center of the crowded courtroom was a human head "with the skull bone removed, shrunken, stuffed, and preserved" (figure 1).[5]

The reaction among the members of the tribunal and the spectators was understandably one of shock and revulsion. Earlier in the afternoon, the tribunal had already endured a display of flayed human skin, covered with tattoos, which had been preserved as an ornament for Ilse Koch, the wife of the Buchenwald commandant (figure 2).[6] The exhibits scandalized the court. The correspondent for the

Figure 2. The flayed skin. IMT Document no. 3420-PS (USA 252). Courtesy National Archives.

Times (of London) later described the "two gruesome relics from Buchenwald," focusing particularly on the shrunken head:

> At the time when Buchenwald was overrun many persons refused to believe the accounts of sadism practiced there. . . . But here in court was the proof—the preserved head of a hanged Pole, which, by removing the skull bones, had been reduced to the size of a fist.[7]

Photos of the head (and to a lesser degree, the skin) became some of the best-known images associated with the trial. A pictorial record of the trial, compiled by Charles W. Alexander, director of photography for the International Military Tribunal, includes several shots of the head and skin, the only pieces of material evidence depicted in the volume.[8] In later histories such as Robert Conot's *Justice at Nuremberg*, Airey Neave's *On Trial at Nuremberg*, and Whitney Harris's *Tyranny*

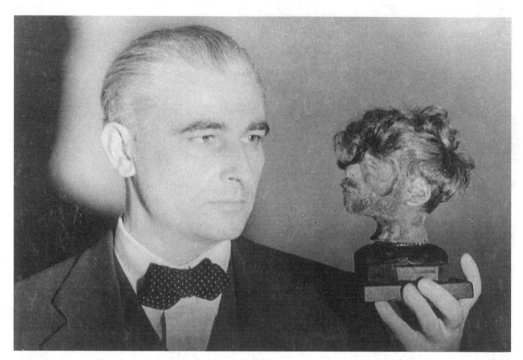

Figure 3. United States Executive Trial Counsel Thomas J. Dodd contemplates the shrunken head of Buchenwald. Courtesy Sovfoto, New York.

on Trial, the shrunken head of Buchenwald and the flayed skin are again the only pieces of evidence pictured among photographs otherwise devoted to shots of the courtroom and the trial's principal protagonists. Particularly astonishing is the photo in *Tyranny on Trial* of Thomas Dodd holding the shrunken head and gazing at it, like Hamlet contemplating the skull of Yorick (figure 3).

Yet even in those works in which photos of the head and skin are reproduced, virtually no textual reference is made to their evidentiary relevance. This omission suggests that the shrunken head and the flayed skin functioned largely as spectacle—at best, as pieces of "stark reality" meant to penetrate the "air of remoteness that . . . hung over the Nuremberg trial"; at worst, as grotesque artifacts offered more to satisfy voyeuristic impulses than to clarify questions of legal guilt.[9]

Yet however minor its evidentiary value, the shrunken head of Buchenwald cannot be dismissed as simply a morbid reminder of spectacular crimes. On the contrary, the head performed a role, to borrow language from Joseph Conrad's *Heart of Darkness,* "not ornamental but symbolic": it signified an understanding and materialized a very particular representation of Nazi atrocities before the Nuremberg tribunal.[10] Introduced as evidence under the novel concept of crimes against humanity, the shrunken head of Buchenwald conjured an image of these atrocities as *crimes of atavism:* horrific deeds committed in an orgy of mass savagery and lawlessness.

This understanding has been largely discredited by many scholars of Nazi genocide (such as Raul Hilberg and Zygmunt Bauman), and, as we shall see, other icons of atrocity submitted by the prosecution at Nuremberg challenged the representation materialized by the head. Yet within the context of the trial, this representation performed a valuable, if not instrumental, role. For by serving as an icon of atavism, the shrunken head presented an image of atrocity familiar to liberal jurisprudence: of the law as civilization's bulwark against barbarism.

Why did the shrunken head and flayed skin of Buchenwald arouse such shock in the Nuremberg courtroom? If the question seems odd, the assumption that the objects capacity to repulse was a feature of the things in themselves merits closer scrutiny. The sight of a shrunken head might, for example, have been familiar to Sir Geoffrey Lawrence, the British jurist who served as the chief judge of the Nuremberg tribunal, and who, when chosen to preside at Nuremberg was described by the London *Observer* as "thoroughly representative of all those values which are associated, especially by foreigners, with the English Gentleman."[11]

In 1932, when Lawrence was elevated to England's High Court, Oxford University, his alma mater, acquired two shrunken heads that were placed on permanent display at the university's Pitt Rivers Museum (figure 4). The shrunken heads of Oxford, war trophies of the Jivaro of Ecuador, had long straight hair and broad nostrils and were hung from a cord fastened to the top of the head; whereas the shrunken head of Buchenwald sported a short beard, had a small nose, and was mounted on a wooden base. In other respects, however, the heads resembled one another, and a similar technique and standard of care seem to have been present in their respective preparations. Indeed, it appears that the Nazi head-shrinkers studied the methods of the Jivaro, whose techniques had been documented in anthropological studies.[12]

That the war trophies of the Jivaro should be seen as artifacts appropriate for permanent display in an Oxford museum (the heads remain on exhibit today, with postcards available in the museum gift shop) while the shrunken head of Buchenwald should be seen as a something shocking and repulsive seems to have an obvious enough explanation: the Nuremberg tribunal did not expect to discover twentieth-century Europeans shrinking the heads of fellow Europeans. What may have been considered a "natural" practice among a "primitive" people seemed shocking when done by modern Westerners. (And here we note the grotesque irony that an anthropological study served for the Nazis as a how-to manual.) As scholars such as Tzvetan Todorov and Edward Said have argued, our concept of "civilization" can be understood in terms of the distance we have established from practices such as head-shrinking—a distance that museums such as Oxford's Pitt Rivers preserve (and also perhaps inadvertently deconstruct, as the self-conscious visitor begins to reflect on the sensibility that would recoil from the practice of head-shrinking but would sanction the displaying of shrunken heads).

Figure 4. The shrunken heads of Oxford: war trophies of the Jivaro on display at the Pitt Rivers Museum, Oxford. Courtesy Oxford University.

To encounter a shrunken head not in a museum of colonial ethnography but in a European courtroom is to share the amazement that seizes the narrator Marlow in *Heart of Darkness* when he realizes that the shapely "attempts at ornamentation" that sit atop the fence surrounding Kurtz's compound are, in fact, severed human heads.[13] The disciplining and ordering effects of civilization have been peeled away; we have entered a space of primitive lawlessness, and all that remains are the "unsound methods" that issue in Kurtzian excess—*the horror, the horror.* Indeed, Buchenwald perfectly fits the image of a site of perverted culture, constructed, as it was, around Johann Wolfgang von Geothe's beloved beech tree on the outskirts of Weimar. The head itself was prepared and displayed in the camp's "Department of Pathology"—another dark irony. And Ilse Koch, who as wife of the camp's commandant was known alternatively as "the Bitch," "the Witch,"

and "the Beast of Buchenwald," emerges as a distinctly Kurtzian figure.[14] Apparently even the Nuremberg defendants were shocked to learn that a German woman had displayed human remains as curios; in a grim echo of Conrad's novella, Field Marshall Keitel, himself no stranger to brutal behavior, whispered, *"Furchtbar! Furchtbar!"*—Horrible! Horrible![15]

Granted, the picture of Ilse Koch sketched by the Nuremberg prosecution might have drawn upon materials both truthful and apocryphal. Notwithstanding the affidavit of an eyewitness who claimed that Frau Koch had ordered the flayed skin "fashioned into lampshades," the Allies were never able to locate, or even positively verify the existence of, these notorious objects.[16] Moreover, in submitting the shrunken head to the Nuremberg court, the prosecution neglected to mention that Koch's husband's stewardship of Buchenwald had been marked by such extreme irregularities and corruption that, in an extraordinary proceeding, *Standartenführer* Koch had been investigated and executed by the SS.[17] The prosecution's failure to mention this circumstance led to a vehement protest by the defense, which objected to the "incalculable . . . consequences" of "such prejudiced statements."[18] Yet the very vehemence of the defense's objections simply confirmed the evidentiary power of the shrunken head and the flayed skin, objects about which, as Ernst Kaltenbrunner's attorney acknowledged, "civilization is justly indignant."[19]

One can, of course, argue that in the wake of a staggeringly brutal and destructive war it was naive to be shocked by the sight of a shrunken head or a piece of flayed skin. Yet the reaction of the tribunal to these extraordinary artifacts expressed an understanding that shaped the rhetorical and jurisprudential complexion of the Nuremberg case: Nazi practices had not, according to this view, eroded the distinction between "primitive" and "civilized"; rather, they represented a *rebirth* of the primitive, an explosion of the savagery normally kept in check by institutions of modernity. (This view was further supported by the affidavits submitted along with the shrunken head indicating that the Polish prisoner had first been hanged "for having relations with German girls," that is, for committing a *Rassenschande*, a distinctly totemic offense.)[20] The distinction is crucial, for whereas the former sensibility destabilizes the very concept of "civilization," the latter preserves the normative distinctiveness of occidental modernity, yet recognizes its vulnerability to what Zygmunt Bauman has called "hiccups of barbarism."[21]

The shrunken head of Buchenwald served, then, as the most tangible representation of Nazi crimes as atavistic. This same understanding found expression in the rhetoric of the prosecution, in particular in Robert Jackson's opening statement, widely considered one of the great courtroom orations of the century. In Jackson's telling, "civilization" was presented as the principal victim—and ultimate conqueror—of Nazi pathology: "The wrongs which we seek to condemn and punish have been so calculated, so malignant, and so devastating, that civilization cannot tolerate their being ignored, because it cannot survive

their being repeated."[22] In affirming the necessity of a juridical response to Nazi crimes, Jackson insisted that "civilization can afford no compromise with the social forces which would gain renewed strength if we deal ambiguously or indecisively with [these] men."[23] Later, when enumerating the chronology of Nazi outrages, Jackson asserted, "These are things which have turned the stomach of the world and set every civilized hand against Nazi Germany."[24]

By comprehending Nazi aggression as a barbaric assault upon civilization, Jackson's position built upon classical arguments within liberal jurisprudence. As Peter Fitzpatrick has sought to demonstrate, a key predicate of liberal jurisprudence since Thomas Hobbes has been the belief that "it is the irredeemable savage which provides the ultimate limiting case against which law is constituted."[25] Civilization in general, and the rule of law in particular, have thus often been defined in terms of their opposition to a "primal and chaotic savagery": precisely the image conjured by the shrunken head.[26] This opposition, of course, often helped to rationalize empire building as a noble enterprise to "civilize . . . barbarism, to render it susceptible to laws."[27] Striking in Jackson's position was the irony of applying arguments once deployed to justify colonial expansion against a nation that, prior to the rise of Nazism, had for many represented some of the greatest virtues of civilized Europe.

Within the context of the prosecution's case, however, Jackson's invocation of the concept of civilization served ends that were at once rhetorical *and* doctrinal. Although the chief prosecutor's praise of the "highly respected systems of jurisprudence" of nations such as Honduras, Panama, and Haiti is enough to make one wince, Jackson's strong globalist vision must be seen as part of an effort, familiar within international law, to argue that civilization denotes a set of customs, practices, and usages laden with normativity.[28] This point is crucial, as one of the central weaknesses in the prosecution's case was the absence of a secure basis in positive law (that is, law posited by a human authority) for trying the defendants for many of their allegedly criminal acts. One obvious way to address this problem would have been to anchor the Allies' position in natural law, the universal maxims of obligatory conduct binding upon reasoning beings. Yet Jackson specifically eschewed this approach. Perhaps anticipating the disastrous appeals to natural law, and specifically to "the Christian-Judeo absolutes of good and evil" that would be made by prosecutor Joseph B. Keenan in the war crimes trial before the International Military Tribunal in Tokyo that began six months after the Nuremberg proceeding, Jackson attempted to deliver an argument more consonant with the ideals of liberal legality.[29] In this argument, the practices of civilization were understood as positing the content of rules enjoying the status of law. As such, these rules authorized the court to sit in judgment upon persons whose conduct might arguably not have been proscribed by any specific enactment, such as a statute, treaty, or convention. In the absence of a clearly determinable code of criminality, one could nonetheless locate binding rules of conduct within the very notion of civilized practice.

It is important to bear in mind that by "binding," Jackson did not simply mean enforceable with a sanction. Within the context of international practice, many rules would fail under this definition. More to the point, such a bluntly positivist perspective would not have served the prosecution's end. Bindingness, in Jackson's understanding, had to mean obligatory in a normative sense. In this regard, Jackson's argument can be understood as an effort to import a strong obligatory character into international law without appealing to natural law. By locating a deep normative core in the existing practices of civilized nations, Jackson thus delicately steered a course between the Scylla of natural law and the Charybdis of strict legal positivism.[30]

This observation reveals an added complexity in Jackson's argument. For just as civilization rescues law by serving as the source of the legal code at Nuremberg, law, in turn, serves as the protector of civilization. In his stirring peroration, Jackson declared, "The real complaining party at your bar is Civilization," a formulation that strikingly placed law itself on trial: "Civilization asks whether law is so laggard as to be utterly helpless to deal with crimes of this magnitude by criminals of this order of importance."[31] He returned to this question months later in his closing argument before the tribunal, when he offered his most ambivalent account of civilized practice:

> It is common to think of our own time as standing at the apex of civilization, from which the deficiencies of preceding ages may patronizingly be viewed in the light of what is assumed to be "progress." The reality is that . . . [i]f we cannot eliminate the causes and prevent the repetition of these barbaric events, it is not an irresponsible prophecy to say that this twentieth century may yet succeed in bringing the doom of civilization.[32]

In the face of this threat, law was seen as the protector of civilization in two regards: first, by helping to prevent "the repetition of these barbaric events," it safeguards civilization from physical doom; second, and more provocatively, by providing and example of rule-governed existence, it implicitly protects civilization as a normative ideal worth preserving. Jackson developed this point toward the end of his summation. Defending the legal adequacy of the trial against the defendants' objections, he declared that the Nuremberg trial

> marks a transition in International Law which roughly corresponds to that in the evolution of local law when men ceased to punish local crime by "hue and cry" and began to let reason and inquiry govern punishment. The society of nations has emerged from the primitive "hue and cry," the law of "catch and kill." It seeks to apply sanctions to enforce International Law, but to guide their application by evidence, law, and reason instead of outcry.[33]

The rhetoric of primitivism now found itself applied not to describe Nazi practices but to describe the state of international law before the advent of Nuremberg. By offering an example of a legal advance beyond this primitive retributional state, the Nuremberg trial itself helps resurrect the concept of "progress" so battered by

recent history. Civilization distinguishes itself, then, from Nazi atavism in terms of its rule-governed normativity as made manifest in the impersonal operation of the rule of law.

Finally, if we consider Jackson's argument in light of the understanding of atrocity materialized in the shrunken head, we see that together they supported a belief in the legitimacy and appropriateness of submitting Nazi practices to legal judgment. This view served specifically to silence the arguments of two separate groups of critics who questioned the wisdom of trying Nazi criminals. The first group, which included members of the British and Soviet governments and militaries, favored the summary execution of leading Nazi functionaries without the pretense of following legal form; the second group, whose position later found its most articulate formulation in a number of writings of Hannah Arendt, questioned the adequacy of any legal response to wrongdoing of such staggering proportions.[34] Thus, even as the shrunken head conjured horrors before which the law could ill-afford to remain mute, it also helped frame such atrocities in the conventional Hobbesian terms of liberal legality, conjuring an atavistic state of nature desperate for the ordering effects of the rule of law.

As a doctrinal matter, however, the shrunken head of Buchenwald also stood as the most vivid representation of a radically new category of criminality. Although the Nuremberg prosecution understood the waging of a war of aggression as the defendants' most serious criminal offense, arguably the trial's most important contribution to the development of law was its creation of a novel category, Crimes Against Humanity. As defined by the Nuremberg tribunal's enabling charter, these crimes included

> murder, extermination, enslavement, deportation and other inhumane acts committed against any civilian population, before or during the war, or persecutions on political, racial or religious grounds in execution of or in connection with any other crime within the jurisdiction of the Tribunal, whether or not in violation of the domestic law of the country where perpetrated.[35]

Admittedly, the concept of crimes against humanity predated the Nuremberg trial, and the trial itself did not provide an altogether satisfactory precedent for the prosecution of such crimes. Often cited in this regard was the tribunal's crabbed interpretation of its own jurisdictional mandate and specifically its conclusion that its authority extended only to those transgressions committed in preparation of, or in connection with, the Nazis' war of aggression. The tribunal concluded, for example, that although "revolting and horrible," the anti-Jewish actions perpetrated by the Nazis before the *Wehrmacht* crossed the Polish border were not crimes against humanity under the charter that defined the tribunal's jurisdiction.[36] Further complicating matters, neither the trial's enabling charter nor the tribunal was able to clarify what was meant by humanity—whether the term meant

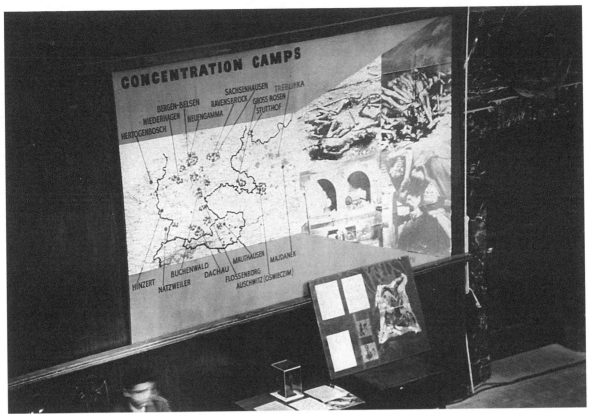

Figure 5. Crimes of atavism: the shrunken head and flayed skin framed against a map of Nazi concentration camps on display before the Nuremberg courtroom. Courtesy U.S. Holocaust Memorial Museum (USHMM), Washington, D.C.

humankind as a whole, or some quality of humanness against which transgressive behavior could be measured.[37] Finally, the tribunal failed to make clear the difference between crimes against humanity and other conventional municipal crimes such as murder and torture.[38]

These problems notwithstanding, the notion of crimes against humanity bespoke a recognition that Nazi atrocities posed a challenge to the legal imagination grave enough to require an innovation in the law's available idiom of criminality. How this challenge was conceptualized, however, recapitulated the uncertainties structured into the category of the offense, for at the same time that the prosecution presented evidence of extermination in factories of death, the most evocative representation of crimes against humanity remained the shrunken head of Buchenwald. As a mute signifier, the head suggested that crimes against humanity differed from conventional categories of murder not in terms of the numbers killed or the logic of extermination, but in the perverse connection to atavistic practice (figure 5). Thus, the shrunken head offered its own parsing of crimes against humanity, one that anticipated and echoed the arguments of the Nuremberg prosecutors. In his opening address, François de Menthon, the French

chief prosecutor, openly wondered, "How can we explain how Germany, fertilized through the centuries of classic antiquity and Christianity by the ideals of liberty, equality, and social justice . . . could have come to this astonishing return to primitive barbarism?"[39] Unable fully to answer his own question, Menthon ultimately condemned the Nazis' crimes against humanity as outpourings of "all the instincts of barbarism, repressed by centuries of civilization, but always present in men's innermost nature."[40]

This understanding of crimes against humanity found expression in an additional piece of extraordinary evidence submitted at Nuremberg. Almost immediately on the heels of the display of the shrunken head on the afternoon of December 13, 1945, the prosecution showed the court a brief documentary film, one that strengthened and complicated the rhetoric of atavism. Following assistant prosecutor William Walsh's description of how the Nazis "lighted and fanned" the "flame of prejudice" against the Jews, the prosecution submitted what at the time was described as "perhaps one of the most unusual exhibits that will be presented during the Trial": a silent film, unambiguously entitled, "Original German Eight-Millimeter Film of Atrocities Against the Jews."[41] Shot with a home camera, its celluloid partially burned, and with a running time of only ninety seconds, the film presented such a confusing and disturbing set of images that it had to be shown twice in rapid succession. It revealed, according to Walsh, "the extermination of a ghetto by Gestapo agents, assisted by military units."[42]

"Atrocities Against the Jews" is an active document of violence. In its hurried register, naked and half-naked women are seen chased through cobbled streets littered with fallen bodies. A man, bleeding from a head wound, is viciously beaten. A woman is dragged by her hair over a curb (figure 6). The shots are skewed and blurred by the motion of the camera, suggesting the agitation of the hand that did the filming, and it is this disturbed quality, as much as the images themselves, that accounts for the film's power. Yet as terrifying as the film is, it does not seem to describe an organized effort of extermination. Rather, its horrific images suggest the passion and violence of a mob run amok. The uniformed Germans captured on film appear less as perpetrators than as entertained observers, and in this regard the film seems to bear witness to a pogrom—an act of savagery that had been visited upon the Jewish communities of Europe since the Black Death.

Taken together with the display of the shrunken head of Buchenwald, "Atrocities Against the Jews" offered a particular representation of the Nazis' crimes against humanity: atavistic in the sense not only of suggesting the practices of the colonized savage but also of reviving a culture of violence that can be seen as distinctly medieval. On numerous occasions, Jackson and other prosecutors used the term *pogrom* to describe Nazi persecutions. In this way, the prosecution's "tangible" evidence created an understanding of Nazi crimes in which the hysteria of the dark ages merges with the primitivism of the savage. Nazi crimes thus conjure the Other Within and the Other Without—a temporally remote Europe that predates the civilizing logic of the Enlightenment and a geographically remote

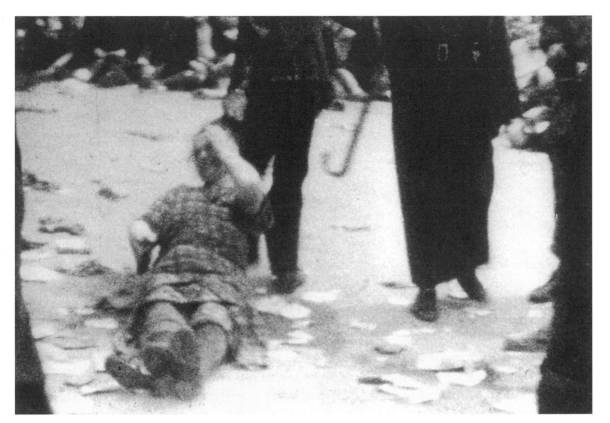

Figure 6. Still from "Original German Eight-Millimeter Film of Atrocities Against the Jews (A Woman is Dragged by Her Hair Across the Street)." IMT Document no. 3052-PS (USA 280). Courtesy USHMM.

colonial outback whose barbaric practices rebel against the disciplining practices of modernity.

From a contemporary perspective, such an understanding seems fundamentally to misapprehend the nature and meaning of the Nazis' most extreme crimes. To take but one notable example, Jackson's position finds itself sternly interrogated in Zygmunt Bauman's *Modernity and the Holocaust*, a work that expands upon both Raul Hilberg's and Hannah Arendt's understandings of the Holocaust as a bureaucratic phenomenon.[43] Bauman's work begins with a telling epigraph from Richard Rubenstein and John Roth's *Approaches to Auschwitz:* "Civilization now includes death camps and *Musselmänner* among its material and spiritual products."[44] The contrast between Jackson's position at Nuremberg and the sensibility expressed in the epigraph could not be greater. Whereas Jackson understands Nazi atrocities as acts *against* civilization, Rubenstein and Roth present the Holocaust as an act *of* civilization.

Carefully elaborating this latter understanding, Bauman challenges the understanding that would see the Holocaust as a "failure of civilization to contain the morbid natural predilections of whatever has been left of nature in

man."[45] Against this "malfunction" or "pathology" thesis, Bauman argues that "Holocaust-style phenomena must be recognized as legitimate outcomes of the civilizing tendency, and its constant potential."[46] By "legitimate," Bauman of course does not mean to register approval. Rather, he means to denote a position that problematizes the distinction between the "normal" and "abnormal" features of modernity and, in so doing, diverts attention from one of the most trenchant and ineradicable aspects of civilization—namely, its destructive potential. Bauman challenges, then, the view that sees modern civilization as predominantly a moral force, that is, as "a system of institutions that cooperate and complement each other in the imposition of normative order and the rule of law, which in turn safeguard conditions of social peace and individual security poorly defended in pre-civilized settings."[47]

This conventional understanding of civilization is, as we have seen, precisely the view articulated by Jackson at Nuremberg. Bauman's position can be read, then, as presenting two foundational challenges to Jackson's argument. First, by problematizing the view that extreme violence only proliferates in a Hobbesian space evacuated of civilized practice, it calls into question the soundness of applying the classic arguments of liberal jurisprudence to justify a legal response to Nazi atrocities. Second, and more crucial, by challenging the view that civilization can be grasped in terms of its underlying normativity, Bauman's view undermines faith in the belief that binding—and here again I mean in the sense of being obligatory, not merely coercive—rules of conduct can be located in the practices of civilization. Even if general rules can be located in ordinary civilized practice, we cannot be assured that such rules possess the deeper normativity needed for Jackson's robust theory of international legal obligation.

This is not to suggest that Jackson's argument is simply wrong or that Bauman's vision of the Holocaust is wholly correct or entirely adequate. Yet Bauman's critique remains important because it powerfully echoes aspects of the prosecution's case that implicitly challenged, however unwittingly, the theory of atrocity materialized in the shrunken head and conjured in the rhetoric of civilization. Here it is important to bear in mind that the connection between Nazi atrocities and techniques of modernity was not lost upon the prosecution. It was the prosecution's recognition of the inextricable link between unprecedented crimes and bureaucratic organizations that accounted for one of the most unusual and controversial aspects of the prosecution's case: the indictment of entire organizations. On trial, then, were not only leading functionaries such as Hermann Göring and Joachim von Ribbentrop, but the entire SS and Gestapo. The effort to criminalize these organizations was born, Jackson argued, of the recognition that "no system of jurisprudence has yet evolved any satisfactory technique for handling a great number of common charges against a great multitude of accused persons."[48] The Nuremberg technique was meant to make possible any number (potentially tens of thousands) of subsequent prosecutions based on evidence of a person's membership in an organization declared criminal. Whether this effort was successful

or even appropriate can be debated; ironically, Hans Kelsen, the influential legal theorist and critic of Nuremberg, condemned this aspect of the trial as itself legally atavistic, a "regrettable regress to the backward technique of collective criminal responsibility."[49] Yet Jackson believed the charges against the organizations were so critical to the law's response to Nazi criminality that he argued, "It would be a greater catastrophe to acquit these organizations than it would be to acquit the entire twenty-two individual defendants in the box."[50]

To recognize the bureaucratized and industrialized dimension of Nazi atrocity is not, however, necessarily to insist upon a connection between such atrocity and civilized practice. Barbarism of a primitive variety can, after all, exploit modern practices. This is the thrust of Jackson's assertion that "the terror of Torquemada pales before the Nazi inquisition."[51] Yet other aspects of the prosecution's case offer a more foundational challenge to Jackson's effort to erect a strict separation between civilized practice and Nazi atrocity. Perhaps most striking in this regard was a piece of material evidence submitted by the Soviet prosecutor L. N. Smirnov: a bar of soap allegedly made from human fat.

Responsible specifically for submitting evidence of crimes against humanity, Smirnov began his presentation by using the familiar rhetoric of atavism, referring to the Nazis' "cannibal theories of racism" and the "cannibalistic theories of German fascism."[52] And like the Americans, Smirnov turned to documentary film to support his case, screening "The Atrocities by the German Fascist Invaders in the U.S.S.R.," a movie that, in the words of one observer, showed "piles of corpses dwarfing those in Dachau and Buchenwald."[53] The power of this visual record perhaps overshadowed Smirnov's words, which despite a couple of unfortunate missteps (such as the regrettable formulation, "the excessive anti-Semitism of the Hitlerite criminals . . . assumed a perfectly zoological aspect") offered the most telling descriptions of the Nazis' "special technique . . . for mass killing and for the concealment of the traces of their crimes."[54] In particular, Smirnov detailed how the "SS technical minds" used human bodies to manufacture certain products.[55] Toward this end he submitted to the tribunal Exhibit USSR-393: "a small piece of finished soap, which from the exterior . . . reminds you of ordinary household soap" (figure 7).[56]

Rumors that the Nazis were producing soap from human bodies circulated widely during the war. Raul Hilberg reports that stories among Poles that Jewish "resettlers" had been killed and that fat from their bodies had been used to make soap, circulated through Lublin as early as October 1942.[57] The Germans themselves were aware of the rumors, as Heinrich Himmler had received a letter describing the Poles' belief that "the resettlers were 'being boiled into soap'" ("*daß die Aussiedler 'zur Seife verkocht werden'*").[58] The letter indicated that the Poles also feared that, like the Jews, they too would now be used for soap production ("*Die Polen kommen jetzt genau wie die Juden zur Seifenproduktion dran*"). These rumors seem to have been so widely circulated that segments of the Polish population actually boycotted the purchase of soap.[59]

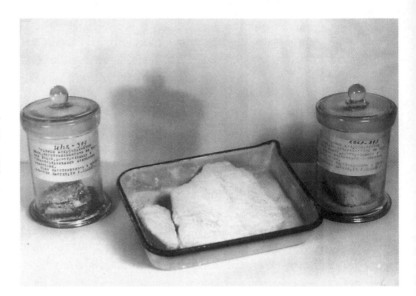

Figure 7. Tribunal Exhibit USSR-393: "A small piece of finished soap, which from the exterior . . . reminds you of ordinary household soap." Courtesy National Archives.

In submitting the bar of soap to the Nuremberg tribunal, Smirnov attempted to demonstrate the truth of these rumors. Beyond the physical object itself, he offered the court several affidavits, including that of Sigmund Mazur, a laboratory assistant at the Danzig Anatomic Institute, who described the "semi-industrial" experiments in the production of soap from human bodies.[60] Mazur's statement was supported by the actual "recipe for soap produced from the corpses of the executed" as well as the affidavit of a corporal in the British Royal Signal Corps who claimed to have witnessed the production process.[61] Finally came the bar itself.

Granted, what Smirnov displayed before the court probably was ordinary household soap, after all. Despite the prosecutor's best efforts, no positive evidence has ever been adduced proving that the Nazis used human fat to make soap. At the time of the Adolf Eichmann trial, David Ben-Gurion continued to refer to the Nazis' extermination process as a "soap factory"; and although cakes of soap allegedly made from Jews have been preserved in Israel and at the Yivo Institute in New York, scientists have been unable to detect human remains in this material.[62] More recently, the U.S. Holocaust Memorial Museum tested several bars of soap purportedly made from humans, but no human fat was detected.[63]

Yet even if apocryphal, the bar of soap, within the context of the trial, offered a dramatically different representation of crimes against humanity than that conjured by the shrunken head of Buchenwald. If the head served as a figure of atavistic practice, the soap represented a grotesque triumph of the very logic of efficient production upon which the economy of civilization is based. For here the tribunal encountered the victim not as curio for talismanic display, but as recyclable and consumable "raw material discarded in the process of manufacture."[64] Even if one cannot say for sure whether the Nazis in fact used Jews to make soap,

no similar uncertainty is associated with the claims that dental gold was deposited in the *Reichsbank,* or that human ash was used as fertilizer, or that human hair was used in manufacturing felt footwear of *Reichsbahn* employees.[65]

Yet the bar of soap disturbs Jackson's understanding of civilization even more powerfully than do the bales of hair. For in soap we find a powerful trope of civilization itself, a tangible artifact of civilization's triumph over the forces of defilement and excrement. The psychoanalytic-anthropological literature on this subject is large, and perhaps it suffices to recall Sigmund Freud's famous claim that "we are not surprised by the idea of setting up the use of soap as an actual yardstick of civilization."[66] Dirtiness, by contrast, "seems to us incompatible with civilization," an argument that finds support in Paul Ricoeur's observation that the "excremental state" supplies one of the most ancient and persistent images of evil.[67] Not coincidentally, it was precisely this state to which camp inmates found themselves reduced. The filth, rot, and fecal waste amid which the inmate had to live was all part, Terrence Des Pres argued, of the camp's "excremental assault" upon its inmates: its attempt to strip the prisoners of the last vestiges of dignity and self-worth.[68] One can only ponder the dark ironies of taking living creatures reduced to a state of abject filth and transforming them, in death, into instruments of cleanliness. Such a logic is beyond the merely perverse. Instead, it is a stunning inversion of the values we all "civilized": not a betrayal or a travesty of these values, but the most distilled reductio of the norms of cleanliness, order, and efficiency that define, in a conventional view, our advance from a primitive state. Pondering the shrunken head of Buchenwald, we can continue to believe in the intrinsic normativity of civilized practice. Handling Smirnov's bar of soap, we cannot. In the bar of soap we find, to quote Bauman, a "test of the hidden possibilities of modern society."[69] Even if we acknowledge the apocryphal status of Smirnov's cake of soap, we remain troubled by the knowledge that Nazi logic could, or rather, *should,* have led to its manufacture.

Among the members of the prosecution, there was no clear recognition of, much less clash over, the dissonant materializations of crimes against humanity offered at Nuremberg.[70] From a perspective over fifty years removed, however, the clashes we have detected in the prosecution's evidence can be understood as offering an early example of the crisis of representation that, in the words of one commentator, "has by now become a *typos* of Holocaust research."[71] In this regard, the search for an idiom adequate to the task of describing and explaining the distinctive horror of Nazi atrocity not only troubled the Nuremberg prosecution but has itself emerged as a subject of inquiry within Holocaust studies. On a somewhat different level, the clash between the images conjured by the head and the soap can be understood as anticipating, however indirectly, the fractious disputes that have emerged among scholars of the Final Solution. In this telling, the understanding of atrocity materialized in the shrunken head finds fresh expression, however

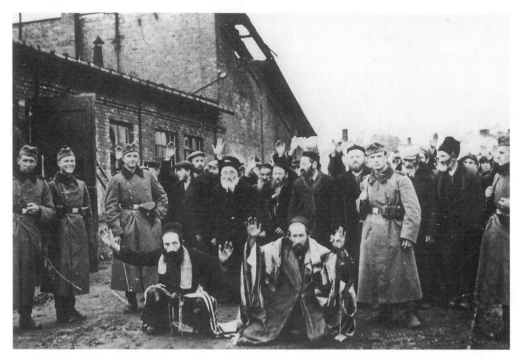

Figure 8. A different iconography of atrocity: the taunting smiles of the German soldiers photographed alongside Jewish victims. Courtesy Yad Vashem, Jerusalem.

indirectly, in Daniel Goldhagen's polemical insistence that "Germans' beliefs about Jews unleashed indwelling destructive and ferocious passions that are usually tamed and curbed by civilization."[72] The bar of soap, by contrast, can be seen as standing for a belief that German atrocity was exemplary because, as Hilberg argued, "for the first time in Western civilization the perpetrators had overcome all administrative and moral obstacles to a killing operation."[73]

Today, however, neither the shrunken head nor the bar of soap is seen as a quintessential representation of Nazi atrocity. The soap, not surprisingly, fell into disfavor because of its questionable authenticity, and now has been appropriated by Holocaust "revisionists" as evidence that the entire Holocaust was a hoax.[74] The diminution of the representational value of the shrunken head was more complex. As the bodily remains of a Polish prisoner of war, the head could serve only imperfectly as a symbol of the Holocaust and, by extension, as a materialization of a Goldhagen-like argument. In fact, Goldhagen's position supports an entirely different iconography of atrocity. If Jackson's argument found its most vivid materialization in the shrunken head of Buchenwald, then the arguments of Daniel Goldhagen (and the more balanced and chilling work of Christopher Browning) now ask us to find the essence of the Holocaust in the taunting smile of the German soldier photographed alongside his Jewish victim (figure 8). No longer the atavist who shrinks heads or the administrator organizing factories of death, the Nazi (or, pace Goldhagen, German) killer is now defined by a wholly

different relationship to technology: as the soldier posing brightly before the latest Leica. Of course, long before Goldhagen's revisionism, the predominance of Hilberg's bureaucratic model of Nazi atrocity found expression in artifacts of extermination that have long since become quintessential icons of the Holocaust: a discarded canister of Zyklon B, a photo of railway tracks converging at the Birkenau entrance, a pyramid of eyeglasses.

Nevertheless, in the years after its appearance at Nuremberg, the head enjoyed a brief career as a piece of shocking evidence in other war crimes trials. Exhibited at the trial of Ilse Koch and other Buchenwald functionaries before a special American military court in Dachau in the summer of 1947, the head was again used at Ilse Koch's trial before German authorities in the early 1950s. Perhaps most spectacularly, the head demonstrated its continuing power to shock in an appearance before a Senate subcommittee investigating the army's commutation of Ilse Koch's sentence in 1948.[75] Around this time, however, it seems that the head had turned into something of a benign artifact among the members of the army's war crimes division, as shipping records refer to it as "Little Willie."[76]

After the end of its career as a piece of trial evidence, the shrunken head of Buchenwald seemed destined to follow the path of the Jivaro specimens at Oxford. Plans were considered to exhibit the head in the Smithsonian, although it is unclear why the museum balked.[77] Other proposals included placing the head in the army's Museum of Military Medicine. Before any of these could be implemented, the head somehow vanished. It is now believed to be in the hands of a private collector, although efforts to locate it by private researchers have proven unsuccessful. At least one person I have met has turned the search for the head into something of a crusade in the hope that in the not-too-distant future, it will be placed on display at the U.S. Holocaust Memorial Museum; the museum, no doubt reluctant to encourage voyeurism, has expressed little support for these efforts.[78]

Yet the eclipse of the representational significance of the shrunken head does not simply remind us that the iconography of atrocity changes with evolving historical understandings. For as I have tried to argue, the shrunken head served as something more—or perhaps less—than a representation of a historical understanding: it was the materialization of a *legal argument*. In saying this, I do not mean to exaggerate the distinction between a historical and a legal argument. The difference cannot be described simply in terms of the former discourse's greater claims to impartiality of judgment; nor will we illuminate the matter by insisting on a rigid difference between teaching history and doing justice. As Nuremberg itself reminds us, criminal proceedings are often justified as both instruments of justice and tools of exigent pedagogy.[79]

Still, the tensions between these two goals cannot be denied. And as Jackson's statements before the Nuremberg tribunal make clear, these tensions will surface most dramatically in extraordinary trials, those in which the law's effort to clarify the historical record must be framed against the larger effort to justify

the efficacy and legitimacy of a legal response to radical criminality. This is not to say that the Nuremberg prosecution willfully distorted the historical record to force a refractory history to support a vulnerable jurisprudential vision. Rather, it is to claim that the representation of atrocity at Nuremberg must be seen in light of both the historical materials available at the time of the trial *and* in terms of the law's need to justify its own beleaguered normativity. Only then can we appreciate the juridical uses of the shrunken head within the context of the Nuremberg trial. For by serving as a talisman of the very style of atrocity warded off by the rule of law, the shrunken head supported the prosecution's jurisprudential vision of civilized practice as the fount of legality and its vision of law as the bulwark of civilization.

The Nuremberg prosecution could, no doubt, have succeeded without conjuring Nazi atrocities as crimes of atavism. After all, turning people into soap seems no less criminal than shrinking their heads. Yet if Nuremberg was to vindicate the power of law to restore order to a space of physical ruin and confidence in a concept of civilization, it was certainly expedient, if not necessary, to comprehend and represent novel crimes in the familiar terms of liberal jurisprudence. Through the sober ministrations of law, civilization could, then, recover from the worst "hiccups of barbarism."

NOTES

For their helpful comments and suggestions, I would like to thank Robert Burt, Rand Cooper, Owen Fiss, Nasser Hussain, David Luban, Michael Marrus, Nancy Pick, Robert Post, Austin Sarat, and James Young. William Connelly, Research Librarian at the U.S. Holocaust Memorial Museum; Kenneth Kipperman, an independent researcher; Alexander George and Jarkko Cain provided valuable research assistance.

1. Richard Jenkins, "Child's Play," *New York Review of Books* 64, no. 12 (1997): 44.

2. Robert G. Storey, foreword to Whitney R. Harris, *Tyranny on Trial* (Dallas, 1954), vii.

3. Rebecca West, *A Train of Powder* (New York, 1955), 3.

4. Prosecution counsel William Donovan's vehement argument that a greater reliance upon eyewitness testimony would have provided the trial with "an affirmative human aspect" led to his unceremonious removal from the prosecution after the first week of the trial; see Telford Taylor, *The Anatomy of the Nuremberg Trials* (Boston, 1992), 146–49.

5. *Trial of the Major War Criminals Before the International Military Tribunal,* 42 vols. (hereafter *IMT*) (Nuremberg, 1947–49), 3:516.

6. Ibid., 3:514.

7. *Times* (London), December 14, 1945, sec. 1, 4.

8. Charles Alexander and Anne Keeshan, *Justice at Nuremberg: A Pictorial Record of the Trial* (New York, 1946).

9. *Times* (London), November 30, 1945, sec. 1, 4.

10. Joseph Conrad, *Youth and Two Other Stories* (New York, 1922), 130.

11. *New York Times,* August 30, 1971, sec. 2, 32.

12. Apparently Ingatz Wegerer, an inmate working in Buchenwald's medical wing who helped prepare the heads, had read descriptions of Jivaro techniques. See "Lady mit Lampenschirm," *Der Spiegel,* February 16, 1950, 12–16, 14.

13. Conrad, *Youth and Two Other Stories,* 130.

14. *IMT,* 3:515.

15. G. M. Gilbert, *Nuremberg Diary* (New York, 1947), 68.

16. Rumors concerning the lampshade continued to circulate for a number of years after the

Nuremberg trials. *Life* magazine, for example, ran a famous photo of Ilse Koch with the caption, "Lady of the Lampshades." Yet the trials of Koch before both American and German authorities never established the existence of the lampshade; see Arthur L. Smith, *Die "Hexe von Buchenwald": Der Fall Ilse Koch* (Cologne, 1983).

17. At the time of his execution Koch was no longer at Buchenwald, having assumed the command of the Lublin killing center. Yet he was returned to Buchenwald for his execution and was cremated in one of the camp's ovens. For a discussion of the unusual case, see Smith, *Die "Hexe von Buchenwald,"* 67–96; and Raul Hilberg, *The Destruction of the European Jews* (New York, 1979), 578–79.

18. *IMT*, 3:542. The defense's objections led to one of the more important exchanges between the prosecution and the defense concerning the rules of evidence that would control the submission of proof at the trial. Robert H. Jackson defended the relaxed rules of evidence of the Charter of the International Military Tribunal, noting the "impossibility of covering a decade of time, a continent of space, a million acts, by ordinary rules of proof, and at the same time finishing this case within the lives of living men" (543). The tribunal dismissed the defense's objection.

19. Ibid., 3:542.

20. Ibid., 3:516.

21. Zygmunt Bauman, *Modernity and the Holocaust* (Ithaca, N.Y., 1991), 13.

22. *IMT*, 2:99.

23. Ibid.

24. Ibid., 2:130.

25. Peter Fitzpatrick, *The Mythology of Modern Law* (London, 1992), 80.

26. Ibid., 91.

27. J. Axtell, *The Invasion Within: The Conquest of Cultures in Colonial North America* (New York, 1985), 50.

28. For a discussion of the notion that the practices of civilized nations constitute a source of international law, see M. Cherif Bassiouni, *Crimes Against Humanity in International Criminal Law* (Dordrecht, 1992).

29. See Judith Shklar's excellent critique of Joseph B. Keenan's position in *Legalism: Law, Morals, and Political Trials* (Cambridge, Mass., 1964). Within the trial itself, Keenans' argument was sternly criticized by Justice Pal of India who, in a dissenting opinion, argued that the distinction between just and unjust wars must be left to legal theorists and could not be resolved by appeal to natural law; see Robert K. Woetzel, *The Nuremberg Trials in International Law* (New York, 1960), 226–32; also Richard H. Minear, *Victors' Justice: The Tokyo War Crimes Trial* (Princeton, N.J., 1971). More important, Justice Pal attacked the implicit conservatism of Keenan's argument, which by proscribing aggressive war, would freeze the international status quo. This status quo, Pal argued, was itself defined by aggressive military conquest by the very powers now arguing the illegality of aggressive warfare. Pal thus concluded with a sweeping attack on Keenan's jurisprudential vision, as the very rhetoric of legality that once rationalized acts of colonial conquest by the West was now being used to prevent others from tampering with the international status quo.

30. That legal positivism has long struggled to offer a satisfactory account of the obligatory character of law is familiar to any student of jurisprudence; see, for example, Hart's famous critique of Austin in H. L. A. Hart, *The Concept of Law* (Oxford, 1961). Hart's attempt to reformulate the positivist position to account for law's normativity has, in turn, been sternly challenged; see Ronald Dworkin, *Taking Rights Seriously* (Cambridge, Mass., 1978).

31. *IMT*, 2:155.

32. Ibid., 19:397.

33. Ibid., 19:398.

34. See Taylor, *Anatomy of the Nuremberg Trials*, 25–40. See, for example, Hannah Arendt, *The Human Condition* (Chicago, 1958).

35. Article 6 of the Charter of the International Military Tribunal, *IMT*, 1:11.

36. Ibid., 22:493. For additional discussion of the tribunal's holding in this matter, see note 70.

37. Jacob Robinson, for example, argues that Hannah Arendt's *Eichmann in Jerusalem* confuses these two different parsings; see Jacob Robinson, *And the Crooked Shall Be Made Straight:*

The Eichmann Trial, the Jewish Catastrophe, and Hannah Arendt's Narrative (Philadelphia, 1965).

38. See Leila Sadat Wexler, "the Interpretation of the Nuremberg Principles by the French Court of Cassation: From Touvier to Barbie and Back Again," *Columbia Journal of Transnational Law* 32, no. 2 (1994): 289–380, 310. See also Bassiouni, *Crimes Against Humanity in International Criminal Law.*

39. *IMT,* 5:375.

40. Ibid., 5:423.

41. Ibid., 3:535.

42. Ibid., 3:536. While the Nuremberg Trial's use of documentary film was unprecedented in a juridical setting, *Atrocities Against the Jews* was not the first film to be screened before the tribunal. On November 29, 1945, the eighth day of the trial, the prosecution had screened *Nazi Concentration Camps,* a documentary film that, by all accounts, had left an extraordinary impression upon the judges as well as the defendants. Prepared by the Army Signal Corps under the direction of George Stevens, the popular Hollywood filmmaker, the grim documentary, made of footage from the liberation of the western camps, is filled with images of the dead—including the now famous footage of British bulldozers plowing mounds of corpses into mass graves at Bergen Belsen. A careful observer would also have caught a glimpse of the shrunken head of Buchenwald and the flayed skin, captured in footage taken from that camp. (The film clip actually shows two heads, consistent with the testimony of Dr. Sitte before the Senate subcommittee in 1948.) For an examination of the evidentiary uses of this film, see Lawrence Douglas, "Film as Witness: Screening 'Nazi Concentration Camps' Before the Nuremberg Tribunal," *Yale Law Journal* 105, no. 2 (November 1995): 449–81.

43. This is not to suggest that Hilberg's and Arendt's arguments are identical. Hilberg himself vigorously resisted Arendt's appropriation of his argument and has consistently expressed reservations about the banality thesis; see Raul Hilberg, *The Politics of Memory: The Journey of a Holocaust Historian* (Chicago, 1996).

44. Richard Rubenstein and John Roth, *Approaches to Auschwitz,* quoted in Bauman, *Modernity,* 1.

45. Ibid., 13.

46. Ibid., 28.

47. Ibid.

48. *IMT,* 8:357.

49. Hans Kelsen, "Will the Judgment in the Nuremberg Trial Constitute a Precedent in International Law?" *International Law Quarterly* 1, no. 2 (1947): 167.

50. *IMT,* 8:376. Actually there were twenty-one defendants in the box, as Martin Bormann was tried in absentia.

51. Ibid., 29:397.

52. Ibid., 7:596. Ibid., 8:238.

53. "Films Back Charge of German Crimes," *New York Times,* February 20, 1946, sec. 1, 6.

54. *IMT,* 8:294. Not only does Smirnov inadvertently imply that a measure of anti-Semitism may be normal; more crucially, he characterizes genocide as "excessive": an overboiling of savagery unleashed by sinister forces. This view echoes Jackson's rhetoric when in his opening statement he declared, "At length bestiality and bad faith reached such excess that they aroused the sleeping strength of imperiled civilization"; ibid., 2:100. The concept of "excess" thus stands in opposition to the notion of "civilization": it denotes the violence that gushes forth once the disciplining institutions of modernity have been corrupted and destroyed by modern Attilas. Ibid., 7:597.

55. Ibid.

56. Ibid., 7:600.

57. Hilberg, *Destruction of the European Jews,* 331.

58. Ibid., 470.

59. Ibid., 624.

60. *IMT,* 7:597.

61. Ibid., 7:599.

62. Tom Segev, *The Seventh Million: The Israelis and the Holocaust,* tr. Haim Watzman (New York, 1993), 327. Hilberg, *Destruction of the European Jews,* 624.

63. Michael Berenbaum, "Dimensions of Genocide," in *Anatomy of the Auschwitz Death Camp*, ed. Yisrael Gutman and Michael Berenbaum (Bloomington, Ind., 1994), 80.

64. Ibid.

65. Hilberg, *Destruction of the European Jews*, 614.

66. Sigmund Freud, *Civilization and Its Discontents* (New York, 1961), 46.

67. Freud, *Civilization*, 46. For this reference to Paul Ricoeur I am indebted to Robert-Jan Van Pelt's excellent discussion of Auschwitz in "A Site in Search of a Mission," in Gutman and Berenbaum, *Anatomy of the Auschwitz Death Camp*, 93–156.

68. See Pelt, "Site in Search of a Mission," 130.

69. Bauman, *Modernity*, 12.

70. Still, the tensions between the understanding represented by the head and that conjured by the bar of soap implicitly left their mark upon the judgment of the court. This conclusion gains support when we consider two notable aspects of the final judgment delivered by the tribunal at the conclusion of the trial in the fall of 1947. The first concerns the court's parsing of Otto Ohlendorf's testimony. As the commander of the *Einsatzgruppe* D, Ohlendorf had organized and oversaw the killing of ninety thousand Jewish men, women, and children, primarily in the Ukraine and Russia. "Small of stature, young-looking, and rather comely," Ohlendorf had spoken "quietly, with great precision, dispassion, and apparent intelligence"; Taylor, *Anatomy of the Nuremberg Trials*, 248. And as Taylor has observed, Ohlendorf's testimony was "not a confession, but an avowal" (248). Thus when asked by Ludwig Babel, counsel for the SS, how he could participate in such atrocities, Ohlendorf replied, "Because to me it is inconceivable that a subordinate leader should not carry out orders given by the leaders of the state":

B: Was the legality of these orders explained to these people under false pretenses?

O: I do not understand your question; since the order was issued by the superior authorities, the question of illegality could not arise in the minds of the individuals, for they had sworn obedience to the people who had issued the orders. (*IMT*, 4:353–54)

Ohlendorf's statement, "the question of illegality could not arise in the minds of these individuals," anticipated the arguments that Adolf Eichmann would make before the Jerusalem court some fifteen years later. And like the Jerusalem court, the Nuremberg tribunal found it impossible to believe that a fidelity to the logic of command could lead to such a disastrous suspension of one's moral sense. Thus Ohlendorf was considered a "Jekyll and Hyde," and, despite his demeanor, which belied such a conclusion, the tribunal explained Ohlendorf's actions in terms of the psychology of hatred. The court's judgment specifically quoted the words of Erich von dem Bach-Zelewski, another witness, who when asked about Ohlendorf's actions, replied, "I am of the opinion that when . . . for decades, the doctrine is preached that the Slav race is an inferior race, and the Jews not even human, then such an outcome is inevitable"; *IMT*, 1:248. Thus the tribunal transformed Ohlendorf, the faithful functionary, into a passionate killer, and the rule-regulated conduct of the officer was understood in terms of the lawless passions of racial hatred. (Again we find anticipations of Daniel Goldhagen's argument.)

Second, and more important, the tribunal's interpretation of its jurisdictional mandate also implicitly supported the prosecution's vision of atrocity. As I have noted earlier, the tribunal concluded that Nazi atrocity was essentially an ancillary offense to the principal charge of waging aggressive warfare. Atrocities unconnected to the war of aggression were not, the court argued, crimes against humanity. The court's reasoning in this matter was complex: on one level, it was motivated by a desire to legitimate the court's authority by exercising restraint by not tampering with respected principles of sovereignty; relatedly and less nobly, the Allies were reluctant to create a precedent that would permit other nations to raise legal challenges to the domestic arrangements within, say, the United States or the Soviet Union. Although the tribunal's crabbed reading of its jurisdiction marked a defeat of the prosecution's specific position that *Kristalnacht* was a crime against humanity, on another level the tribunal's decision implicitly supported Jackson's position. For by checking its jurisdiction, the court implicitly argued that the logic of crimes against humanity derived from, and was reducible to, the Nazis' foundational crime of engaging in the "barbarism" of aggressive war.

71. Anton Kaes, "Holocaust and the End of History: Postmodern Historiography in Cinema," in *Probing the Limits of Representation*, ed. Saul Friedlander (Cambridge, Mass., 1992), 207.

72. Daniel Jonah Goldhagen, *Hitler's Willing Executioners: Ordinary Germans and the Holocaust* (New York, 1996), 397. As I argue later in the text, the head provides a highly problematic representation of Goldhagen's argument. For a critique of Goldhagen, see Lawrence Douglas, "The Goldhagen Riddle," *Commonweal* 124, no. 9 (1997): 18–21.

73. Hilberg, *Destruction of the European Jews*, 669.

74. See Kenneth S. Stern, *Holocaust Denial* (New York, 1993), 3.

75. The trial at Dachau condemned Ilse Koch to life imprisonment (she was spared the death penalty because, however improbably, she had gotten pregnant while in her cell). A year later, in 1948, her sentence was reduced by American Army officials to a four-year term, occasioning a spasm of outrage in the United States. (The stated reason for the reduction was that the prosecution of Koch had relied too heavily on hearsay, material not formally barred by the rules of evidence of the military court, but whose reliability remained open to question.) A Senate subcommittee was convened to investigate the reduction of charges, and it was before this committee that the shrunken head was next summoned as evidence. The report of the Senate subcommittee was published as *Conduct of Ilse Koch War Crimes Trial: Interim Report of the Investigations Subcommittee on Expenditures in the Executive Departments*, 80th Cong., 2d sess., 1948, S. Rept. 1775, part 3.

Dr. Kurt Sitte, who, as a Buchenwald inmate, had worked in the camp's "pathological laboratory," spoke before the committee about the head. To Arkansas Senator John McClellan's simple question, "That is the actual shrunken head of a human individual?" Sitte replied, "Yes. We had in the collection at Buchenwald, while I was there, two of these heads." At this point Homer Ferguson, a senator from Michigan and the chairman of the subcommittee investigating the Koch affair, took over the questioning, and the exchange that followed demonstrated the head's continuing power to shock:

> SENATOR FERGUSON: Had you ever seen this one before at Buchenwald?
>
> DR. SITTE: This man? I saw him before he was hanged.
>
> SENATOR FERGUSON: Before he was hanged?
>
> DR. SITTE: Yes.
>
> SENATOR FERGUSON: You saw him before he was hanged, alive?
>
> DR. SITTE: Yes. These two prisoners were Polish prisoners who managed to escape I think late 1939 or 1940.
>
> SENATOR FERGUSON: But you had seen him as a live man?
>
> DR. SITTE: Yes, and only these two prisoners were brought back and exhibited on the place and it was said that these were captured again and brought back and they were beaten first of all in public and then they were brought to the crematorium where later, some of these . . . people who escaped were publicly hanged. These were not publicly hanged.
>
> SENATOR FERGUSON: But that man, you had seen him when he was alive?
>
> DR. SITTE: Yes.

(Stenographic transcript of hearings before the Senate Investigations Subcommittee on Expenditures in the Executive Departments, December 8, 1948, vol. 14, 883–84).

Remarkable in this exchange is the senator's fixation on the fact that Sitte had known the man now on display. In museums, such as Oxford's Pitt Rivers, it is commonplace to ask *what* is on display, not *who*. The senator is shocked precisely because the head—a talisman, curio, or ornament, but certainly no one we *know*—is suddenly reconstituted before the subcommittee as a person with an identity. It is as if one entered the British Museum and recognized the Lindow Man as a missing relative. We are reminded that the logic of display is predicated on temporal and geographic displacement that guarantees strict anonymity.

76. See memo from T. L. Borom, Executive of the War Crimes Branch, to the Judge Advocate General of the War Crimes Division: "Two packages containing exhibits from the Buchenwald trials have been sent to you, via registered mail, this date. One package contains a shrunken head, "Little Willie," and the other contains three (3) skin exhibits. These exhibits were sent to

this office by you for use by the German court in the trial of Ilse Koch. It is requested that you acknowledge receipt of these exhibits"; APO (Army Post Office) 403, May 3, 1951.

77. Smith, *Die "Hexe von Buchenwald,"* 224.

78. Thus while researching this essay I was put in contact with Kenneth Kipperman, a private researcher and a child of Holocaust survivors who for years has been searching for the shrunken head. Kipperman believes that the U.S. Holocaust Memorial Museum's refusal to support his research is a sign of the museum's desire to sanitize the Holocaust for popular consumption.

79. See, for example, Mark J. Osiel, "Ever Again: Legal Remembrance of Administrative Massacre," *University of Pennsylvania Law Review* 144, no. 2 (1995): 463–704, and Carlos Nino, *Radical Evil on Trial* (New Haven, Conn., 1997).

Dora Apel

The Tattooed Jew

In an editorial on Judaism and body modification posted on the website of *Body Modification Ezine* in January 1996, 23-year-old Joshua Burgin posed the following question: "Can a proper Jew practice body modification?"[1] Leaving aside the nettlesome question of what a "proper" Jew might be, we are left to ask, What does being Jewish have to do with whether or not one practices this increasingly popular form of adornment among the young?[2] Permanently marking or making cuts on the body is prohibited by the Hebrew Bible. (This does not include circumcision, which is regarded as a covenant with God.) Burgin, a Haverford philosophy major and Reform Jew who is familiar with the scriptures, nevertheless practices body modification, sporting a Star of David tattoo and brand on his arm created by tattoo artist Raelyn Gallina in 1995 (figure 1). Burgin's apparent contradiction—of being both, in his terms, a "proper" Jew and in violation of Jewish law (*Halacha*)—has brought about some trying chastisements for him, including unsolicited reminders from observers that tattooed Jews "cannot be buried in Jewish cemeteries." Burgin counters, "For me to take the Star of David as a Jewish symbol of identity and mark myself permanently with it makes me feel more Jewish than I ever felt before."[3]

The decision to be "branded a Jew" immediately evokes the historical trauma of Jewish persecution, from the pogroms of the Middle Ages to the catastrophe of the Holocaust. Precisely because Jews, in effect, have been branded historically as Other, for Burgin the voluntary and literal self-identification through branding represents a reclamation of the chastened body and enforced identity of the Jew by and as the Other. The Star of David is, of course, particularly significant as a symbol of ethnic identification because Jews were indeed historically marked with it, from fifteenth-century Spain to the yellow Star of David patches worn on arms and chests during the Third Reich. Jewish prisoners in Auschwitz were then forcibly tattooed and their identities wretchedly reduced to the blue numbers on their arms. This is the burdened history to which Burgin commits himself when he says, "For me to take the Star of David as a Jewish symbol of identity and mark myself permanently with it, makes me feel more Jewish than I ever felt before." In his desire to visibly bind himself more closely to a public Jewish identity, Burgin participates in a larger revival of ethnic consciousness among many young American Jews.

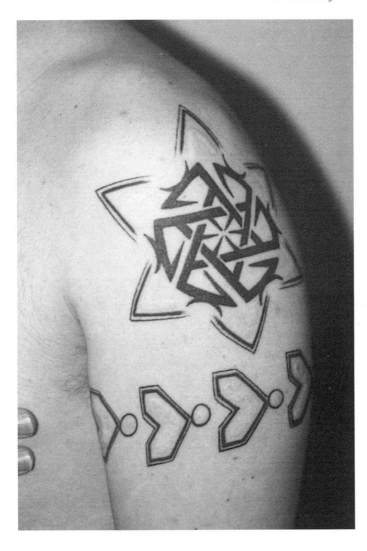

Figure 1. Joshua Burgin's Star of David tattoo and arm brand, created by Raelyn Gallina, 1995. Photo: Amy Jay. Courtesy Joshua Burgin.

Traditional Jewish law forbidding tattoos is found in Leviticus (19:28), where the relevant line reads: "Ye shall not make any cuttings in your flesh for the dead, nor print any marks upon you." Many Reform Jews, including Burgin, believe the Bible should not be interpreted literally; indeed, the heads of the Reform Jewish Council of America agree that the Bible should be understood in the context in which it was written, that is, six thousand years ago, and therefore Reform Jews (and Conservative Jews, but to a lesser degree) are called upon to interpret the Bible and give it meaning for their own lives.[4]

Burgin suggests that this also facilitates Reform Judaism's acceptance or tolerance of other such alleged "sins" as homosexuality, premarital sex, birth control, and eating pork or shellfish, as well as the general rejection of antiquated sexist and racist ideas contained within the Bible. If the Reform movement is willing to accept or tolerate these formerly heretical ideas, Burgin argues, then certainly

body modification, which warrants only one admonition in Leviticus, also can be accepted or tolerated.

Burgin's body modification may be regarded as the recuperation of a tattooing practice already performed on the body of the Jew. His voluntary tattoos in some sense are meant to expiate the suffering of the forcibly tattooed, the rage of those who had no choice about the needle and the ink. The process of acquiring tattoos as signs of Jewish ethnicity, however, seems not so much a question of mourning the past as one of grappling with the contemporary significance of Jewish identity.

Burgin further asserts that the admonition against cutting or marking the body was most likely directed at pagan practices and notes that there is nothing in the scriptures about not being buried in a Jewish cemetery because of one's tattoos. Italian survivor Primo Levi also reminds us that tattooing was forbidden by the law of Moses in order to distinguish Jews from other ancient peoples, who were considered barbarians. It was therefore particularly painful for Orthodox Jews in the concentration camps to be tattooed, because for them it represented an identification with barbarians. Levi describes the tattoo practice in Auschwitz: "From the beginning in 1942 in Auschwitz and the Lagers under its jurisdiction (in 1944 they were about forty) prisoner registration numbers were no longer only sewed to the clothes but tattooed on the left forearm . . . men were tattooed on the outside of the arm and women on the inside. . . . The operation was not very painful and lasted no more than a minute, but it was traumatic. Its symbolic meaning was clear to everyone: this is an indelible mark, you will never leave here; this is the mark with which slaves are branded and cattle sent to the slaughter, and that is what you have become. You no longer have a name; this is your new name. The violence of the tattoo was gratuitous, an end in itself, pure offense."[5] Levi points out that only non-Jewish German prisoners were exempt from these tattoos.

The tattoo was a necessary marker of difference, for the Jew was already indistinguishable from everyone else. For decades before the war, the dominant trend for most French and German Jews was to blend in with the majority culture. In an attempt to achieve even greater invisibility in the 1930s, more and more German Jews actually went uncircumcised, a remaining marker of difference. Sander Gilman argues that the increasing inability to distinguish the Jew helps explain "the need to construct another 'mark' of difference in the concentration camps of the 1930s." The tattoo was "an 'indelible' mark upon the body which uniformly signified difference."[6]

Those blue numbers, now fading, have come to mark those who bear them as history's witnesses. Discussing his own tattoo, Levi wrote: "At a distance of forty years, my tattoo has become a part of my body. I don't glory in it, but I am not ashamed of it either; I do not display and do not hide it. I show it unwillingly to those who ask out of pure curiosity; readily and with anger to those who say they are incredulous. Often young people ask me why I don't have it erased, and

this surprises me: Why should I? There are not many of us in the world to bear this witness."[7] In an act of surrogate witnessing, some members of the postwar generation have gone so far as to have numbers tattooed on their bodies. While organizing an exhibition called "Tattooing without Consent," at the Triangle Tattoo and Museum in Fort Bragg, California, artist "Chinchilla" came across the diary of a tattooer who had put the number 79496 on an infant girl born and killed in Birkenau in 1944. In an act of personal commemoration for an unknown child, Chinchilla had the same number tattooed on her own arm on what would have been the baby's fifty-first birthday.[8]

The anxiety-charged work of Canadian artist John Scott, dealing with the consequences of industrialization and war, is suffused with an apocalyptic, post-Holocaust reckoning with the moral effects of the catastrophe. Scott had his thigh tattooed with three small roses and a seven-digit number—6339.042. The decimal point marked it as similar but different from the numbers of concentration camp inmates. This area of his skin was then surgically removed and displayed in a carefully fabricated metal and glass case. Entitled *Selbst* (1989), it was first shown at the Carmen Lamanna Gallery in Toronto in 1990, where it evoked a controversial reception among critics. Kenneth Baker, writing for *Artforum*, viewed it as a shallow attempt at direct identification, finding the work an unacceptable cultural misappropriation because "the parallel the title proposes between the artist's fate and that of death-camp victims is distastefully expedient."[9] Other critics perceived *Selbst* as a gesture of solidarity with the suffering of others.[10] Yet the issue here is both more complex and larger than that of either a presumptuous or empathic personal identification with suffering. Scott, a non-Jew, attempts to rattle the cultural boundaries between Self and Other. In a gesture of blood solidarity, Scott literally "showcased" the consequences of the behavior of ordinary people who became perpetrators of unspeakable acts. "When the allies opened the camps in 1945 and the rest of the world discovered what had happened there," Scott writes, "the trajectory of modernism, arcing from the enlightenment to that moment at the close of the war, ended. People saw that the notion of modernism had been unable to prevent the holocaust—had maybe even led to it. It changed forever our notion of what people were capable of and what culture was really about. As for *Selbst*, it was never a matter of *identification*. I was trying to reverse that process that the camps had redefined—a certain notion of our collective self image."[11] *Selbst* may be regarded as "an act of physical defiance against passivity."[12] Scott's deeply personal gesture stands against the silence, indifference, or resignation of the majority.

Confrontations with the Holocaust are more common, however, among Jews coming to terms with the meaning of Jewish difference. The revival of Jewish ethnic identity has found expression in a variety of mediums. Even fashion designer Jean Paul Gaultier got into the act with his Fall Collection of 1993. Using the traditional black robes, wide-brimmed hats, and yarmulkes of ultraorthodox Judaism as his inspiration, Gaultier creates a chic new Jewish body, a "Semitic"

look that anyone can wear, with sexy sidecurls and a stylish exoticism updated from that old-fashioned shtetl look and spiced up, for the more daring, with a hint of the dominatrix. This "Hasidic" collection by the "couturier-provocateur Gaultier," as Linda Nochlin has dubbed him, figures the Jew as nothing if not excessive.[13] Gaultier, a Jew, played it to the hilt, sending out invitations to the show in Hebraic-looking script and serving Manischewitz wine at the opening. The show was also provocatively transgressive by cross-dressing women in traditional men's clothing. As Nochlin suggests, Gaultier's models in drag pointed to the traditional segregation of the sexes within Judaism, calling into question its fundamentalist authoritarian structure. It was this aspect which most offended the Orthodox Jews of Borough Park in New York, a center of Hasidic and Orthodox Judaism where French *Vogue* decided to photograph the collection. "The whole thing is very offensive," said Rabbi Morris Shmidman, the executive director of the Council of Jewish Organizations of Borough Park. "To take men's mode of clothing and make that into a modish thing for women is extremely inappropriate in this community."[14] Gaultier's transvestite gesture is one of parody, but also a daring confrontation with traditional Judaism. In the latter sense, it has something in common with the challenge to Orthodox bans on body modification practiced by young Jews today.

As part of the renewed ethnic consciousness movement, the Jewish literary magazine *Davka*, founded in 1996 by four children of Holocaust survivors, was meant to serve as a rallying point for a generation of disaffected, punked-out young Jews.[15] *Davka*'s editors perceived a "Jewish cultural revolution" and aimed the magazine at secular Jews searching for access to Judaism (*Davka* has since been transformed into the online magazine *Tattoo Jew—The Online Magazine for Jews with Attitude*). *Davka* included essays, interviews, poetry, and profiles by writers such as Allen Ginsberg, David Mamet, Kathy Acker, Jay Hoberman, and Tony Kushner. The journal responded to what it perceived as an explosion of Yiddish culture in the arts, a new iconography of Jewish painters, performance artists, writers, and musicians who are celebrating Jewish culture with unprecedented enthusiasm. Within this contemporary approach, *Davka*'s mission to bring secular young Jews back into the religious fold is perfectly captured in the cover photograph of the first issue. A young woman with short, fuschia-colored hair, nose and lip pierces, and tattoos inspired by tribal designs is wrapped in the Jewish prayer shawl traditionally worn only by men (although now adopted by women in Reform Judaism). While crossing gender boundaries and defying the admonition against tattoos, this transgressive woman of the 1990s, who rejects mainstream values, nevertheless wraps herself in the traditional symbol of Jewish belief (figure 2).

Davka hoped to change the perception of Jewish tradition as old-fashioned, conservative, and unrelated to modern lives by relating Jewish religious practice to the young, the hip, and the body-modified. At the same time, it attempted to restore a sense of Yiddish culture, because the contemporary sense of Jewish iden-

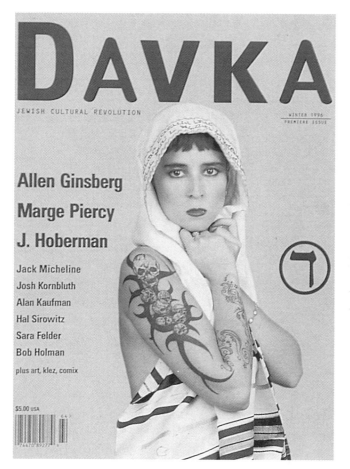

Figure 2. Cover of Davka: Jewish Cultural Revolution, *Winter 1996.* Cover concept: Alan Kaufman/photo: Marcus Hanschen/cover graphic design: Jill Bressler. Copyright 1996 Davka: Jewish Cultural Revolution. Permission granted courtesy Davka: Jewish Cultural Revolution (now Tattoo Jew—www.tattoojew.com), Alan Kaufman, Editor-in-Chief, 1126 Bush Street, Apt. 605, San Francisco, CA 94109.

tity has become empty at its core, filled with whatever the surrounding culture has to offer. For many of those seeking to establish a sense of community, Jewish difference is reduced to the observance of ritual practice, and ritual practice is adopted by many without religious belief. Thus many young Jews, who finally have the freedom to embrace Jewish identity, do so at a moment when definitions of Jewish identity have been lost due to the very process of assimilation and acceptance that has made this freedom possible.[16]

An episode that illustrates this identity confusion is the controversy among Reform Jews that was provoked by *Davka*'s cover. Rabbi Stephen Pearce, the leader of San Francisco's Reform synagogue who gave seed money to the magazine, who is listed on its advisory board, and who appears in a photo essay about hip Bay Area rabbis, was scandalized when he discovered that *Davka*'s tattooed cover model was not Jewish. If she had been, he said, she would have been "expressing her Judaism in some way."[17] Feeling betrayed, the rabbi resigned as a *Davka* board advisor after having bought subscriptions for his entire board of directors. No doubt the fact that Gaultier's models were non-Jewish would have

been equally disturbing to him. But why should the rabbi have objected so strongly? Perhaps the fact that there is no absolute signifier for the Jew is at the core of his uneasiness. Indeed, anyone can "pose" as a Jew.

———————

More than any young, body-modified Jew in America today, photographer Marina Vainshtein proclaims her identity in ways that are both more explicit and more extreme through her permanent bodyart. By the age of 23, Vainshtein had tattoos of graphic Holocaust imagery over most of her body. On her upper back, the central image represents a train transport carrying Jewish prisoners in striped uniforms toward waiting ovens.[18] Smoke billows above the train cars while a swastika, represented in negative space, wafts through the ashes that are spewed forth by a crematorium chimney. Across her shoulders, Hebrew letters carry the message "Earth hide not my blood," from the Book of Job's passage, "O Earth, hide not my blood / And let my cry never cease." Atop the train car, figures, some blindfolded, hold each other or reach their arms hopelessly upward, one clutching a flag marked with a Star of David (figure 3). Other figures are pressed together inside the cattle car, one shaven-headed person staring forlornly through the bars. Ribbons of barbed wire float upward from broken fence posts. Below the train and the brick-lined ovens, a tattoo represents the notorious inscription on a number of concentration camp gates, *Arbeit macht frei* (work gives freedom), while the results of that absurdly false promise are presented as tombstones, engraved with Hebrew text, and a column of skeletons. To the right of the chimney is a guard tower with an armed guard who watches as an elderly man trying to escape dies on an electrified barbed wire fence. On the small of Vainshtein's back is an image of an elderly woman chained to a coffin of nails who is engulfed in the flames of a burning Star of David. Underneath are the words "Never forget" in Hebrew. Above the burning star is a tattoo of a skeleton, which Vainshtein identifies as an angel, sitting on an open casket. The skeleton holds the book of *Kaddish*, the Hebrew prayer for the dead (figure 4).

Vainshtein was born in the Soviet Union. Her grandfather fought with the Red Army against the Nazis; her grandmother told of moving from town to town to escape anti-Jewish pogroms. Her family continued to be subjected to anti-semitism under the Stalinist regimes until she and her parents were granted exit visas and moved from Ukraine to California in 1977, when Vainshtein was 4 years old. She grew up in Melrose, a neighborhood in Los Angeles primarily inhabited by Russian Hasidic Jews and, in the 1980s, by punks. Entering public school in eighth grade after spending her first seven years at a Jewish school, she experienced a kind of identity shock because there were so many different kinds of people. A secure sense of Jewish identity was suddenly destabilized by the realization that, except for saying she was Jewish, there was nothing which visibly distinguished her as such. By the age of 15, searching for a way to define her identity as "other" in a sea of pluralistic sameness, she started thinking about getting a tattoo and

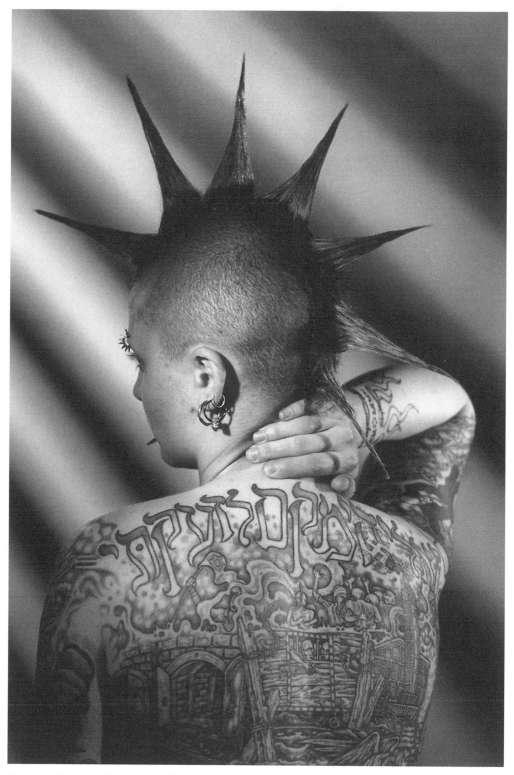

Figure 3. Marina Vainshtein, back tattoos, 1997. Photo: Anacleto Rapping. Permission granted by *Los Angeles Times*.

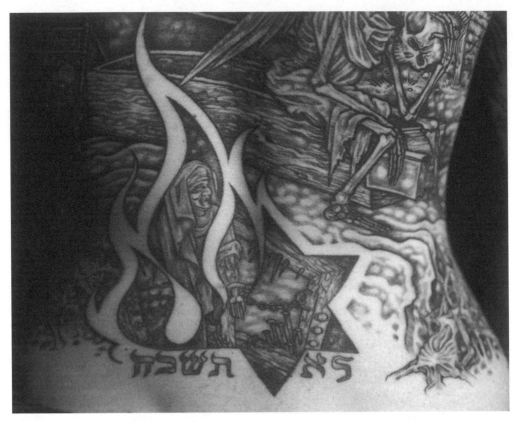

Figure 4. Marina Vainshtein, lower back tattoos, 1997. Photo: Courtesy Marina Vainshtein.

embracing the punk aesthetic. It was also while she was in high school that Vainshtein became obsessed with Holocaust literature, and was profoundly affected by meeting Nina Schulkind, a survivor of seven concentration camps, who spent a day with Vainshtein telling her story.[19] For Vainshtein, as for many Jews, being born even decades after the event did not prevent the Holocaust from playing a defining role in shaping her identity. It can be argued that the Holocaust stands behind any contemporary sense of Jewish identity, whether it is addressed obsessively, ambivalently, or not at all.

The reaction to Vainshtein's tattoos, made public by a full-page article in the *Los Angeles Times* when she was 22, was mixed.[20] Some people congratulated her. Others, especially in her own Orthodox neighborhood, accused her of defiling the meaning of Jewish suffering by violating the Jewish law against body modification. In defending her tattoos, Vainshtein asks: "Why not have external scars to represent the internal scars?"[21] Like Burgin, Vainshtein reclaims the body of the tattooed Jew; in addition, the tattoos represent a form of explicit personal commemoration and a continuation of historical memory, the "internal scars" of a people made visible on the body of one of its young. To demonstrate her belief that the postwar generations must carry on the memory of the Holocaust, she places her own body between the past and future as a barrier to forgetting.

The growth of the Neo-Nazi and other white supremacist movements in the United States in recent years and the rapidity with which old hatreds have flared into new regimes of terror in Europe are chilling reminders that we may not allow ourselves to believe our forms of difference safe in our seemingly enlightened "multicultural" world. Faith in the possibility of successful assimilation has been a precarious position historically; in fact, it has never succeeded. Although assimilation for Jews would seem more successful at this moment in America than ever before, antisemitism is by no means dead, whether in the form of the ravings of the popular black demagogue Louis Farrakhan, the program of the American militia movements, or the unchallenged rhetoric of Republican presidential candidate Patrick Buchanan in the 1996 New Hampshire primaries, or in more subtle forms, such as of the Southern Baptists' appointment in 1996 of a missionary to undertake the conversion of American Jews to Christianity.[22]

In another reaction to the *Los Angeles Times* article, a young Jewish man who grew up in an Orthodox family walked into a tattoo shop one day clutching the newspaper clipping about Vainshtein and requested his own first tattoo, a tribal (i.e., solid black) six-pointed Star of David. The tattoo artist, a friend of Vainshtein's who was moved by the young man's fervency, recounted the story to her. We don't know how the Orthodox family reacted, but it seems safe to say that for the young man, the contemporary reinvention of Jewish identity was a more powerful force than the prohibitions of the old European Jewish culture. Moreover, it connected him to contemporary youth culture across class and religious lines.

Not surprisingly, Vainshtein supports the revival of contemporary Jewish consciousness among many young Jews. Like Burgin, she defines herself as a Reform Jew and the most important principle of Jewish faith for her is the concept of the *mitzvah*. A *mitzvah* is commonly understood as the doing of a good deed, but it is more than this. It means performing an act which fulfills a commandment or precept or the spirit of such a commandment or precept as defined in the body of Jewish scripture and scriptural commentary known collectively as the Torah. So one could argue that as a sign of an irreversible and *public* commitment to her Jewish identity, Vainshtein's tattoos ironically constitute the performance of a *mitzvah*, because, according to the Torah, it is a *mitzvah* to be seen in the world as a Jew.

Vainshtein's arm tattoos include a violin player, referring to the orchestra at Auschwitz composed of Jewish prisoners, surrounded by hanging corpses, a can of Zyklon B, the killing agent used in the gas chambers, and an anguished face (figure 5). Screaming faces of prisoners being gassed are tattooed on her right breast. Other tattoos include a wrist bracelet of Hebrew text, "And now we are the last of many," between two rows of barbed wire from which flames arise; a black armband with a Star of David; a large eyeball pierced by needles, referring to the notorious medical experiments by Nazi doctor Joseph Mengele, in which attempts to change eye color through experimental injections left children blind. The large form of a skull fills the space on her stomach and chest. The eye sockets contain

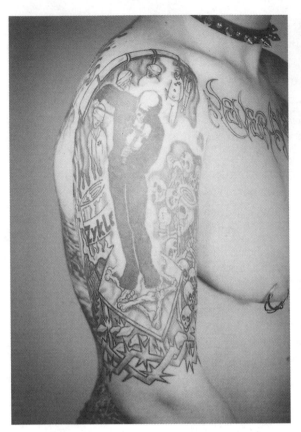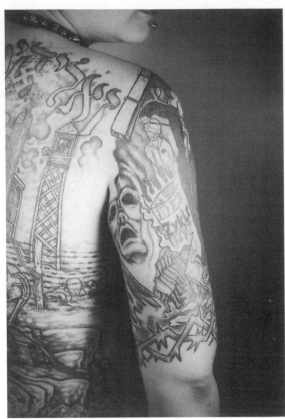

Figure 5. Marina Vainshtein, arm tattoos, 1997. Photo: Courtesy Marina Vainshtein.

a graveyard scene with tombs for the dead; the top of the skull depicts a bombing raid on the right, and prosthetic body parts on the left. Below the skull is an image of a lampshade made of Jewish skin sewn together in patches. Next to it, a synagogue on fire refers to *Kristallnacht*, the notorious Nazi pogrom of 1938. Gothic letters across the top of her chest declare "Never Again" in English. On one leg, tattoos depict a train traveling through a European cityscape where people hide in ghettos; on the other leg, she has a plant of life with two fetuses, both branded with Stars of David on their foreheads. This is Vainshtein's only major color piece, and would seem to be the most optimistic image. For most survivors of the Holocaust, the very birth of a next generation was regarded as a kind of resurrection and ultimate defeat of Hitler's deadly vision. But we can also read the Stars of David branded on the foreheads of the fetuses as the mark of Cain; they are branded by and as the Other. Overall, Vainshtein has created a kind of body narrative which begins with Jewish ghettoization and deportation on her left leg and travels upward, showing the horrors of the concentration camps, the reign of terror, torture, and death that culminates in the ashes of the crematorium on her upper back.

For Marina Vainshtein and Joshua Burgin, their sense of Jewish identity is unequivocal. But for many American Jews, there is a contradiction between their

sense of Jewish ethnicity and their rejection of the public visibility that that identity entails. The catalogue for the 1996 exhibition *Too Jewish? Challenging Traditional Identities* at the Jewish Museum in New York focused on this ambivalence and pointed to the understanding that, until recently, almost any marker of Jewish ethnicity was regarded, by many Jews themselves, as embarrassingly "too Jewish." The very conception that one could be "too Jewish" exposed a sense of continuing vulnerability, which made the wartime generation anxious to assimilate, and, if they could not, their children usually did. Postwar descendants of Jews now strive to master the embarrassment of "Jewishness," to redefine it and make it their own. As one critic commented on the reclamation of Jewish identity in the arts, particularly the revival of Yiddish music: "Generations removed from the immigrant Jews who hid their Jewish roots in exchange for acceptance in America, these artists, now securely American, pursue a heritage that more profoundly defines them, beyond their mere Americanness."[23]

Traditionally, the conflict for Jews has been between a private and a public sense of Jewish identity. This in turn came about because identity has often been seen as a question of race, an idea which itself has undergone major shifts in conceptualization since the nineteenth century. Early on, race was regarded as a category of social organization rooted in assumed differences that were often regarded as cultural, but eventually were seen as innately biological and psychological. The more recent emphasis on discourse and representation has transformed the treatment of "race" and ethnicity into socially constructed phenomena. In both North America and Europe, however, the far right has revived eugenic concepts of race, even as minorities have found a stronger voice. The continuing debate over questions of race, ethnicity, and hybridity is complex.[24] Suffice it to say that race has been used mainly for abusive ends, not the least of which are the legacy of slavery, colonial practices, and the slaughter of European Jews and Gypsies. One important cultural response to the idea of race has been to stress "the uniqueness of the individual over the uniformity of the group."[25] Thus, to be a public Jew, in the absence of so-called racial markers, ironically involves the reinscription of the category of Jew as a unified subject. It signifies the subordination of one's individuality, even as one seeks to assert it, by linking oneself with a generalized group. The courage of Vainshtein's stance, and those with tattooed Stars of David, is apparent in the sense that they openly and irreversibly associate themselves with a historically despised and persecuted group, rather than seeking the anonymity of invisibility.

The taint of race is still constructed on the body in a number of stereotypical ways; one of the best known is the Jewish Nose, which has spawned the medical invention of the Nose Job. As Sander Gilman notes, "suffering from a Jewish nose" became a powerful image in the 1930s, when being seen as a Jew meant being persecuted, and many Jews sought surgical solutions. (The nose job lost its efficacy as a means to invisibility, however, with the introduction of the yellow star.)[26] In the 1960s and early 1970s, tens of thousands of American teenage Jewish

girls whose parents wanted their children to fit into the Protestant mainstream had their noses "fixed" through rhinoplasties. The effects of a surgical solution were immortalized by Andy Warhol as early as 1960 in his painting *Before and After*, which presents a female profile with a hooked nose followed by the same profile with its nose smoothed out.[27] While the nose job strives for assimilation, the Holocaust tattoo is implacably nonassimilationist. Yet the nose job and the Holocaust tattoo have something in common: each operates on the body of the Jew because of the effects of antisemitism. And each, in its own way, is a distortion. Although extreme, or precisely because of its extremity, Vainshtein's tattooed body, while establishing a unique late-twentieth-century form of Jewish identity, ironically reproduces central aspects of traditional Jewish identity: the Jew as outsider, the Jew as Other, the body of the Jew as deformed, the Jew as excessive and inassimilable. We can read her action as a backlash against a too successful assimilation into the dominant culture. Where there is no cultural specificity to distinguish the newly conscious Jew, the Holocaust tattoo itself becomes the mark of difference.

But it does not necessarily produce unity with other Jews, in general, but rather with those who also deliberately position themselves as outsiders, that is, in Vainshtein's case, with the community of those who practice body modification. Yet even in the world of the inked, Vainshtein's tattoos have incited an antisemitic response in the form of disdainful snickers by Hell's Angels at a 1995 tattoo convention (where the proud owners of tattoos go to strut their stuff and admire each other). The reaction of these racist bikers produces the ironic spectacle of a widely distrusted segment of an outsider group attempting to construct the tattooed Jew as more "outside" the inside than they are. The response of the Hell's Angels, however, might not impress another group of tattooed bikers captured in a photograph by French photographer Frédéric Brenner (figure 6). Brenner documented a group of Jewish bikers perched astride their Harley-Davidsons as one of a series of unusual post-Holocaust forms of Jewish self-invention found even in this fringe enclave of American particularity. The tattooed Jews on bikes gathered in Miami Beach in 1994 and posed in front of a synagogue, in a picture Brenner entitled *Jews with Hogs*. The witty incongruity of the title parallels the peculiarly postmodern pairing of the Star of David poised between sacred tablets on the synagogue in the background with the Harley-Davidson logo on the T-shirt of the biker with a flowing white beard, like a latter-day Moses, in the foreground. The beard itself operates as a double signifier of modern cultural rebellion and the traditional, observant Jew.

This photograph is part of a larger series Brenner has produced over the past two decades on the subject of the Jewish diaspora. Brenner's project tracks the elusive Jew, trying to understand how Jews maintain a specific identity even as they immerse themselves in the culture of the nation in which they live, or, as Brenner puts it, "how much can one people become part of another and yet remain themselves?"[28] In his search for the diversity of the diaspora, Brenner has photo-

Figure 6. Frédéric Brenner. Jews with Hogs, Miami, *1994. Gelatin silver print.* Photo: Courtesy Frédéric Brenner.

graphed groups such as the Jewish Lesbian Daughters of Holocaust Survivors; Jews who reenact a Civil War battle in period clothing; Passover celebrants at a maximum security women's correctional facility; and the staff of the Nice Jewish Boys Moving and Storage in Palm Beach, Florida, none of whom are Jewish.[29]

Marking herself as a public Jew with the imagery of the Holocaust, Vainshtein perhaps makes herself vulnerable to the critique that her embrace of the "yellow star of ostracism" is an "appropriation" of an experience which is not her own, an act of "draping" herself with "the torture that others underwent."[30] This is how French writer Alain Finkielkraut, in *The Imaginary Jew,* criticized his own efforts as a radical youth when he thought of himself as a persecuted Polish Jew in a period of revolutionary zeal. Finkielkraut confesses to a realization that he was only pretending and argues that memory of the Holocaust must extend to memory of the Jewish community and culture based on the common language of Yiddish that the Holocaust destroyed. Because Jewish ethnicity itself was lost in that destruction, he contends, Jewishness today cannot properly link itself to its past

and claim a mantle of continuity: "The Jew may be civilization's Other, but it is an otherness none can possess. To put it still more bluntly: the Holocaust has no heirs. No one can cloak himself in such an experience, incommunicable, if not the survivors. Among the people that constitute our generation, it is given to no one to say: I am the child of Auschwitz."[31] Finkielkraut sees himself as a proud, yet imaginary Jew, unable to claim any specific kind of cultural difference. He asserts that Jews no longer exist as they once did, that today's Jews are cut off from Jewish culture by the disaster in which it perished. For Finkielkraut, commemoration of the Holocaust still leaves in oblivion the face of the living culture that came before and has been lost forever. While courageously refusing "a tragic, heroic, self-righteous, and delusive identification on the part of children of Jewish survivors of Nazism with the victims themselves," in the words of Jonathan Boyarin, Finkielkraut's disillusionment with the possibility of a continued "Jewish" identity, based on his own sense of "pretending," is too categorical. Boyarin observes that Finkielkraut has left no "space of the imaginary within which 'Jewish' is constituted." Thus, "having once dismantled the illusion of a total identification with his ancestors, he still imagines identity as an all-or-nothing affair. . . . Finkielkraut imagines the world of the 'real Jews' to be an actual whole, irretrievably in the past. He has made himself an imaginary 'not-Jew.'"[32]

Marina Vainshtein, on the other hand, feels no sense of pretense in her identification with the Jewish genocide. She projects a truth that many historians, children of Holocaust survivors, psychiatrists, and psychoanalysts have come to understand: *even those born later can be traumatized by the Holocaust.* Geoffrey Hartman, founder of the Fortunoff Video Archive for Holocaust Testimonies at Yale University, calls those experiencing this phenomenon "witnesses by adoption," referring to those who have been damaged by the transmittance of memory by those who survived.[33] I find the term "secondary witness" more adequate to encompass this phenomenon. As a secondary witness, Vainshtein's body must be read as her own testimonial to the event, a reenactment of historical memory performed by a surrogate witness in whom trauma has also been induced, even as she attempts to reclaim the body of the Jew that was tortured, burned, and forcibly tattooed.

Assuming the risks of exposing herself as a target for those who hate outsiders, Vainshtein defies what Finkielkraut calls that "crushing imperative," the one always borne by outsiders that says: "Don't stand out."[34] In rejecting Jewish invisibility and assimilation, the body of the tattooed Jew more broadly constitutes a postmodernist rejection of an idealized bourgeois "norm." It represents an abandonment of the liberal humanist ideal of the flattening out of all difference, a homogeneous universalism. This modernist aspiration used as its universal model the white, middle-class, heterosexual, and *Gentile* male.

A distinction must be made here between the assertion of difference, or the "politics of identity," on one hand, and "identity politics" on the other. The politics of identity may be defined as articulating problems of everyday life, as

well as criticism and theory, in an interrogative and analytical way. Identity politics may be defined as an organized way of articulating group identities and differences as both aim and strategy. The main complaint against identity politics has been a fear that once articulated, such identities are either triumphant or fixed, generating a potentially destructive tribal mentality. Art Spiegelman, author of the comic book volumes *Maus: A Survivor's Story*, argues against what he perceives as just this sort of ethnic "excess." Spiegelman is regarded by many newly militant Jews as the godfather of renewed Jewish consciousness. Yet Spiegelman warns against the nationalist divisiveness of identity politics: "This is the problem with an America that has gone crazy," Spiegelman says, "that's just gone into ethnic madness. I think what you're seeing is a response to the Balkanization of America, where Jews who felt themselves too embraced in America's assimilationist arms have now started to desperately backpedal. It seems to me that America has entered into an age of competing victimhoods, and that the left has become sapped by the rise of multiculturalism. The energy that used to go into trying to create a generally more just society has been rerouted into competing claims of ethnic rights."[35] Spiegelman, in effect, counterposes a more materialist political view of history to the politics of liberal pluralism. A more nuanced view, argued by Jonathan Boyarin, suggests that specific differences can be used as a productive field for exploring more general issues related to the politics of difference.[36]

Despite the loss of prewar Yiddish culture, the language of Yiddish not only survives among certain ultraorthodox communities, but is undergoing something of a revival, from the Broadway play *Mamaloshen* (Mother Tongue) starring Mandy Patinken, to a segment of the Jewish gay and lesbian community. Yiddish is also the predominant language of Jewish klezmer groups such as the Klezmatics, who not only use it on their CDs but also teach it at their annual five-day Yiddish music, language, and culture extravaganza known as Klez/Camp.

Marina Vainshtein is also an open lesbian. In addition to her tattoos, she has twenty-five body pierces and a nine-inch red Mohawk. Perhaps precisely because Yiddish culture in Europe *was* destroyed, a culture which included its own forms of misogyny and homophobia, today's newly conscious postmodernist Jews can be anything they want—gay, feminist, pierced, and tattooed—and no one can tell them they don't belong. But, we might ask: What is the relationship between Vainshtein's pierces and her Holocaust tattoos? Marianna Torgovnick has argued that African initiation rituals are closest in spirit to contemporary Western piercing rituals because they physically mark the passage into adulthood with a badge of identity that is lacking in American culture.[37] The rituals that are available for Jews, such as the bar or bat mitzvah, only approximate initiation without achieving it, she suggests, because there is no visible marker left behind.[38] In the marriage of "mineral and flesh," by contrast, the piercing ritual is seen as "affirmation of the bodily self" through the acquisition of a permanent, recognizable mark of identity and as a rite of passage that symbolically confronts mortality.[39] We can extend the logic of piercing as a coming of age ritual to certain other forms of body

modification, including tattooing and branding, as exemplified by the bodyart of Joshua Burgin and Marina Vainshtein.

When I asked Vainshtein about embracing two forms of body modification at the same time—the pierces and punk aesthetic as well as the Holocaust tattoos—she insisted that they had nothing to do with each other, despite the fact that they both were contemplated and adopted at the same time in her adolescence and both have something to do with finding forms of self-expression that establish her sense of identity. She asserts her enjoyment of her twenty-five body pierces as adornment only and for the sensual pleasure they give her.[40] Her sense of their separateness from her tattoos points to the ironic tensions produced by the multiple ways in which we define ourselves. We are, indeed, always negotiating among various and even contradictory senses of self, other, and group.

Vainshtein is right to suggest that Jewish ethnicity per se has little or nothing to do with punk culture. American punk may be read as a "middle-class expression of alienation from and disgust with the mainstream values of society."[41] The punk ethos is anarchistic and nihilistic, focusing on apocalyptic themes of destruction and death, as well as the development of new styles of music, art, writing, and body adornment. The most popular hairstyle associated with the punk aesthetic, the Mohawk, evokes stereotyped notions of the primitive, or youth on the warpath, an assertion of identity that challenges dominant notions of feminine beauty just as tattooing challenges dominant notions of the sanctity of the body. Punks create the impression that they are "sacrificing their bodies out of postmodern despair," that is, out of the conviction that our civilization has no future.[42]

But this brings us back to Vainshtein's imagery of the Holocaust and the use of her body as a medium. Her unique form of bodyart precisely expresses alienation from and disgust with mainstream values and is profoundly concerned with apocalyptic themes of destruction and death. For the postwar generations that were raised with filmic and photographic images of emaciated bodies bulldozed into open pits, it is only a short step to cynicism about the future of civilization and disgust with Western notions of beauty and the sanctity of the body. The experience of the camps, vicariously embraced, has subverted notions of the sanctified body. What unites the punk ethos and aesthetic that Vainshtein has adopted with the content of her bodyart is not the issue of Jewish ethnicity per se but the shattered idealism of the post-Holocaust era. The latter half of the twentieth century was the era of disillusionment with Enlightenment values of rationality, progress, the goodness of humanity, and the benefits of technology. This is the era of proliferating genocides. And yet, by converting the tattooed numbers, which mutely allude to the Holocaust experience, into a full-blown exposition of what those numbers mean, Vainshtein effects a symbolic reversal of *Halachic* law. Through her devotion, the desecrated body becomes the body beautiful.

Among historians and writers there has been a debate for some years over whether the Holocaust can be compellingly described or represented at all without being aestheticized or in some way ethically compromised. Writers such as

Elie Wiesel, who has produced a number of his own books, have called for silence as the only response that will not trivialize the enormity of the event or produce what historian Saul Friedländer has called "Holocaust kitsch."[43] What about the aestheticization of the Holocaust in the easily recognizable icons of emaciated bodies, barbed wire, and ovens on Vainshtein's body? Is this a trivialization of the Holocaust into kitsch imagery? As the veritable explosion of Holocaust representation demonstrates, it is not a subject that can or should be silenced. Vainshtein's tattoos succeed in evoking both horror and admiration: horror for the defamiliarization of the body with representations of death and suffering, but admiration for the level of commitment she demonstrates, for the extremity of her stance. The peculiar medium of the body for such painful imagery might remind us of Kafka's story, *In the Penal Colony*, in which history as inscription on the body also finds a literal treatment. In Kafka's penal colony a torture machine writes the prisoner's "sentence" on the body by piercing the flesh with needles. The condemned man then deciphers his sentence with his wounds. This is not to suggest that Kafka predicted the mass murder of the Holocaust; on the contrary, Kafka's story takes place on the level of internal, individual consciousness. Marina Vainshtein's body inscription is also a singular, albeit self-inflicted, act; she, however, knows who the enemy is and what the punishment was. The fact that Vainshtein marks this knowledge *on her skin* is what freights the familiar imagery with its sorrowful power. We are further reminded that it was the tattooed skin of murdered prisoners that was tanned into lampshades and pocket-knife sheaths for the German SS, which Vainshtein herself pictures on her chest.[44] The chilling resonance of *this* dimension to Vainshtein's body modifications allows us to read the imagery of catastrophe on the skin of her body as not only *representing* the subject of the Holocaust, but *reproducing* the abject subject at its center. For what is astonishing about Vainshtein's tattoos is perhaps not so much the imagery itself, but the willingness to imprint an experience of pain never actually felt on the feeling body, to physically inscribe herself into a history for which she was born too late.

The assimilating Jew wants to be recognized for his or her accomplishments without being noticed as a Jew, that is, visible as a universal citizen but unmarked by ethnicity. The assimilating Jew wishes, perhaps, to remain a Jew only on the inside, or among friends. Those who oppose assimilation denounce it as a trap; yet now that, on the whole, assimilation is no longer forced upon Jews, it is ironic how much like everyone else the Jew has already become—speaking the same language, wearing the same clothes, engaging in the same cultural practices. As a tattooed Jew with Holocaust scenes, Hebrew script, and Stars of David, on the other hand, Vainshtein not only rejects assimilation but also its implied forgetfulness of Jewish history. The marked body says: "I am a remembering Jew, a public Jew, an unashamed Jew." At the same time, this is a form of memory in which the Jew as always-already dead or victimized is imprinted on the living body; it is not only a representation but, in a sense, a continuous performance of memory and difference. As such, the tattoos are not meant to convey information and knowledge

about the Holocaust so much as to perform the unspeakable, to present the unpresentable. For the admonition to "remember" the Holocaust acquires a new meaning with the passage of time. With the dying out of the survivors, new ways of bridging the gap between then and now must be invented. What we cannot remember, we must imagine through representation, and our response is less immediately to the event than to the medium that has conveyed it to us.[45] It is precisely the medium of skin and the permanence of the action that gives the iconographic content of Vainshtein's tattoos its undeniable emotional charge, and thereby gives her project its power. Perhaps it is a way of reminding us that "ultimately, the world we live in is the same world that produced (and keeps producing) genocide."[46] While we can walk out of a film like *Schindler's List* or turn off the television, Vainshtein removes herself from a privileged position of spectatorship by using her own body as a medium for the message.

Above all, I would suggest that the Holocaust tattoos are meant to have what the Greeks called *apotropaic* value, to form a shield that repels enemies and wards off evil just as the fierce head of Medusa was meant do. Vainshtein inscribes herself with the memory of a horrific slaughter as a form of protection against its repetition. Armoring her body against the otherness without, against a history of fear, incarceration, mutilation, and murder, the tattoos are meant to resist the very events they represent. Marina Vainshtein and Joshua Burgin, in different ways, claim the mark of the barbarian in order to subdue the terror of barbarism.

NOTES

1. Joshua Burgin, "Judaism and Body Modification." [WWW Body Modification Ezine]. Available [Online]: http://www.BME.FreeQ.com/new/bmenews.html [January 23, 1996].
2. The debate over who is a "proper" Jew has been particularly heated in Israel, both in regard to immigration laws that are still being determined on the basis of ethnic criteria, and even more notoriously, regarding the rule of Orthodox versus Conservative and Reform synagogues, affecting who may perform marriages, conversions, and the like. This debate has had strong repercussions in the organized Jewish community in the United States.
3. Burgin, "Judaism and Body Modification."
4. Reform Judaism is now the largest organized religious movement among American Jews, with a constituency of 1.5 million.
5. Primo Levi, *The Drowned and the Saved,* tr. Raymond Rosenthal (New York: Vintage Books, 1989), 118–19. Many women in Auschwitz/Birkenau were also tattooed on the outside of their arms. It has also been reported that some prisoners in Buchenwald were tattooed on their stomachs, and photographs at the U.S. Holocaust Memorial Museum show prisoners at one of the Gusen subcamps of Mauthausen with numbers tattooed on their chests.
6. Sander Gilman, *The Jew's Body* (New York: Routledge, 1991), 219. For a discussion of American assimilation from the perspective of a nonassimilationist, see Barry Rubin, *Assimilation and Its Discontents* (New York: Random House, 1995).
7. Levi, *The Drowned and the Saved,* 119–20.
8. Margot Mifflin, *Bodies of Subversion: A Secret History of Women and Tattoo* (New York: Juno Books, 1997), 115.
9. Kenneth Baker, *Artforum* (May 1990), quoted in Gary Michael Dault, "Painspotting: The Art of John Scott," *John Scott: Engines of Anxiety,* exhibition catalogue (Montreal: Gallery of the Saidye Bronfman Centre for the Arts, 1997), 13.
10. See Melony Ward, *C Magazine* 25, Spring 1990, cited in ibid.

11. Quoted in ibid., 14.

12. David Liss, "Engines of Anxiety," in ibid., 5.

13. Linda Nochlin, "The Couturier and the Hasid," in *Too Jewish? Challenging Traditional Identities*, ed. Norman L. Kleeblatt, exhibition catalogue (New York/New Brunswick: The Jewish Museum and Rutgers University Press, 1996), xviii.

14. Quoted in ibid., xix.

15. *Davka* is Yiddish for "doing something in spite of being warned not to," or more loosely, "up yours." See the inaugural issue, Winter 1996.

16. See Rubin, *Assimilation and Its Discontents*. From Rubin's perspective, "Jewishness," which remains undefined, must be linked to religious practice, and further, to Zionist support for the State of Israel.

17. Quoted in E. J. Kessler, "An Upstart with an Underground Edge," *Forward*, February 9, 1996. In other interviews Rabbi Pearce said that the cover was not in "good taste" and was not the appropriate image to be associated with the largest congregation in the Bay Area. See Katherine Seligman, "Risky New Jewish Magazine Off to Lively Start," *San Francisco Examiner*, February 25, 1996, and Joseph Berkofsky, "Alternative Magazine Pushes Boundaries of Jewish Law, Taste," *Jewish Bulletin of Northern California*, January 26, 1996.

18. The content of Vainshtein's bodyart is based on documentary photographs and drawings she found in books of artworks by Holocaust survivors. Her backpiece was produced by tattoo artist Bob Vessells; her other tattoos were created by Jaime Schene, Louis Favela, Jason Schroeder, Mark Paramore, and Henry Martinez.

19. Marina Vainshtein, telephone conversation with author, July 29, 1996.

20. Jordon Elgrably, "In Your Faith," *Los Angeles Times*, May 13, 1996.

21. Marina Vainshtein, telephone conversation with author, July 29, 1996.

22. See Leonard Garment, "Christian Soldiers," *New York Times*, June 27, 1996, and Jeffrey Goldberg, "Some of Their Best Friends Are Jews," *New York Times*, March 16, 1997. At a 1996 conference in New Orleans with 14,000 delegates, the Southern Baptist Convention adopted a resolution calling for a major campaign to convert American Jews to Christianity, and appointed a missionary to take charge of the conversion operations. Garment points out that this resolution is the latest in a centuries-long line of conversion efforts among Christians, as old as Christianity itself, in which Judaism is viewed as obsolete, unnecessary, and a challenge to the idea of the inevitability of Christianity as the natural culmination of Jewish history. Hence, only the Jews stand in special need of spiritual improvement. For a discussion of Christian antisemitism, also see Steven T. Katz, "Ideology, State Power, and Mass Murder/Genocide," in *Lessons and Legacies: The Meaning of the Holocaust in a Changing World*, ed. Peter Hayes (Evanston: Northwestern University Press, 1991), and John Weiss, *Ideology of Death: Why the Holocaust Happened in Germany* (Chicago: Elephant Paperbacks, 1996).

23. Barry Singer, "In Yiddish Music, A Return to Roots of Torment and Joy," *New York Times*, August 16, 1998.

24. See Robert J. C. Young, *Colonial Desire: Hybridity in Theory, Culture and Race* (New York: Routledge, 1995).

25. See Gilman, *The Jew's Body*, 170–71.

26. Ibid., 184–85.

27. More recently the Jewish nose has been addressed in works such as *Jewish Noses* (1993–95) by Dennis Kardon, an ongoing project that makes sculptural likenesses of noses belonging to Jews in the artworld, and Deborah Kass's 1992 *Four Barbras (the Jewish Jackie Series)*, which borrows the format of Andy Warhol's celebrity portraits to present the repeated stereotypical profile of Barbra Streisand. Both works were shown in the *Too Jewish? Challenging Traditional Identities* exhibition at The Jewish Museum in New York, March 10 to July 14, 1996.

28. Frédéric Brenner, quoted by Charles Hirshberg in "Portraits of a People," *Life* Special, *Life*, September 1996.

29. See Robin Cembalest, "Documenting the Diaspora with a Cast of Hundreds: Frédéric Brenner's Unconventional Portrait of American Jewry," *Forward*, Arts & Letters, September 13, 1996.

30. Alain Finkielkraut, *The Imaginary Jew*, tr. Kevin O'Niell and David Suchoff (1980. Lincoln: University of Nebraska Press, 1994), 32.

31. Ibid., 34.

32. Jonathan Boyarin, *Thinking in Jewish* (Chicago: University of Chicago Press, 1996), 165–66.

33. See Geoffrey H. Hartman, *The Longest Shadow: In the Aftermath of the Holocaust* (Bloomington/Indianapolis: Indiana University Press, 1996).

34. Finkielkraut, *The Imaginary Jew*, 126.

35. Quoted in Elgrably, "In Your Faith."

36. Boyarin, *Thinking in Jewish*, 5.

37. Marianna Torgovnick, "Skin and Bolts," *Artforum International* (December 1992): 64–65.

38. Ibid.

39. Ibid.

40. Marina Vainshtein, telephone conversation with author, July 29, 1996.

41. Daniel Wojcik, *Punk and Neo-Tribal Body Art* (Jackson: University of Mississippi Press, 1995), 8–9.

42. Ibid., 11.

43. See Elie Wiesel, "Art and the Holocaust: Trivializing Memory," *New York Times*, June 11, 1989, and Saul Friedlander, *Reflections of Nazism: An Essay on Kitsch and Death* (Bloomington/ Indianapolis: Indiana University Press, 1993). Also see Saul Friedlander, ed., *Probing the Limits of Representation* (New Haven: Yale University Press, 1992), and Peter Hayes, ed., *Lessons and Legacies*.

44. Ilse Koch, wife of the commandant of Buchenwald, was apparently responsible for selecting the living prisoners whose skin she wanted, after they were killed, for her own collection and for making lampshades of tattooed skin and other objects to be forwarded to the main administrative office of the SS in Oranienburg. The SS also requested shrunken heads, presumably to be used as desk ornaments. Koch was made SS-*Aufseherin* (overseer) at Buchenwald when her husband, Karl Otto Koch, was appointed SS-*Standartenfuehrer* in August 1937, and became notorious for her extreme cruelty to prisoners. In 1945 her husband was executed, but Ilse Koch was acquitted. She was arrested by the Americans on June 30, 1945, tried in 1947, and sentenced to life imprisonment. In 1949 she was pardoned and rearrested, and in January 1951, again sentenced to life imprisonment. In September 1967, she committed suicide in her prison cell in Augsburg. See Israel Gutman, ed., *Encyclopedia of the Holocaust* (New York: Macmillan, 1995), 809; and Arnold Krammer, book review of David A. Hackett, ed., *The Buchenwald Report* (Boulder: Westview Press, 1995), in *German Studies Review* 3 (October 1996): 593–94.

45. See Philip Gourevitch, "What They Saw at the Holocaust Museum," *New York Times Magazine*, February 12, 1995, 44–45.

46. Omer Bartov, *Murder in Our Midst: The Holocaust, Industrial Killing, and Representation* (New York: Oxford University Press, 1996), 53.

Internet and the Web

Anna Reading

Clicking on Hitler:
The Virtual Holocaust @Home

The Holocaust has taken on a virtual dimension. For young people in particular, visual memories of the Holocaust are constructed not only from films, museums, and art but also from Internet sources and CD-ROM materials.[1] Many major Holocaust museums and memorial sites, such as the U.S. Holocaust Museum and Yad Vashem in Israel, have their own websites. Museum shops generally sell CD-ROM materials as well as videos and books to supplement visitors' memories of their visit to the museum. University and community libraries also make use of such materials. These many websites as well as multimedia CD-ROMs, such as David Cesarani with Logos Research System's *Lest We Forget* and Nadine Burke's *Images from the Holocaust,* provide interactive access to documents, photographs, film footage, and commentaries in digital memory form through the personal computer. Yet how different are these virtual relays from other visual forms? How should we understand the ways in which cyberspace constructs our understanding, knowledge, feelings, and memories of the atrocities of the Nazi era?

This chapter aims to enhance our understanding of cybermemory and the representation of the Holocaust accessed through the computer and the impact of cyberspatial representations on our collective remembering. I begin by defining cyberspace and multimedia, before discussing some of the conventional approaches to the Internet and digital multimedia. I then consider what is available on the Holocaust in the matrix of cyberspace and in CD-ROM, who uses the Internet, and why people visit Holocaust sites. The reasons given, I suggest, indicate that we should move beyond the conventional approaches to digital media and understand the process of reading the translations of the events of the Holocaust in cyberspace in terms of a journey of remembering that involves the reproduction of elements of trauma and recovery. Distinctive aspects of the technology and the codes and conventions of the digitized form itself give rise to processes and experiences that are in articulation with the particular content of Holocaust-related sites. For the visitor to a Holocaust-related site in cyberspace, this produces interpretive experiences of dislocation, relocation, connection, and interconnection, which may be understood as reproducing the processes of traumatic memory and recovery suggested by psychiatrists such as Judith Herman in relation to war atrocities and

abuse (1994). This, I argue, is not to deny that there are certain limitations as well as important problems with the representation of the Holocaust on the Internet and in interactive digital media. But it does offer one possible understanding of how Holocaust memory is articulated within the particular possibilities of digital codes and conventions.

Defining Cyberspace and Multimedia

Cyberspace, a term initially popularized through the fantasy fiction of books such as William Gibson's *Neuromancer* (1984), constitutes a range of different forms: first, it includes the world of dialogue and conversations epitomized by personal e-mails and virtual chat rooms. Second, it includes posted pages and electronic communications within a given community or organization. Third, it includes presentations that can be personal or collective, non-profit making or commercial through web pages that may or may not be registered with a search engine on the World Wide Web of global computers. The World Wide Web is what concerns us here: in discussing the construction of Holocaust memories, young people mentioned primarily the Web rather than e-mails and local discussion groups (Reading, forthcoming).

But the virtual Holocaust does not end with the world of cyberspace. There is also the construction of Holocaust memory within a multimedia environment. The multimedia environment includes games, software programs, and the specialist write-only mediascapes of CD-ROMs. The essential difference between cyberspace and multimedia such as CD-ROMs is that the latter are "write-only" media: once written and programmed, they are fixed. In contrast, presentations and conversations within cyberspace are characterized by their fluid nature, in which presentations may be subject to changes, and conversations (as in everyday life) may be left unfinished and subsequently altered.

Approaches to the Virtual

Established academic approaches to digital technologies within media and communications studies provide a number of starting points for how we may understand the place and role of virtual memory of the Holocaust in multimedia and on the Web.

Political economists have emphasized the underlying economic dimension of the Internet, arguing that in cyberspace corporate visions dominate and commercial imperatives structure who has access to sites, the kinds of sites available, and the software framework of representations in cyberspace. A number of critics

have suggested that far from the Internet providing a new democratic medium to which all have equal access, in fact, those who do have access to the Internet and thus Holocaust memory within cyberspace are those of privilege and wealth (Streck 1999, 31). According to David Carter (1997), what lurks before us is a division between the information rich, with access to the Internet, and the information poor, who may not even have access to other mass media. Indeed, although the percentage of home Internet use has increased dramatically over the past five years (Cornford and Robins 1999, 116–17), many argue that its use is limited to those termed the cybergoisie, who live in city cyburbias (Dear and Flusty 1999, 64–85). This points to the importance of recognizing the structural context in which cybermemories work. In many ways it is no different from recognizing, following Pierre Bourdieu (1990), the structural context that interacts with visitors in other art forms. Thus the majority of people who visit an art exhibition about the Holocaust or Holocaust museums or see Holocaust-related films will in a global context be skewed in favor of a Western urban elite.

Various research suggests that this structuring of Internet and computer use is also gendered: fewer women than men use the Internet, according to Bergman and Van Zoonen, with figures ranging between fifteen and twenty-five percent of all users (1999, 106). Of these, it is argued, women use the Net primarily for conversation and letter writing rather than for information gathering (Bergman and Van Zoonen 1999, 90–107). However, other studies have suggested that while most users of the Internet are still overwhelmingly white and with higher than average incomes, the gendered use of cyberspace has, in fact, changed: in 1993 the majority of users, according to Tim Jordan, were men, but by 1999 Internet use is about equal between men and women (1999, 53–54). This would certainly fit in with my own research in which seventy-five young people were asked where they had obtained their information concerning the Holocaust: an equal number of male and female respondents cited the Internet as a source. The greater variant was not gender but cultural context: while no respondents in Poland cited the Internet as a source (focus groups, Gdansk, Lodz, and Kracow, April 1998), 25 percent of American respondents included the Internet as important to the development of their understanding of the Holocaust (focus groups, New York, Washington, D.C., March 1999). My own analysis of visitor profiles given on one Holocaust particular website in July 1999 also supports the view that both men and women access Holocaust sites in equal measure (Jeff and Elliott's Holocaust Page: http://geocities. com/Athens/Olympus/9589). Further, what is important is not just the kind of people who visit but why people visit and what kind of sites they visit. This, as I argue later, suggests a more nuanced way of understanding the place and processes of cyberspace in memories of the Holocaust than simply pointing to the structural context alone.

A political economy approach also suggests that Holocaust sites in cyberspace may be dominated by corporate sites or historical perspectives packaged by big business. However, cyberspace memories include an enormous variety of sites,

ranging from the institutional to the individual. A general search of cyberspace—activated by using the word "Holocaust" in Netscape and using standard search engines such as Lycos, Yahoo, and Go-Network—elicits between 55,000 and 60,000 results. These include a mixture of museum sites, news articles, references to other media such as CD-ROM materials and books, and people's personal home pages. A search of reviewed and rated Holocaust websites through PlanetClick (http://www.PlanetClick.com) offers the possibility of ninety-one websites. The overwhelming majority of these sites provide access to documentary sources or educational materials on the Holocaust. Of these a number specialize in the dissemination of written documentation, such as Stuart Stein's site provided through the University of East Anglia (http://www.ess.uwe.ac.uk.). Six sites are projects specifically geared to provide collections of hypertext links or guides to materials available in cyberspace such as the Cybrary of the Holocaust (http://www.remember.org). More than half provide information and contacts in relation to particular issues such as the Remember the Women project in New York that specializes in providing a link for those involved in research on the Holocaust concerned particularly with gender issues (http://www.rememberwomen.org) or the Euthanasia T-4 Programme (http://www.us-israel.org/jso). Three sites specialize in visual media-based presentations that draw on or provide a cyberspace archive of photographs, film clips, and artsworks about the Holocaust, such as the Holocaust Pictures Exhibition (http://www.fmv.ulg.ac.be/schmitz/holocaust/html).

What is significant here is that twelve sites provide multimedia presentations that interface with museums, including the U.S. Holocaust Museum in Washington, D.C. (www.ushmm.org), the Simon Wiesenthal Museum of Tolerance in Los Angeles (http://www.wiesenthal.com), the Museum of Jewish Heritage: Living Memorial to the Holocaust in New York (http://www.mjhnyc.org), the Jewish Historical Museum in Amsterdam, The Netherlands (http://www.jhm.nl), and Yad Vashem in Jerusalem (http://www.yad-vashem.org.il). A few refer to former concentration camp sites such as K-Z Mauthausen-Gusen (http://linz/org.at.orf/gusen/index). Such sites have been established at the behest of the government or local government and are usually maintained within the ethos of providing a public memorial and educational public service rather than as corporate enterprises.

Furthermore, despite reservations about the costs involved to set up a site, the Web does allow individuals to set up and maintain Web-based projects and sites in ways that can circumvent the gatekeepers in other big business media. Some of these, such as "Forty Years Later: A Personal Recollection by Rav Yehuda" (http://www.virtual.co.il/edu), are run by survivors themselves, providing a medium through which survivors can and do tell their stories. Other sites are run by second- or third-generation individuals who feel duty-bound to remember, such as Alan Jacobs's site, which presents photographs of Auschwitz-Birkenau taken by him in 1979–81 (http://www.remember.org. auschwitz). The Web also allows young people to explore and establish their own sites in ways that may be less possible with other media: Jeff and Elliott's Holocaust Page, for example, was con-

structed by two grade 12 students in Ontario. "Dedicated to the six million Jews and millions of others who died in the Holocaust," it provides, underneath an icon of a yellow star, hypertext links to thirty other Holocaust sites (http://geocities. com/Athens/Olympus/9581).

In this respect, then, the view of corporate domination or commercial imperatives governing Holocaust memory in cyberspace is not entirely true. However, the ethos of cyberspace being free of governmental controls and providing a new space for anyone to present their views has a serious downside. Jeff and Elliott's site also provides visitors with hypertext links to fascist sites and Holocaust revisionist and denial sites. This section of their website, prefaced with the warning "Beware These Sites," provides a series of chilling links for visitors in an endeavor to be "even-handed" in their approach. Neither does one have to go via Jeff and Elliott's site to find these links: any surfer of cyberspace searching via the word "Holocaust" in May 1999 would find ten sites on Netscape under the search string "Holocaust, denial." As Michael Whine (1999, 209–21) notes, the Internet provides unprecedented access to and means for propagating racist ideas and promoting Holocaust denial by Neo-Nazis. This is further illustrated by the fact that the major promoter of Holocaust denial in the United States, the Institute for Historical Review, has made Internet publications a priority (Whine 1999, 213).

Further, although Holocaust denial sites may transgress national legislation, countries have found it difficult to implement effective censorship because of the nature of the technology itself. In Germany, prosecutors tried to close down Neo-Nazi sites that went against the country's national laws, but they could not prevent the copying and posting of the sites from countries without laws preventing the promotion of fascism. "Having done this Germany's only choice was to sever its connection to cyberspace, a choice with an almost impossibly high cost, or to accept that the uncensorable and global net had subverted its national laws" (Jordan 1999, 35). Internet technology and the way it works—sending global messages as small packets of information accessible from more than one source—has allowed for the relay of aspects of Holocaust revisionism that have been prevented in particular national contexts within other visual media. The Internet treats any attempt at censorship, including the censorship of Holocaust denial and Neo-Nazism, "like damage, it routes around it" (http://www.cygnus.coms/~ gnu).

In this respect, cyberspace has allowed for the development of Holocaust denial within the public sphere. In other visual media it may be possible to censor those who wish to deny the atrocities that happened; within cyberspace this is problematic. Users can easily download, if they wish, Holocaust denial web pages. Given this, how do people themselves react to the presence of such sites? One of my interviewees said this had motivated her to monitor the number of denial sites over six months, where she found that the numbers had not, to her relief, increased (Maria, Washington, D.C, March 1999). Another interviewee stated that visiting denial sites (in addition to Holocaust sites) had convinced him further of the necessity to remember the Holocaust and the lessons to be learned

from it, since the sites demonstrated that racism was still alive (Marcus, New York, March 1999). Several visitors to Jeff and Elliott's site expressed the view that providing links to Holocaust denial materials resulted in Holocaust deniers damning themselves through their own words (Jeff and Elliott's Holocaust Page; http://geocities.com.Athens/Olympus/9589). Two of my interviewees articulated the feeling that such material was so repugnant to them that downloading denial sites would in some way contaminate them (Aysha, London, November 1998; Carlos, New York, March 1999). One suggested that denial sites would expose one's computer to viruses that might destroy their "memory" or result in loss of data.[2] Certainly, with the advent of worm viruses and viruses that can disguise themselves as friendly attachments, as well as the very real possibility that downloading web pages can bring home electronic spies, burglars, and vandals, this is a development worth monitoring (see http:// www.datafellows.com).

For a small but visible minority, though, it should be recognized that Holocaust denial sites serve to confirm and promote anti-Semitic and racist ideology: one visitor to Jeff and Elliott's site asked for more denial sites to be listed; another remained stuck in his denial, despite having viewed the range of Holocaust sites listed by Jeff and Elliott: "I repeat: show me or draw me a gas chamber, one of these machines of mass murder invented by these wicked Nazis, a machine that no one has ever seen" (Jeff and Elliott's Holocaust Page: http://geocities.com/Athens/Olympus/9589). Although his or her words within the context of other visitor feedback emphasize the offensive nature of his or her denial, they bring home the fact that there are still those who seek to deny the reality of Nazi mass murder. (For further information on Holocaust denial sites, see Whine 1999.)

Yet another issue raised by a political economy approach concerns developing an understanding of virtual Holocaust memory. Although not all Holocaust sites are commercial enterprises, their content is viewed through a series of commercial electronic windows. At the beginning of the twenty-first century, our view of material on the World Wide Web is predominantly provided by one company, Microsoft. Tim Jordan estimates that between 80 and 90 percent of personal computers use a Microsoft operating system, which with Windows 98 (and Windows NT) increasingly collapses the distinction between our electronic desktop and the browser required to surf the Net (Jordan 1999, 125). Further, the technology, as Sean Cubitt (1998) points out, is based on WIMP—the windows, icon, menu, pointer interface—in which icons rather than indices (images corresponding to actual existing things) are used. To some, the acquisition of the same skills and practices to access cyberspace through WIMP is perceived as a form of "intellectual and economic colonisation," in which cultural diversity is increasingly being eroded (Pickering 1999, 180).

Thus, whether we enter the Simon Wiesenthal Web site (http://www.motlc.wiesenthal.com) from Tel Aviv, London, or New York, it is visually framed in the majority of cases through Bill Gates's Microsoft Netscape Browser. With its mixed metaphor of windows providing access to pages that are part of nonactual sites,

we experience the same visual frame design and tool bar with its active buttons and split screen. We use the same icons to decode Holocaust memory: we have our virtual home [page] that we return to through the click on an icon of a house; we have our own cyberhistory accessed through a time-piece icon; our own list of 'favorites.'

Further, although we may each customize our window on the history of the Holocaust, it will be translated through the same software using the same digital language and same choice of commercial search engines. Thus a search with the word "Holocaust" using *Lycos: Your Personal Internet Guide* tells us:

> Results
> Matches 1–10 out of 56019
> 1 2 3 4 5 6 7 8 9 10
> Holocaust Archives
> Holocaust Archives Anne Frank WWW Site Fighting Hate: Neo-Nazi's, Fascists and Holocaust Related Archives Holocaust Index
> http://reenic.itexas.edu/reenic/Subjects/Holocaust/holocaust.html
> (100% OK).

The Lycos search engine provides a summary, links, and estimation of the total memory space for each match of the 56019 matches relating to the word "Holocaust." We are also entreated to "Check These Out": books about the Holocaust, pictures of the Holocaust, sounds relating to the Holocaust. Further, framing the first ten Holocaust matches are additional moving and flickering icons and text messages: at the top are colored hotspots with advertisements for low-cost flights to a variety of worldwide destinations; around the right of the page are invitations to visit CD music stores on-line and leisure planet. Hypertext links on the left hand side provide temptations to click on pictures of the day, look at the weather, or obtain an update of the news (http://www.lycos.co.uk).

How should we understand this way of representing the history of the Holocaust? Since the Internet is not immune from commercial imperatives, sites dedicated to the Holocaust are not exempt from the encroachments of capitalism and commercialism. Perhaps it is indicative of what Raphael Samuel notes has been pilloried within cultural studies—the way in which capitalism is seen to commodify history (Samuel 1994, 259–60). In this respect it is not just the Internet that can be accused of commercializing our experience of the history of the Holocaust: it can also be found at memorial sites such as Auschwitz-Birkenau, with its nearby hotel, coach tours, bookshop, and cafeteria (personal observation, April 1998). Likewise, the same charge can be made for other visual representations of the Holocaust, such as films. The success of Stephen Spielberg's *Schindler's List* has been used to stimulate further interest in the Holocaust: in Kracow, for example, visitors are invited to go on a tour showing the sites of the film *Schindler's List* (Zaglada Zydow Krakowskich, 1998).

From this perspective we could argue that capitalism undermines the

representations of the Holocaust in cyberspace, providing inappropriate commercial framing and distasteful distractions in the light of something so important and so serious. However, I suggest that this raises the need to understand our own reliance on digital technologies for accessing representations of the Holocaust. It underscores the fact that we should recognize that these practices take place within a commercially framed context. In this way, rather than dismissing Holocaust sites as somehow contaminated or ruined by their commercial context, I would suggest a reading that places the tension between the two—between the Holocaust and the commercial software that tells its story, using a visual language of shared icons, flickering quicktime figures, and hot spots at its heart.

The Atrocious Dialectic

The visual content of the web page may be understood in terms of the dialectic between the central panel providing information specifically on the Holocaust and the window through which we view it. There is a contradiction between the commercial invitations for low-cost flights, the weather and news, and hypertext links to the desired Holocaust sites; in other words, we are pulled between clicking on the Holocaust or a CD music store.

This unsettling experience in some ways mimics particular processes that we know are typical of traumatic memory. Judith Herman's (1994) research on trauma and memory in its domestic, political, and wartime contexts has shown us how personal and wartime atrocities give rise to a central dialectic of trauma which involves both the desire to deny and the urge to remember. This suspends victims/survivors between the past and the present, between remembrance and avoidance:

> The ordinary response to atrocities is to banish them from consciousness. Certain violations of the social compact are too terrible to utter aloud. This is the meaning of the word unspeakable. Atrocities, however, refuse to be buried . . . the conflict between the will to deny horrible events and the will to proclaim them aloud is the central dialectic of psychological trauma. (Herman 1994, 1)

I would argue that what is true at the individual level is also the case at the social and collective level. Societies have subsequently experienced the post-Holocaust world in terms of the simultaneous urges to deny, forget, and remember. A web page in cyberspace with its central panel that provides us with hypertext links to the Holocaust surrounded by commercial framing may be understood as mimicking this process, placing the visitor or user within the nexus of a virtual dialectic similar although obviously not the same as the post-traumatic. There

is a contradiction between the everyday (invitations for low cost flights and the weather) and the unique (the Holocaust), between the present (hypertext links to the news and the weather) and the past (hypertext links to Holocaust sites), between wanting to find out about and remember the Holocaust and its history (click on the Holocaust) and wanting to avoid it (click on the CD music store).

Thus, the underlying economic dynamic and commercial framing of digital representations is, as the political economy approach suggests, important. But the contradictions highlighted here also point to the importance of understanding them in connection to specific content, in this case content relating to the representation of the history and memory of the Holocaust in cyberspace. One way of understanding this is to use an approach that considers the processes of trauma and recovery within collective memory. As I argue in the following section, this approach provides us with some insights into other codes and conventions distinctive of digital forms on the World Wide Web and on CD-ROM in articulation with the content of the Holocaust.

Clicking on Hitler: From Icon to Home [page]

A distinctive aspect of both the Internet and CD-ROM to be considered in articulation with their translations of the Holocaust is their recency. Unlike the other visual media considered in this collection, they were not available as visual media during the events themselves. The World Wide Web only became accessible to nonspecialist users with the advent of HTML (Hyper Text Markup Language), invented in 1991 by British physicist Tim Berners-Lee at CERN in Switzerland. HTML meant that the Internet was made accessible to people who are not acquainted with complex computer programming codes. This accessibility occurred only as recently as the 1990s, enhanced by HTML Internet browsers such as Netscape to provide people with access to the Web through the simple click of a mouse on their home computer (Toulouse 1999, 2). In contrast, artifacts in museums are material legacies of the past with a real provenance. Other visual media, including black-and-white and color film and photography, provide representations from the time of the events themselves, as Dariusz Jablonski's (1998) use of color slides of the Lodz ghetto or Adrian Wood's extraordinary *The Second World War in Colour* (Wood 1999) have shown.[3] In contrast, web sites and CD-ROMs are solely reliant on these dislocated earlier representations.

Conversations and presentations in cyberspace are further characterized by their dislocation from time and space in a number of other ways; an e-mail address is not rooted within a national boundary, and neither is a web address. People may have multiple e-mail addresses, and the addresses of web pages change over time. Unlike films or videos, web presentations have no fixed narrative time;

unlike galleries, archives, and museums, cyberspace presentations may be easily "taken home," by downloading onto one's computer or visited frequently at any time of day or night.

In many ways this would seem to support Jean Baudrillard's (1993) description of a postmodern society that is characterized by the compression of time and space within an economy of simulation, in which our experiences and knowledge of the world are increasingly constructed not from the actual or real but their copies. Fabricated from something real, copies subsequently come to substitute for it (Baudrillard 1993, 125–85). John Pickering has subsequently argued that the Internet is the epitome of the simulacra society in this respect and that people's relationship with the world is increasingly becoming a virtual one (Pickering 1999, 175–80).

From this perspective, to visit the Simon Wiesenthal Centre on-line could be understood as part of a postmodern world of simulacra: there in the pixels of the VDU are 'Virtual Exhibits: on-line versions of past exhibitions from the Simon Wiesenthal Centre's Museum of Tolerance' (http://www.motlc.wiesenthal.com/). There one sees digital copies of artifacts, some of which may themselves be copies of artifacts. Likewise, one sees copies of photographs which are in themselves copies of originals. Little of the text is original but is extracted from other sources, such as the *Encyclopedia Judaica.* Click on an unnamed icon of a man—Hitler—to learn more about "The Nazis." Alternatively, click on an icon of an unnamed girl—Anne Frank—to learn more about "The Jews." At the top of each page we see another copy of Hitler, another copy of Anne Frank that may link us to further pages.

Likewise, an analysis of the CD-ROM *Lest We Forget* also demonstrates the dominance of simulacra and its reliance on previous forms, images, and recordings. This begins with the packaging of the disc itself. The CD-ROM comes in a gray box with a painted style Star of David in yellow. Over it we see the title *Lest We Forget,* and beneath it is the black-and-white photograph of a small boy in an overcoat, short trousers, and hat with his hands in the air in a gesture of surrender. Inside, the box opens to include six images from the CD surrounded by text headed with the caption "[we will never understand the Holocaust]." The images include an extract of text surrounded by stills of Adolf Hitler and Julius Streicher; a photograph of Hitler Youth; the same young boy as on the cover but with the figure of a German soldier aiming a gun at him also visible. Underneath these are digital stills of a graphic map of Poland and an aerial view of Auschwitz. The CD itself combines "photography, film footage, and sound with the historian's craft of information and context." A footnote informs us that the historian is Professor David Cesarani, academic consultant to the Wiener Library of London and professor of modern Jewish studies at the University of Manchester. The CD provides "archival video clips" and "a gallery of photographs from the collections of the Yad Vashem Museum in Jerusalem, the Holocaust Museum in Washington, the Bundes-Archiv in Berlin, the Auschwitz Museum in Oswiecim, and many other sources around the World." On the CD-ROM itself we see the same images from the box

cover. One returns between each section of the CD-ROM to the same three photographs of unnamed prisoners from Auschwitz.

Understanding these Holocaust memories in cyberspace from Baudrillard's perspective suggests that we consider these simulacra in terms of the general trend in late capitalism toward the loss of authenticity, truth, and originality. Yet, the evidence suggests that how people treat copies of the real in relation to the Holocaust is not in terms of Baudrillard's pessimistic vision of people believing that the copy is the real thing. It is notable that on the CD-ROM the nature of pixelated photographs or film stills is that of exaggerated reproduction, particularly if one clicks on the option to make the images full screen. The pixelated image is very obviously a poor copy with indistinct edges and patches lacking in detail.

The copying of Holocaust images and the subsequent tendency toward the formulaic has been remarked on by Barbie Zelizer in relation to the recycling of Holocaust photographs, to the extent that they "reduce what was known about the camps to familiar visual cues" (Zelizer 1998, 158). As visitors to not only websites but also museums and as viewers of documentaries and films, we often find ourselves seeing the same images over again. This is also a recognized feature of individual traumatic memory in response to atrocities, rendering it a feature of the way in which communities and societies respond over time to remembering the Holocaust. Part of the process of moving from trauma to recovery involves the shift from what has been described as frozen or indelible images out of context, to building a narrative of what happened:

> Out of the fragmented components of frozen imagery and sensation, patient and therapist slowly reassemble an organized, detailed, verbal account oriented in time and historical context. . . . At times the patient may spontaneously switch to non-verbal methods of communication, such as drawing or painting. Given the "iconic", visual nature of traumatic memories, creating pictures may represent the most effective initial approach to these "indelible images." (Herman 1994, 177)

In the Simon Wiesenthal Multi-Media Learning Centre website (http://www.motlc.wiesenthal.com), we have the experience at the beginning of our visit of clicking on copies of dislocated photographs relating to the Holocaust, some of which may already be habituated in our memories or in some way frozen. But within the website, we go through the process of linking and relocating these images to their historical and spatial context, beginning by clicking not on words or indexes of memory, but on icons. We enter the virtual Multi-Media Learning Centre, for example, and face a choice of icons: one choice is to click on Hitler, and from there we are led into the historical context and different aspects of the Nazis and the Holocaust. We read text about and look at photos relating to anti-Semitism, the rise of the Nazis, biographies of different Nazis, including Hitler, the policies and practices of the Nazis, their occupation of Europe, the establishment of concentration camps, ghettos, and death camps.

In addition, if we consider evidence on how people make meaning from Holocaust sites in cyberspace, we find an altogether different picture from the simplistic one of visitors mistaking copies for the real thing. PlanetClick (http://www. PlanetClick.com) rates Holocaust websites in terms of the number of visits to the site and the confidence rating given by visitors to the information available. Notably, the most highly rated sites are those that are not only constructed in virtuality but also have a reference to actuality.

Anne Frank's House (website) has a rating of 9.02 and a confidence rating that is "high." Yad Vashem has a rating of (8.97) and a confidence rating that is also "high." The U.S. Holocaust Museum site, the Mauthausen Concentration Camp Memorial site, and the Shoah Museum in Belgium site are also highly popular and rated with high to medium confidence. All of these virtual sites have actual sites. This suggests that visitors seeking memories and historical information on the Holocaust in cyberspace look for sites that are given legitimacy through a terrestrial anchor. Sites that visitors do not recognize as having a "real" counterpart in the world are less visited and treated with greater skepticism. In some ways this could be interpreted as the Internet equivalent of Roland Barthes's ideas concerning the ways in which words or text provide an anchor for the photograph (Barthes 1975, 15–31) or in terms of Susan Sontag's suggestion that archival footage in Holocaust documentaries leads to the need to anchor that footage (Sontag 1982, 403–21). The museum, memorial site, or archive could be seen as providing an institutional anchor for the website.

Yet, an analysis of the reviews by visitors on PlanetClick of various Holocaust websites suggests that the sites act as rehearsals or substitutes for visits to real places: reviewers often visit the cyberspace Holocaust site before or after visiting an actual memorial or museum. For example, one reviewer of the site for the Anne Frank House, Natalie Cohen, states: "I visited the Anne Frank House when I was in Amsterdam. *This site is as good as it if gets without a personal visit.* It is moving and informative; I recommend it highly" (www.PlanetClick.com/ reviews) (my emphasis).

A similar intertextual reference between the site's institutional anchor and its virtual counterpart is made by the anonymous reviewer for the site for Yad Vashem:

> The world-wide holocaust Museum in Jerusalem. The Jewish people's response to the Holocaust/Shoah, Yad Vashem is the fullest and most enriching Holocaust Memorial in the world. *If you can't get there in person, this site is the next best thing.* (www. PlanetClick.com/reviews). (my emphasis)

In addition, other reviews suggest that many visitors to Holocaust sites in cyberspace elide the virtual with the real. One anonymous reviewer for Yad Vashem simply describes the genesis of the institution itself: "Yad Vashem is the Holocaust memorial of the Jewish people. . . . A complex of museums, mon-

uments, research, teaching and resource centres" (http://www.PlanetClick.com/reviews). The review continues by providing basic facts about the Holocaust itself. Similarly the anonymous reviewers for Mauthausen Concentration Camp and for the Shoah Museum in Belgium (www.PlanetClick.com/reviews) describe the memorial and the museum respectively and the historical facts relating to them. The visitors to the Holocaust cybersites in these instances thus read virtual reality as actual reality. This could be interpreted as the epitome of the simulacra society in which people cease to notice that what they are experiencing is a copy of a copy and instead see the simulacra as the real thing. However, I would suggest that the visitor to a Holocaust website refuses the dislocation in terms of time and space that is a feature of cyberspace and of traumatic memory and instead seeks anchorage and authentication for the memories of the Holocaust in the real. The visitor in these instances who writes a review to introduce others to the site of Holocaust memory seeks to connect real people sitting at their computers at home or work with actual memorial sites and places rather than their virtual simulacra.

Furthermore, we know that one of the horrifying features about the Holocaust was the manner in which families and loved ones were torn apart, the manner in which Jewish culture and social groupings were relocated and dislocated. In many places Jewish people's history and culture were all but destroyed or eradicated in what Primo Levi in the *Drowned and the Saved* has termed the war on memory (Levi 1998). In contrast, the difficult journey of recovery from trauma, both collective and individual, caused by such atrocities involves the opposite: Judith Herman (1994) notes that one of the key steps to recovery after atrocity and to begin resolving the painful dialectic of traumatic memory is to rebuild the connections that were torn apart.

The particular processes experienced by the visitor to Holocaust websites articulated within the codes and conventions involved in digital media are similar, albeit on a much diluted level of the processes of reconnection involved in recovery from trauma. We tend to think of computers as apart from ourselves, as disconnected from human beings. Yet, ultimately, as Tim Jordan reminds us, "people do not communicate with computers but use computers to communicate with each other. And in so doing, genuine heartfelt communities may be built" (Jordan 1999, 57).

The cyberspacial memories of the Holocaust, with the particular codes and conventions of digital media, in some ways take us through the reverse of an atrocious journey of dislocation, annihilation, and disconnection. Initially, we enter a virtual world that is dislocated in time and space, we experience at moments the contradictory impulses of wanting to remember and wanting to forget as we are confronted with the dialectic of the commercial search engine page framing our matches on the word "Holocaust." As we enter a particular site, we begin with icons and seek to reconnect the virtual with the real. Ultimately, whereever we go, unlike the victims of the Holocaust, we can and do return to our own home [page].

The Virtually Unspeakable

In this respect, I would argue that the interactive and nonlinear narrative possibilities offered by digital formats using hypertext links allows for the history and stories of the Holocaust to be articulated in ways that are distinct from other visual forms. As Michael Frieling argues, multimedia with its combination of image sound and text moves beyond fragmentary aesthetics and allows for a layered approach to narrative (1996, 269). Similarly, Erkki Huhtamo has suggested that the hypertextual structure of CD-ROMs provides a new alternative to linear progression (1996). Hypertext in the CD-ROM, *Lest We Forget,* allows both direct access overview and instant access to any portion of the program. It allows for interactive and detailed timelines, interactive maps, and interactive graphics. It allows the reader to stop and start film footage and audio excerpts, to zoom in on photographs, to go back and forth in a nonlinear manner. An interactive map section allows the user to click on a timeline at the bottom and view gradually the expansion of Nazi Germany and its establishment of ghettos and camps throughout Europe, while exploring any individual camp or ghetto by clicking on its name and bringing up a text box with additional facts and figures. Further, one of the other features of atrocities is, as Herman's research shows, its "unspeakable" nature. Much of the debate concerning how to remember the Holocaust has concerned which form or medium is best to attempt this process of speaking the unspeakable. The computer has enabled the translation of previously divergent media into one form that also includes the iconic, which perhaps offers a new generation different possibilities for speaking the unspeakable and remembering the atrocious.

In some ways, this discussion calls to mind the more negative aspects of cyberspace caused by interactive hypertext links. For example, on the first page of the Simon Wiesenthal site, we are offered the choice to view a panel discussion on war crimes and war criminals. Yet, one's access is denied if the visitor does not have an updated version of Real Player software. There is, then, the opportunity to be redirected through a hypertext link to another website (http://www.real.com) so as to download the necessary viewing software. If one clicks on Real Player Plus even with a 56k modem it can take up to four hours to download the software, during which the website connection can be broken. One has been *distracted* from the original reason for going on-line to access information on the Holocaust and view a panel discussion for war crimes, which is frustrating and confusing. Interestingly, though, this too seems in some way to reenact a particular aspect of the central dialectic of trauma caused by atrocity. It involves both the urge to repress and remember, while the urge to repress or not remember often gives rise to symptoms of distraction, confusion, and distress (Herman, 1994).

To conclude, conventional approaches to the Internet and multimedia point to the importance of the structural context of Holocaust memories in cyberspace. They underscore too the extent to which Holocaust images are recycled or made

into simulacra. However, I would suggest that a more complex understanding can be achieved by moving away from conventional approaches to digital media toward considering how Holocaust websites and Holocaust multimedia are articulated within digital codes and conventions. How people themselves experience and relate to the Holocaust in cyberspace suggests a journey of remembering that reenacts or mimics the processes of traumatic memory and recovery from atrocity described by psychiatrists such as Judith Herman. The processes of dislocation, contradiction, relocation, connection, and interconnection that are involved when we engage with Holocaust sites in cyberspace makes clicking on Hitler a potentially different kind of journey from that offered by other visual media.

NOTES

1. This chapter is based on research I conducted in Poland, Britain, and the U.S. between 1998 and 1999. The research, funded by the United Kingdom's Higher Educational Funding Council via South Bank University, involved focus groups and interviews with young people aged between 16–24 years, in London, New York, Washington, D.C., Gdansk, Cracow, and Lodz in March 1998, November 1998, and March 1999.

2. I found similar fears among undergraduate students concerning denial sites for Serbian atrocities in Kosovo. It was suggested that they were infected with viruses that would affect the software of any visitors that downloaded pages from them. It is not clear whether this fear was real or gossip intended to put off people from accessing such sites.

3. Dariusz Jablonski's film (1998) about the Lodz ghetto, screened on many public television stations in Europe since 1998, makes use of the collection of some of the first color slides taken by ghetto official Walter Genewein and rediscovered in a Viennese antique shop in 1987. *The Second World War in Colour* (1999) makes use of color film and photographs unearthed by film archivist Adrian Wood since 1989.

REFERENCES

Barthes, Roland. 1975. "The Photographic Message." In Stephen Heath (ed.), *Image Music Text*, 15–31. London: Fontana.

Baudrillard, Jean. 1993. *Symbolic Exchange and Death*. London: Sage.

Bergman, Simone, and Liesbet Van Zoonen. 1999. "Fishing with False Teeth: Women, Gender and the Internet." In John Downey and Jim McGuigan (eds.), *Technocities*, 90–107. London: Sage.

Bourdieu, Pierre, and Alain Darbel, with Dominique Schnapper. *The Love of Art (Amour de l'Art): European Art Museums and Their Public*. Translated by Caroline Beattie and Nick Merriman. Cambridge: Polity Press, 1990.

Carter, Dave. 1997. "'Digital Democracy' or Information Aristocracy? Economic Regeneration and the Information Economy." In Brian D. Loader (ed.), *The Governance of Cyberspace: Politics, Technology and Global Restructuring*, 136–54. London: Routledge.

Cornford, James, and Kevin Robins. 1999. "New Media." In Jane Stokes and Anna Reading (eds.), *The Media in Britain: Current Debates and Developments*, 108–26. New York: St. Martins.

Cubitt, Sean. 1998. *Digital Aesthetics*. London: Sage.

Dear, Michael, and Stephen Flusty. 1999. "The Postmodern Urban Condition." In Michael Featherstone and Scott Lash (eds.), *Spaces of Culture: City—Nation—World*, 64–85. London: Sage.

Frieling, Michael. 1996. "Text in Motion and the Textscape of Electronic Media." In Lynn

Hershman Leeson (ed.), *Clicking in: Hot Links to the Digital Culture*, 269–80. Seattle: Bay Press.

Gates, David. "Of Texts and Hypertexts." *Newsweek*, February 27, 1995, 71–73.

Gibson, William. 1984. *Neuromancer*. London: Gollancz.

Herman, Judith Lewis. 1994. *Trauma and Recovery: From Domestic Abuse to Political Terror*. London: Pandora.

Huhtamo, Erkki. 1996. "Digital Treasures or Glimpses of Art on the CD-Rom Frontier." In Lynn Hershman Leeson (ed.), *Clicking in: Hot Links to the Digital Culture*, 308–19. Seattle: Bay Press.

Jablonski, Dariusz (Director). 1998. The Lodz Ghetto. Apple Film Production. Broadcast Av. TVP. S.A. Canal. Polska. Agencja Produkcjii Filmowej. MDR.

Jordan, Tim. 1999. *Cyberpower: The Culture and Politics of Cyberspace and the Internet*. London: Routledge.

Levi, Primo. 1998. *The Drowned and the Saved*. London: Abacus.

Pickering, John. 1999. "Designs on the City: Urban Experience in the Age of Electronic Reproduction." In Mike Featherstone and Scott Lash (eds.), *Spaces of Culture: City— Nation—World*, 168–85. London and New York: Sage.

Reading, Anna. Forthcoming. *Gender, Memory and Culture*. London: Macmillan.

Samuel, Raphael. 1994. *Theatres of Memory*. London: Verso.

Sontag, Susan. 1982. "Syberberg Hitler." In *Sontag: A Susan Sontag Reader*, 403–21. New York: Vintage.

Streck, John M. 1998. "Pulling the Plug on Electronic Town Meetings: Participatory Democracy and the Reality of the Usenet." In Chris Toulouse and Timothy W. Luke (eds.), *The Politics of Cyberspace*. New York and London: Routledge.

Toulouse, Chris. 1999. "The Internet and the Millennium." In *The Politics of Cyberspace*. New York and London: Routledge.

Whine, Michael. 1999. "The Far Right on the Internet." In Brian D. Loader (ed.), *The Governance of Cyberspace: Politics, Technology and Restructuring*, 208–27. London: Routledge.

Wood, Adrian. 1999. The Second World War in Colour (Three Parts) First screened on ITV, September 9, 1999, 9 P.M.

Zaglada Zydowa Krakowskich: Przewodnik Inspirowany Filmem Stevena Spielberga 'Lista Schlindera'. 1998. Kracow: Agencja Reklamowo-Wydadnicza 'Gestum'.

Zelizer, Barbie. 1998. *Remembering to Forget: Holocaust Memory Through the Camera's Eye*. Chicago: University of Chicago Press.

DIGITAL REFERENCES

CD-ROMs

Burke, A. Nadine. 1997. *Images From the Holocaust*. NTC Publishing Group.

Lest We Forget [A History of the Holocaust]. Multimedia CD ROM. 1999. Original Text by David Cesarani. Marketed by Logos Research Systems. Published by Endless S.A. Sitac and Media Investment Club.

Websites, accessed between June 15 and July 30, 1999
Alan Jacobs Photographs of Auschwitz:
http:// www.remember.org
Datafellows Virus Updates:
http:// www.datafellows.com
Euthanisia T-4 Program:
http://www.us-israel.org/jso
Forty Years Later: A Personal Recollection by Rav Yehuda:
http://www.virtual.co.il/edu

Holocaust Pictures Exhibition:
http://www.fmv.ulg.ac.be/schmitz/holocaust/html
Jeff and Elliott's Holocaust Page:
http://geocities.com/Athens/Olympus/9589
Jewish Historical Museum (Amsterdam):
http://www.jhm.nl/e home.htm.
K-Z Mauthausen-Gusen Concentration Camp:
http://linz.org.at/orf/gusen/index
Lycos Search Engine:
http:// www.lycos.co.uk
Museum of Jewish Heritage (New York):
http://www.mjhnyc.org
PlanetClick:
http://www.PlanetClick.com
PlanetClick Reviews:
http://www.PlanetClick.com\reviews
Survivors of the Shoah Visual History Foundation:
http://www.vhf.org
Remember the Women, New York:
http://www.rememberwomen.org/
Simon Wiesenthal Museum of Tolerance:
http:// www.wiesenthal.com
Stein's Resources on Genocide:
http://www.ess.uwe.ac.uk/genocide.
Wiesenthal Multimedia Learning Centre On-Line:
http://www.motlc.wiesenthal.com
U.S. Holocaust Museum Site:
http://www.ushmm.org
Yad Vashem Site:
http://www.yad-vashem.org.il/

Elizabeth Legge

Analogs of Loss:
Vera Frenkel's *Body Missing*
(http://www.yorku.ca/BodyMissing)

"Write."—"For whom?"—
"Write for the dead, for those in the past whom you love."—
"Will they read me?"—"No!"
An old saying slightly altered.

Revised in final copy; see 146:18:
[Deleted:] **death**
[Added in margin:] **disappearance**

—Pap.IV B 97:6 n.d., 1843[1]

The website constructed by the Canadian artist Vera Frenkel, *Body Missing*, deals with the great Nazi art plunder, and, obliquely, with the depredations of the Holocaust. *Body Missing* is a virtual palimpsest, in which layered confusions of time and location are of central importance. It is also a development of Frenkel's practice as an artist, which has been associated with complex videos about apparently fictitious and mysterious characters, installed in evocative staged settings—the generic bureaucratic office of a pornographer, the Paris hotel room of a Canadian woman novelist during the interwar years. Of particular relevance to *Body Missing* is Frenkel's own earlier installation piece, *. . . from the Transit Bar* (1992–96), which provides a locus for the framing narrative. Originally constructed for exhibition at the international art exposition *documenta IX* (1992),[2] *. . . from the Transit Bar* creates a highly ambiguous environment, combining the anonymity of an airport lounge with the crudeness of a school play version of *Casablanca*. Frenkel, who assumes a persona to play the narrator in her own work, served shifts as a bartender during the course of *Transit Bar's* exhibition, presumably adding the stories of the museum visitors to those that are part of the fabric of the piece.

Of key importance for *Body Missing* are the six television screens in the Transit Bar. These offer something other than hard-to-hear, easy-to-ignore bar television. On Frenkel's screens the speakers talk about experiences of immigration,

racism, loss of cultural identity, and exclusion. Behind them trains—identifiably North American trains—move by, which affiliate all these "ordinary" experiences of transportation and displacement with the Holocaust, especially as inflected by Claude Lanzmann's *Shoah*. The speakers' monologues, some of which are also part of *Body Missing*, are disconcertingly dubbed into Yiddish and Polish (languages lost to Frenkel by the displacement of her own family), with subtitles in dominant European languages: English, German, and French. This discrepancy between what one sees and what one hears intercepts any casual reception of these accounts. In one memorable story, a woman recalls her mother trying to push her off the train taking them to western Canada after the war. Her mother was certain that the train was not going to Regina, but, again, to Auschwitz.

Beyond the question of whether we are in a real bar with an art theme, or an art installation with a bar theme, there is further confusion for the museum spectator in the *Transit Bar*. Is this bar to be imagined as being at the edge of a war zone in 1940, with everyone trying to procure identification papers and visas? Or is it in some urban present, a downtown "themed" bar, a psychoanalytic version of a sports bar, where intellectuals discuss issues of identity and trauma? Further ambiguities arise from the conventional use of bars in movies and television, as places of transitory respite, unlikely encounters, confidences, artificial cheer, melancholy, and potential violence. The ambiguities of . . . *from the Transit Bar* carry through into *Body Missing*.

. . . *from the Transit Bar* and *Body Missing* derive from Frenkel's long-standing interest in charismatic figures and their various promises of "bliss." This first took shape in 1987 when Frenkel was an artist-in-residence at the Chicago Art Institute, and was billeted in Hefner Hall, formerly the Playboy Mansion. Among the ghosts of bunnies past, Frenkel began to consider the synthetic sexual bliss offered by Hefner. The work that came out of this, *TRUST ME IT'S BLISS: The Richard Wagner/Hugh Hefner Connection*, was based on an analogy between Hugh Hefner and another master of totalizing vision, Richard Wagner. From this exploration of relative aesthetic bliss Frenkel turned to consumer bliss. As an extension of an installation dealing with a new shopping center in Newcastle upon Tyne, Frenkel installed an electronic text on a billboard in Piccadilly Circus, beginning: "This is your Messiah speaking, instructing you to shop . . . " From the high and low blisses of Hefner, Wagner, and the shopping messiah, Frenkel has moved to address that most terrifying of modern blissmongers, Hitler. Frenkel is aware, of course, that all the loci of these promises of bliss implicate monuments (the Playboy Mansion, Bayreuth, the shopping mall, Berchtesgaden) and works of art as fulfillment of aesthetic bliss—the perfect centerfold, the Ring cycle, the art desired by Hitler, and, by implication, Frenkel's own transit bar and website.

The website, *Body Missing*, is cumulative and collective, encompassing some of Frenkel's own earlier work and contributions by a dozen other artists and writers.[3] It relocates or disembodies the more material (video and photographic transparency) version of the work, first installed in stairwells and windows of the

Offenes Kulturhaus in Linz, Austria.[4] *Body Missing* also derives from Frenkel's experiences as an artist-in-residence in Austria: at the Akademie der Bildenden Künste in Vienna (where Hitler had been twice rejected as a prospective art student, and where Nazi sympathizers on its staff later collaborated with Hitler's art theft policies); and at the Offenes Kulturhaus in Hitler's hometown, Linz. Struck by the basement corridors of crates at the Akademie, Frenkel began to consider Hitler's massive acquisition of art and his mania for monuments. The ostensible subject of *Body Missing* is the *Kunstraub*, the complex and secret wartime transportation of thousands of confiscated and stolen works of art. Those destined for the great unrealized Linz museum, under the operation known as Sonderauftrag Linz, were hidden in the nearby salt mines at Alt Aussee in Austria. After the war, these hoards were discovered by the Allies, who realized that many works were missing, possibly hemorrhaged to Russia, the United States, and elsewhere, including Austria. Many remain untraced.

Body Missing, then, ostensibly surveys the residue of one of Hitler's visions of bliss, with its massive mechanical apparatus of transportation and attendant bureaucracy of record keeping. This displacement of works of art amplifies the theme of human displacement in . . . *from the Transit Bar.* The *Transit Bar* within *Body Missing* is now fictively located on the real ground floor of the Offenes Kulturhaus in Linz; and its imaginary, all-infiltrating installation is inflected by the knowledge that the Offenes Kulturhaus once served as a Wehrmacht prison. There are floorplans and photographs and references to buildings, including Hitler's bunker, the Reichschancellery and the tunnels beneath it, throughout the website: its fictive times and spaces are layered and haunted (figure 1).

Vera Frenkel is present within *Body Missing* in the sly persona of a *Transit Bar* bartender. Privy to everyone's stories, she uses the information to observe the network of bar regulars/artists/resistance workers/art restorers/spies. She is both controlling author and disingenuous not-author, a narrator issuing disclaimers (she never listens in "on purpose"). She is partly a character from Le Carré or Deighton's spy novels, and partly the contemporary intellectual mindful of disowning authorship, weaving her own and others' memories, histories, lies, and exaggerations from the pose of neutral authority: "I write down everything just as I hear it . . . I hope you will excuse me if I remind you that what you are about to read is true."

In *Body Missing*, Frenkel raises questions and doubts, but turns any accusing fingers around like weathervanes in the Internet wind. Where do we stand? What did we do? What do we do now? All the artists and writers who contribute to *Body Missing* are moved to address a missing work of art. This does not mean a copy, which would imply that something lost could be replaced, but simply some empathetic "gesture" toward "an earlier artist and an absent work." Here, Frenkel acknowledges the ways in which our comprehension of the past involves the projection of current cultural values. So the Transit Bar "regulars" in *Body Missing* are simultaneously at work in different periods: they are a cultural resistance movement during the war, during the black marketeering period after the war, and now,

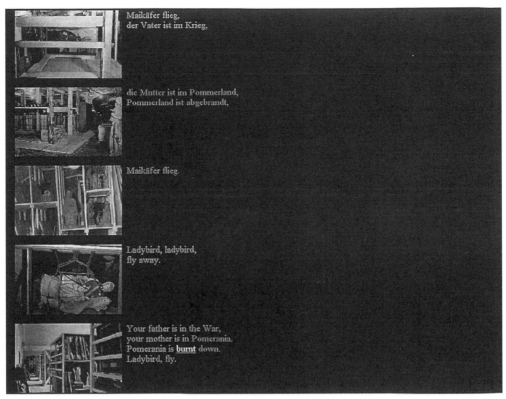

Figure 1. Vera Frenkel, "Storage Spaces," Body Missing, http://www.yorku.ca/BodyMissing/history/salt_mines.html

at the time of international debate about the appropriation of cultural properties of other countries and cultures, repatriation laws, and UNESCO conventions. And they, of course, emerge now, at a time when Nazi art theft, especially from Jewish collections, and potential restitution, have become an intensively studied legal, academic, and media topic.[5] Frenkel's project is, in part, a version of the role-playing games available on the Internet. It suggests that, as bar "regulars," we might occupy a time and space in which our participation and knowledge could influence the course of events.

The site begins with a diagram in Frenkel's fine archaic copperplate handwriting, like a cryptic treasure map (figure 2). Inside the website, we move from documentation (excerpts from the Breitenbach report of the United States Monuments and Fine Arts and Archives Section, 1945–48, newspaper articles, Hitler's last will and testament), to the stories, poems, pictures, and dream accounts of the *"Transit Bar* Regulars" (artists, bartenders, piano players). The website, then, is a collaborative work of indefinite, or infinite, dimensions. It anticipates change as more contributions—including, implicitly, our own, since there is a message board—are added. The contributions of the bar regulars range from Judith Schwarz's enigmatic image of hands in crude pixels holding up what is apparently a photograph of lightning (a literalization perhaps of the "gesture" toward a lost work of

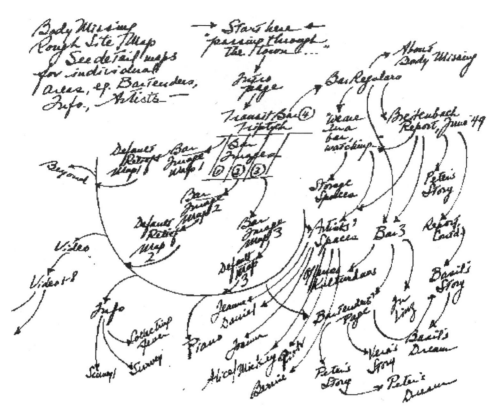

Figure 2. Vera Frenkel, "Site Map," Body Missing, http://www.yorku.ca/BodyMissing/
barspace/site_map.html

art), to Jeanne Randolph's startling Moebius strip poem playing on psychoanalysis's
revelation of loss in language, to Daniel Olson's accounts of never-quite-believed
grandfather's tales of the war. Mickey Meads and Alice Mansell take on the psy-
chosexual anxieties underlying Hitler's choice of a pilfered Courbet lesbian scene
for his bunker under the chancellery; this is weighed against the puritan official
meanings—health, sport, reproduction—attached to the nude by Nazi cultural the-
ory, in which life was required to imitate the normative in art. This consideration
of which cultural values may be 'inscribed' on the nude body also stakes out con-
temporary issues. Mansell and Meads also raise the matter of canonicity: Why are
some works considered masterworks? Bernie Miller, similarly, in considering the
nature of monuments, draws attention to the "other" body of artwork, the mod-
ernist "decadent art" destroyed or sold off by the Nazis to raise money to buy
the pure "masterworks" intended for the Linz Führermuseum. In this, the values
informing current museum practice, the critical and intellectual standards that
determine which works may be deaccessioned to buy more desirable works, are
queried by their travesty in the Nazi Decadent art purges, and equally, in the
mix of masterworks and kitsch selected by Hitler and his aesthetic arbiters. ("Do

we have to do the kitsch as well?" laments one of Frenkel's bar regulars, an art restorer.)

As a culmination of this conjured space and time, Frenkel's website is, ironically, the final site of collapse of the unrealized Linz Führermuseum. One hotlink drops us into a passage from Hitler's private will (April 29, 1945), dealing with the intended fate of his art collection. Written in the face of his defeat, it is a reverse House-That-Jack-Built: "All I own . . . if any of it is of value—belongs to the Party, and if the latter should no longer exist, it belongs to the state, and if the latter should be destroyed as well, no further decision on my part is needed." Here, Hitler's evocation of neo-classical models of deathbed self-sacrifice for higher patrial causes is equally a shrugging of responsibility. The self-deprecating "if any of it is of value" necessarily inflects all the works of art, past and present, imagined in Frenkel's website. Whatever commercial value the confiscated works of art may have had, their value is paradoxically inflated by the enormity of their theft.

Body Missing builds itself around an absence (the lost works of art and the museum that was intended to house them). Contemporary intellectual preoccupation with loss and absence involves the theorizing of representation as a failure: no representation can fully represent or materialize what was actually desired or intended, and any artwork can only be a substitute for the desired thing. It is characteristic of Frenkel's wry intelligence that she takes a tangible loss—the works of art for the Linz museum—and uses it to suggest the metaphors of loss permeating our cultural theory. Frenkel has observed, "To say we live in invented reality is a way of saying that we live in metaphor, but it's an invention that's just air without the evidence of the body, and that evidence in turn, concrete as it seems, has no meaning without metaphor."[6]

The title of *Body Missing*, offered with characteristically wry bathos, suggests a formulaic mystery novel, with an ingenious solution and ultimately retrievable body. It also resonates with the principle of justice, habeus corpus, necessarily failed if the body is missing. If the body in question is the body of lost art, this of course appears to be a metaphor: the crates in the corridors of the Vienna Art Academy, suggesting both contents and emptiness, inevitably call to mind the piles of confiscated suitcases, the shoes, the mass graves, the Holocaust. Or, rather, the ambiguous or neutral images of various architectural environments and objects in Frenkel's website evoke other, horrifyingly inhabited photographs, which are not present. *Body Missing* leads to an infinity of bodies. In fact, Frenkel investigated the surviving Jewish communities in Kassel, Germany, when . . . *from the Transit Bar* was exhibited there at the 1992 *documenta IX* exhibition, and again, in Linz. She discovered only a handful of people, of whom a number were Germans or Austrians living as Jews—the principle of substitution and displacement actively at work. But there is a paradoxical caution in Frenkel's work against our sealing the lost artworks and lost people into a closed metaphorical loop; closure would force too limited and too trivial a meaning. "Loss," like the "other,"

is not one homogeneous thing. Frenkel, more subtly, multiplies the possibilities and shifting categories of loss. While each may project the shadow of another disappearance, losses are not equivalences.

The categories of loss within *Body Missing* take the form of lists. In this, modern art's love of documentation is uneasily quoted and turned inside out by Frenkel, who examined uncatalogued plans and documents in the Linz archives. Most startling of the art-related lists is the "master list" assembled by Frenkel, the "list of lists." As various art hoards were looted after the war, lists circulated on the black market of which works of art might be available. One middleman with a list would lead to another middleman with a list, and so on—perhaps eventually leading to an actual work of art. Frenkel's master list of categories, however, is a litany of loss: "what was collected, what was stolen . . . what was hidden, what can only be shown privately, what is heirless, what is still in dispute in the courts, what was unsuccessfully claimed, what is still missing . . . " This list of lists and the attendant regiment of middlemen is almost comically illustrative of a metonymic, Lacanian, endless deferral of the desired object.

Betty Spackman and Anja Westerfrölke's contribution to *Body Missing* contains savagely ironic lists of horrifying disproportions and absurdities: a list of theories about Auschwitz (denial, product of chance, complicity of its victims, liberation of the modern world from an archaic cultural fossil, Jews dying for the sins of the world, Zionist conspiracy, "thou shalt not make theories about Auschwitz"), and its parody, "What makes an artist?" (being abused as a child, being abused as an adult, having a crush on Warhol, taking art history courses, being male, being female, going to the right art academy, suffering persecution for your beliefs, having a sales strategy). All of these lists mutually distort, and all lead back to Hitler as master of genocide, failed artist, and would-be curator.

The recognition of Hitler's delusional role as master-curator functions as a cautionary model to any art museum in which *Body Missing* is accessed. Legitimate ownership of art is a vexed contemporary problem, addressed at symposia in Linz and in Bremen, at the time of the first and third installations of *Body Missing*. At what point do matters of cultural theft and appropriation stop? There were exhibitions in 1994 in Russia of works plundered from Germany by the Soviets: are these legitimate war reparations? The Musée d'Orsay exhibited works in possession of the French government that had never been claimed by their owners—in this case, it is the owners, not the works, that are lost. Recently, the Museum of Modern Art in New York has been involved in legal action concerning Nazi-confiscated paintings in a traveling exhibition; and Austria's restitution commission has decided against restoring Klimt paintings to the families from whom they were stolen.[7] *Body Missing* inevitably draws attention to the residual taint of the *Kunstraub* within the commercial and institutional circulation of art.

The consumerism of art buying takes us back to the varieties of lists that echo through *Body Missing*. Frenkel's work tells us that each work of art transported by the Nazis had an acquisition number, inventory number, insurance

number, auction or source of sale number, numbers for country, region, district, city, public museum, and private collection. With such a row of numbers, one could learn everything about the history of a work—except for the fact that the key to the codes has been lost. The numbers are just numbers, with no remaining function. This neatly turns the thoroughness of the filing system inside out; it also incidentally parodies the bar code, so essential to commercial retail and archival inventory systems. These lists inevitably stand both for the efficiency of Nazi bureaucracy and for the curious inadequacy of its record keeping regarding mass murder.

As consumers of Internet information navigating *Body Missing*, we enter into all its histories. These include the Nazi plan to blow up the salt mines of Alt Aussee along with the six thousand artworks stored there, in the event of Allied invasion. After the war, the miners, along with many others, took credit for sabotaging this plan. This is a small allegory of complicity and historical revisionism, and, as "bar regulars" working on the project to recuperate the lost artworks, we are, like the miners, lined up to take credit with the resistance and the good guys. But we are also consumers of museum culture and—perhaps stolen or appropriated—art.

If *Body Missing* is the limbo of works of art intended for Hitler's Linz museum, it is also the museum at large, the mythic museum of our times available in infinite photo reproduction, from Benjamin to Malraux to current projects to digitize and download the collections of major art museums (including the contents of their giftshops). *Body Missing* raises questions about the status of art objects on the Internet. Will the physical work of art exist as a material referent anymore, or, rather, will it exist as something more than a *referent? Body Missing* refers to the absence of works of art, and, in its website form, it necessarily embodies this absence.

In various ways *Body Missing* both celebrates and questions the claims made for the technology of the "worldwide" web—its earth-spanning, boundary-crossing information, its possibilities of communication and community of interests as a kind of super pen-pal, its McLuhanist version of blissful messianic promise. On the dark side of these utopian claims, the pornography, hate literature, and Holocaust denial so readily retrieved from the Internet provoke debate about censorship. (Frenkel has long rejected the simple censorship solution, arguing that it is in collusion with pornography.)[8] Her *Transit Bar* texts repeatedly raise the matter of the "truth" of stories, and we are cautioned in *Body Missing* that "the truth is always partial." None of the stories, memories, drawings, documents, and fictions of *Body Missing* can be guaranteed or authenticated; and this suggests a particular response to the demands for proof that attend Holocaust denial. The very layering of the buildings, real and imagined in *Body Missing* (the *Transit Bar*, the Offenes Kulturhaus, the Hitler Museum, the Wehrmacht prison), uneasily conjures a staple of Holocaust denial: that "that" building was not used for that sinister purpose.[9]

If Frenkel's bar regulars are asked to make a gesture toward a lost work of art, that gesture evades status as "representation." The tracking of lost artworks, the picture trails and provenances, have no claim to "represent." The new "gestures" (not restorations, not reproductions) stand in relation to the lost artworks (many of which are beyond recall as they were not photographed) as the wielding of representation stands in relation to the Holocaust. Frenkel's starting point is the unrepresentability of the events and places of destruction of European Jews, but her work argues for the necessity of making a gesture. That gesture is itself a metaphor. In *Body Missing* metaphor is sustained by its own ironic fragility: the machinery of loss operating through the *Kunstraub* certainly functions as a transparent representation—that is to say, more precisely, evasion—of representing the Holocaust. While the apparatus of the *Kunstraub* may be homologous to the apparatus of Nazi mass murder, the *Kunstraub* cannot be analogous to the Holocaust. Frenkel's *Kunstraub* is akin to the astronomer's "light-year," as a way of achieving a comprehensible scale for enormity.[10] While a light-year is, of course, not a metaphor, it may be used metaphorically.

There is throughout *Body Missing* an ambiguity about what the nature and purpose of the site actually might be. There is a constant shift of identity, in that it functions as an archive of material relative to Nazi art theft, a bibliography of Third Reich cultural policies, an art restoration project, and a conceptual artwork. Conceptual art has always skirmished with documentation in its critique, supporting its skepticism about the institutional terms of its own existence. For example, Hans Haacke's 1974 project for the Cologne Wallraf-Richartz Museum simply charted a corrosive provenance for Manet's *Bunch of Asparagus*, in the museum's permanent collection: it had been owned by Jewish collectors and dealers before the war, until it was purchased for the museum. There has always been a degree of cynical play in conceptual art's use of supporting material, recognizing the paradox that, to the degree that it is art, it undermines its own documentary capacity.[11] Here Frenkel takes up this game, but with the highest possible stakes. Her website is perhaps an effective example of a sign made credible by its allusions to its own artifice and arbitrariness—and here we enter the great hall of mirrors surrounding the rhetorics of persuasion.[12]

Frenkel's deployment of the rhetoric of fact—Hitler's will, archival photographs, floor plans, excerpts from official reports—breaks against the apparently fictional, evocative, and poetic stories and images contributed by the governing narrative and its various "regulars." The virtual times and spaces peculiar to the Internet are exploited by Frenkel, as her website's hotlinks "drop" us into different eras, and places, and buildings. Equally, we drop from one rhetorical mode to another. The heterogeneity and inconsistencies of the site, as in a dream of falling, bedevil any notion of tracking or finding something lost. The structuring of the website makes it clear that there is no possible single method of investigation and no solution. If, ultimately, documentary evidence can be doubted, art's fabrications and provisional nature, while evidently fabricated, must persuade.[13]

But persuade whom? Frenkel's work, which makes a provisional virtue of its own partial nature, its obliqueness, synecdoche, and the insufficiency of its metonymy, addresses a particular audience—we imagine artists, collectors, curators, critics, those interested in art—in ways diametrically opposed to the rhetorical expectations we might have of a denier of Holocaust denial. The stereotypical plain-speaking Holocaust-denier, who argues from evidence and its lack, is not to be addressed here on his or her own terms. Frenkel's work alludes to, but does not claim to be, one of the vast websites that offer information ("cybraries") and documentation of the Holocaust.[14] At the heart of Frenkel's mystery story is another fundamental incommensurability: truth and evidence, with testimony, as always, residing between them.

Finally, in its discrepant times and spaces, *Body Missing* suggests Foucault's "heterotopias"—those real "countersites" that exist "outside of all places" in which society isolates crises or deviance.[15] A heterotopia may juxtapose within its single real space several sites that are, in themselves, incompatible. Frenkel's website, arguably, makes of the museum—as horde of missing art, as concentration camp—just such a heterotopia, and draws into itself any other situation in which it is presented, including the inherently heterotopic anthology.[16]

NOTES

My thanks for their various advice to: Vera Frenkel, Naomi Marrus Kriss, and Professors Suzanne Akbari and Marc Gotlieb of the University of Toronto.

1. Annotations of Søren Kierkegaard journal notes, *Fear and Trembling* (Princeton: Princeton University Press, 1983), 244. Daniel Olson presents this passage as copied into his grandfather's journal, in "Barfly," *Body Missing* website.

2. *documenta IX* was held in Kassel, Germany. . . . *from the Transit Bar* has since been installed, among other places, at The Power Plant, Toronto; the National Gallery of Canada, Ottawa; Royal University College of Fine Arts, Stockholm; Lillehammer Art Museum, Norway; Ars Nova and Turku Art Museum, Finland; and the Centre of Contemporary Art, Warsaw, Poland.

3. The contributors to *Body Missing* are: Thomas Büsch and Reinhard Moeller, Peter Chin, Michel Daigneault, Catherine Duncanson, Claudia Eichbauer, Monica Haim, Gordon Jocelyn, Joanna Jones, Alexina Louie, Alice Mansell, Mickey Meads, Bernie Miller, Piotr Nathan, Daniel Olson, Basil Papademos, Karin Puck, Jeanne Randolph, Iain Robertson, Julian Samuel, Bernie Schiff, Stephen Schofield, Betty Spackman, Barbara Sternberg, Judith Schwarz, Eileen Thalenberg, Elyakim Taussig, Anja Westerfrölke, and Tim Whiten.

4. It has also been exhibited as a multimedia installation at the Gesellschaft für Actuelle Kunst, Bremen. Most recently, in July 2000, it will be installed in the Freud Museum in Vienna, as an extended installation that takes into account issues raised by the ascendance of Haider's Freedom Party. Frenkel says, "There are few sites more telling than the apartment from which that old man was forced in 1938 to take a stand against the anti-immigrant policies of the so-called Freedom Party; so that, in various ways, is what is planned" (letter to Elizabeth Legge, February 27, 2000).

5. Frenkel includes an extensive bibliography of relevant material in *Body Missing*. For one recent example of popular media attention to art stolen from Jewish collections, see Suren Melikian, "Rothschild Objects Spur Buying Frenzy," *Art Newspaper*, July 10, 1999, <art.newspaper.com>; and Carol Vogel, "Austrian Rothschilds Decide to Sell," April 10, 1999, Arts & Ideas/ Cultural Desk.

6. Conversation with Vera Frenkel, August 1996; also in Matthias Winzen, *Deep Storage: Arsenale der Erinnerung* (Munich: Haus der Kunst, 1997).

7. See Judith H. Dobrzynski, "Appeal Court Tells Museum to Hold Austrian Paintings," *New York Times*, March 17, 1999, Metropolitan Desk; and Judith H. Dobrzynski, "Austria Refuses to Cede Klimt Paintings," *New York Times*, July 1, 1999, Arts/Cultural Desk.

8. Vera Frenkel dealt with this in her videotape and installation, *The Business of Frightened Desires, or, the Making of a Pornographer*, 1987.

9. On the gas chamber argument, see Jean-Francois Lyotard, *The Differend: Phrases in Dispute*, tr. Georges Van Den Abbeele (Manchester: Manchester University Press, 1988), 3–5.

10. There is a danger of lapsing into use of the mathematical sublime itself, as a metaphor.

11. Christian Boltanski sets himself up as an unreliable documentarian, alluding to the Holocaust. See Martin Kimmelman, "Dead Reckoning," *New York Times*, January 15, 1991, Art.

12. See James Young, *Writing and Rewriting the Holocaust: Narrative and the Consequences of Interpretation* (Bloomington: Indiana University Press, 1988), 79.

13. See Young, 133, on the uses of "inequitable metaphor"; and Miriam Bratu Hansen on Claude Lanzmann's rejection of archival footage, "*Schindler's List* is not *Shoah:* The Second Commandment, Popular Modernism, and Public Memory," *Critical Inquiry* 22 (Winter 1996): 301.

14. See, for example, Stuart D. Stein, University of West England, Web Genocide Documentation Centre http://www.ess.uwe.ac.uk/genocide.htm, and Michael Declan Dunn, Cybrary of the Holocaust www.remember.org/index.html.

15. Michel Foucault, "Of Other Spaces," in *Visual Culture Reader*, ed. Nicholas Mirzoeff (London and New York: Routledge, 1998), 239–41.

16. See Kevin Hetherington, *The Badlands of Modernity: Heterotopia and Social Ordering* (London and New York: Routledge, 1997), 56–64. On website as heterotopia, see "Heterotopic Spaces Online"—<http://english.ttu.edu/kairos/3.1/coverweb/galin/archive.htm>.

Contributors

DORA APEL is the W. Hawkins Ferry Chair in Twentieth-Century Art History and Criticism at Wayne State University. "The Tattooed Jew" is a shortened version of a chapter in her current critical study of contemporary Holocaust imagery in American culture. She has also published on imagery of World War I during the Weimar Republic in *The Art Bulletin* and *New German Critique*.

LAWRENCE DOUGLAS is an Associate Professor of Law, Jurisprudence, and Social Thought at Amherst College. He is the author of *The Memory of Judgment: Making Law and History in the Trials of the Holocaust* (2000).

MIRIAM BRATU HANSEN is the Ferdinand Schevill Distinguished Service Professor in the Humanities at the University of Chicago, where she teaches in the Department of English and the Committee on Cinema and Media Studies. She is currently working on her book, *The Other Frankfurt School: Kracauer, Benjamin and Adorno on Cinema and Modernity*.

GEOFFREY HARTMAN, Sterling Professor of English and Comparative Literature (Emeritus) at Yale University, is a founder and the project director of its Fortunoff Video Archive for Holocaust Testimonies. His latest books are *The Longest Shadow: In the Aftermath of the Holocaust* (1996), *The Fateful Question of Culture* (1997), and *A Critic's Journey: Literary Reflections, 1958–1998* (1999).

MARIANNE HIRSCH is Professor of French and Comparative Literature at Dartmouth College. Her recent books are *The Mother/Daughter Plot Narrative, Psychoanalysis, Feminism* (1989) and *Family Frames: Photography, Narrative and Postmemory* (1997). She also coedited *The Voyage In: Fictions of Female Development* (1983), *Conflicts in Feminism* (1991), and *Ecritures de femmes: Nouvelles Cartographies* (1996), and is the editor of *The Familial Gaze* (1998).

ANDREAS HUYSSEN is the Villard Professor of German and Comparative Literature and Director of the Center for Comparative Literature and Society at Columbia University. His publications include *After the Great Divide: Modernism, Mass Culture, Postmodernism* (1986) and *Twilight Memories: Marking Time in a Culture of Amnesia* (1995). He is coeditor of *New German Critique*.

TAMAR KATRIEL is a Professor of Communication and Education at the University of Haifa. She is the author of *Talking Straight: "Dugri" Speech in Israeli Sabra Culture*

(1986), *Communal Webs: Communication and Culture in Contemporary Israel* (1991), and *Performing the Past: A Study of Israeli Settlement Museums* (1997).

ELIZABETH LEGGE is Assistant Professor of Fine Art and Art History at the University of Toronto and is a fellow of Victoria College. She has written on Dada, surrealism, and contemporary art. She is currently working on a study of the artist and filmmaker Michael Snow.

YOSEFA LOSHITZKY is Senior Lecturer in the Department of Communication and Journalism at the Hebrew University of Jerusalem, Israel. She is the author of *The Radical Faces of Godard and Bertolucci* (1995) and *Conflicting Projections: Identity Politics on the Israeli Screen* (2000) and editor of *Spielberg's Holocaust: Critical Perspectives on "Schindler's List"* (1997). She has also written extensively on film, media, and culture, and is on the editorial board of *Cinema Journal.* She is currently writing a book on the representation of the "other" and "stranger" in European cinema.

ANNA READING is Principal Lecturer in Media and Arts and Director of the Media and Society Program at South Bank University, London, United Kingdom. Her book on gender representation, collective memory, and the Holocaust, *Gender, Memory, and Culture,* is forthcoming (Macmillan).

LISA SALTZMAN is Assistant Professor of Art History at Bryn Mawr College. She is the author of *Anselm Kiefer and Art after Auschwitz* (1999) and is currently working on a project about memory and representation.

JEFFREY SHANDLER is presently the Smart Family Fellow at the Allen and Joan Bildner Center for the Study of Jewish Life at Rutgers University. He is the author of *While America Watches: Televising the Holocaust* (1999). He is currently working on a study of Yiddish culture in the post-Holocaust era.

ERNST VAN ALPHEN is Professor of Comparative Literature at the University of Leiden, The Netherlands. He previously published, in English, *Caught by History: Holocaust Effects in Contemporary Art, Literature, and Theory* (1997) and *Francis Bacon and the Loss of Self* (1993).

LILIANE WEISSBERG is the Joseph B. Glossberg Term Professor in the Humanities and Professor of German and Comparative Literature and Chair of the Program in Comparative Literature and Literary Theory at the University of Pennsylvania. Among her recent publications are the critical edition of *Hannah Arendt's Rahel Varnhagen: Life of a Jewess* (1997) and the anthology *Cultural Memory and the Construction of Identity* (1999, together with Dan Ben-Amos). Her anthology, *Romancing the Shadow: Poe and Race* (with J. Gerald Kennedy), will appear later this year from Oxford University Press. She is currently completing a book on German-Jewish autobiography in the late eighteenth century.

JAMES E. YOUNG is a Professor of English and Judaic Studies at the University of Massachusetts at Amherst and currently Chair of the Department of Judaic and Near Eastern Studies. He is the editor of *The Art of Memory* (1994) and the author of *Writing and Rewriting the Holocaust* (1988), *The Texture of Memory* (1993), and *At Memory's Edge: After-Images of the Holocaust in Contemporary Art and Architecture* (2000), from which the essay in this volume is drawn.

BARBIE ZELIZER is the Raymond Williams Term Chair and Associate Professor of Communication at the Annenberg School for Communication at the University of Pennsylvania. She is most recently author of *Remembering to Forget: Holocaust Memory*

Through the Camera's Eye (1998), which won the Simon Wiesenthal Center's Bruno Brand Tolerance Book Award, the National Communication Association's Diamond Book Award, and the International Communication Association's Best Book Award. A media critic whose work has appeared in *The Nation* and *The Jim Lehrer News Hour,* she also published *Covering the Body: The Kennedy Assassination, the Media and the Shaping of Collective Memory* (1992) and coauthored *Almost Midnight: Reforming the Late Night News* (1980). She is coeditor of *Journalism: Theory, Practice, and Criticism* (2001).

Index